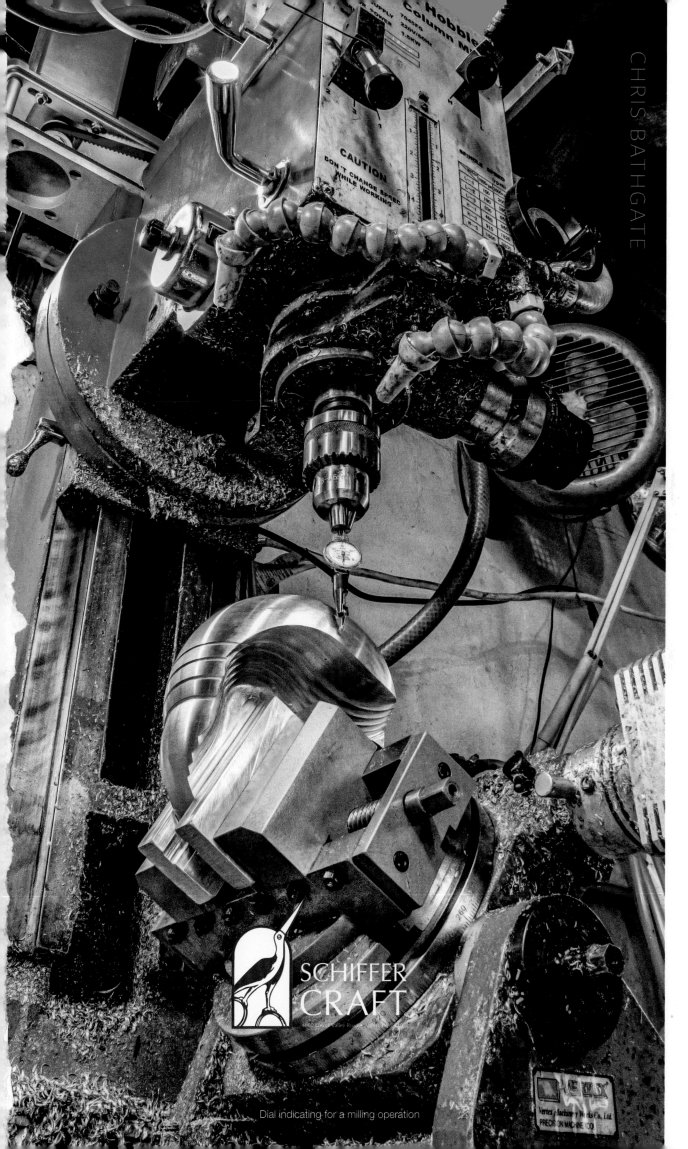

THE MACHINIST SCULPTOR

CHRIS BATHGATE

SCHIFFER CRAFT

4880 Lower Valley Road • Atglen, PA

Dial indicating for a milling operation

Other Schiffer Books on Related Subjects:
Direct Metal Sculpture,
Dona Z. Meilach,
ISBN 978-0-7643-1254-0

Korean Metal Art: Techniques, Inspiration, and Traditions,
Komelia Hongja Okim,
ISBN 978-0-7643-5779-4

Designed by Chris Bathgate
Cover design by Ashley Millhouse
Type set in Avenir Next

ISBN: 978-0-7643-6755-7
Printed in China

Published by Schiffer Publishing, Ltd.
4880 Lower Valley Road
Atglen, PA 19310
Phone: (610) 593-1777; Fax: (610) 593-2002
Email: Info@schifferbooks.com
Web: www.schifferbooks.com

For our complete selection of fine books on this and related subjects, please visit our website at www.schifferbooks.com. You may also write for a free catalog.

Schiffer Publishing's titles are available at special discounts for bulk purchases for sales promotions or premiums. Special editions, including personalized covers, corporate imprints, and excerpts, can be created in large quantities for special needs. For more information, contact the publisher.

We are always looking for people to write books on new and related subjects. If you have an idea for a book, please contact us at proposals@schifferbooks.com.

DEDICATION

There are many things that go into being a professional artist besides the skills to make the actual work. One must possess diverse talents, far more than one person can become proficient at in a lifetime. Because of this fact, I dedicate this book to the many people who have lent their particular abilities to the cause of seeing me and my work flourish. Thank you to my wife for making me a better writer, husband, and father. Thank you to my best friend Aaron for making me a better photographer. Thank you to my friend April for letting me talk about myself for far too long. And to my twin sister Tiffany who has helped me more in my work than she will allow me to publicly give her credit.

Contents

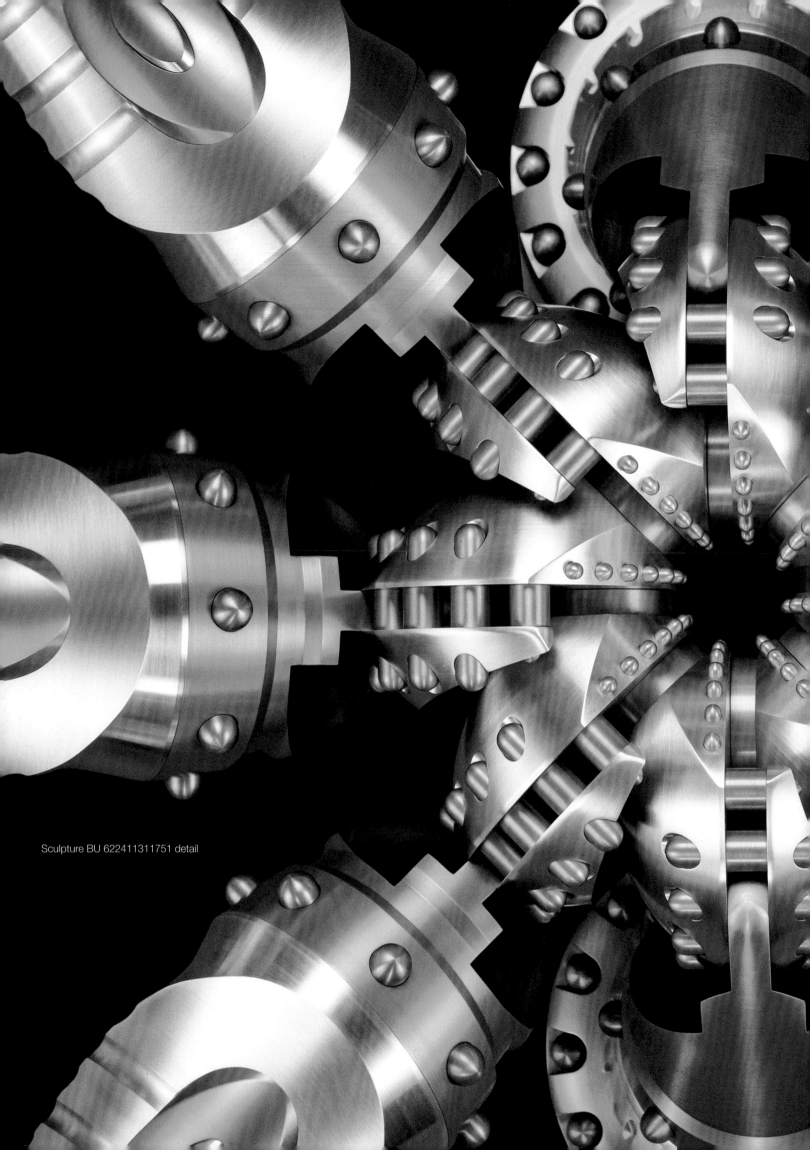

Sculpture BU 622411311751 detail

Preface

One of the earliest habits I picked up as an artist was to write something about each work I make. Sometimes I write about a stray thought I have while I work or a specific challenge I encounter; sometimes it is purely technical. Over time, patterns emerged from these writing exercises that helped me think more clearly about what I hoped to achieve as an artist and to make connections among the worlds of machining, craft, and design. The more I worked, the more I came to realize that my journey was uniquely situated to tell a story a little bigger than myself, and a book emerged. The essays in these pages take you through my experience learning how to be creative within the highly technical field of machining and move into my observations about the confluence of history and contemporary trends that have now opened the doors for all artists to participate in this fascinating craft.

Some logistics: over time, my work has split into two distinct categories—what I consider more "traditional" sculpture, and what I call "design editions." I have attempted to distinguish these two types of work as they appear in the book through a simple color-coded system.

Traditional sculpture is just what it sounds like—one-of-a-kind works that represent the main thrust of my artistic practice. These images populate the book from front to back and are set against white paper. In most cases. there is no accompanying text, since these works are meant to be more openly interpreted.

My design editions are smaller works that have a narrower conceptual focus. Produced in limited editions, these works are oriented toward exploring ideas around craft, design, and other machinist trends. They begin appearing about halfway through the book, and their images are set against gray paper. In most cases, these layouts have accompanying text frames to provide a small amount of context for the project or to describe the object's inner workings.

These two types of sculpture making have an enormous influence on one another, but I feel it is important to distinguish where in my creative practice I place certain works. Highlighting these different approaches to art making helps me structure how I talk (and think) about my journey through the labyrinthine discipline that is modern machine work. I hope that this differentiation will also enhance your experience of the book.

I'd also like to note that within the pages of this book, I use the terms "art," "craft," and "design" (as well as their derivatives) pretty liberally and interchangeably. This is because while, historically, these terms were used to parse the various identities and vocations of makers, in a modern-day context, these distinctions make much less sense. Every artist is a designer and a craftsperson—and the other way around. I do attempt to address each of those ideas separately—since it can be a useful construct—but I have ultimately concluded that if you make stuff, no matter what it is, you embody each of those identities to varying degrees. In the context of machining, this multidisciplinarity is doubly true. If you disagree with this sentiment, you are not alone, but a lifetime of experience has shown me otherwise, and this is my book.

Introduction

It is not uncommon to talk to artists with an interest in digital-fabrication technologies who also express reservations about whether they could be successful at it. They are smart, creative people who nonetheless feel they lack a certain aptitude to learn such seemingly complex and technical tools.

I have also had conversations with engineers, machinists, and the occasional scientist who articulate a desire to pursue some kind of art making, but who are struggling with how to begin. Having spent years in highly technical careers, these professionals crave work that is more creative and personally fulfilling. They want to use their imagination but worry they might not have one. Just as common, they are unable to rationalize making something that has no utility, as if art has no function.

I have somehow found myself neatly situated between these extremes. I see no contradiction in making expressive art that also allows for the pursuit of technical lines of inquiry. I see art as an extension of the kind of discovery that kids partake in through play. As adults, we have no obligation to abandon play; we need only change its nature so that it grows along with us. Art is the vehicle that I chose to try to learn about the world, because it is highly adaptable and arguably more fun. Strangely, the pursuit of art has brought me closer to the world of engineers and the sciences than I had ever imagined.

I find that most artists I talk to intuitively understand and even share my desire to bend creative work toward learning new things. I can usually dispel them of any notion that becoming proficient with a given technology is beyond their ability. However, I often struggle in convincing engineers, tradespeople, and machinists of the intrinsic value of creative work. Even though there is plenty of scientific research showing the personal and cultural benefits of art making, some things are just harder to quantify in the eyes of the technically minded.

The idea that anyone can participate in and derive satisfaction from the arts has its roots in various craft movements that populated the twentieth century. The Arts and Crafts movement in the US dates to around 1900 and arose as a reaction to factory-made goods and a type of ornamentation that was viewed as too far removed from an object's construction and design. The movement celebrated the artist both as a designer and a maker of goods, with an emphasis on the preservation of technical skills that were being undermined by the use of the assembly line and the division of labor. Later, as machine-assisted production matured and spread, the Studio Craft movement, which got underway after World War II, would emerge to embody a more full-throated rejection of the machine, favoring instead handwork over most kinds of automation (with a few exceptions). The Studio Craft movement would also decouple the idea of "utility" from many mediums and oversee the artification of many traditional crafts such as furniture, ceramics, glass, metalwork, jewelry, and fiber.

This wholesale turning away from machines and automation would prove to be a boon for artisans and artists throughout the twentieth century but would regrettably ensure that many fascinating machine tool processes would remain locked out from cultural investigation, relegated as they were to their industrial roles until the turning of the millennium.

Born in 1980, I grew up during a time when the Studio Craft movement was reaching its peak. Traditional crafts, after decades of development, were finally being held in the same esteem as other types of fine art. Works of craft were entering important collections and being exhibited in museums the world over.

As my career as a sculptor got underway, I began investigating metalworking processes that I could incorporate into my practice. I soon became keenly aware that the use of machine tools and other modern manufacturing processes was strangely missing from the fine-art landscape and, with few exceptions, not really a part of any arts-and-crafts traditions either. Fortunately, during this same time the bias against automation within the arts was quickly fading, bringing with it the birth of the maker movement and wider adoption of desktop-manufacturing and digital-fabrication technologies. However, the idea of machining as a studio craft remains a work in progress. While there are lots of exciting things happening with machine tools within the decorative arts, the use of digital-fabrication tools within the fine arts has maintained an element of a novelty.

While this book is autobiographical in some ways, it also provides an artist's perspective on machining's place within the larger arts-and-crafts landscape. Pursuing a medium that exists both as a process and a science has given me a unique window on the current state of craft—one that I feel has been largely overlooked by more-academic analysis.

If I could choose what effect this book might have, it would be to help inspire more people to take up the art of machining—not only to correct its omission from art history, but to explore the possibility of making connections across the worlds of art, design, engineering, and the sciences. I find that many people jump at the chance to learn something new and experiment if you simply invite them to. So for those inclined to do so, I want this book to be a type of permission to engage with both art and technology.

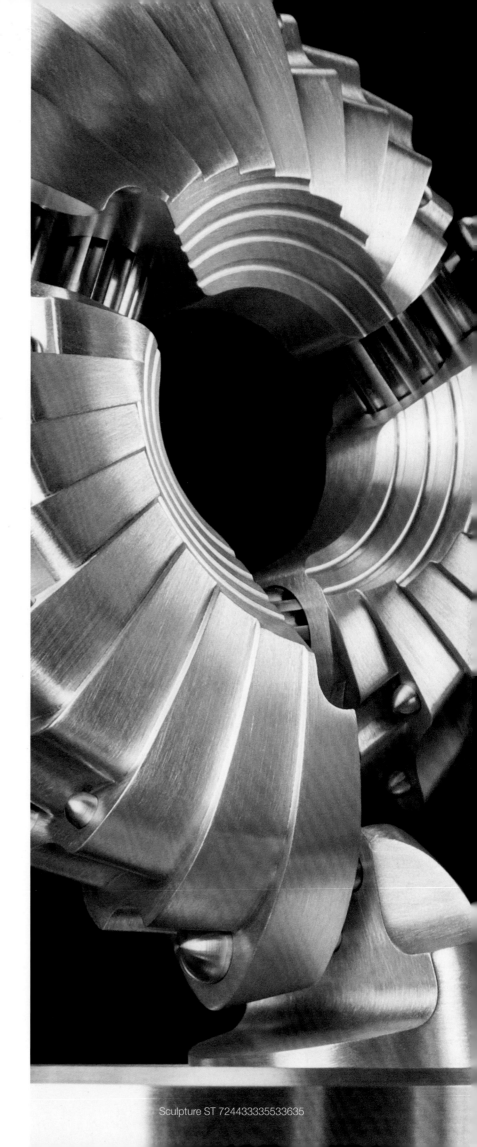

Sculpture ST 724433335533635

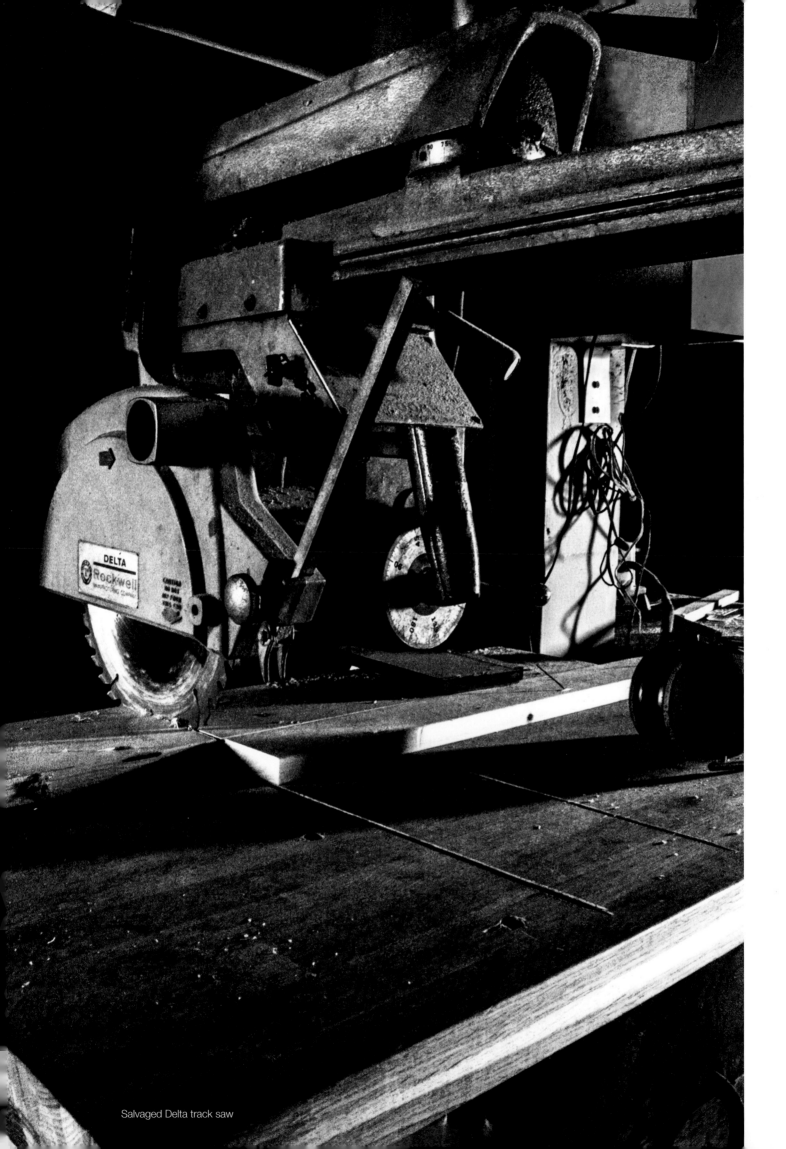

Salvaged Delta track saw

Chapter 1
When Quitting Is Beginning

When people ask me what I do, I am always careful to emphasize that I am a "self-taught machinist" sculptor. I don't mean to set myself apart from other sculptors, and I don't mean to mask that I have some amount of formal training in the arts (because I do); it's simply the case that the most-dominant influences in my art (and my life) are the self-acquired technical disciplines that have come to define my craft. My limited college experience is best described as "complicated," and my most formative fine arts experiences happened during my time in high school. The fact that I'm a self-trained machinist, machine builder, and sculptural engineer has informed my work in ways beyond compare.

Growing up, I was a curious kid who liked to collect random objects and trash and try to assemble it into various contraptions or Rube Goldbergs. I could draw well, but I was also a less than stellar student. I found that I learned best when I could set my own pace, and that was generally not on offer in my public school. But I loved art, and others around me took notice. With an intervention from some caring middle-school art teachers, I bumbled my way into an experimental high school that would become one of the top public arts high schools in the country. There, I was introduced to painting, drawing, photography, and, most importantly, sculpture.

While I showed early promise as a painter, it was in my high school sculpture class that I found something truly special. In my junior year, my sculpture teacher pulled a handful of students aside and asked if we wanted to learn how to weld steel by using oxyacetylene torches. At fifteen years old, having grown up in largely risk-averse schools, I felt like I was getting away with something as I learned to shape, melt, and burn my way through steel rods and, occasionally, my own clothes. My interest in metal piqued, I quickly found myself less interested in most of my other schoolwork; even painting, which was beginning to earn me some recognition, was losing its luster. My time working on metal sculpture in high school was short, but it felt like the most important thing I had ever done.

After graduating high school, I was convinced that my path to becoming an artist was straightforward: I would go to art college. Every art student in my high school was encouraged to go to art school. It was presented as the only option if I wanted to be an artist. As a teenager, it sounded reasonable enough, so that was the plan I adopted to continue the skill building I had started. The summer after graduation, I bought a small MIG welder, ostensibly to restore a Volkswagen I had acquired, but also to continue teaching myself metalworking skills that I could apply to my newfound love of sculpture. Then in the fall of 1998—on a partial painting scholarship, no less—I walked into the Maryland Institute College of Art (MICA), excited to be beginning my journey. At the end of that first year, my excitement had faded, and I would leave for summer break feeling disillusioned and lost.

I have debated how much to share about my time in college. I didn't want to start this book with a negative tone or give a lot of space if I was simply going to be complaining. However, there were a number of episodes that not only convinced me I was in the wrong place, but set the tone for how I would approach my sculpture practice going forward.

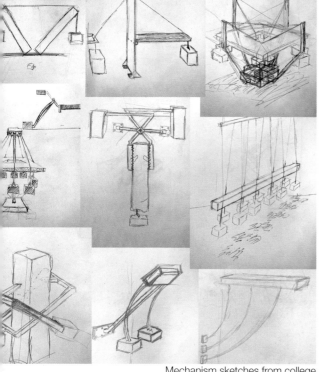

Mechanism sketches from college

In hindsight, my expectations were probably too high. I got into art school on a painting scholarship, but my interests were quickly shifting to sculpture. The practical effect was that I had to take a lot of classes that I was no longer interested in. My sketchbook was quickly filling with ideas for self-balancing sculptural mechanisms, concrete masses, and monumental geometric forms that would require an engineering degree to build. I knew that this flood of ideas wasn't going to make itself, but instead I found myself suffering through art history, color theory, and far too many painting classes. I felt like I was spinning my wheels, but I held on because I managed to get a few sculpture classes onto my schedule. These sculpture classes, however, would turn out to be problematic in their own ways.

Perhaps my memory is a little revisionist, but I remember the sculpture department as painfully traditional. It had a ceramics program, a fibers department, a foundry program, and a general sculpture program, each partitioned into its own section and all of them seemingly frozen in time. My school was supposedly world renowned, but something about the program felt anachronistic, even neglected. I've since learned with much envy of contemporary sculpture programs at universities with innovative cross-disciplinary approaches to art and craft. I have read about classrooms who collaborate with theater departments, music departments, or science departments and about classrooms busting with digital-fabrication technology that have embraced engineering principles, and I feel a mixture of relief and envy.

For my first day of sculpture class, we were ushered into a large room packed with ancient metalworking equipment. It was exciting to see drill presses, saws, bending jigs, and welding equipment lined up along the walls. I was hopeful that things were finally headed in the right direction. Instead, ten minutes into my first class, I was informed by the instructor that he didn't know how to use much of the equipment, and that some of it didn't even work, and that we as his students would not be permitted to use any of it. My hopes sank.

Because of the lack of access to tools in my class, I spent quite a few afternoons driving back to my old high school, where my former teacher would hang around late and let me use the school's equipment. I made more than a few of my college sculptures at my old high school. I remember bringing welded-steel-and-concrete works to class while other students brought pieces made of cardboard or found objects assembled with hot glue. I did my fair share of gluing and taping for studies as well, but it bothered me that much of what we made was so poorly built that it often fell

Refurbished drill press

apart as we critiqued it. Even some of the welded pieces I made would crack and break for lack of proper technique. We were all just winging it, fumbling around with materials through trial and error. There is nothing wrong with winging it as an artist, but you shouldn't have to pay a premium to do it. I continued to stick it out, hoping that the truly useful technical knowledge was right around the corner.

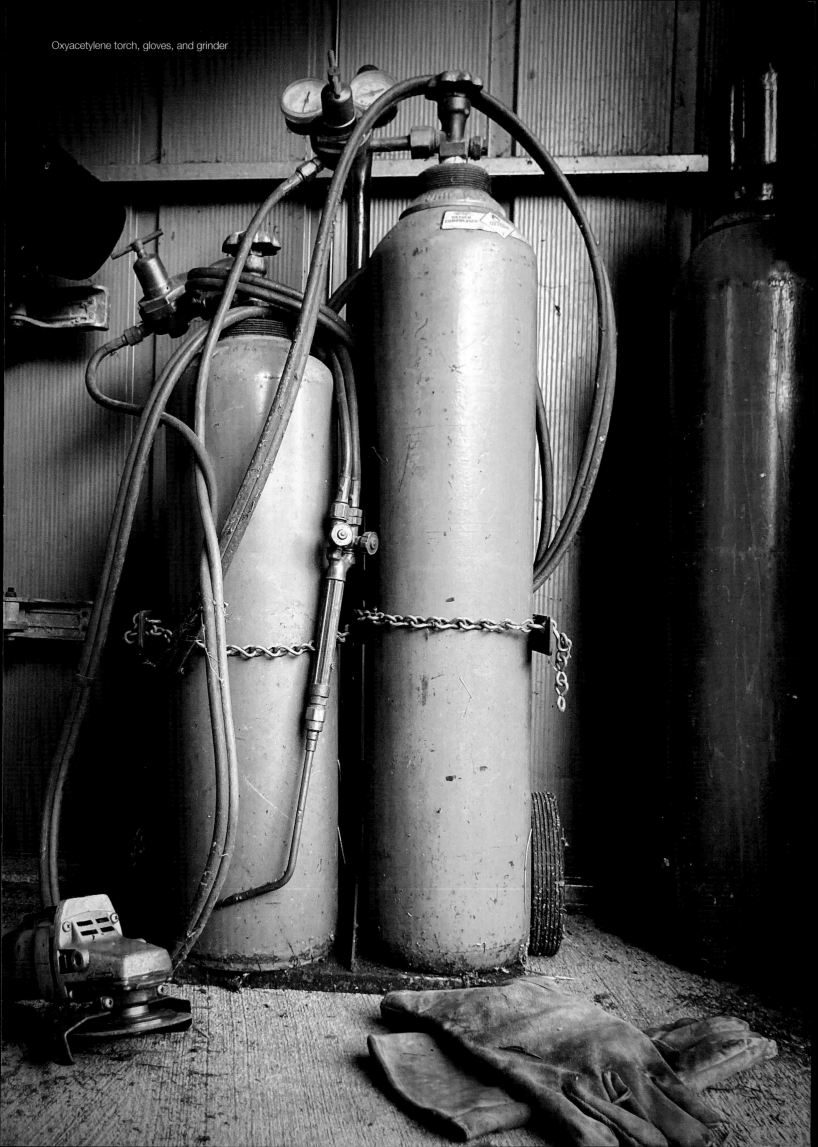

Oxyacetylene torch, gloves, and grinder

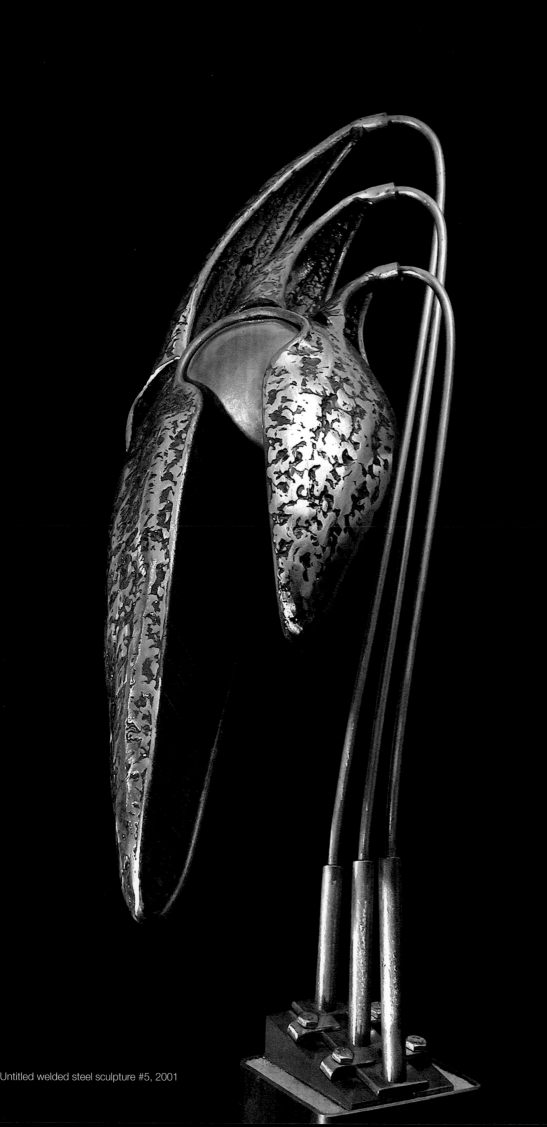

Untitled welded steel sculpture #5, 2001

Disappointingly, the topic of whether or not we would eventually learn proper building techniques never seemed to come up. We were constantly encouraged to think about form and content, but we never talked about basic material processes. There was no connection between how an object might be made, and its final appearance. In my mind, a sculpture was a constructed object, but we never learned how to construct anything. We might as well have been using 3-D software tools to create shapes in a virtual vacuum, because all we ever talked about were the aesthetics of the finished object.

Partway through my first semester, and once again thanks to my endlessly supportive high school sculpture teacher (thank you, Nicole), I picked up a part-time job at a nearby sculpture foundry. It was there that I began to learn about bronze and aluminum casting in a completely hands-on way. In a very short time working at the foundry, I had been given a crash course in mold making, metal pouring, finish work, and TIG welding. I was learning more on the job, in a shorter span of time, than I ever could have in a school setting. Because of this extracurricular activity, I was eventually permitted to use some of the welding equipment in my college classroom, and I spent some time teaching other students in my class how to use it as well. Perversely, I was teaching welding in my own sculpture class.

One day toward the end of my second semester, my painting teacher pulled me aside for turning in some halfhearted painting assignment and, caught up in a moment of real talk, confided to me that "if I wanted a happy life, I should definitely not become a painter." I took the hint. I left school that summer completely deflated. Instead of making art, I spent most of the summer fixing a growing collection of half-restored Volkswagens with a friend.

In the fall of 1999, I once again packed my bags and prepared to start my second year of art school. However, on my walk for the first day of classes, things didn't go as planned. Upon reaching the front of the school, I just couldn't bring myself to go inside. I stared at the big marble building, felt a wave of dread wash over me, and decided to just keep on walking. I don't clearly remember what I did after that. I probably thought I was just skipping school that day. But one day of playing hooky turned into two, then a week, and then it was too late. I would join the ranks of countless artists who dropped out of art school and attempted to do things on their own terms.

While art school can be immensely useful for those needing the time, space, and community to find their direction or their voice, on reflection, the main thing I missed from not finishing art school was a whole lot of unnecessary debt. After a brief recovery period from my perceived failure as an artist, my desire for art making would return stronger than ever. I would soon come to reason that if I wanted to be a sculptor, I should do so with an emphasis on tools and techniques. And if I was going to go into debt for my art, I'd be better off going into the red in setting up a studio full of the equipment I would need.

My foundry job didn't last long, but it showed me that I could learn skills far faster on the job—or on my own. After dropping out of school, losing my job and my rented room, I bummed around Baltimore for a few months. I lived out of my (sometimes working) car, sleeping on friends' couches and convincing their parents to cook me food. But very soon, I would right myself, land a steady day job, rent a small house with a friend, and set up my first humble sculpture studio.

Early welded-steel sculpture: The images in this spread are sculptures I made shortly after dropping out of art school. I spent the fall, winter, and spring of 2000-2001 working in my first, somewhat crude, studio. It was a rusted-out tool shed that lacked electricity—or even a door. In the winter, it was a cold metal box, in the summer an oven, but it was a place for me to work, alone, on whatever I wanted.

Equipped with an acetylene torch, a grinder, and a pile of steel rods, I set out to sculpt my first body of work. The months I spent cutting, welding, and grinding this collection of steel sculptures helped me form a set of working principles that continue to guide my process to this day.

While very different from the machined metal sculptures I would later come to create, these pieces illustrate some of my early instincts about form and line, and they exhibit qualities that resonate in my contemporary work as well.

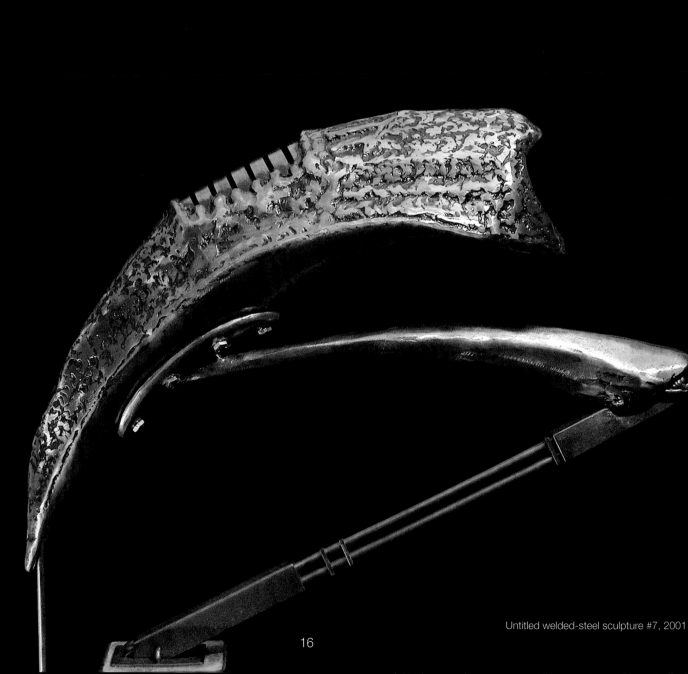

Untitled welded-steel sculpture #7, 2001

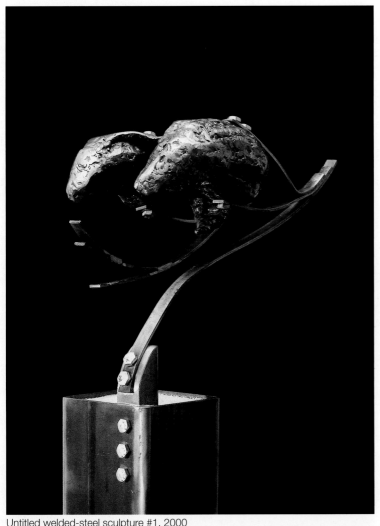

Untitled welded-steel sculpture #1, 2000

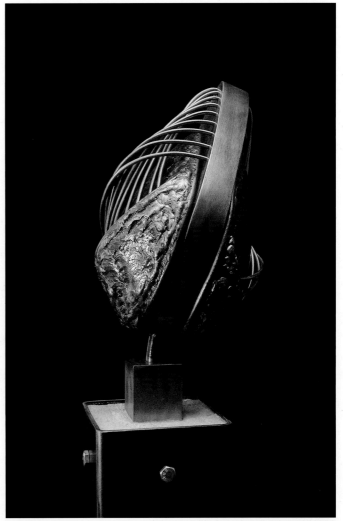

Untitled welded-steel sculpture #10, 2002

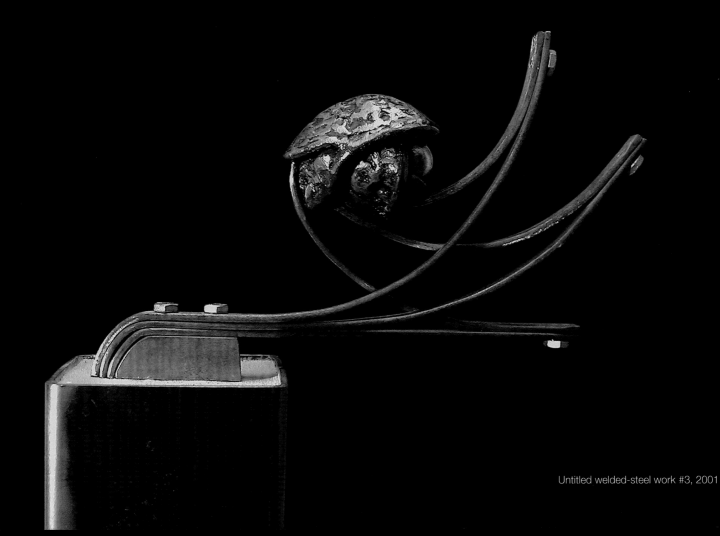

Untitled welded-steel work #3, 2001

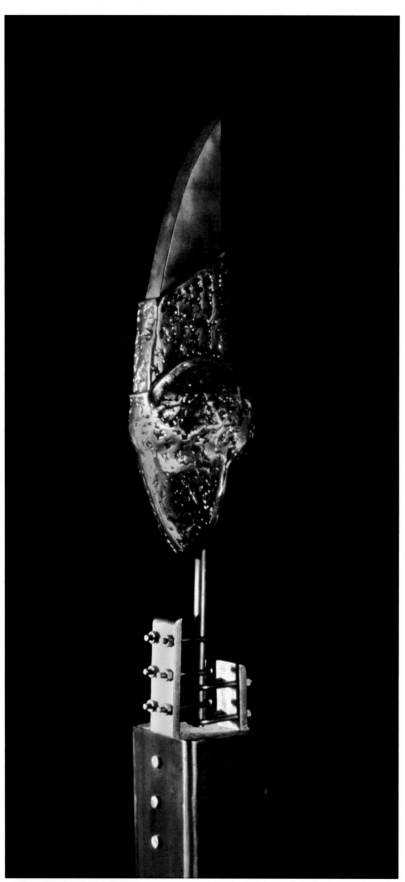

Untitled welded-steel sculpture #12, 2002

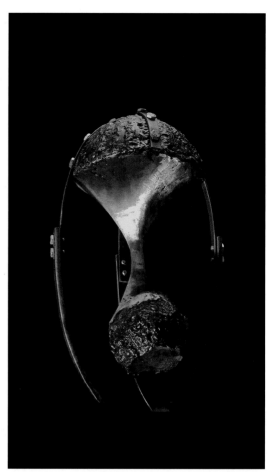

Untitled welded-steel sculpture #4, 2001

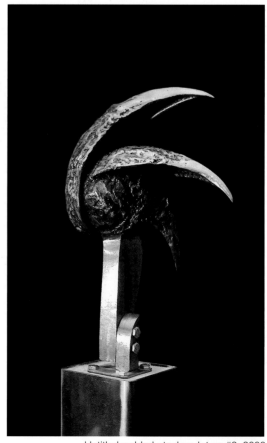

Untitled welded-steel sculpture #2, 2000

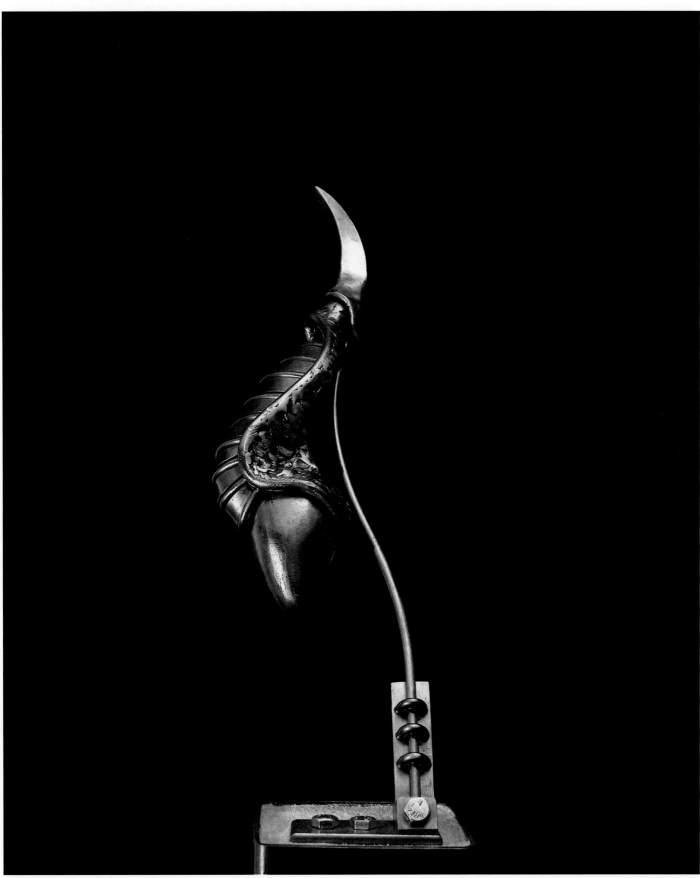

Untitled welded-steel sculpture #9, 2002

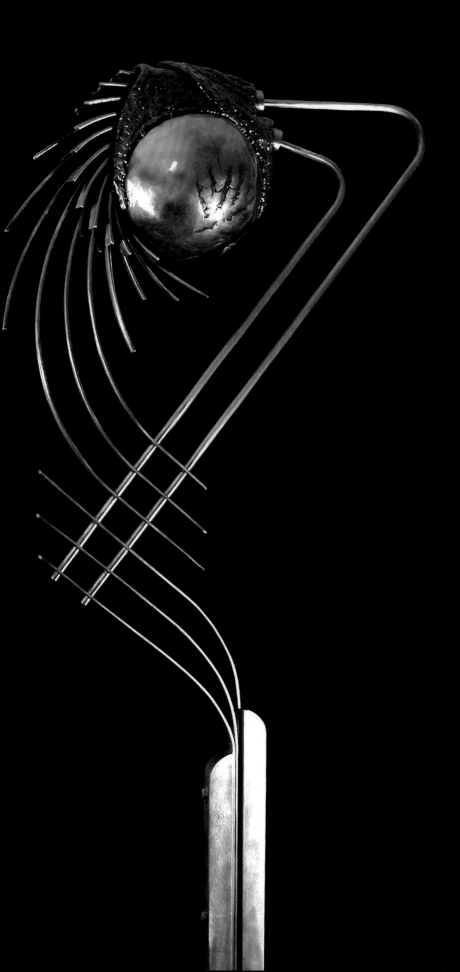

Untitled welded-steel sculpture #6, 2001

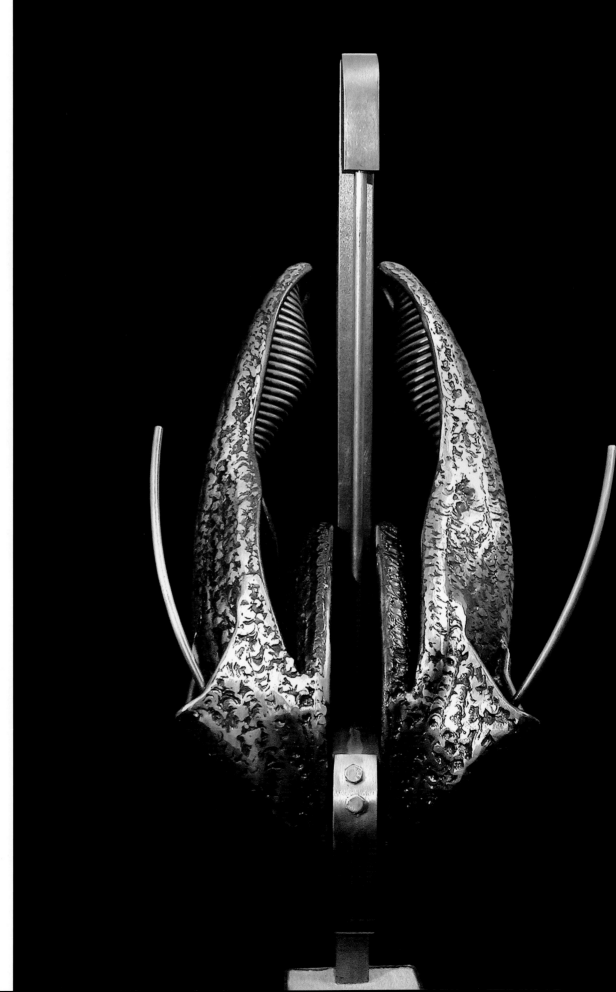

Untitled welded-steel sculpture #11, 2002

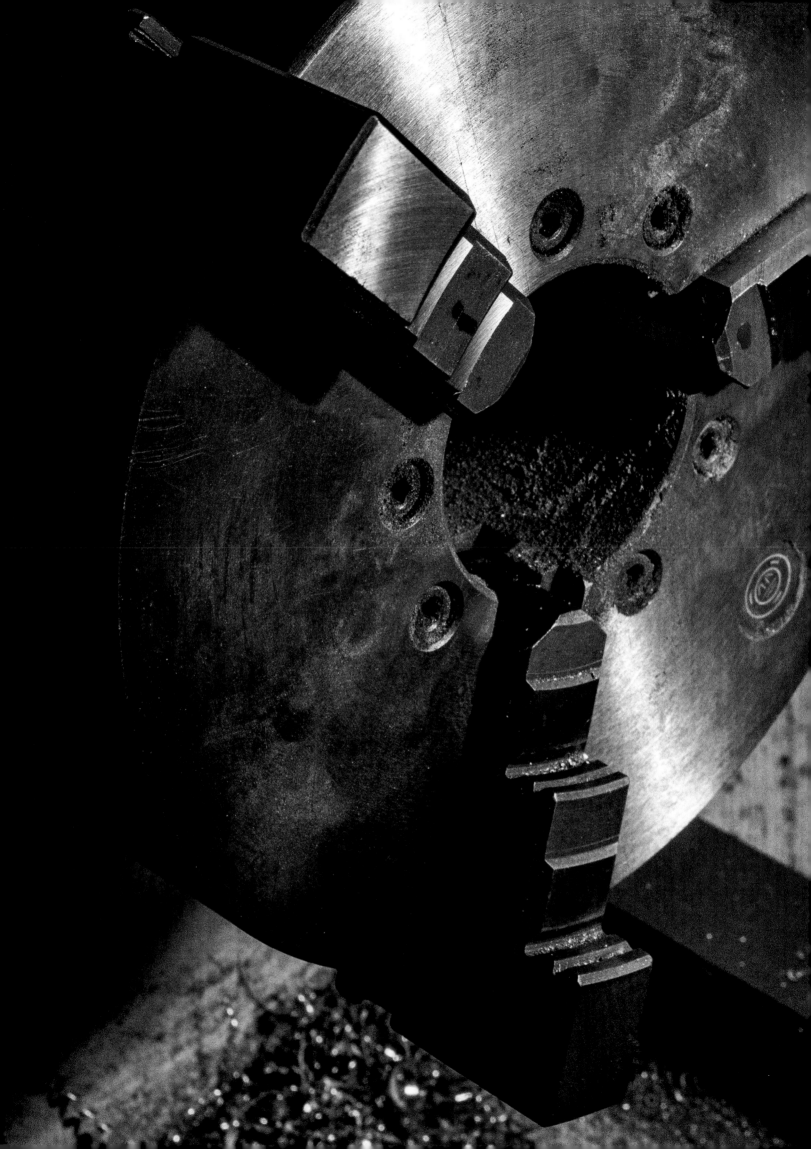

Lathe chuck and boring tool

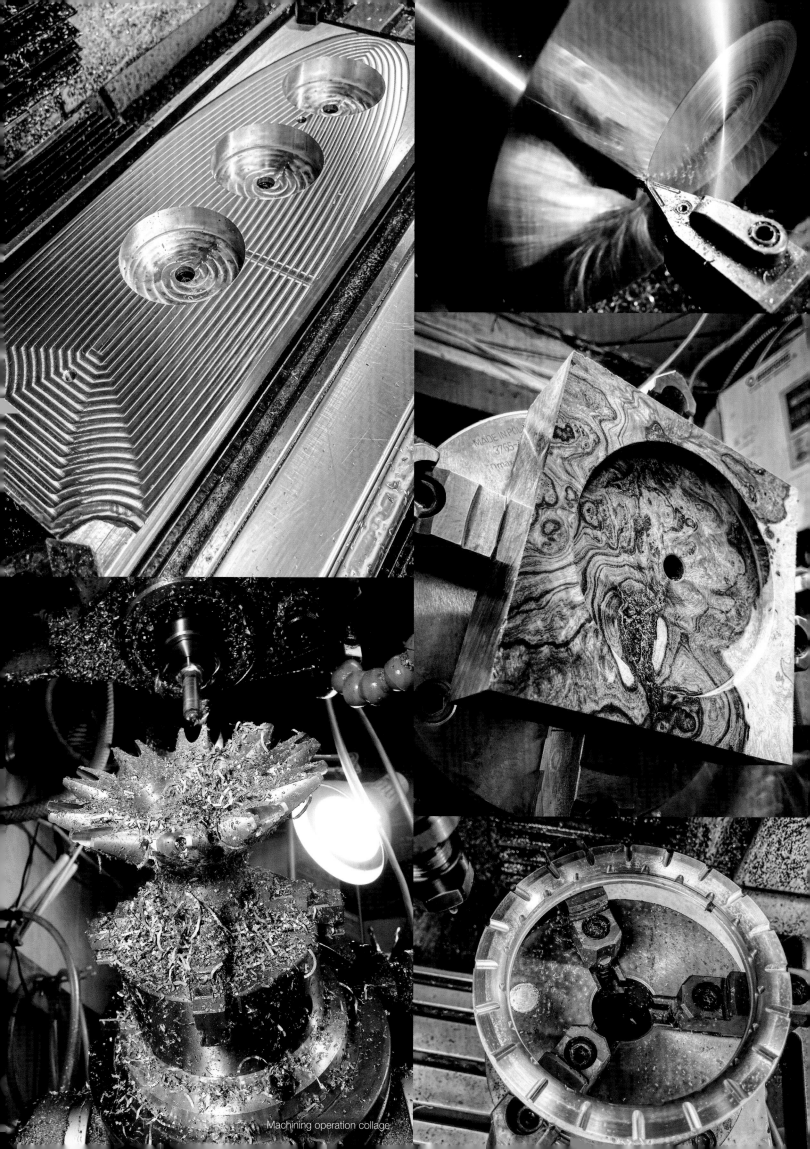
Machining operation collage.

Chapter 2

I found my way into machine work by accident, really. No one in my immediate family or anyone I knew had any meaningful connection to manufacturing of any kind. So as I applied myself to metalworking early on, I latched on to the concepts that I could explore with simple tools and then began adding new ones one at a time.

One of the earliest concepts I explored during my time working in welded steel was the textural contrast one could create by working the metal either hot or cold. When shaping steel with a welding torch (hot), one could achieve very organic and drippy qualities. However, cutting and shaping the steel (cold) by using mechanical means resulted in more-geometric forms. It was a simple yet flexible framework in which to develop a coherent aesthetic. Though many of the pieces would appear creature-like, I intentionally included obvious hardware in the designs to disrupt any sort of fictional interpretation of the works. Even at this early stage in my career, I wanted my works to be interpreted as constructed objects as well as figurative ones.

As this work progressed, I felt I had developed successful techniques for hot-working steel but needed more-accurate ways to produce well-defined geometry and include hardware. One can do only so much using a bandsaw, drill press, grinder, and hand tools, so I cast about to figure out what I was missing.

It turns out I was missing quite a lot. What I found—and what would come to capture my fascination for the next two decades—was a field of metalworking processes classified under the umbrella term "machining." For those who do not know what machining or machine work refers to, it is a reference to a number of subtractive manufacturing techniques such as milling, drilling, turning, broaching, grinding, or sawing. The most commonly used tools to perform these operations are milling machines and engine lathes. The term "machinist" refers to a person who performs machining operations.

If that sounds simplistic, it is—because what is actually being described are the processes responsible for nearly every aspect of our built environment and all material progress achieved in the last century and a half. If you look around any room, you will likely be unable to find a single object that has not been shaped in some way by these tools and processes. The importance of machine work to modern life cannot be understated, and yet, like so many people (and so many artists), I had never heard of it.

In all my time in art school and working at a metal foundry (even during my time fixing cars), the reality that there was an unknown world of manufacturing tools that might be available to me as an artist had never occurred to me, my teachers, or peers; even now, this seems odd. Looking back, it is clear that the influences that shaped my art training had some blind spots. Later in my career, when I began to learn a little more about art history and the crafts movement, the origins of some of the dogmas that surrounded craft and art in terms of material process began to make more sense.

I would slowly piece that story together, but in the meantime I was feverishly trying to find information about a unique process that, to me, was brand new. There were huge obstacles to getting started with machining. I didn't know any machinists, I had never seen a metal lathe or milling machine in person, and I had no idea how they worked. I grew up at a time that straddled the adoption of the internet, so when I was trying to find my way as a metal artist in 2002, resources were sparse; there was no YouTube or maker movement to learn from directly, and no easy way to do research. Even Wikipedia was in its infancy. Given my status as a dropout, I assumed that arts institutions would be no help either.

What I did eventually find were a handful of books and magazines that catered to a community of hobby machinists. These hobbyists were watchmakers, miniature-engine builders, and model makers. In none of the literature they produced on machining was there any notion that these tools might be used for art (as I understood it), but that didn't matter to me. Tapping into this community of amateur engineers was like turning on a firehose of technical knowledge that energized me and filled me with ideas for sculpture. Reading about the range of skills I could learn made me think of my work not as an abstract form, but as a constructed aesthetic object that could be leveraged both for artistic and technical growth. I could see myself making things that addressed technical, aesthetic, and conceptual challenges all at once.

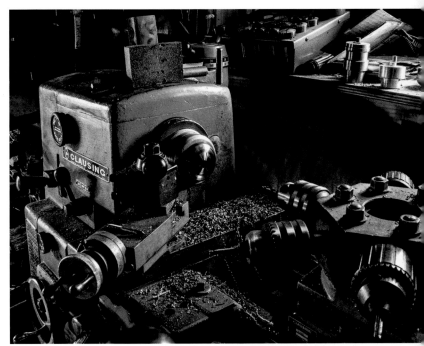

Turret lathe in the morning

Eventually, I found my way onto industrial manufacturing and machinist forums. There I was introduced to a nascent industry of toolmakers selling consumer-sized (manual) machining equipment that catered to hobbyists with small workspaces. I would find that a lot of the tools I might afford were low-quality imports, but that was a trade-off I was willing to make. I reasoned that what was most important was that I begin my journey, and that poor-quality tools simply presented an opportunity for growth, since learning how to repair and modify these cheaper tools would most certainly come in handy later. I purchased my first humble milling machine and lathe, and I was excited that I finally had some modest resources to get myself started down the road to learning more about the world of machining.

There is a cliché that it is much easier to break the rules when you don't know what they are, and that was certainly where I soon found myself. Making art and learning about machining at the same time, I entered into a period of pure discovery—the kind you get to experience only a few times in your life. I approached each new technique as if I had just discovered a new color, considering what aesthetic qualities it could add to my work. I had entered college wanting to make art for art's sake, and there I pursued a classical approach to art education that I found stifling. But now, I was embarking on a journey into a highly technical craft that, by its very nature, required a much-broader knowledge base. Alongside straightforward descriptions of how to perform various machining processes were primers on the math and physics that make them possible. My work forced me to embrace a broader outlook on learning and instilled the need for invention within my practice. I've heard it said that machining is a field that bridges the prescientific and scientific eras. This seems apt, because it brought a much more scientific mindset to my art making.

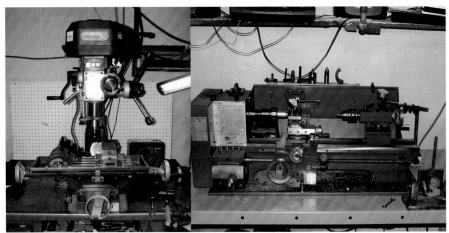

My first milling machine and lathe

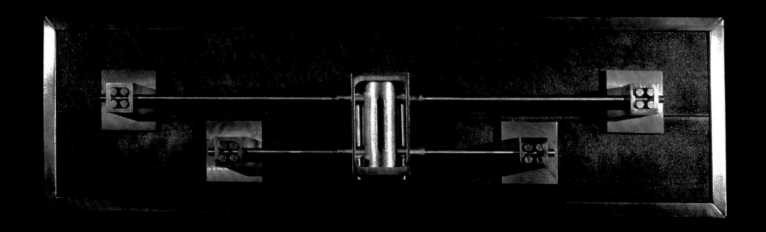

Above: Untitled machined Sculpture #1, 2003

First machined-metal sculptures:

These two works are my earliest experiments with machining metal for the purposes of creating sculpture.

The work evolved quickly as I became familiar with different machining operations and began layering processes in ways that created complexity from relatively simple geometry. Although still a bit crude, some of these works look as if they would be quite at home with the rest of the machined sculpture works that would come to define my art.

Note: These early images were rescued from 35mm slide film. While the image quality leaves much to be desired, to me they carry a certain nostalgia that I have decided to preserve .

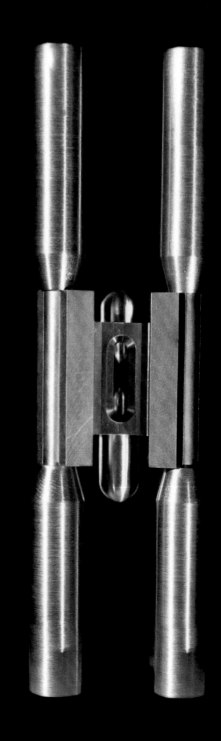

Untitled machined sculpture #3
Steel and copper
12" x 4" x 4", 2003

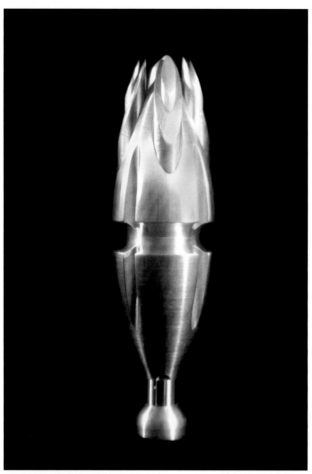

EG 542282853652732452
Aluminum, brass, copper, and steel
7" x 2.5" x 2.5"

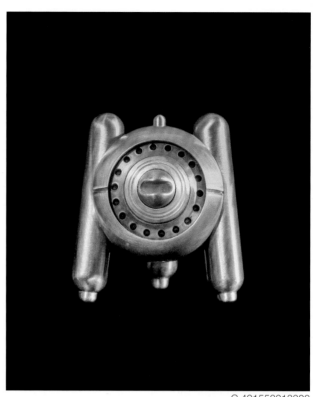

C 491552213382
Aluminum, brass, and copper
3" x 2.5" x 2", 2005

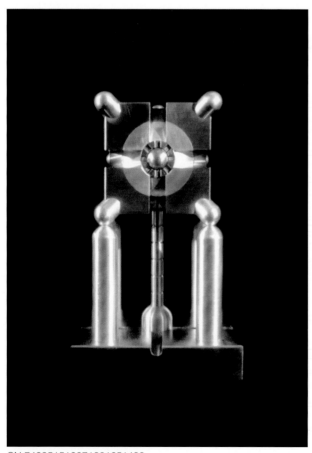

CN 742951513371831651482
Steel, aluminum, and brass
6" x 4" x 4"

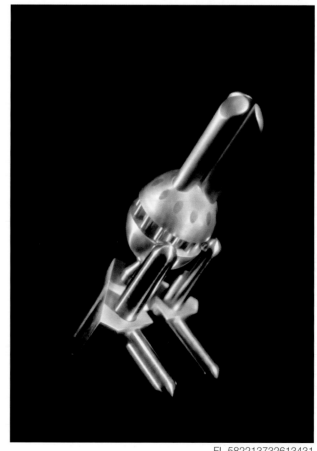

FL 582213732613431
Aluminum, brass, copper, and steel
7" x 7" x 3.5"

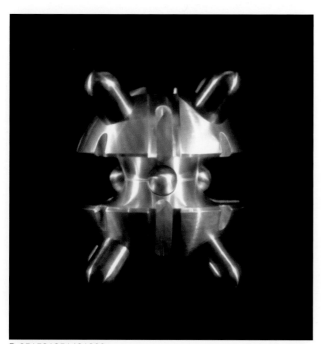

D 651531251491323
Aluminum, copper, and steel
3.5" x 3" x 3"

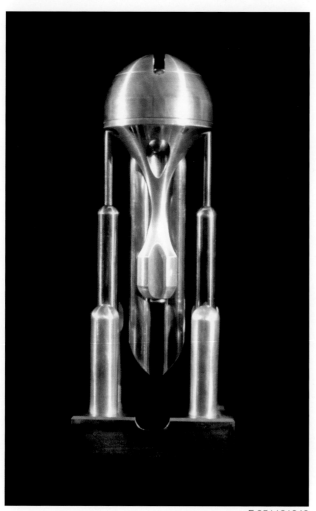

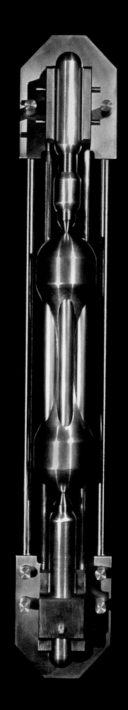

CF 452200632582
Aluminum, brass, copper, and steel
20" x 3.5" x 2.5"

F 351191242
Aluminum, brass, copper, steel
9" x 3.5" x 2.5", 2004

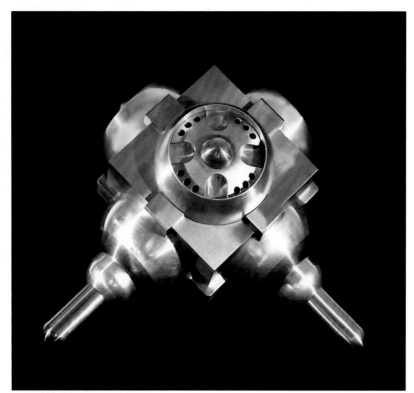

M 492211392
Stainless steel, aluminum, brass, and copper
4" x 5" x 5", 2005

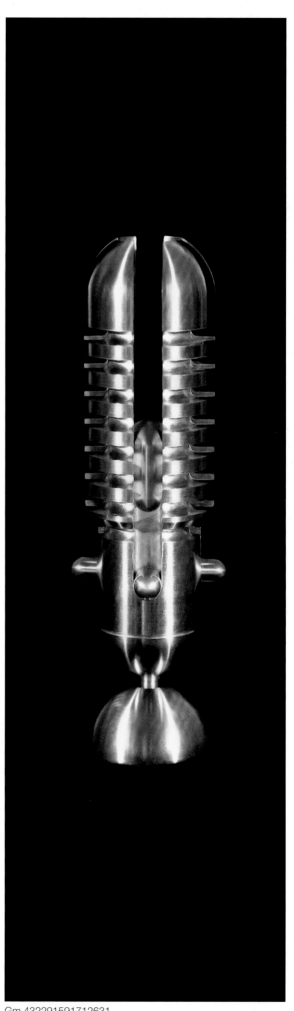

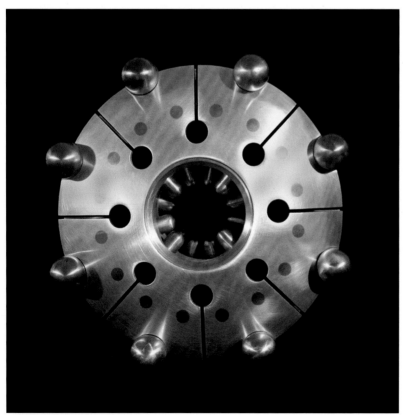

GG 80295171111671482551
Aluminum, brass, and copper
4" x 4" x 2.5", 2005

Gm 432291591712631
Stainless steel and copper
5" x 1.5" x 1.5", 2006

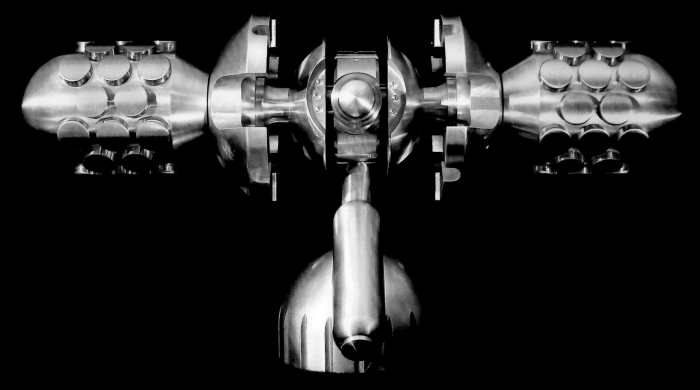

Md 782252522611413
Aluminum, brass, and copper
5" x 10" x 4", 2006

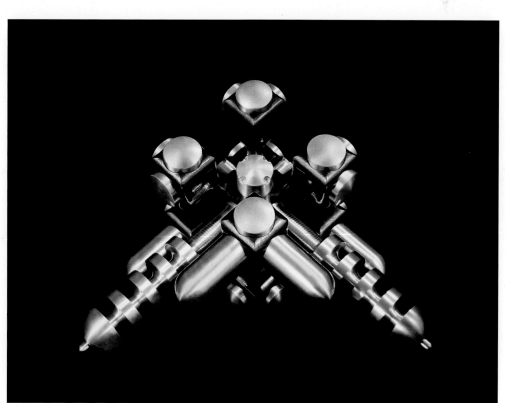

BL 313
Steel and aluminum
5" x 7" x 7"

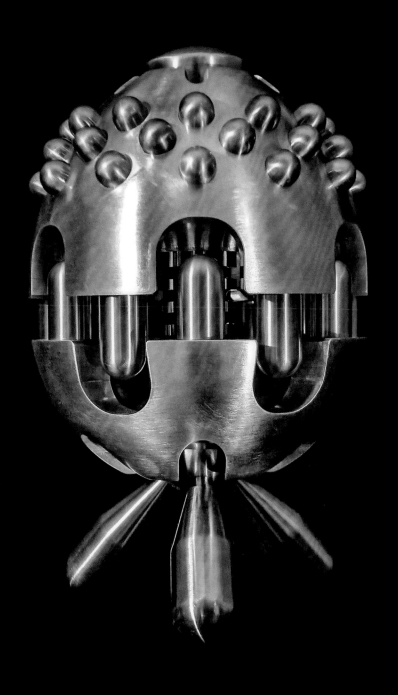

Vn 351151
Aluminum, brass, copper, and stainless steel
6" x 4" x 4", 2006

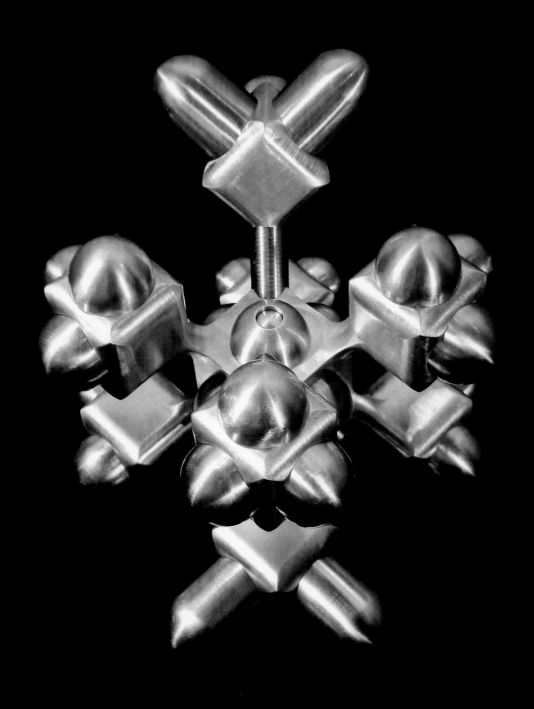

Gr 432251
Aluminum and brass
6" x 5" x 5", 2006

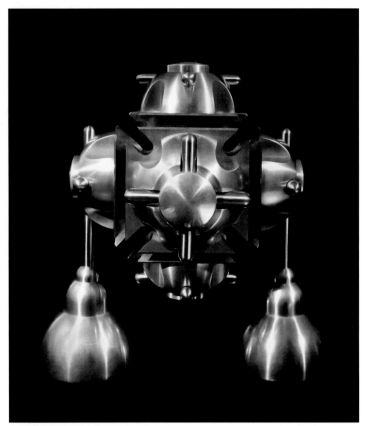

CN 451713302951882543
Stainless steel, aluminum, and brass
6" x 5.5" x 4.5", 2006

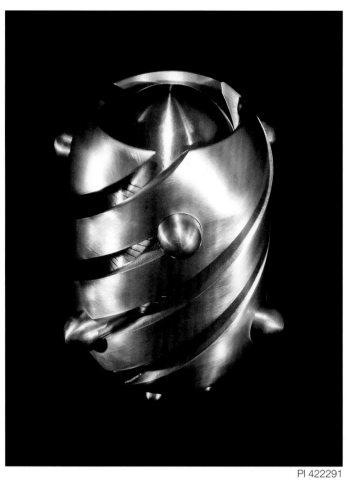

PI 422291
Aluminum, brass, and copper
3.75" x 2.5" x 2.5", 2007

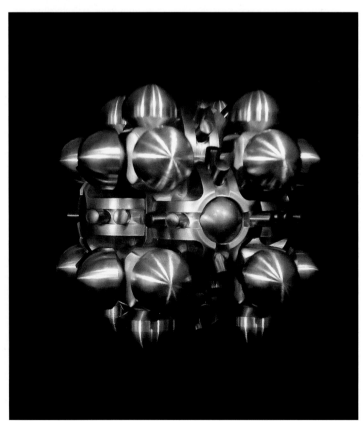

PI 5513111402
Aluminum and copper
4" x 4" x 4", 2007

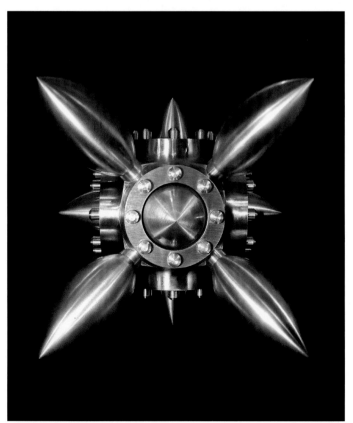

FL 633322251552
Steel, aluminum, copper, and brass
5" x 5" x 5", 2007

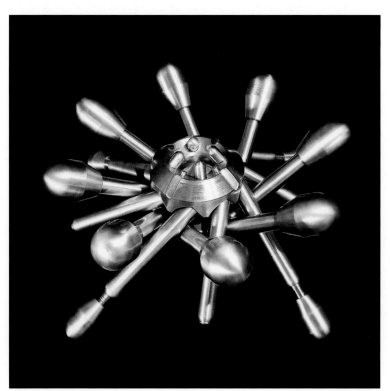

DD 111542432
Brass and aluminum
3" x 7" x 7", 2007

Dn 652253532411
Steel, aluminum, and brass
5" x 5" x 5", 2007

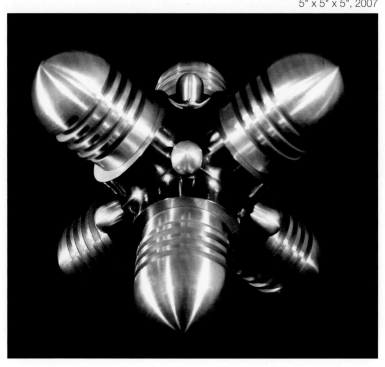

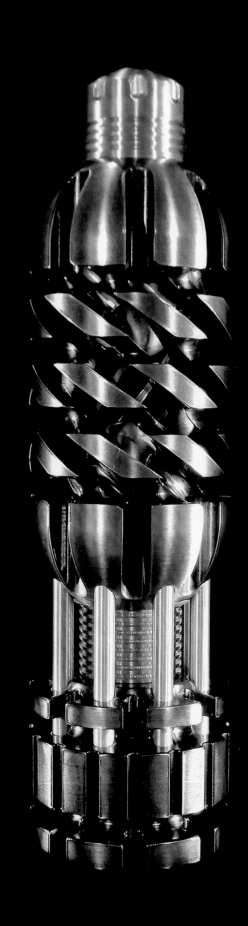

D 213341
Steel, aluminum, and brass
9" x 2.5" x 2.5", 2007

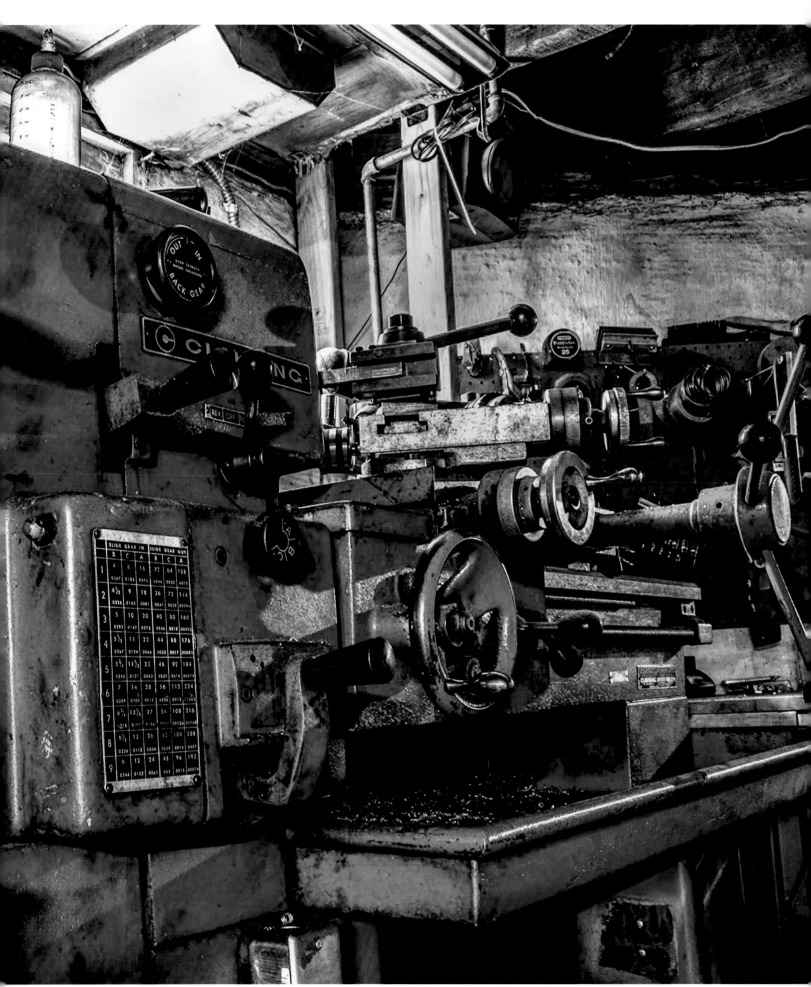

Clausing turret lathe and tool wall

Chapter 3

Humans love the idea of mastery. We all strive to master various tasks in our lives, from the simple and mundane to the hopelessly complex or difficult. It is why we seem able to make a sport out of almost anything and enjoy watching others attempt daring physical feats that risk life, limb, and reputation. Mastery is also something many of us look for when interpreting art. Knowing that an artist has total control over their body, mind, or medium imparts a kind of objective measure of accomplishment to an otherwise subjective activity.

For an artist engaged in the making of art, it is natural to pursue mastery in all its forms. Artists aim to master both themselves and the mediums they study. We study technique far past the point of utility, teasing out endless possibilities and new directions. This strange behavior is rooted in human biology. It is the evolutionary trait that makes us such a successful species. We are hopelessly compelled to try to understand the world—not for practical reasons, but purely for the sake of understanding. We often get it wrong, but bit by bit, we break things down and try to make sense of it in our own way. If that sounds a little like science, well, I would argue that science and art are just two different expressions of the same very human impulse; one strives for objective understanding, and the other seeks to create a personalized meaning from that understanding as only humans can.

I think that mastery—and, by extension, the type of formalism it engenders—is sometimes dismissed by art critics as lowbrow or unintellectual. I think this misunderstands a key function of mastery within a practice. You aren't just learning a physical skill—although there is a lot to be said for the muscle memory and the physical intelligence it imparts to the body—it is that the sheer effort required to get good at something, and I mean really good at something, imparts a kind of empathy that allows one to see the humanity in the work of others. I would argue that the absolute best way to understand art is simply to make art yourself.

For younger artists, the pursuit of mastery is also a way to bridge the gap between our nascent ideas and the fully fleshed-out ones that come only with a lifetime of work and experience. Most people are not born with a mind full of good ideas; striving toward mastery is how we add information to the system and fill the time while inspiration builds inside us.

Looking back on my earliest machined sculptures, it is clear that this period of my practice was all about mastering the basics of my process in order to build a base of knowledge I could draw upon for a lifetime of making. Each sculpture was an opportunity for learning; the works served both as an aesthetic exploration and a skill-building exercise. I was methodically creating the ideal environment for inspiration to happen organically.

During this time, a basic premise emerged. Inspiration does not lead to work; inspiration arises from work. Whenever I felt creatively stuck in my practice, I would simply find an excuse to learn something new. Before long, the ideas were flooding in again, and I was off on a new line of inquiry. Learning, more than anything else, has been my biggest creative guide, and machining is a process that presents an endless supply of things to learn. As I will touch on later, mastery is not a destination, but a nexus for making connections to spheres of knowledge that might not immediately be apparent.

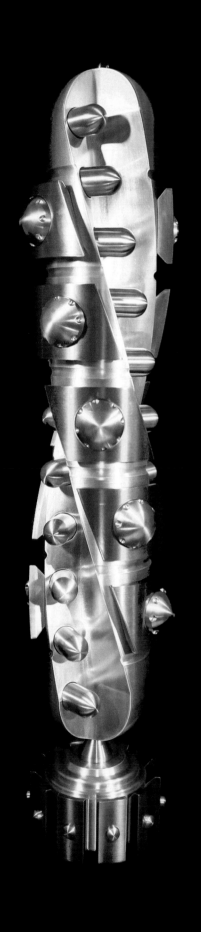

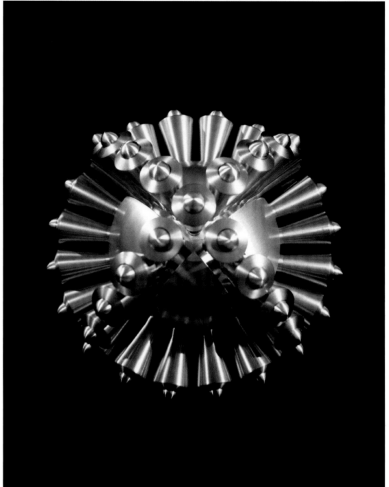

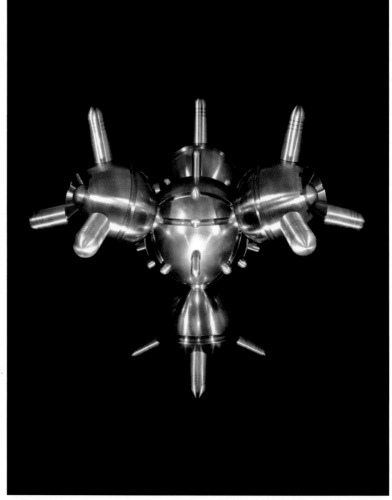

Sp 683343447521
Stainless steel, aluminum, copper, and brass
21" x 4.5" x 4.5", 2009

PC 714455512215355831
Steel, aluminum, and brass
8" x 9" x 9", 2008

Mn 783485521265683
Aluminum and brass
5" x 5" x 5", 2009

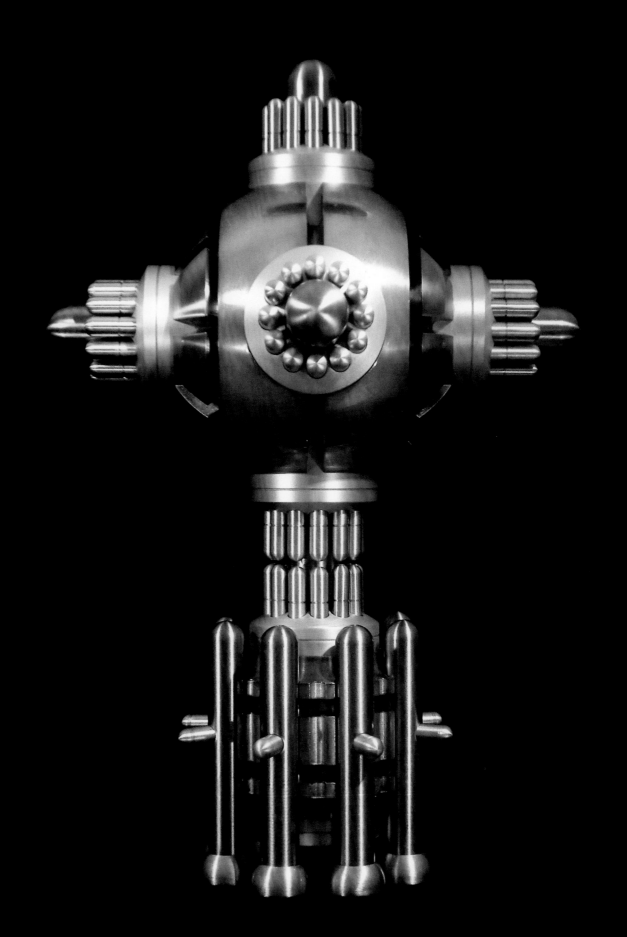

M 331251
Stainless steel, steel, aluminum, and brass
11" x 7" x 7", 2008

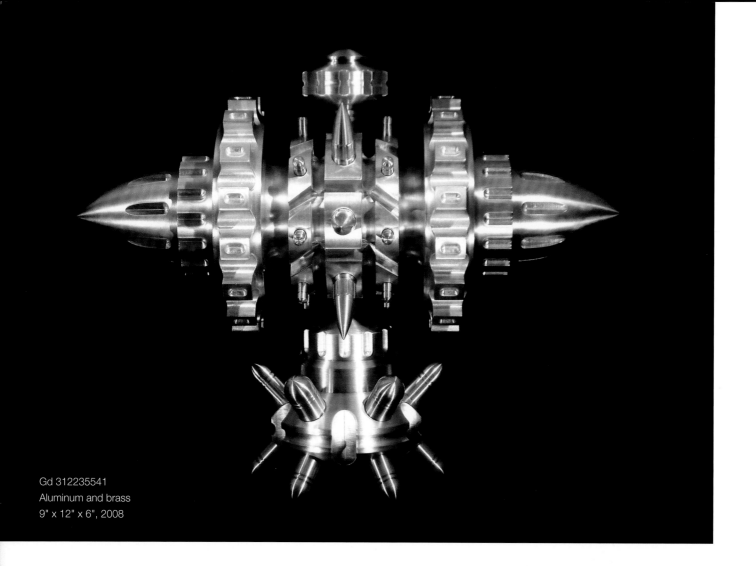

Gd 312235541
Aluminum and brass
9" x 12" x 6", 2008

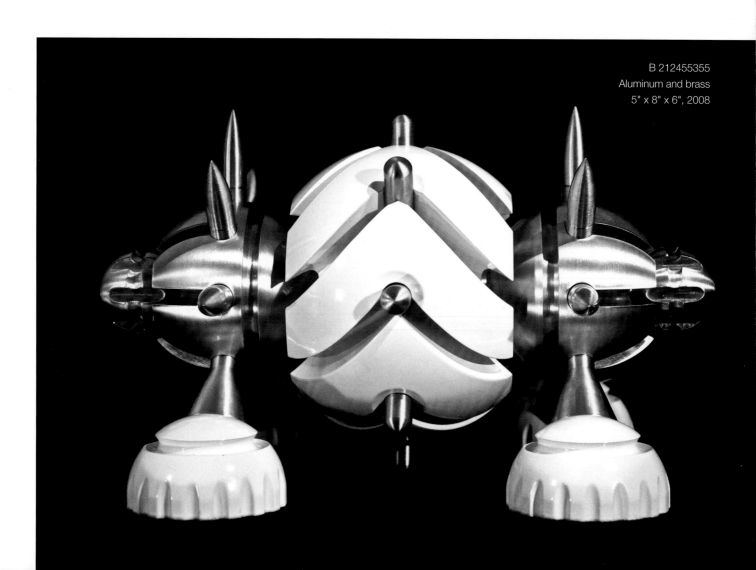

B 212455355
Aluminum and brass
5" x 8" x 6", 2008

VS 65551521545

Stainless steel and steel

7" x 7" x 7"

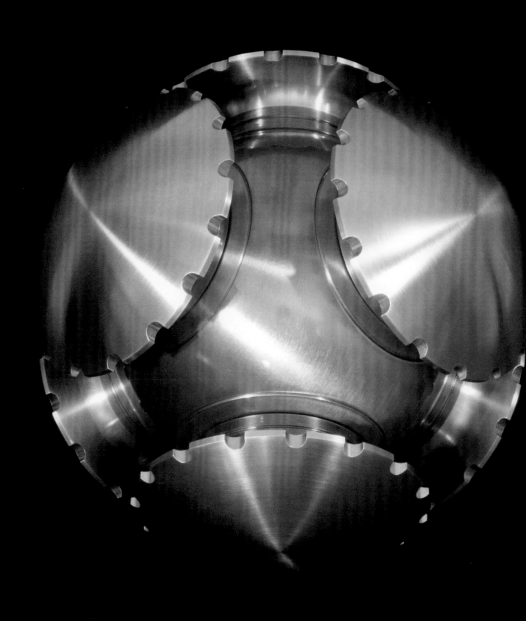

VS 655515215456

Stainless steel and steel

7" x 7" x 7"

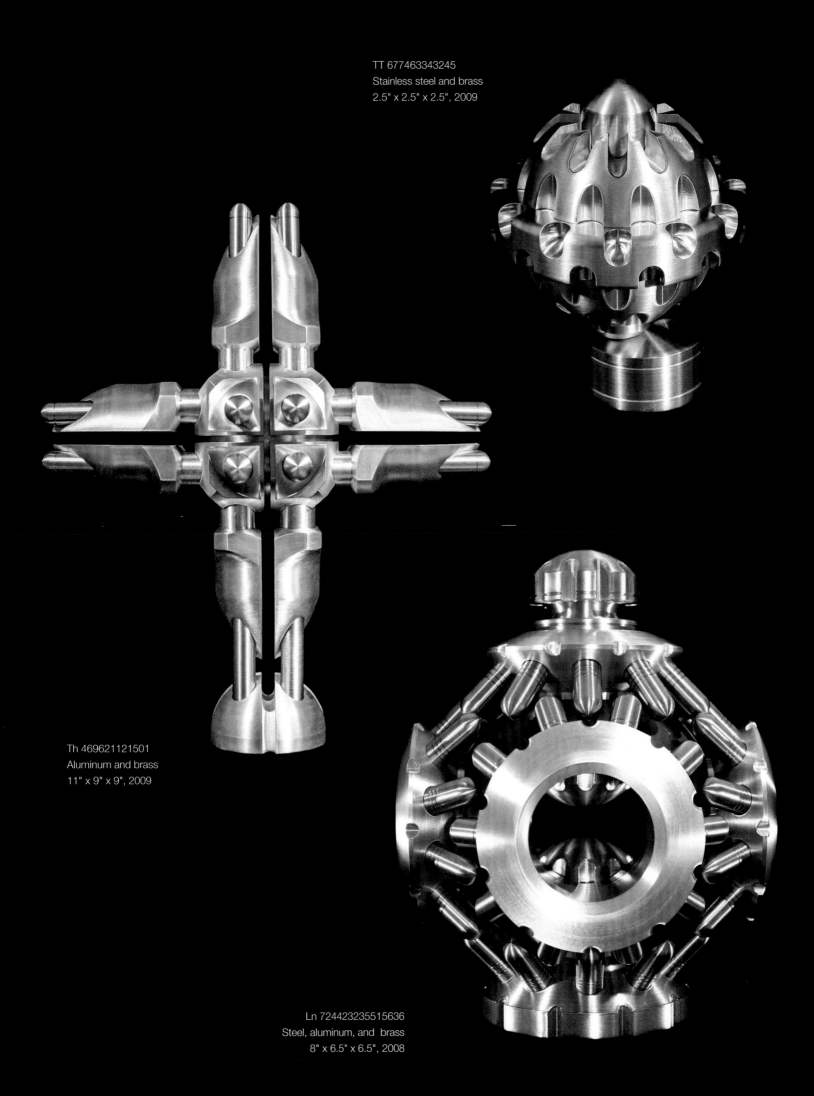

TT 677463343245
Stainless steel and brass
2.5" x 2.5" x 2.5", 2009

Th 469621121501
Aluminum and brass
11" x 9" x 9", 2009

Ln 724423235515636
Steel, aluminum, and brass
8" x 6.5" x 6.5", 2008

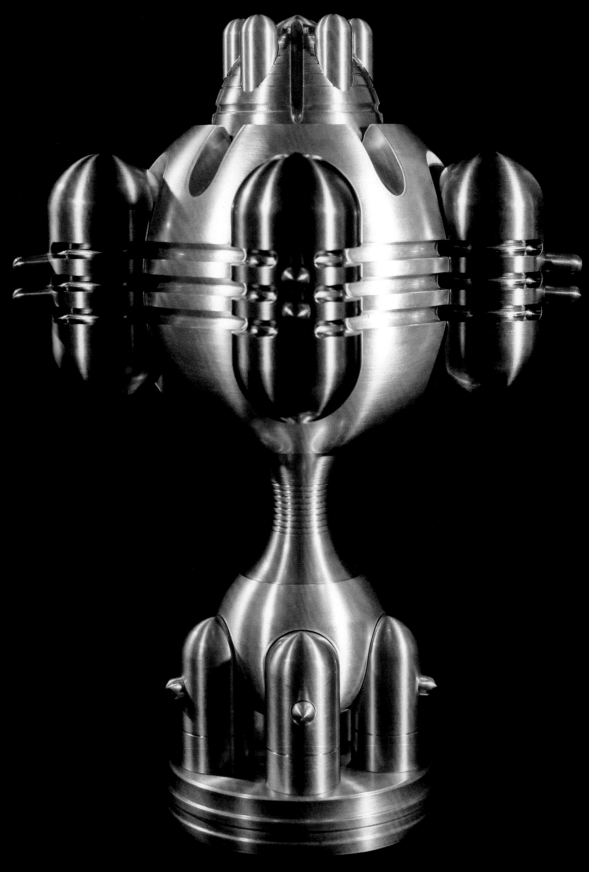

RY 555441253
Steel, aluminum, brass, and copper
13" x 8" x 8", 2008

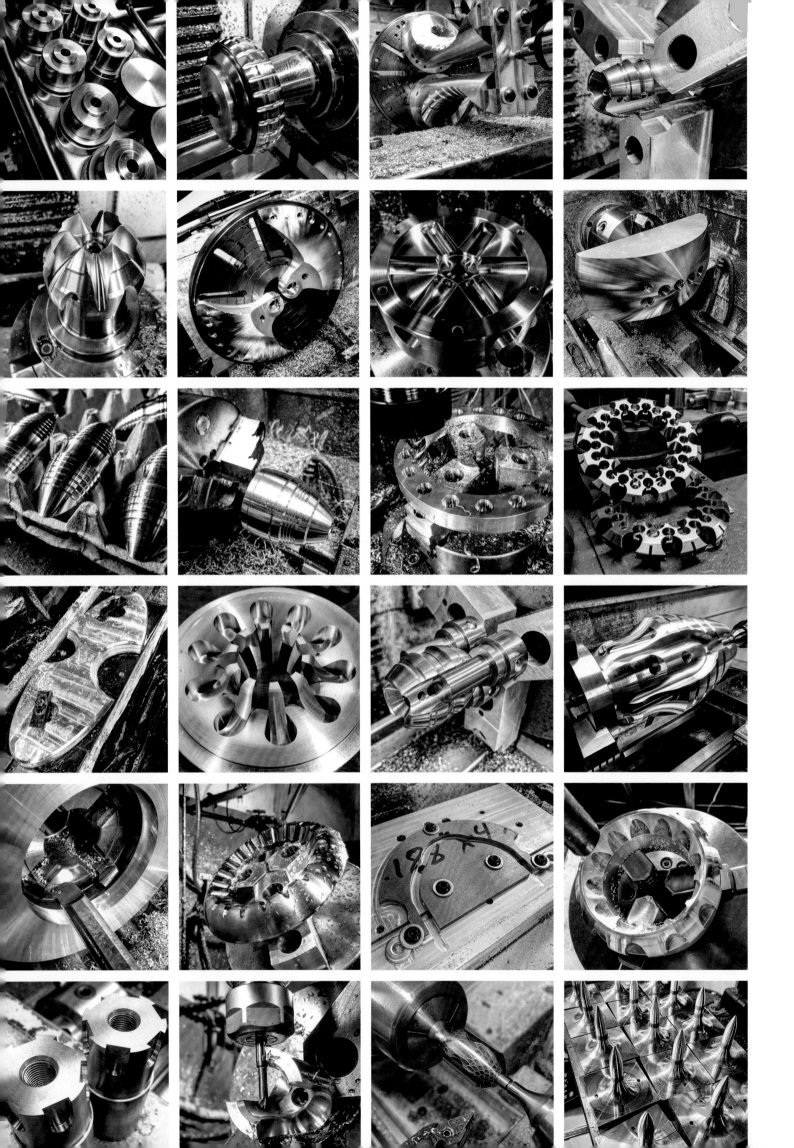

Chapter 4

One of the most appealing things about machine work is how transferable the skill set is. Beyond making art, if I need to repair something in my daily life, be it a piece of furniture, a lawn mower, or something else, I can usually manage it with the tools I have come to embrace for art making. Even if it requires making an obscure piece of hardware, I can simply fabricate what is needed for the project at hand, because I use tools and processes similar to those of the company that manufactures those parts. With a little patience and time, you can make literally anything you might need, from simple brackets and screws on up to the most-complex automobile or even airplane parts. If you can't make it directly on a machine tool, then you can probably make a tool that will aid in fabricating the thing you need. This applies doubly within my sculpture work. If I need a special tool or invent a process to achieve a desired geometry, the medium of machine work is inherently geared toward building the tools necessary to meet that goal.

In machine work, tool building and sculpture making go hand in hand. I have always found this aspect fascinating, both practically and philosophically. That the tools of my trade can be leveraged for self-replication and self-improvement strikes me as a fascinating way to look at an artistic process—tools that build tools, art that builds art.

I have often endeavored to share this aspect of my work to provide context for the forms and the aesthetic it inspires. While it is commonplace these days to broadcast behind-the-scenes images of how a sculpture is made, and provide candid musings on social media, this was not always the case. Surprisingly, many artist friends and acquaintances have cautioned me against this kind of sharing over the years. They have warned me that one of an artist's greatest tools is the mystique you can create around your work if certain aspects of it remain a mystery. They argue that if an audience is left to wonder how something was made, it can seem more fantastic, and that might somehow better serve to communicate that I am a special talent with abilities beyond easy comprehension. By that logic, in sharing the details of my process, I am destroying whatever magic I might create within my art.

First off, let me say simply that I don't believe in magic, at least not in a fantastical way. The magic I believe in is the human ability to inject meaning into any and all things. Mystique is one way that artists have historically used to command respect and attention for their work, but it is based on outdated ideas about the artist as a singular genius, and value judgments that hold fine art as distinct from craft. I believe that sharing my process and freely giving information about how a sculpture is made benefits in multiple ways. For starters, it gives an audience many more ways to find meaning and to make connections within my work. Not everyone is immediately drawn to my particular aesthetic or even has an interest in art, but by demonstrating the multitude of ways my work intersects with other interesting subjects such as science, toolmaking, or engineering, I can connect the idea of art making to something bigger than my own aesthetic instincts. Also, practically speaking, I don't want to live in an ivory tower; I want others to join me on my journey, and how can they do that if my process is opaque? Opening a window into my studio can give others the knowledge and inspiration to pursue making machined works of their own should they choose to pursue a similar path.

Left: Process collage

I understand that my artist friends were well intentioned in counseling me not to give away too much, but I discovered early on that many of the most fascinating things about machine work were not the finished products it produces (although those are lovely as well), but the beauty and visual environment inherent to the process. The environment in which my work is made is dynamic and fascinating in a way that a sculpture can never be. Engineering clever solutions to logistical problems in service to visual art means I get the best of both worlds. I get to apply physics and materials science in an environment that allows me to learn about the natural world, while at the same time letting me explore my imagination to learn about my inner world.

This duality between the creative and technical is often difficult to communicate. The simplest way I have found is to document my process and share it freely. The response to opening my studio has been anything but aura shattering. Instead, I have been rewarded by a vibrant community of enthusiasts and makers, some of whom might have different ends but are nonetheless deeply involved in exploring similar processes and principles. I have learned valuable tips from fellow machinists, been given fascinating perspectives on my work, and, of course, connected with collectors and patrons who might not have otherwise found me. It has cemented an expansive philosophy of what a sculpture practice is and what a sculpture audience can be.

It has been my experience that the art world thrives on exclusivity. Part of this is no doubt financial, since scarcity is connected with value, but part is likely out of a desire to create a coherent narrative within the art scene to foster mystique. That the art world trends toward a smallish community of influencers, academics, and collectors who go on to support an even-smaller number of artists means that success is rare for those seeking recognition purely within the boundaries of the museum and gallery world. I for one am quite fond of the positive things that the art world has to offer, but in terms of making a living as an artist, I have found that it is the whole world, and not the art world, that I am better able to engage with and make my living. This means that in addition to fine-art enthusiasts, I include engineers, architects, machinists, and other technically minded folks as a part of my audience. In many cases, it is those with technical backgrounds and not art backgrounds who are a better-informed and better-patronizing audience.

In business, one might view other artists working in the same mode as competition, but as ideals, art making and being competitive are fairly incongruent. Keeping methods a trade secret might help you corner some niche idea (or market) in the short term, but it stifles evolution and can leave you alone and obscure. Sharing ideas however, has a multiplying effect. It fosters community and allows ideas to disseminate and develop beyond what was initially intended. I have seen many of my designs copied and even counterfeited. But I have also seen those ideas transformed into fascinating works that stand as unique creative expressions. You can't have one without the other, and I would much rather see my creativity become something unexpected in the hands of others. If I am being candid, sharing has rarely caused financial harm to my practice. It has only burnished my reputation and helped more people seeking original artwork—and inspiration—to find me.

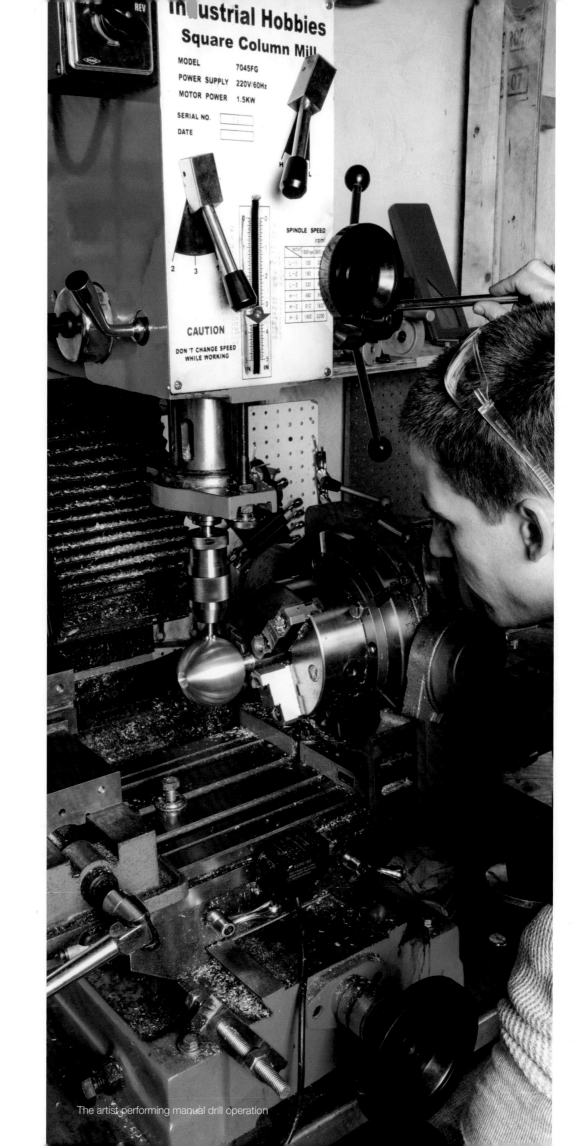

The artist performing manual drill operation

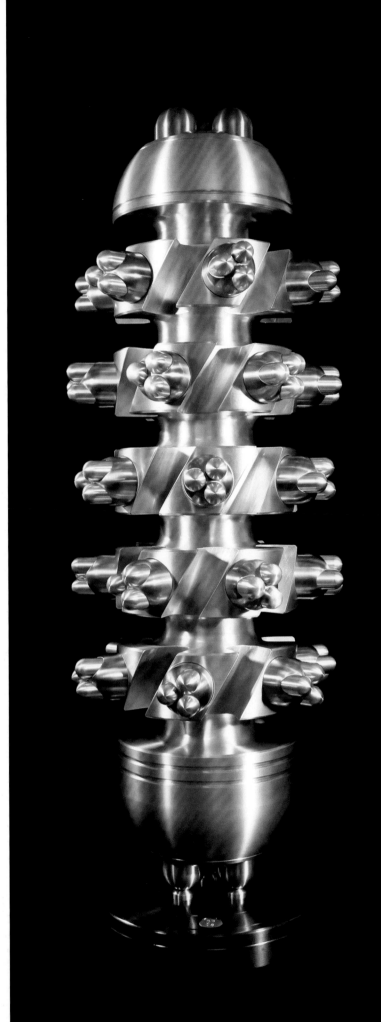

BH 625514455315
Stainless steel, aluminum, and brass
26" x 9" x 9", 2008

I have come to the conclusion that sharing and speaking plainly about my process does not dispel some illusion of professionalism; it gives people an opportunity to find meaning in my humanity as an artist engaged in sincere exploration. I would much rather people engage with my ingenuity as a maker than some manufactured persona. In the end, keeping things a secret, obfuscating in some misguided attempt at mystical novelty, would have been fatal to my practice.

People are smart, and time and distance eventually reveal the true nature of art, so it is better to embrace every aspect of it. The dance between the technical and aesthetic is what is most interesting to me in my practice, and time has shown that it is also interesting to others. While I could fill volumes with images and writing about the trials and tribulations I encounter in my work, for the purposes of this book I have settled for a simple visual method to reveal some of the technical subtext behind a select number of works. Interspersed throughout the remainder of this book are a number of process collages that will help demonstrate the vivid visual environment that exists in my machine shop. These collages help highlight what I find so inspirational, and will go a long way in illustrating why going for mystique over substance would have been a mistake.

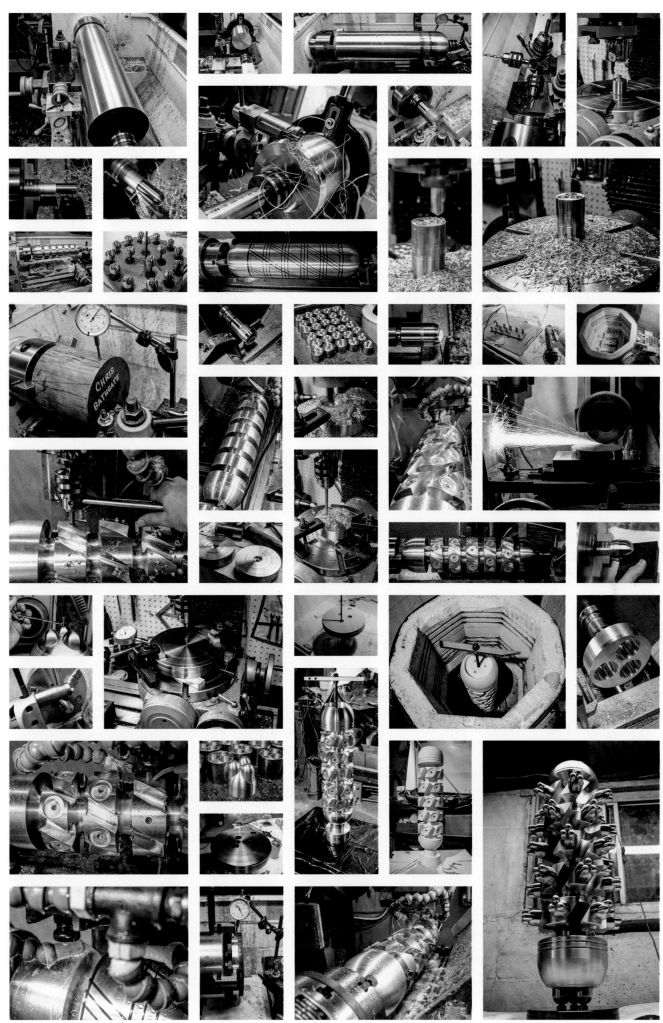

BH process collage

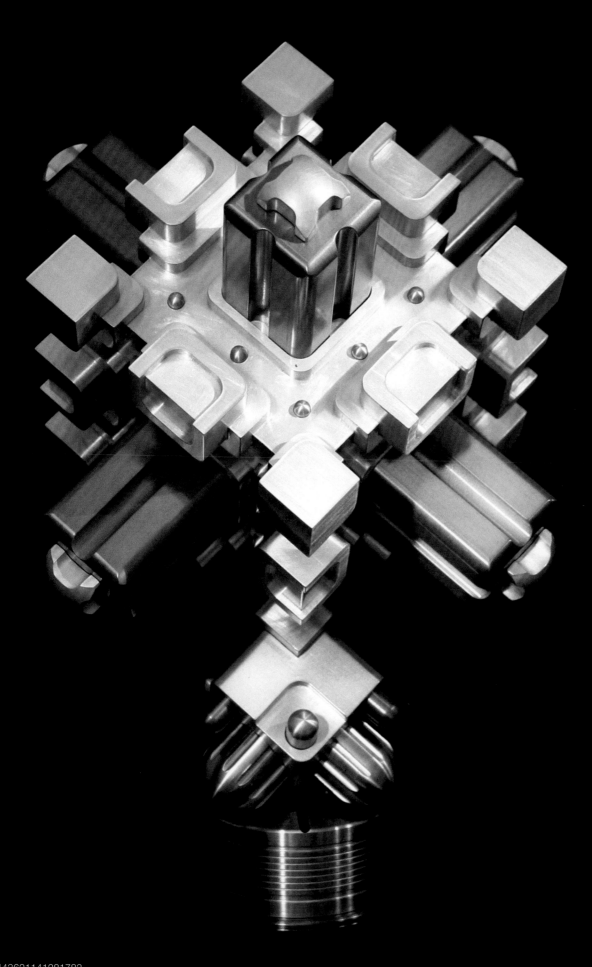

BC 443621141281783
Stainless steel, aluminum, copper, and brass
13" x 9" x 9", 2009

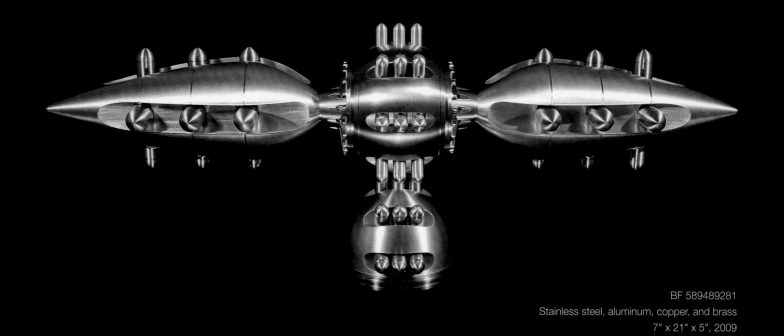

BF 589489281
Stainless steel, aluminum, copper, and brass
7" x 21" x 5", 2009

GN 469247369
Stainless steel, aluminum, and bronze
4" x 3" x 3", 2009

K 229365485
Steel, brass, and copper
6" x 2" x 2", 2009

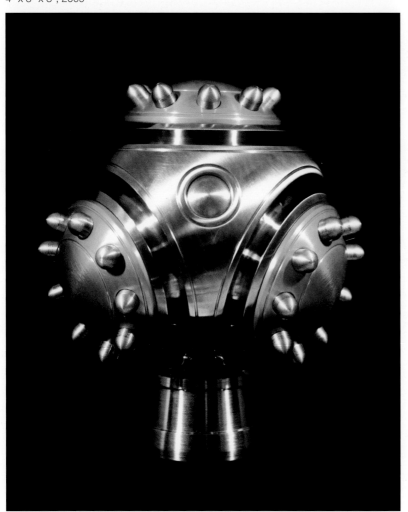

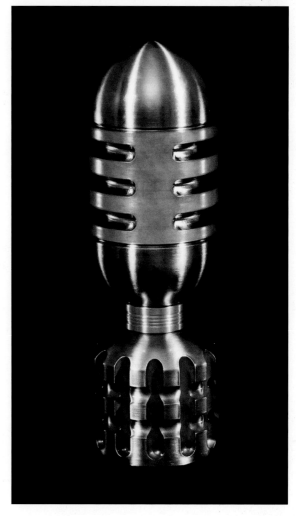

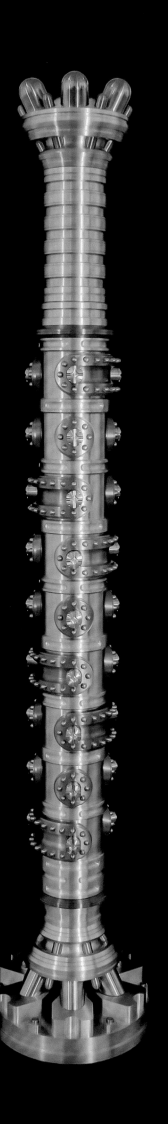

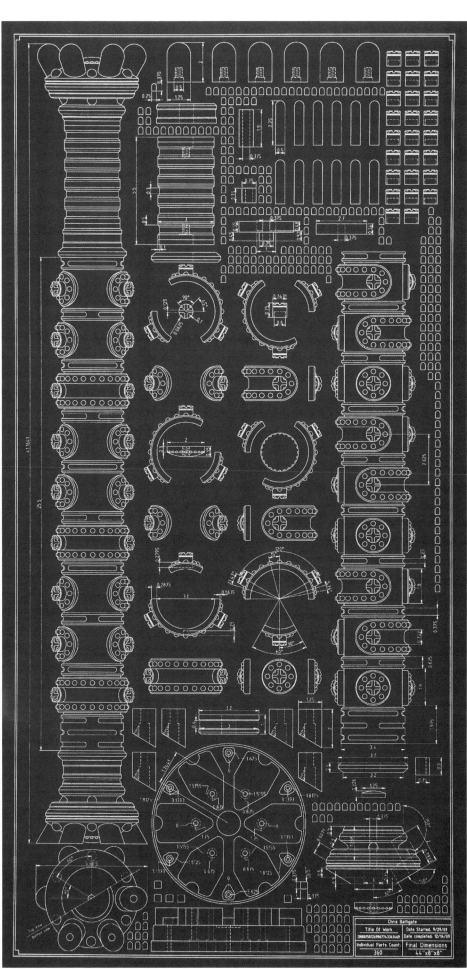

Left: DN 881501269967743341469

Stainless steel, aluminum, and copper

44" x 8" x 8", 2009

Above: DN technical drawing

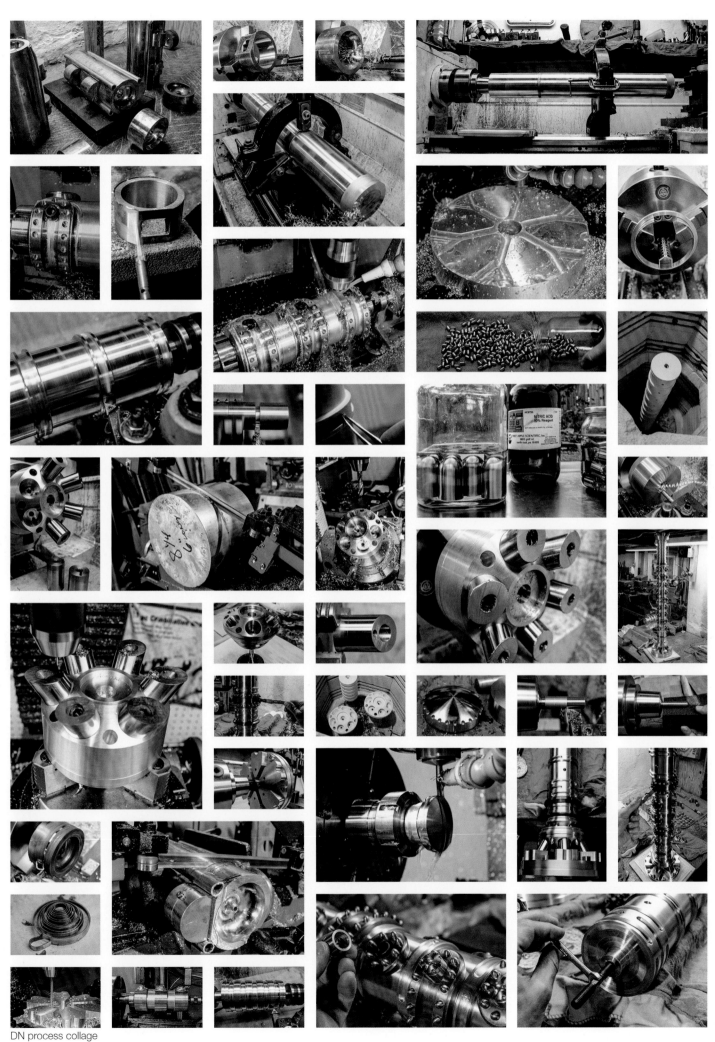

DN process collage

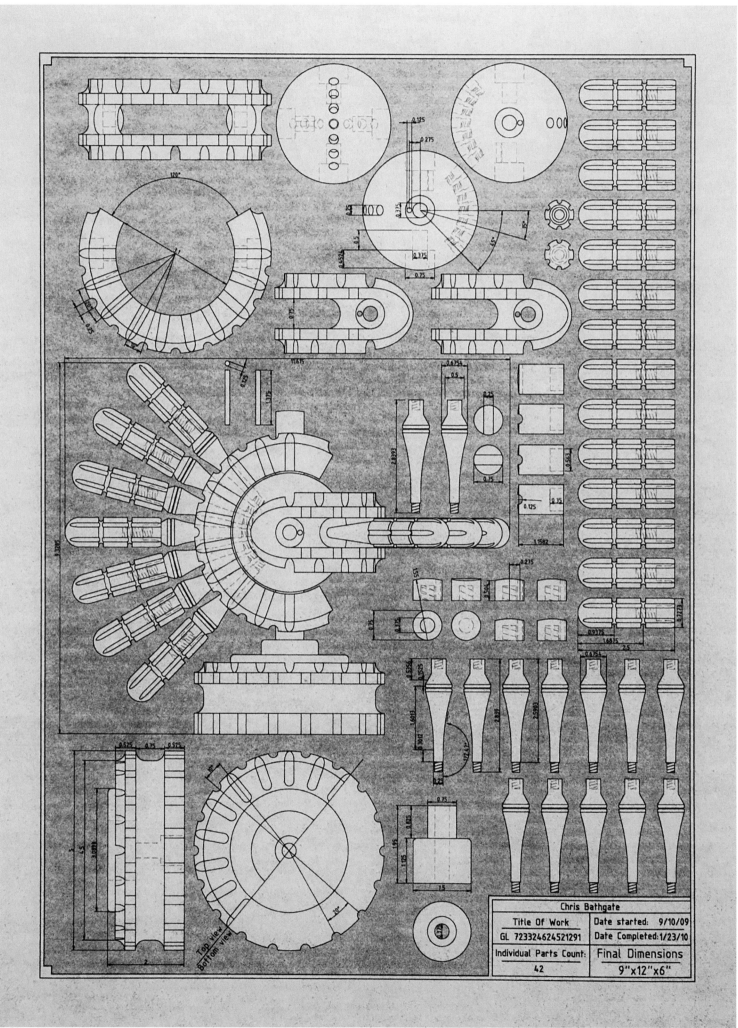

GL Diazo blueprint drawing

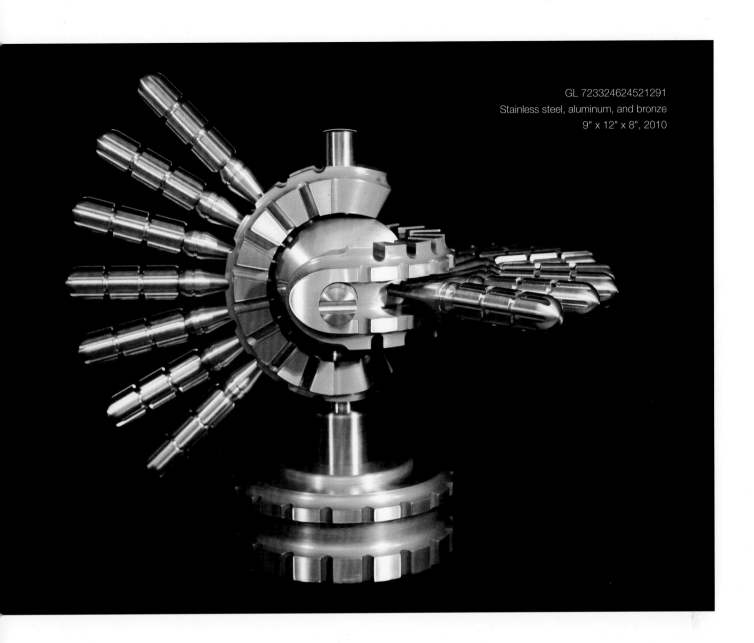

GL 723324624521291
Stainless steel, aluminum, and bronze
9" x 12" x 8", 2010

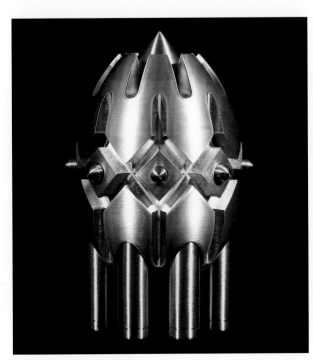

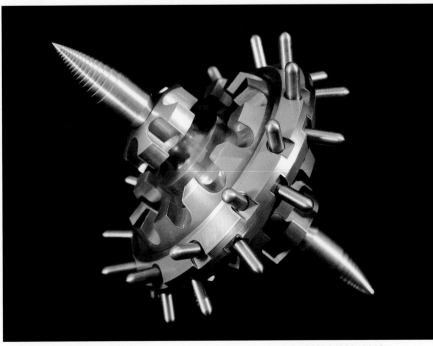

PN 869623783421243523
Aluminum and brass
4" x 2.5" x 2.5"

NT 793323462242642
Stainless steel, aluminum, and bronze
4.5" x 6" x 4.5", 2010

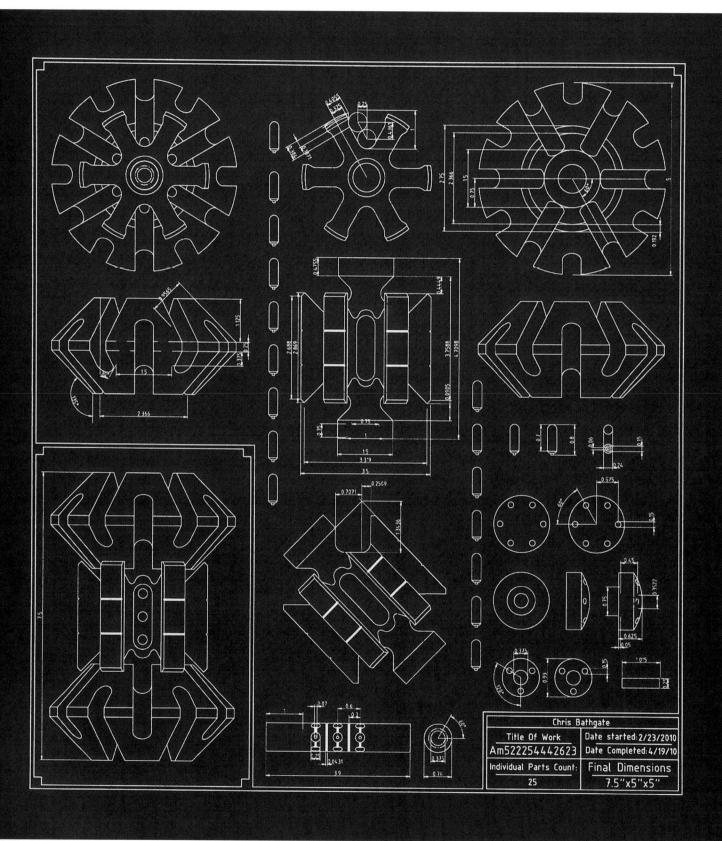

AM Diazo blueprint drawing

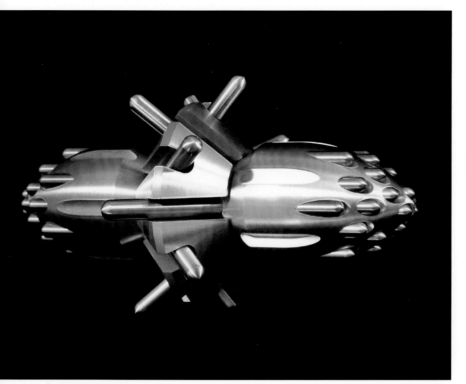

Pa 682524422291
Stainless steel, aluminum, and brass
10.5" x 5.5" x 5.5", 2010

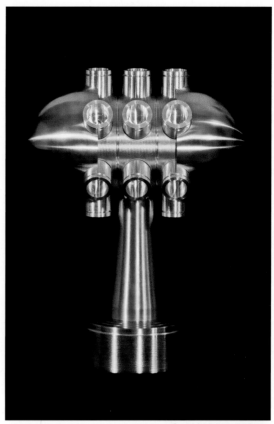

Sr 622224431773524
Stainless steel, aluminum, and brass
3" x 3" x 2", 2010

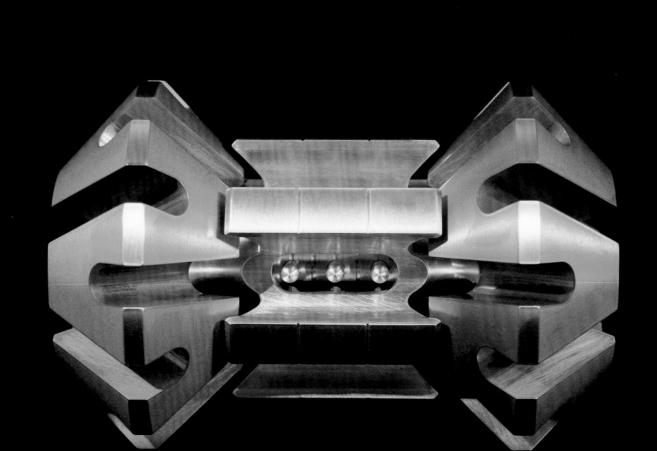

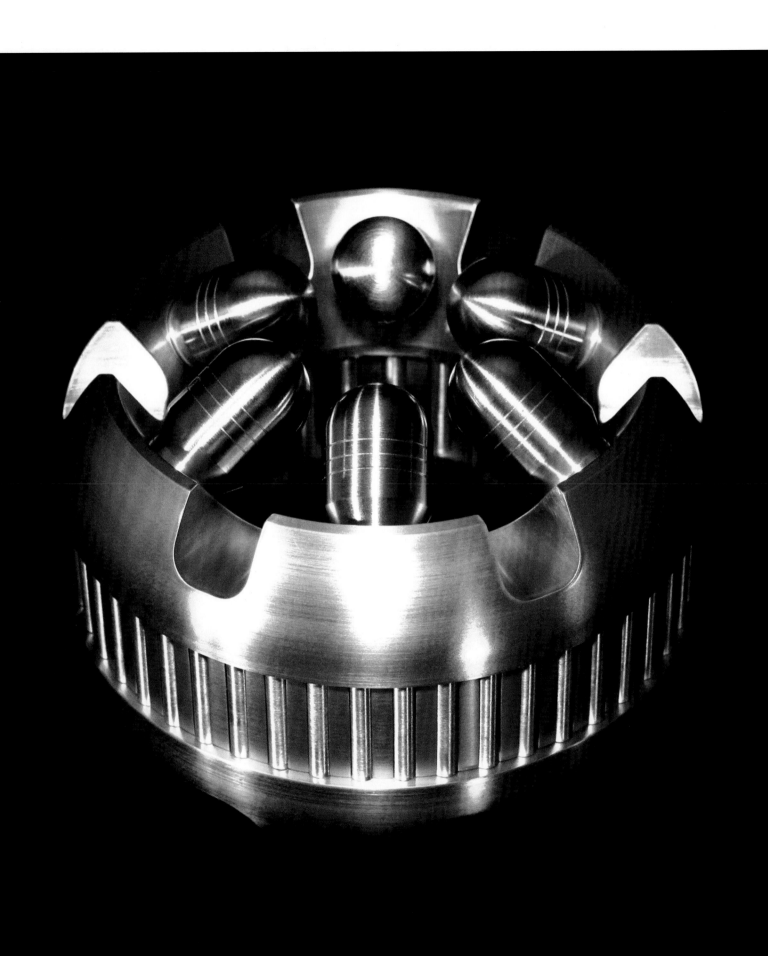

RN 753362224531143
Stainless steel and aluminum
4.5" x 6" x 6", 2010

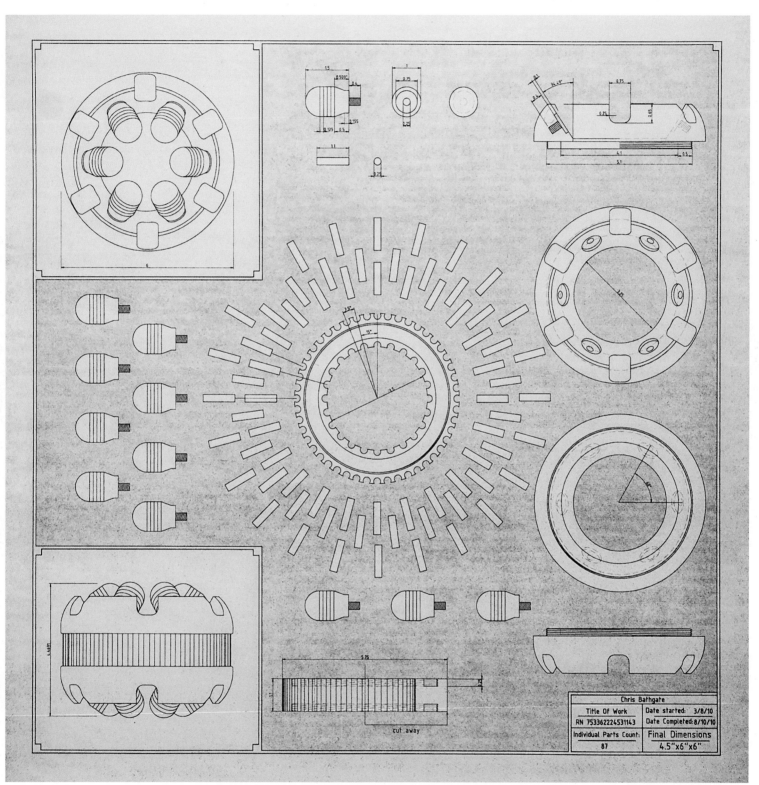

Chris Bathgate

Title Of Work	Date started: 3/8/10
RN 753362224531143	Date Completed:8/10/10
Individual Parts Count:	Final Dimensions
87	4.5"x6"x6"

cut away

RN Diazo blueprint drawing

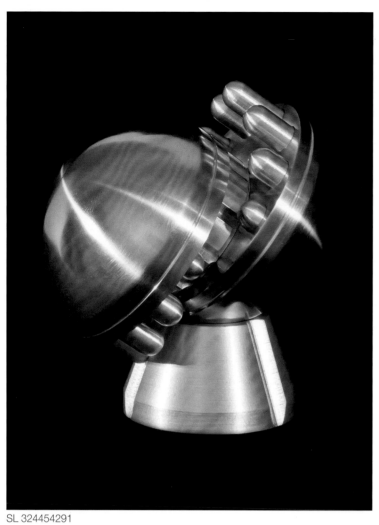

SL 324454291
Stainless steel, aluminum, and brass
3" x 3" x 2", 2010

Ng 623524453251
Stainless steel, aluminum, and brass
2" x 3" x 1.5", 2010

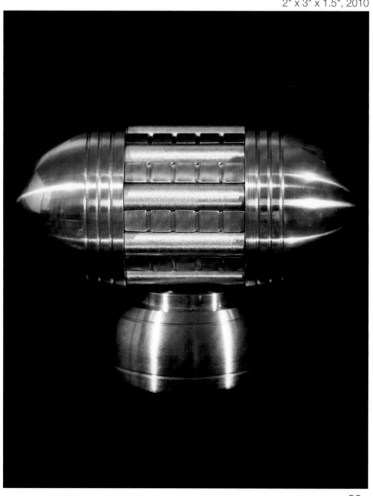

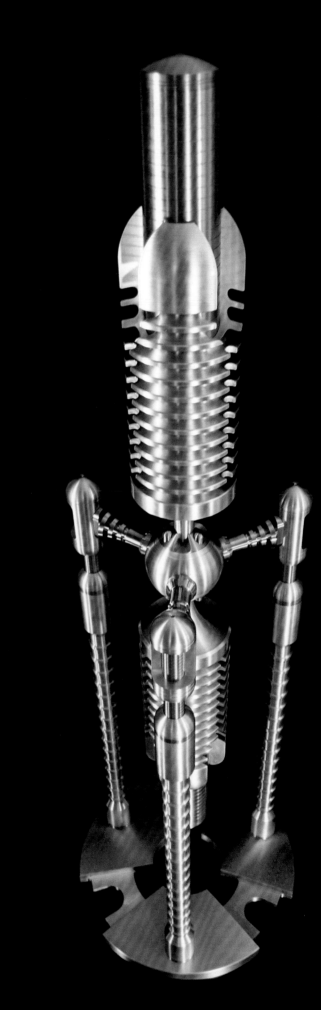

LT 732262633332524
Stainless steel, aluminum, and bronze
52" x 16" x 16", 2010

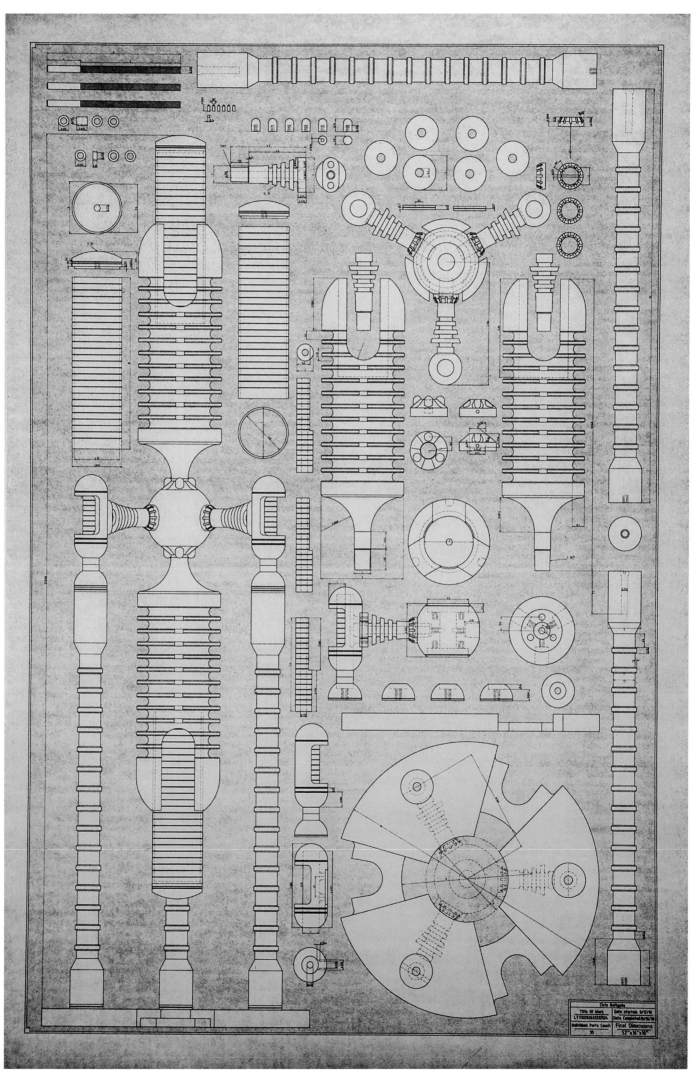

LT Diazo blueprint drawing

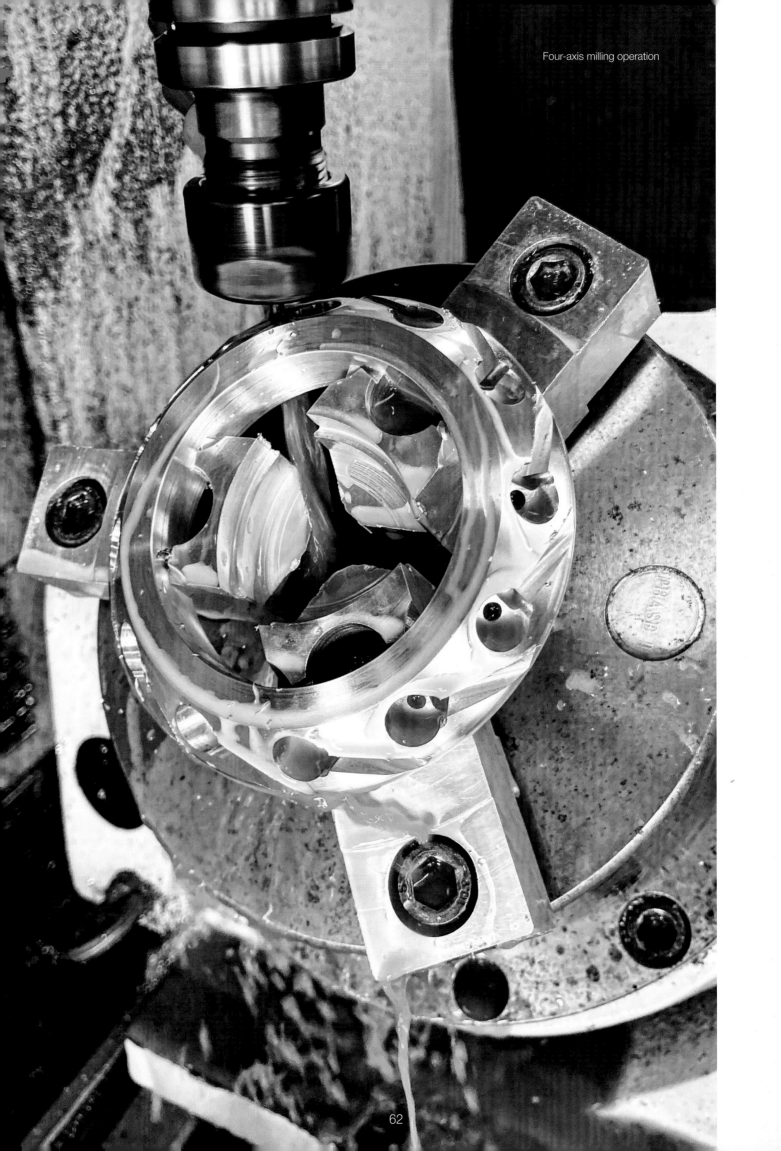

Chapter 5

There is nothing inherently new about machine work. Some of the processes I use have been around for well over a century. Even the more modern types of machines I would come to use, such as computer numerical controlled (CNC) machine tools, have existed in some form or another in industry for many decades. By the middle of the first decade of the twenty-first century, as I became more proficient with my craft, I began to look around for peers who were making similar work. Surprisingly, I came up largely empty handed. I could find hobbyist machinists who occasionally dabbled in art, or artists who used machine tools for purely utilitarian reasons such as repurposing or modifying ready-made machine parts into sculptural compositions, but I struggled to find anyone who was focused on exploring machine work as a studio art medium with its own intrinsic formal qualities. I would later come to expand my definition of what a machinist sculptor might be, but it was clear that if there were other machinist sculptors out there, they were few and far between.

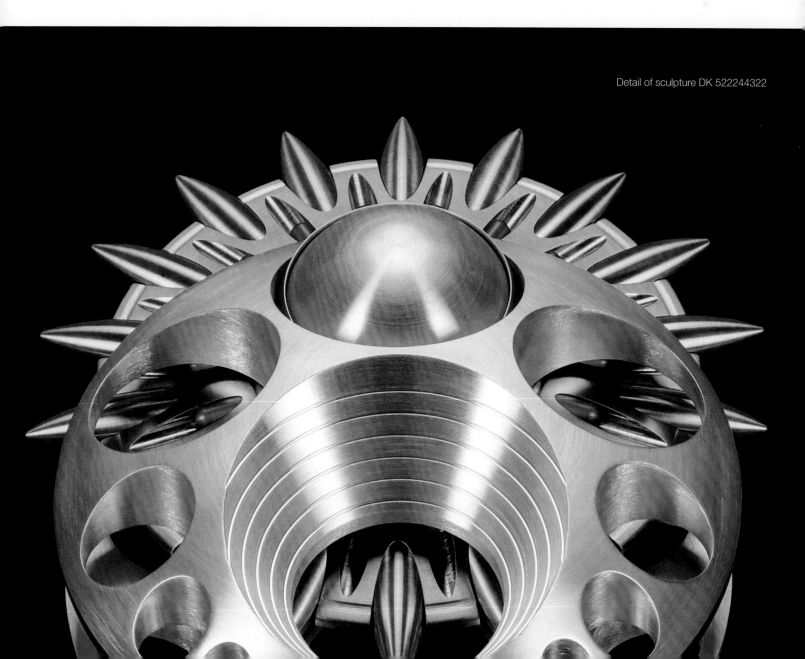

Detail of sculpture DK 522244322

Cutting helical slot for Sp 683343447521

I began to look through art books and visit museums, and I came to a similar question. If machining, as a process, has been so fundamentally important to human progress and culture, then where was all the machined art? Surely the world of fine art hadn't left this fascinating process untouched for a century and a half. While there was no shortage of art movements that were inspired by industrialization (the futurists, art deco, etc.), none effectively appropriated the tools that brought it about. I could find machined things in art museums and in galleries. I saw repurposed objects, collages, and even some custom-fabricated parts here and there, but the work was most certainly not about machining as a process—at least not in the same way that museums are so chockablock with paintings that are fundamentally about painting.

If I had learned anything in art school, it was this; artists love technology. Every time a new invention comes around—such as with the advent of film photography or video—artists have always been the first to line up and explore its potential. How and why were so few artists investigating such an elemental material technology such as machining? The answer to that question would prove complicated. However, the winds were blowing in my direction as I pursued an answer. My work and the work of other machinists, makers, and craftspeople were already writing the next chapter that would define digital manufacturing in the twenty-first century.

So what was changing throughout the decade of the 2000s that made it possible for an art school dropout such as myself to begin to piece together the resources and the knowledge to build a sculpture practice around tools that, up until this point, had been largely inaccessible to artists?

I think one obvious answer is "the internet." It was becoming easier to connect and share information online. But there were also commercial trends that were changing the landscape of what your average person could afford to do with technology. Low-cost machinery, mostly from Asia, was making its way to the United States. Along with it was a flood of cheap electronics and mechanical components. The expiration of a number of crucial 3-D-printing patents would also kick off the RepRap movement and evolve into a race to develop low-cost 3-D-printing technology. By the end of the decade, an ecosystem of cottage industries would spring up around machine tool modification and home-brewed automation. A host of cultural innovations would follow, such as the maker movement, the 3-D-printing boom, and widespread adoption of desktop-manufacturing tools. While much attention has been paid to the rise of 3-D printing, the earliest pioneers of consumer robotics and automation design were machinists.

The potential of more-automated machine tool processes became incredibly appealing to me. I began looking into building my own CNC machine tools, not so that they could do the manual parts of my work for me, but as a way to augment my abilities and pursue work that was otherwise impossible—or at the very least highly impractical. There were commercial machine tools on the market that could have served this purpose for me, but they were very large and prohibitively expensive to own and operate. They were not well suited for artists, hobbyists, or anyone who was not looking to use them expressly for profit.

Stock chucked in lathe for turning

I saw only one viable route to bring digital machining methods into my studio practice: repurposing older equipment where I could, and handcrafting the CNC machine tools that were beyond my means. With that increasingly being a realistic possibility, I set about scouring industrial message boards, which I now regularly inhabited, for guidance. These boards had smaller subgroups that were sharing information on how to build and repurpose imported machinery to build custom CNC equipment. I found links to resources and pieced together both the mechanical and electronic components I would need. And most importantly, I found other hobbyists making and selling parts and instructions that would help smooth the way.

Between 2006 and 2009, with grant assistance from the Pollock-Krasner Foundation, I would construct a number of different pieces of CNC metalworking equipment. While homemade tools are in many ways simpler and less efficient than their industrial counterparts, they compensate for this by virtue of being much better suited to experimentation and use as an artist's tool. They are easily modified for new uses, and the cost of repairing them when things go wrong is much more manageable than a modern industrial machine tool. Accessibility, flexibility, and affordability are key features when it comes to pushing the limits of what can be done with a particular tool or technology. I would turn these tool-building experiences and the knowledge I had gained from their construction into the visual inspiration for a whole series of sculptural works. Employing automated machine tools would give me a fresh perspective on my work, as well as a more nuanced understanding of handwork and craftsmanship.

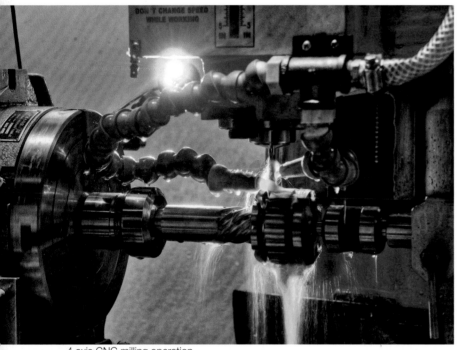
4 axis CNC milling operation

While improvising homemade CNC equipment, I have learned more skills than I can count; electronics, hardware integration, and basic engineering are the obvious ones. However, research into tool building has also fostered an interest in materials science and physics. I have also learned numerous programming languages and visual-software tools. While the list goes on, the thing that is most striking is how intrinsically connected they are to machining. It would have been harder not to have learned many of these things, and once you know something, it is impossible for it not to influence your art.

Industrial tool manufacturers are increasingly interested in offering smaller, easier-to-operate, and lower-cost machine tools aimed at the individual maker or small shop. Other new technologies such as 3-D printers, scanners, and a whole host of design software and services have become more common as well. The rise of the "maker movement" brought much more visibility to this formerly overlooked craft, while "desktop manufacturing" and "micromanufacturing" have become buzzwords used to describe small producers of utilitarian goods and services. This increased visibility, coupled with the help of social media, has spurred a wave of new artists, designers, and craftspeople looking to experiment with these tools for aesthetic purposes rather than as a means of mass production.

When we look back to other industrial craft traditions, we often can point to an inflection point where a technology or cultural moment created the conditions necessary for the wider adoption of a practice. When looking at the landscape unfolding around machine work in the latter portion of the 2000s decade, I felt certain that the experimentation going on with automation and machine tools was the beginnings of a new field within the arts.

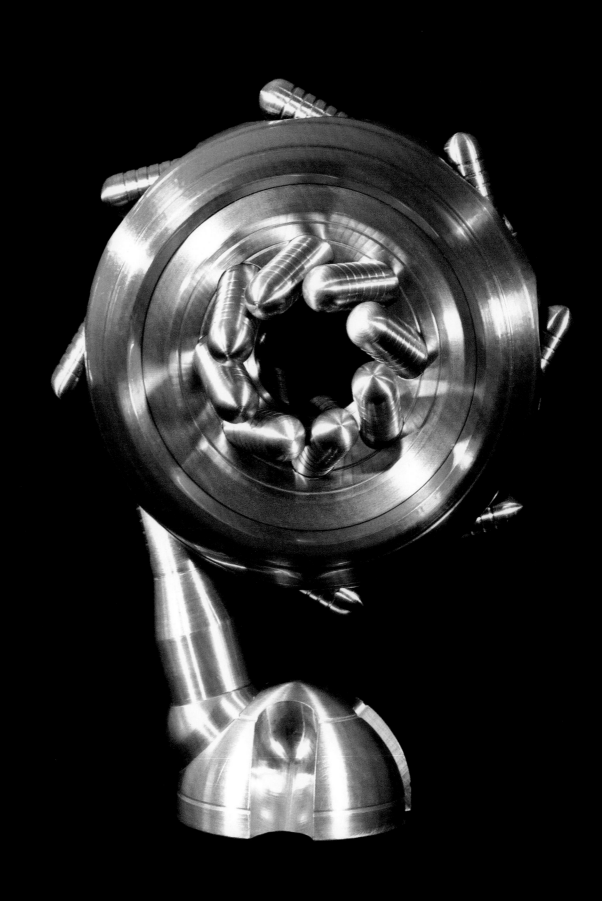

TI 524422363
Copper, stainless steel, bronze, and aluminum
4" x 4" x 5", 2011

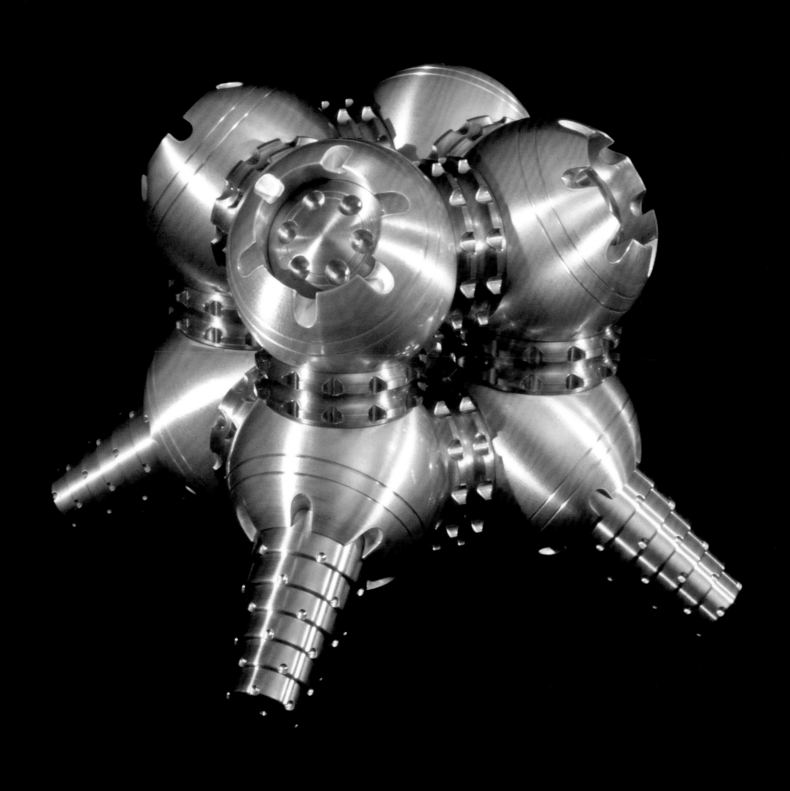

SH 633374451562293724
Stainless steel, aluminum, and bronze
7" x 8" x 8", 2010

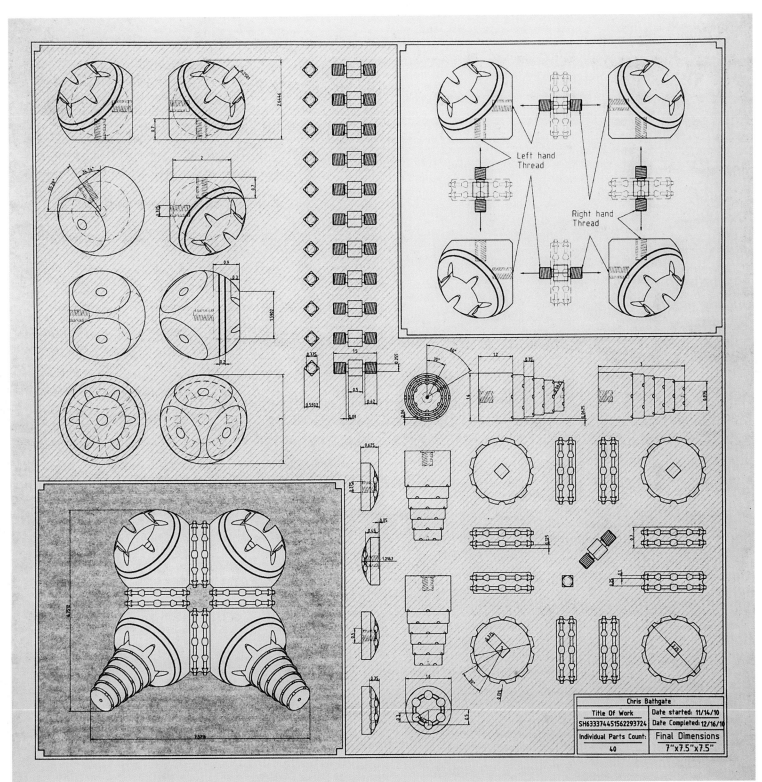

Chris Bathgate

Title Of Work	Date started: 11/14/10
SH63337445156229372A	Date Completed: 12/16/10
Individual Parts Count:	Final Dimensions
40	7"x7.5"x7.5"

Left hand Thread

Right hand Thread

SH Diazo blueprint drawing

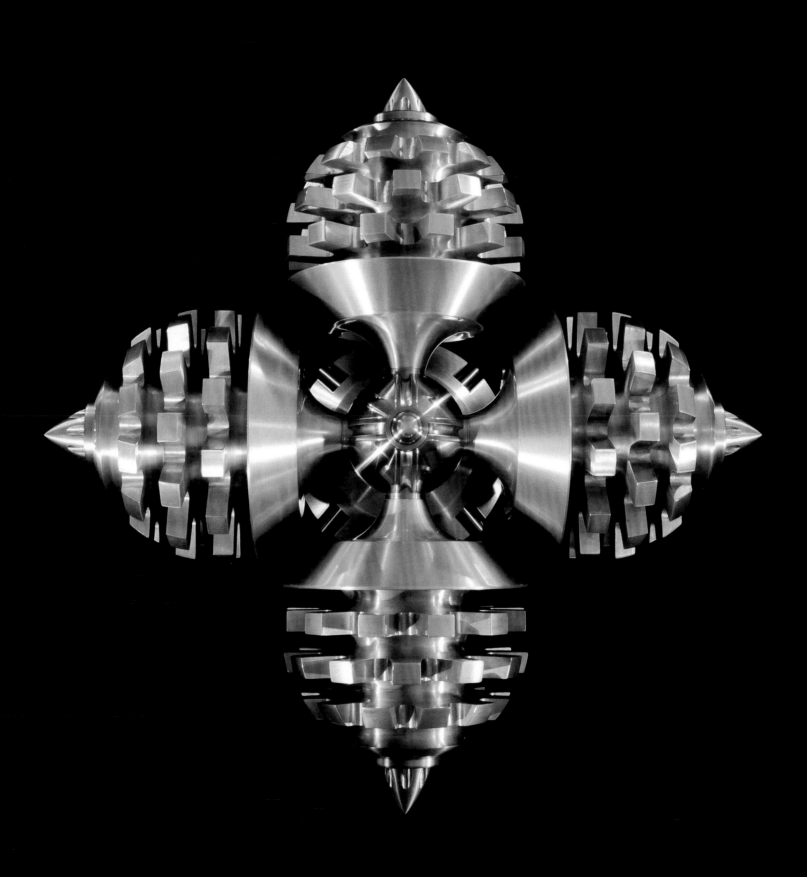

ST 732232835563624434
Stainless steel, aluminum, brass, and bronze
18" x 18" x 7", 2011

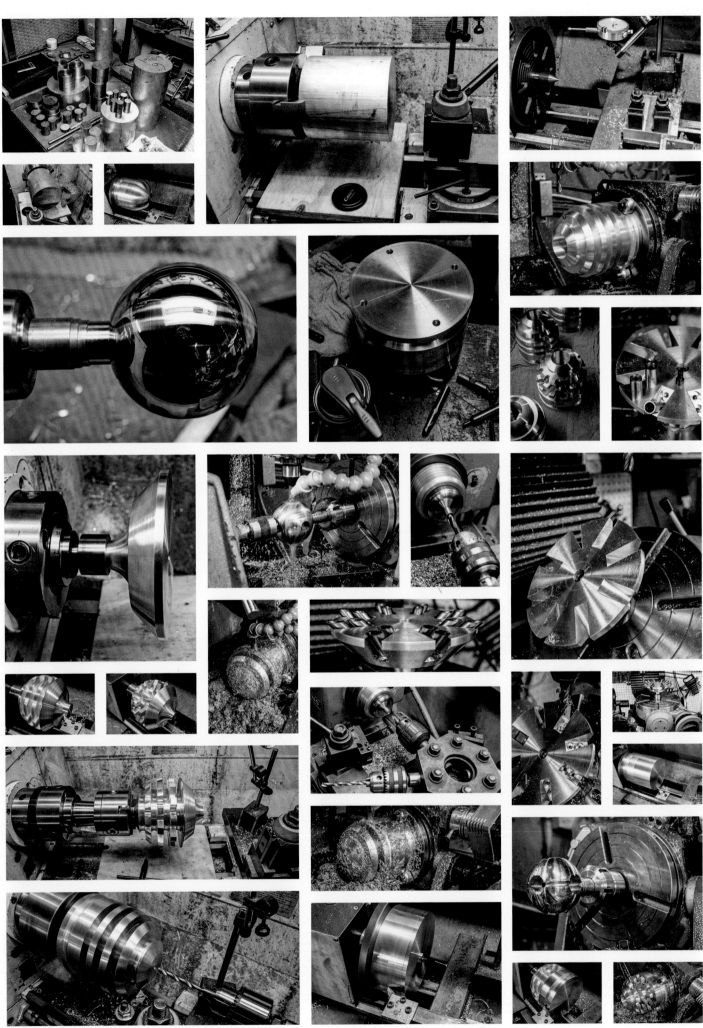

ST process collage

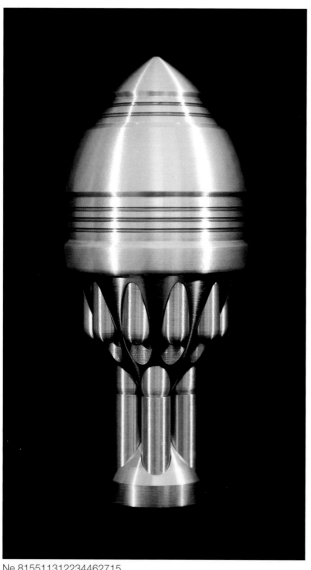

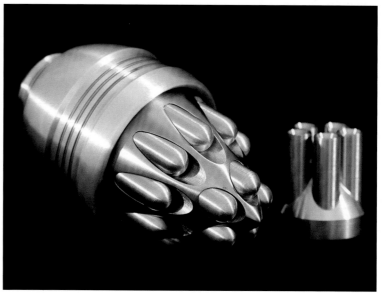

Ne 815511312234462715 removed from stand

Ne 815511312234462715
Stainless steel, aluminum, and brass
6" x 2.5" x 2.5", 2011

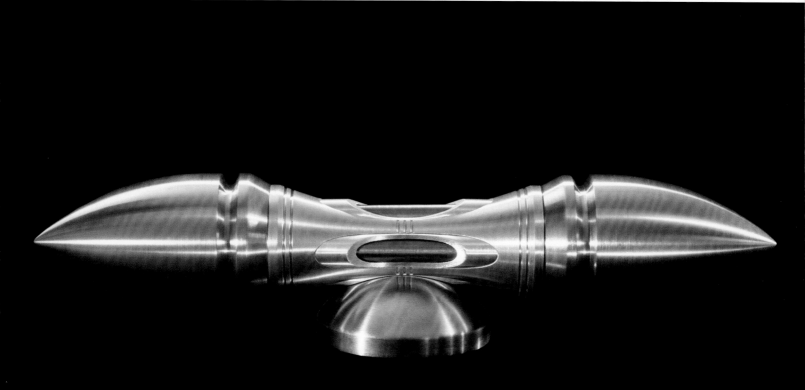

PN 635512223333
Stainless steel, aluminum, bronze, and copper
2" x 8" x 2", 2011

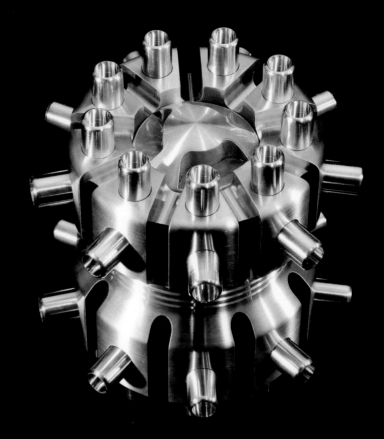

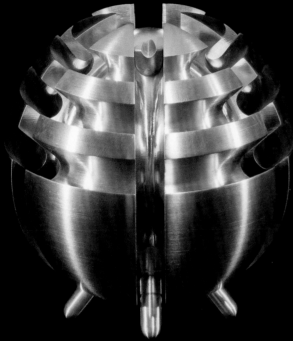

ZB 515514332
Stainless steel, aluminum, brass, and bronze
3" x 3" x 3"

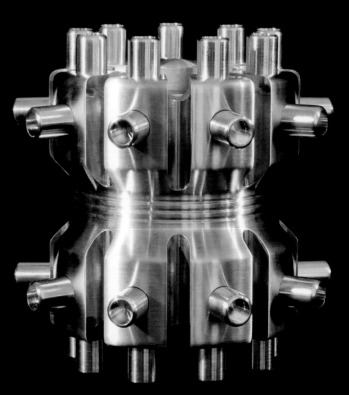

CL 863624433722235525
Stainless steel, brass, and bronze
4" x 4" x 4", 2011

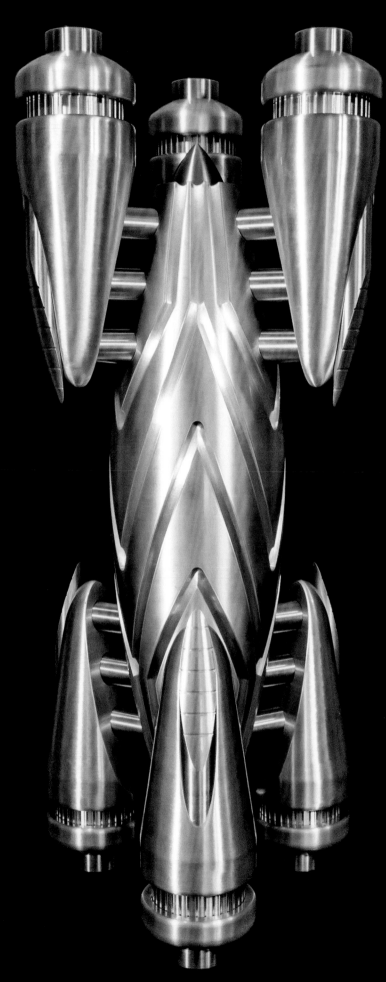

Tr 334425524622211
Aluminum, brass, bronze, and stainless steel
19" x 8" x 8", 2011

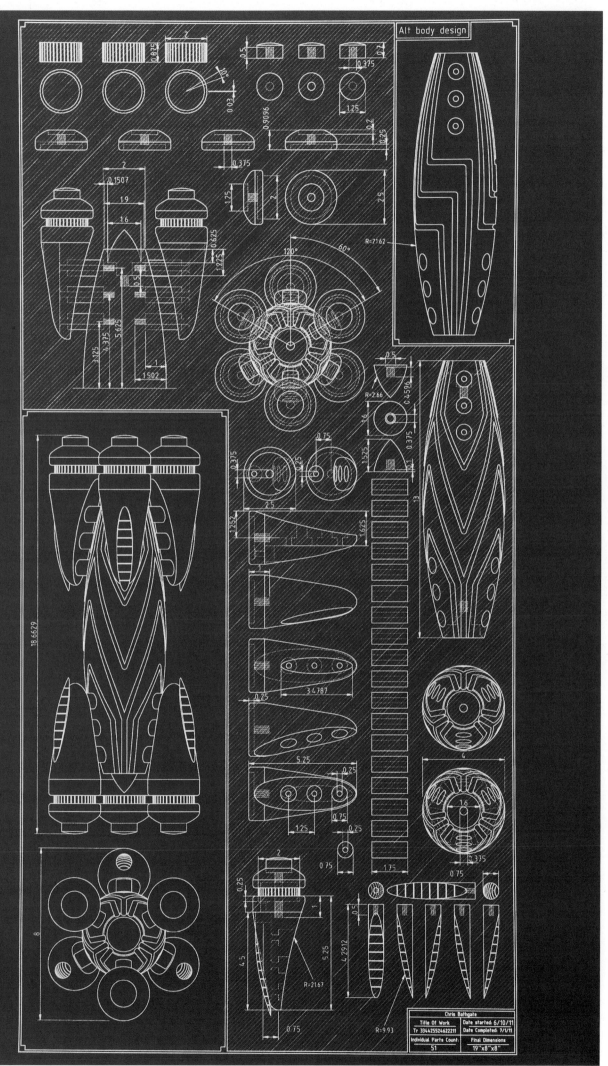

Tr Diazo blueprint drawing

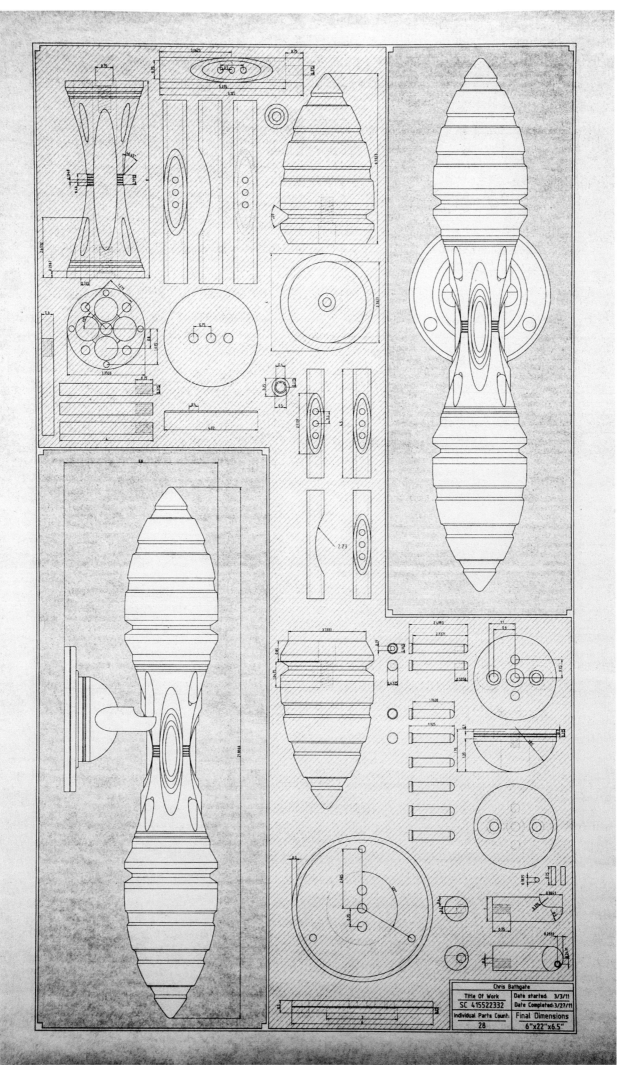

Chris Bathgate

Title Of Work	Date started: 3/3/11
SC 415522332	Date Completed:3/27/11
Individual Parts Count:	Final Dimensions
28	6"x22"x6.5"

Sc Diazo blueprint drawing

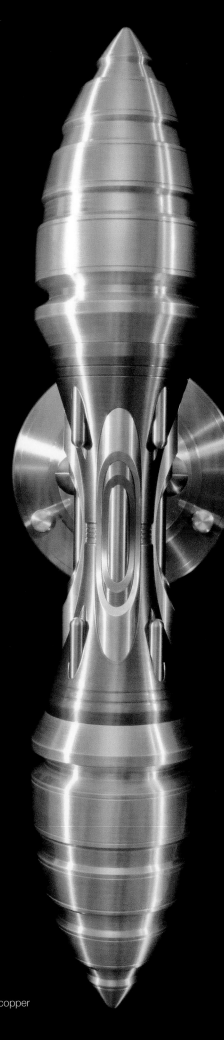

SC 415522332
Stainless steel, aluminum, brass, bronze, and copper
21" x 8" x 8", 2011

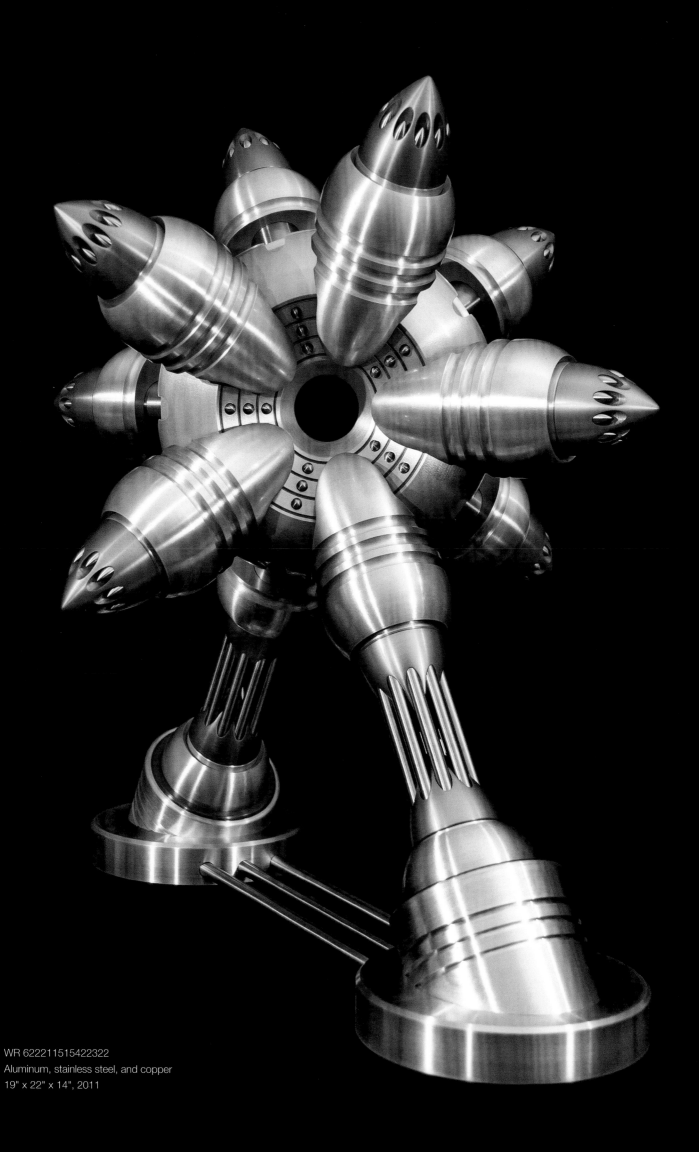

WR 622211515422322
Aluminum, stainless steel, and copper
19" x 22" x 14", 2011

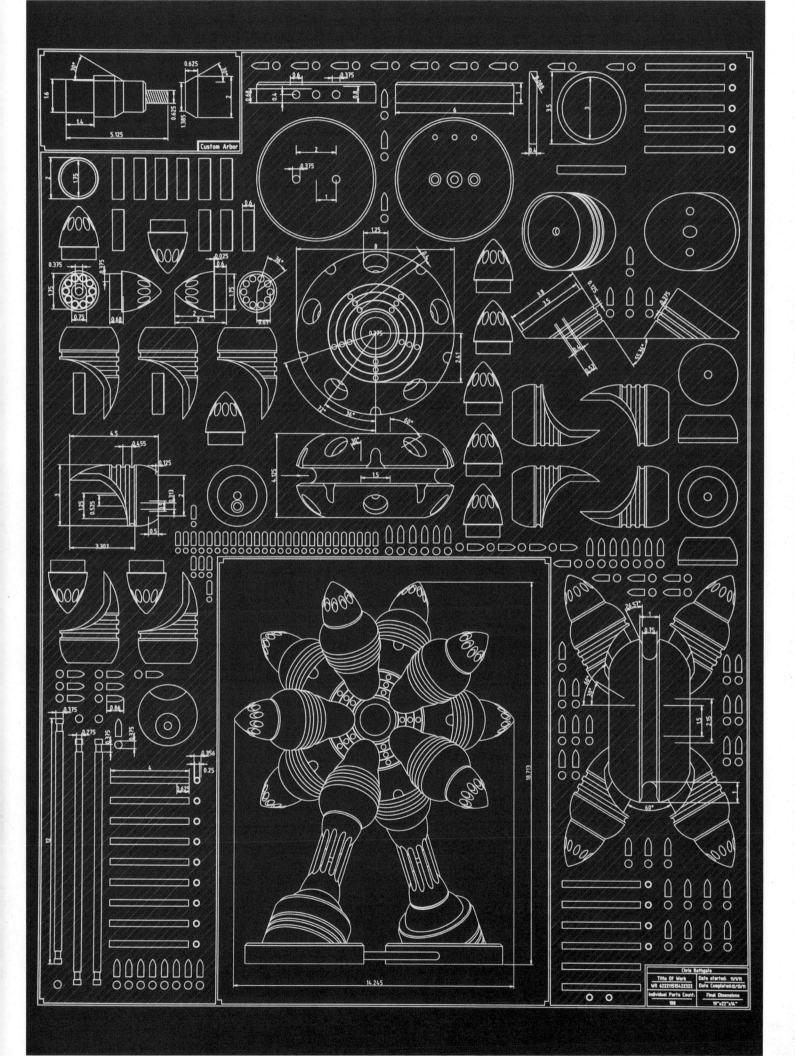

WR Diazo blueprint drawing

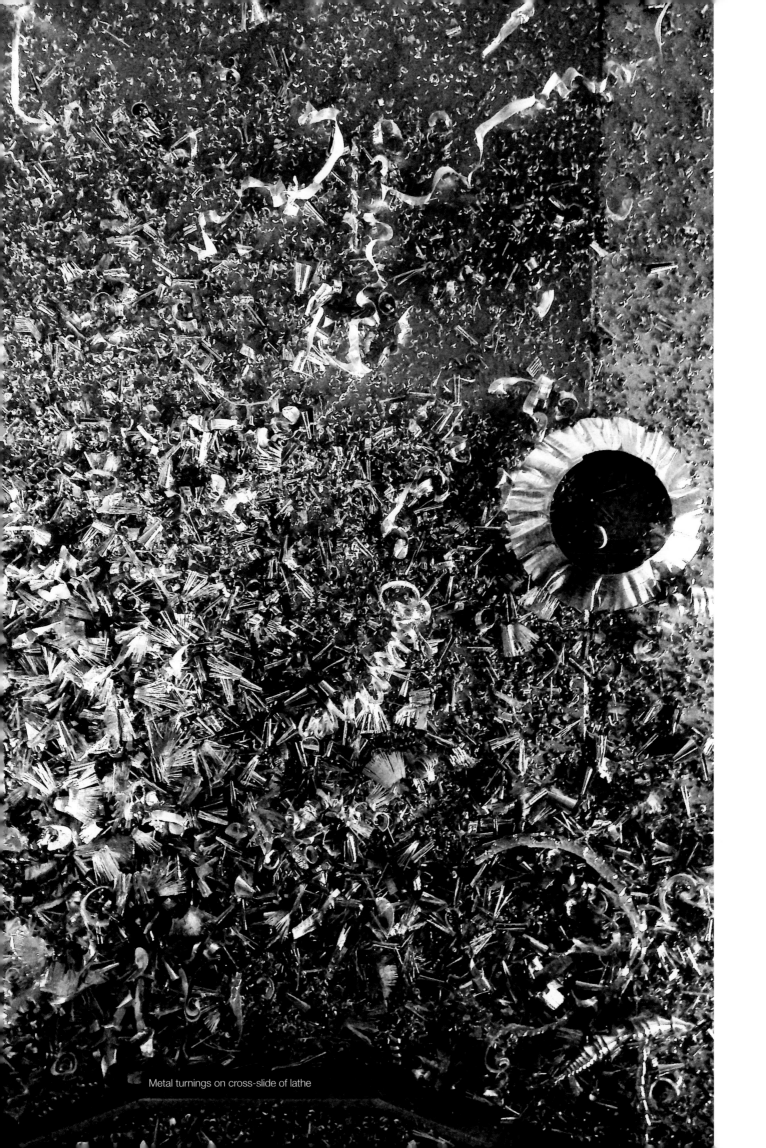
Metal turnings on cross-slide of lathe

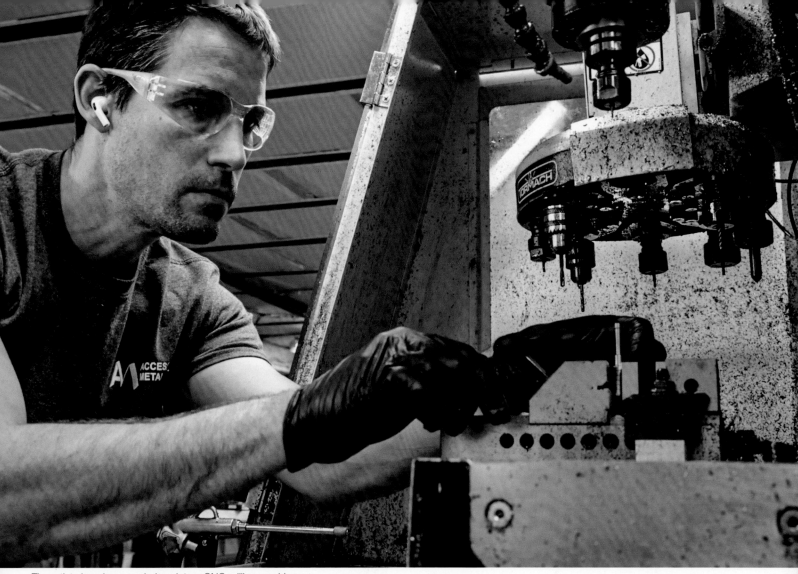
The artist clamping a workpiece into a CNC milling machine

Chapter 6

So then, what comes from mastering new tools and new technology? What do we gain from becoming proficient with a process or medium other than a physical skill? I would argue that what you gain is the ability to learn almost anything, as well as a curious type of empathy.

If you listen to artists, designers, or craftspeople talk, you might notice that they often speak about their work as if it were a kind of language. Considering how varied art interpretation can be, this is an imperfect metaphor, especially if you feel that language should enable precise communication. However, as problematic as the language metaphor is, it gets as close as one can to describing the relationships that creative people develop with aspects of their work. When I have shared a kind of mastery with other artists, I have found it easier to communicate nuanced ideas and, frankly, things for which words fail. I have an easier time relating to their thought process even if it is completely unrelated to my own specialty. Mastery gives me a sense of the rhythm of how the mind works, so even though every artist speaks differently about their work, I usually get the gist of what they're saying.

Mastering one skill also makes it that much easier to master another; skill sets often overlap in fundamental ways, so the additional information required becomes less the more you learn.

Mastery Is Language

The language metaphor can also be turned on its head; our chosen mediums often come with their own jargon and technical languages that can be used as a lens for self-examination. These intrinsic languages may be purely functional, yet bending our ideas through them can give us a fresh perspective on our strengths or shortcomings and suggest original solutions.

In machine work, there are a multitude of technical languages. CAD drawings force one to reduce ideas to well-defined geometry and often require the use of a certain kind of shorthand or symbolism to express different types of information. Programming languages used to operate various machine tools take ideas and break them into alphanumeric codes that a machine tool can interpret; these codes have a format and structure that can suggest all sorts of interesting possibilities—from how to best execute a particular cut to how to think about a piece of geometry in four-dimensional space.

And of course, no discussion of language would be complete without bringing up what many believe to be the true universal language, which is mathematics. Machine work all but requires one to be proficient with quite a few branches of math in order to plan the fabrication of parts. Basic geometry and trigonometry are the most common, but one can also find themselves wrestling with myriad physics equations to solve engineering challenges that arise as well. The possibilities for the interplay between art and math are so strong that "math-art" has become its own stand-alone discipline within the arts.

In addition to empathy, these quirks of language and perspective have helped me catch indirect glimpses of how my own subconscious works, and have offered meaningful clues about my creative impulses. As a technically minded person, I've felt compelled to quantify my aesthetic to the greatest extent possible. I do so in the hopes of discovering rules that govern my taste so that I can better make the things I want to see in the world. And of course, once we become proficient with our own creative language, we can begin to look for new and interesting things to say.

MG1 sculptures lined up during fabrication

```
G90 G00
G00 Z5
M6 T2 G43 (1/4 BALL MILL)
M3 S4000
M8
G00 X-.2 Y0

(FIRST POCKET)
G00 z4
G00 A-5
G00 A0
G00 Z.7
M98 P1111 L1 (CALL POCKET)
G90
G00 z4

(SECOND POCKET)
G00 z4
G00 A120
G00 Z.7
M98 P1111 L1 (CALL POCKET)
G90
G00 z4

(THIRD POCKET)
G00 z4
G00 A240
G00 Z.7
M98 P1111 L1 (CALL POCKET)
G90
G00 z4
g00 x0y0

G00A-5
G00 A0
G00 Z5

(TOOL CHANGE)
M5M9
M6 T3 G43  (3/16 END MILL)
M3 S4500
M8
G90

G00 z4
G00 X0 Y0

G00 A-5
G00 A0
(STARTT GUIDE SLOTS)

(GUIDE1)
G00 z4
g00 x0y0
G00 A0
G00 X.55 Y-.003
G00 Z.5
G01 Z.385 F12
```

Left: example of G-code that most CNC machines use to operate. *Right*: Machine control display and reference drawing

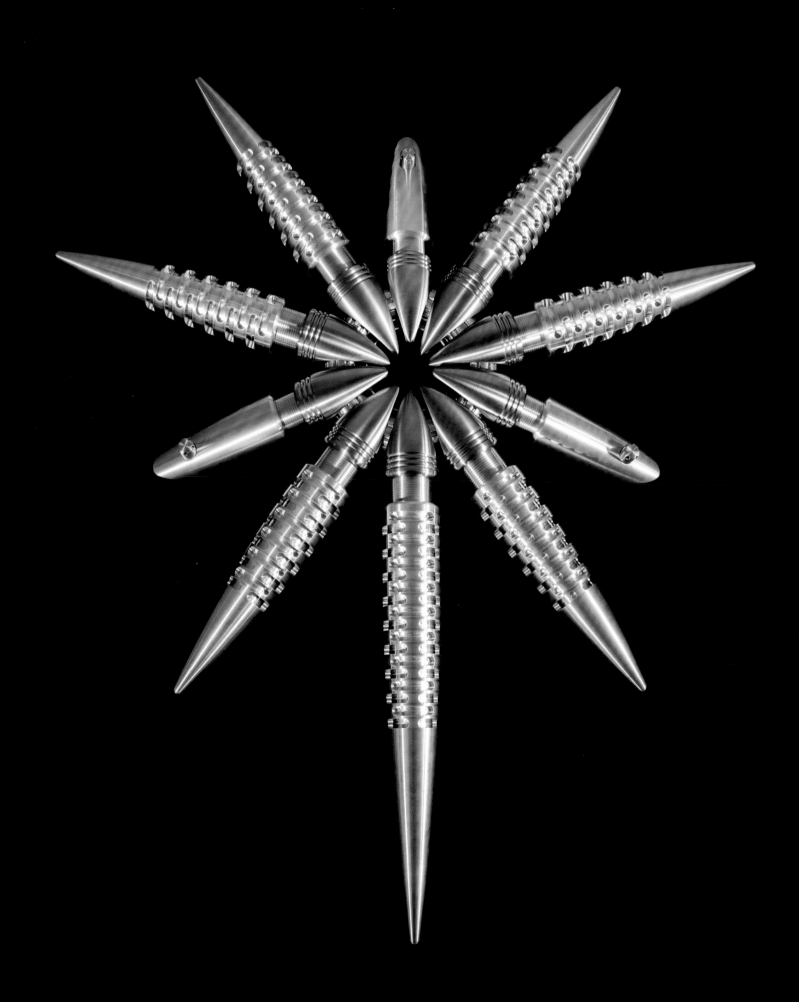

NT 554416312254
Aluminum, bronze, and stainless steel
30" x 25" x 3.25", 2012

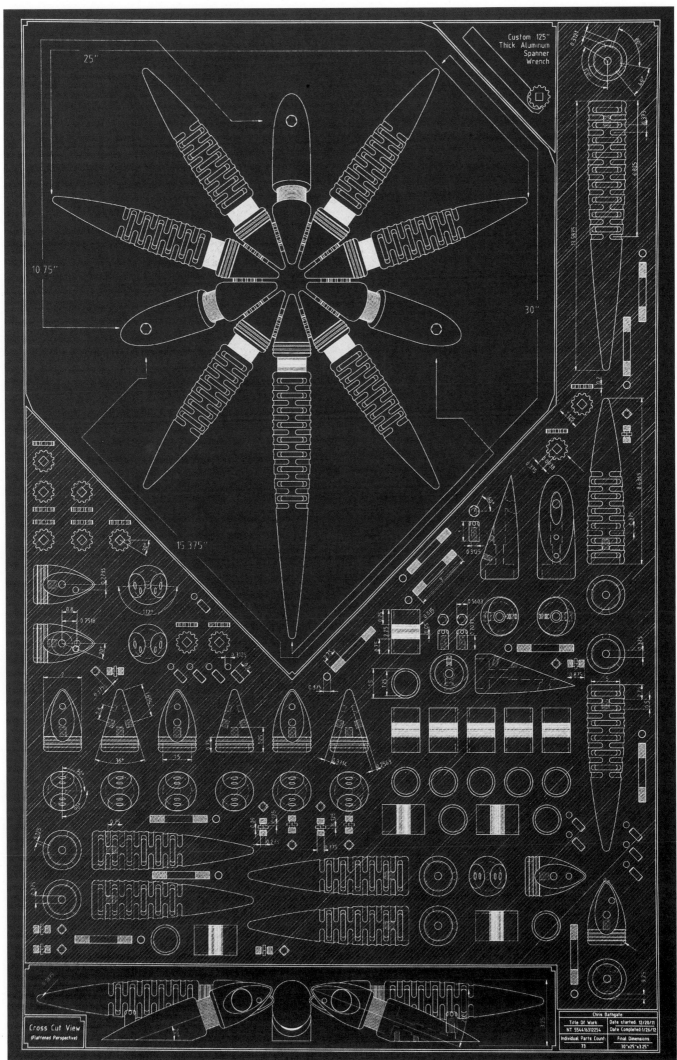

NT Diazo blueprint drawing

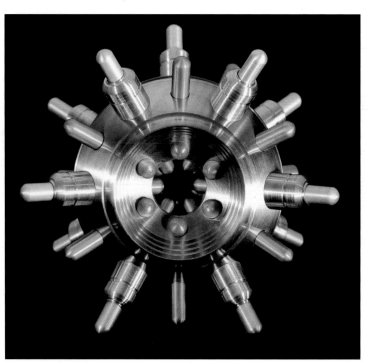

CP 412252645235
Stainless steel, aluminum, and bronze
3.5" x 3.5" x 3", 2013

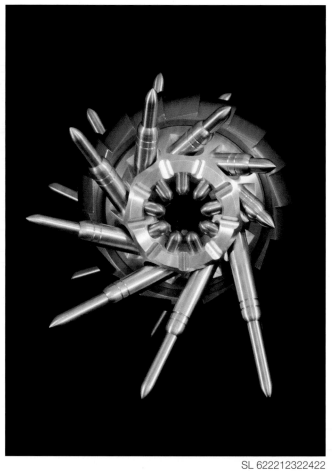

SL 622212322422
Aluminum, bronze, copper, stainless steel, and brass
4" x 4" x 5", 2011

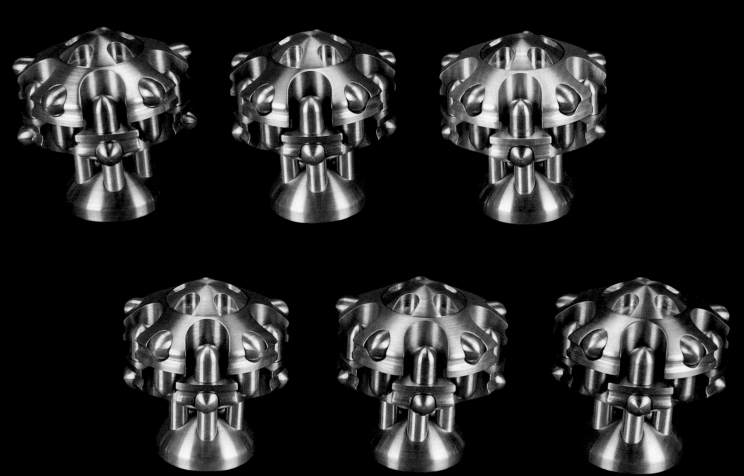

AR 645452222344
Stainless steel, brass, bronze, copper, and aluminum
2" x 2" x 2", 2013

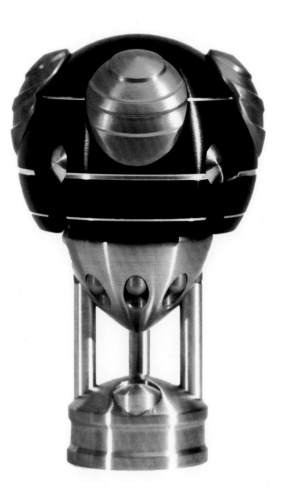

MU 415511322
Aluminum, stainless steel, and bronze
4.5" x 3" x 3", 2013

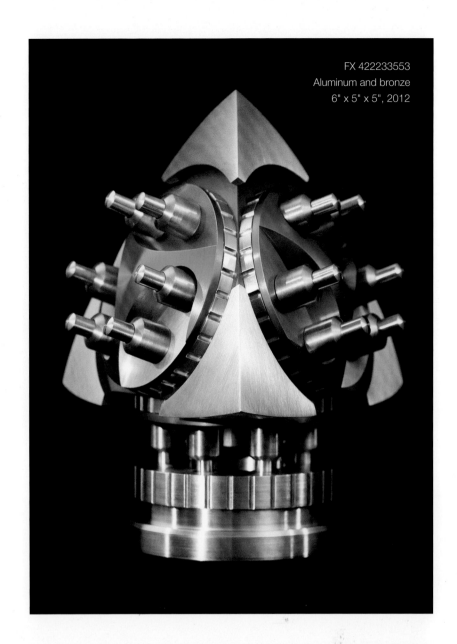

FX 422233553
Aluminum and bronze
6" x 5" x 5", 2012

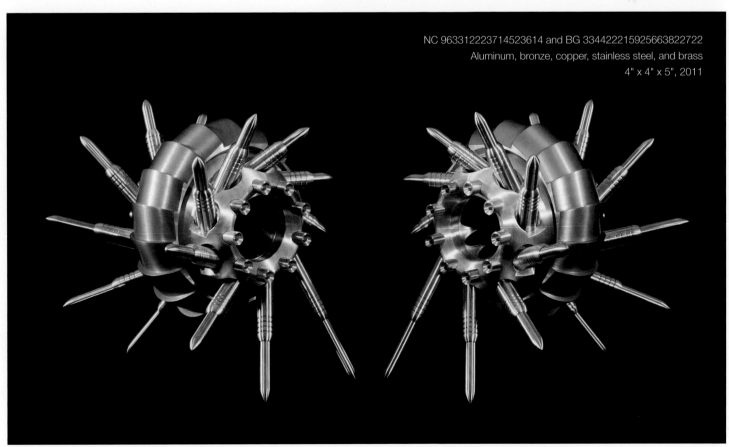

NC 963312223714523614 and BG 3344222159256663822722
Aluminum, bronze, copper, stainless steel, and brass
4" x 4" x 5", 2011

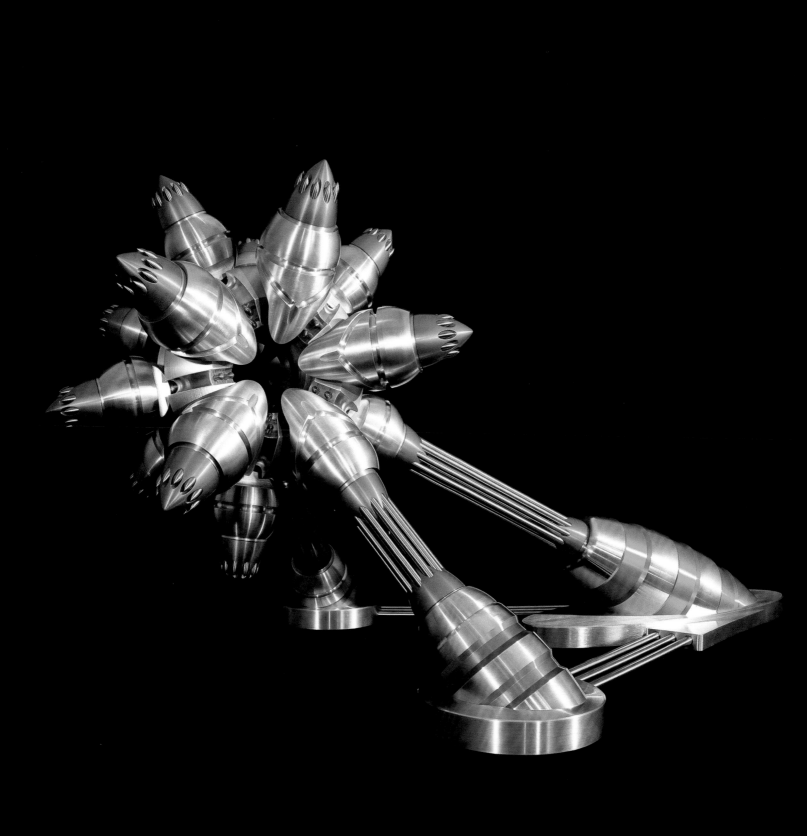

DC 355554254645
Aluminum, bronze, copper, and stainless steel
20" x 37" x 24.5", 2012

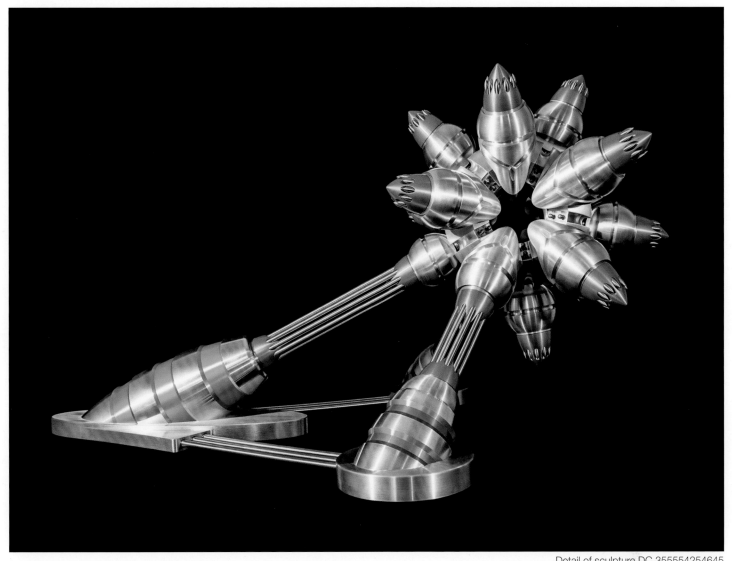

Detail of sculpture DC 355554254645

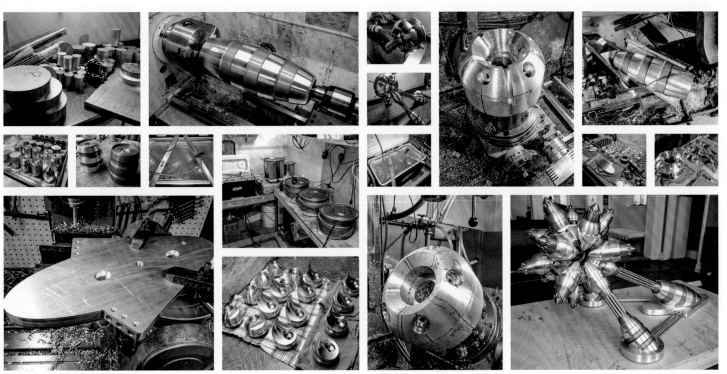

DC process collage

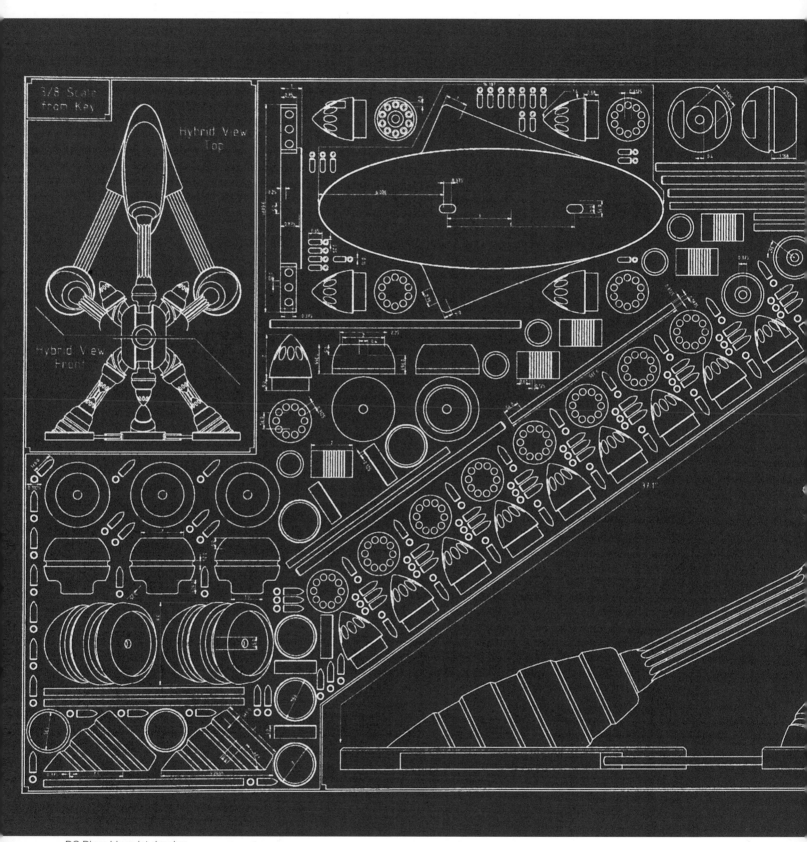

DC Diazo blueprint drawing

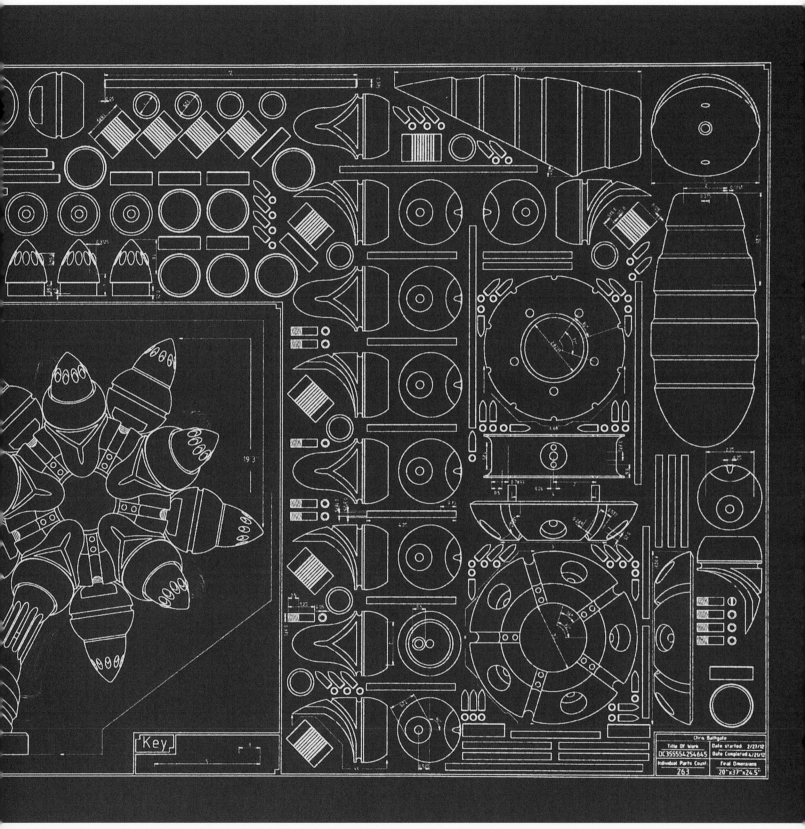

Key

Chris Bathgate
Title Of Work
DC3S5554254645
Individual Parts Count
263
Date started 2/27/12
Date Completed 4/21/12
Final Dimensions
20"x37"x24.5"

K 442214313124
Aluminum and stainless steel
7.5" x 13.5" x 6.5", 2012

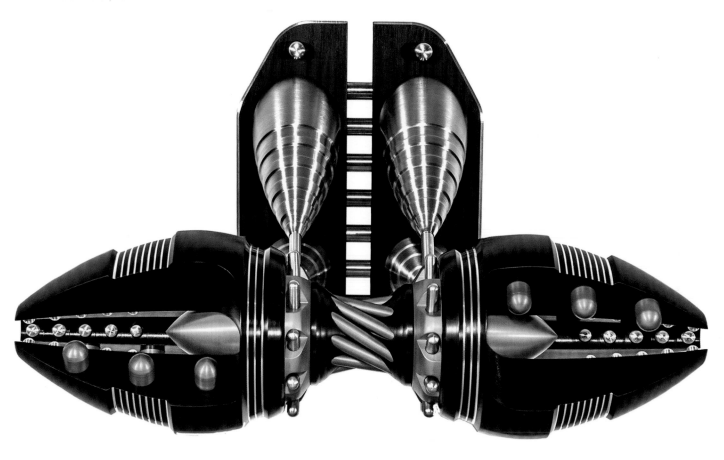

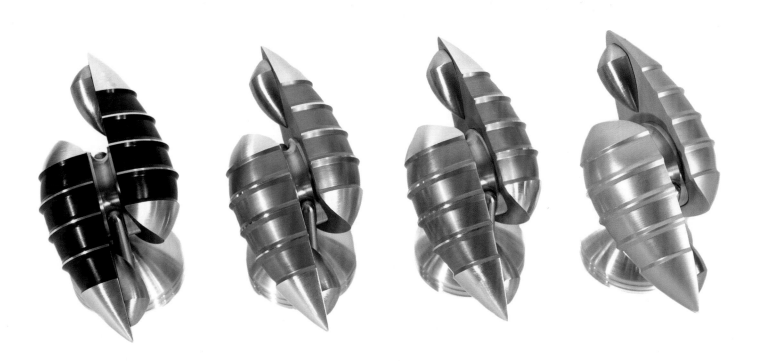

FX 633334453532254
Aluminum, bronze, and stainless steel
3" x 5" x 2.5", 2012

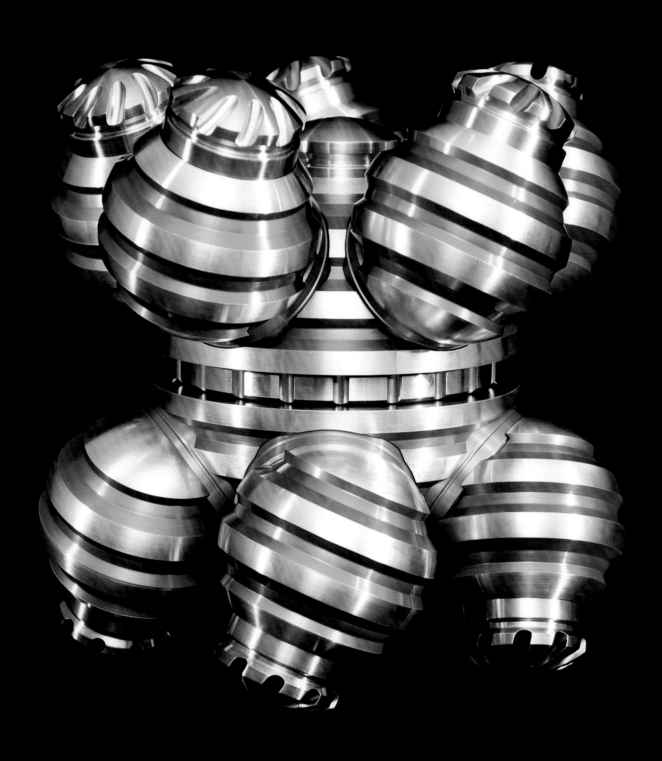

FM 655513312213
Aluminum and stainless steel
7" x 7" x 7", 2012

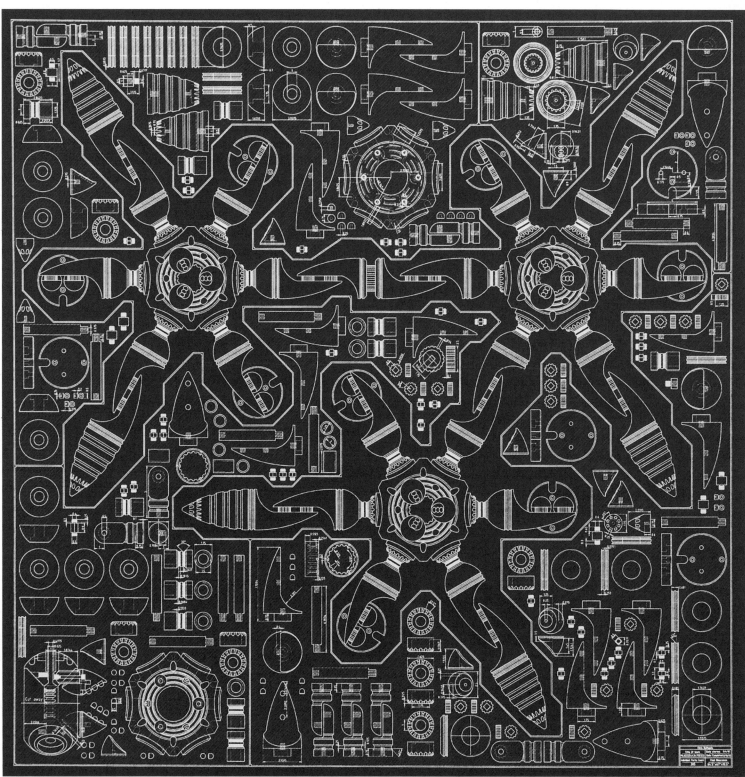

ML Diazo blueprint drawing

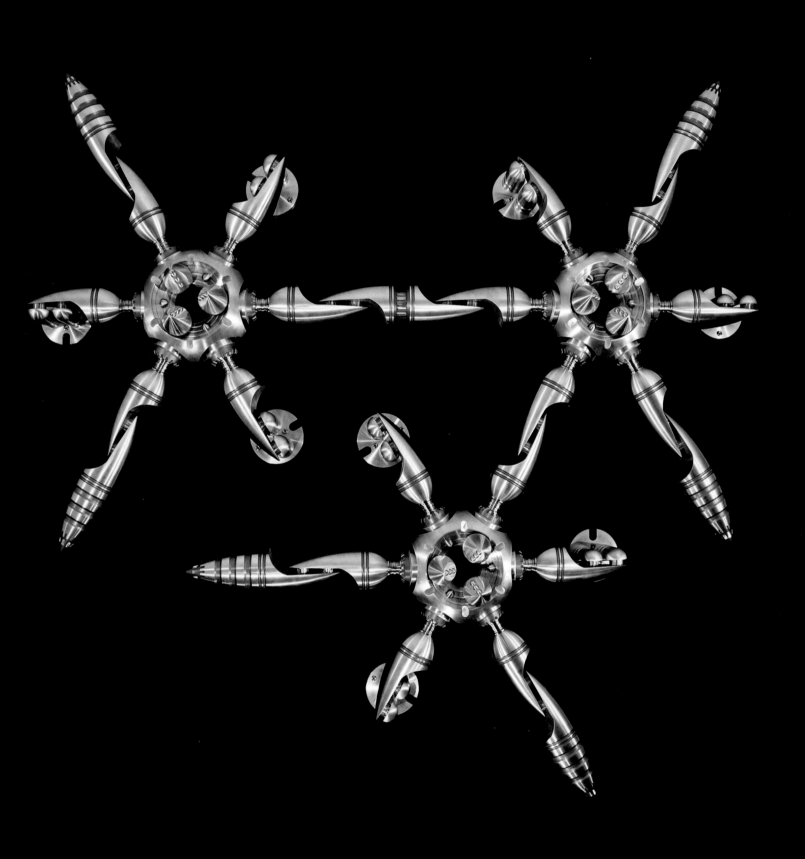

ML 622254434732323
Aluminum, brass, bronze, and stainless steel
64.5" x 67" x 10.5", 2012

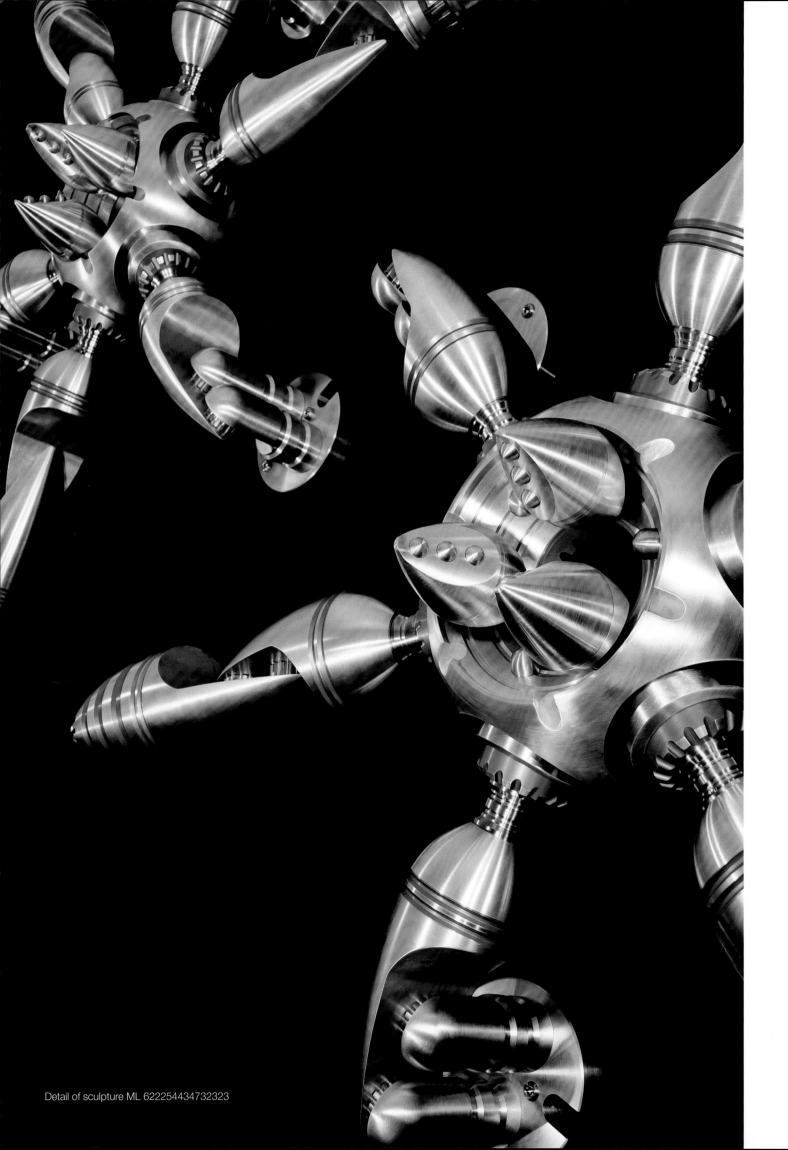

Detail of sculpture ML 622254434732323

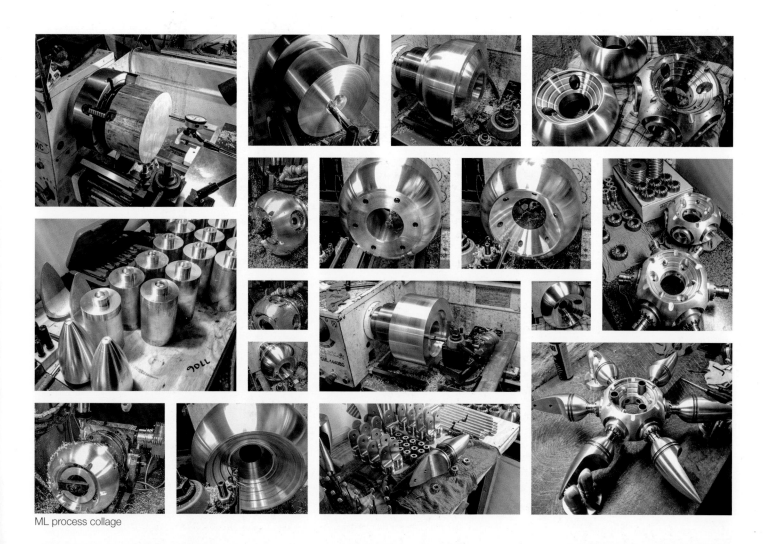

ML process collage

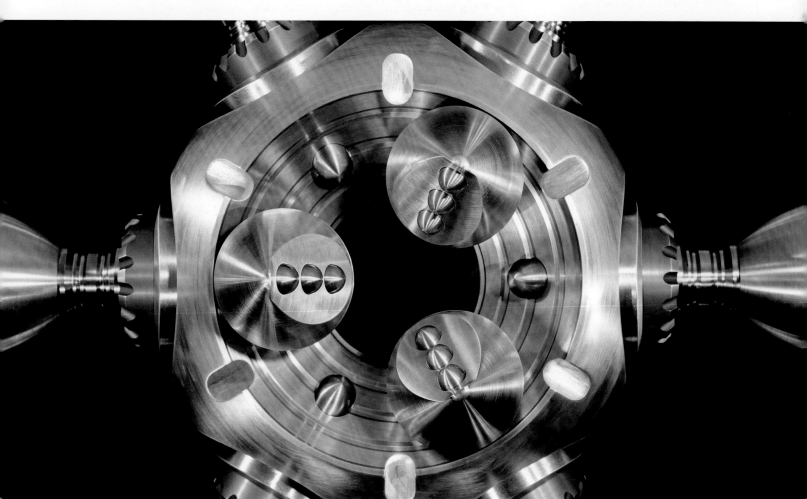

Detail of sculpture ML 622254434732323

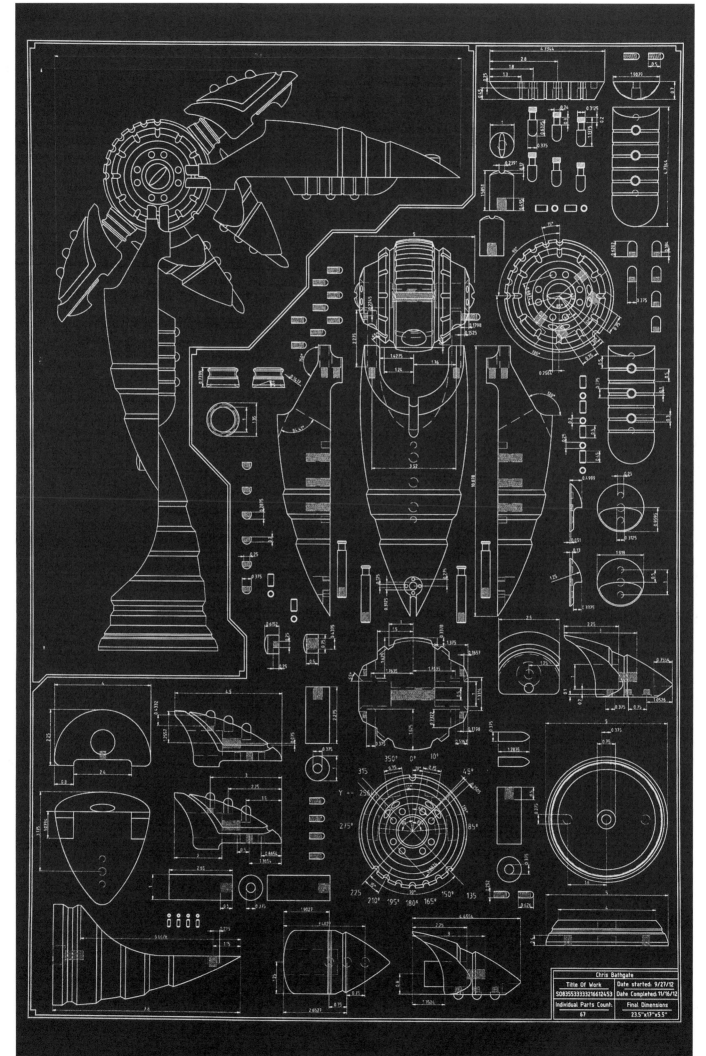

SO Diazo blueprint drawing

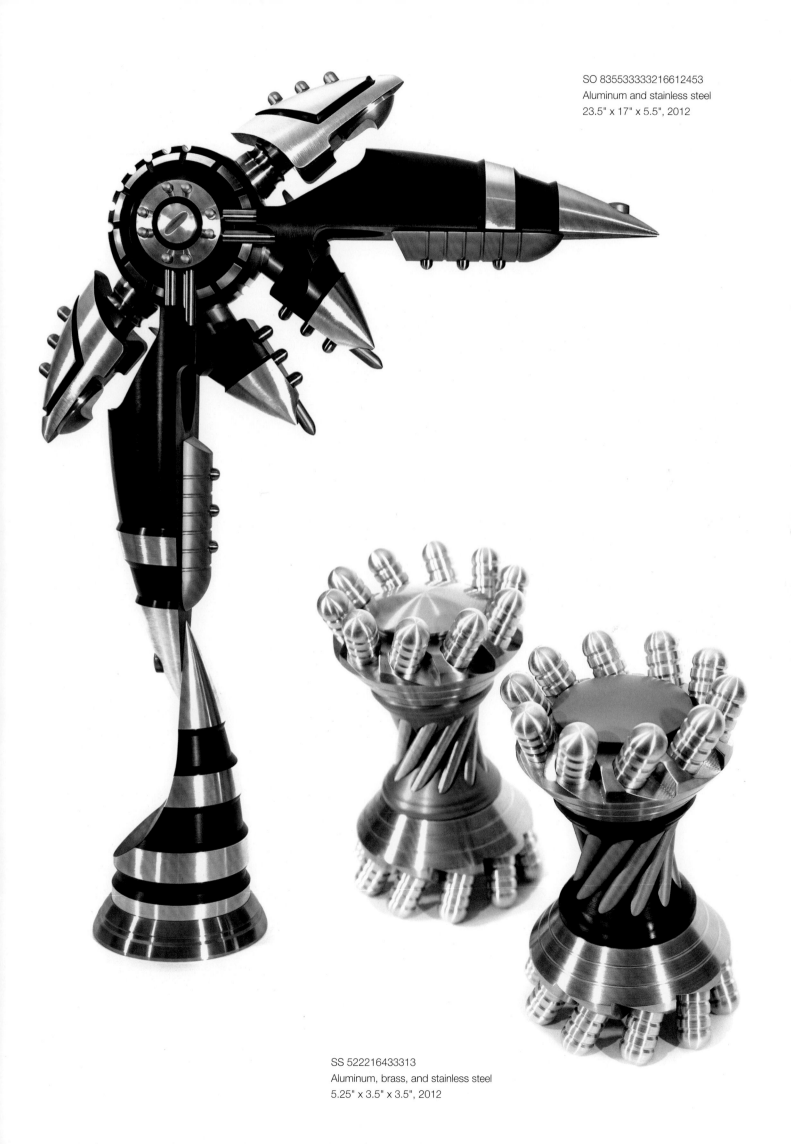

SO 835533333216612453
Aluminum and stainless steel
23.5" x 17" x 5.5", 2012

SS 522216433313
Aluminum, brass, and stainless steel
5.25" x 3.5" x 3.5", 2012

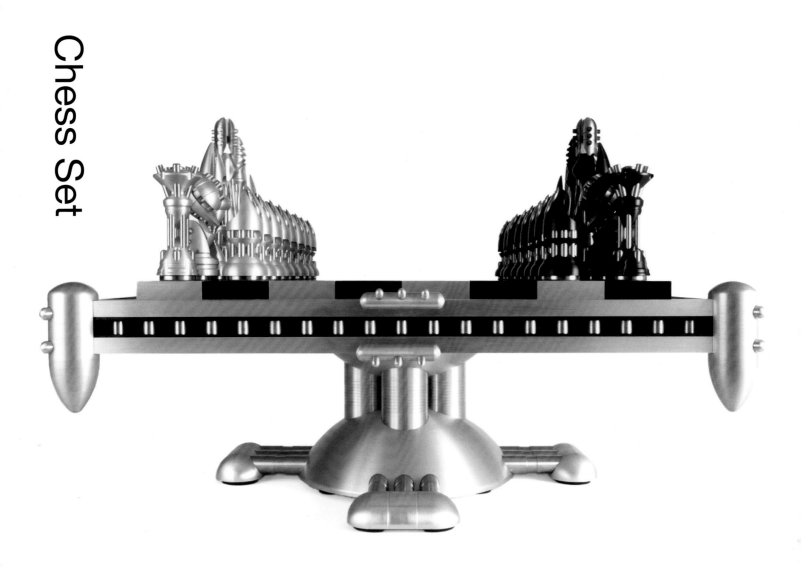

Chess Set

Chapter 7
Use Your Visual Language in New Ways

In 2013, I had an opportunity to test my visual language with a commission for a one-of-a-kind chess set. While it was a bit of a tangent from my main focus, the project reconciled easily with my aesthetic and methods of design. I felt it was important to include it in this book as an example of the ways we might test ourselves against serendipitous opportunities and uncover novel ideas in the process.

Although I occasionally undertake commissions for one-of-a-kind work, I usually limit such projects to things that are more broadly defined. I am always careful to preserve the core of what interests me in my pursuit of sculpture, so requests for figurative work or functional projects such as furniture usually don't appeal to me. Because of this standard, I turn down far more requests for commissions than I accept. However, when approached with the proposition of making a chess set, my usual instinct to decline such a rigidly defined project quickly turned to enthusiasm for a historically fascinating challenge.

Chess has an interesting relationship to the arts. Beyond depictions in classical work, chess sets have become their own kind of craft form, since so many artists and makers have created them; Marcel Duchamp, Bauhaus, Calder, Damien Hirst, and Yoko Ono are just a few prominent examples. There is a universal appeal to chess because its symbolism functions as a kind of language with which artists are familiar. That a chess set can be treated as a process challenge or conceptual

medium is also appealing. I have a short history fashioning crude chess sets when I was a teenager, and I count them among my formative sculptural experiences. With this commission, I was eager to revisit the idea as a professional to see how my aesthetic and technical approach to sculpture would translate into something so iconic.

In making this commission, there were several competing requirements; first the set had to be playable, since many art chess sets typically aren't very functional. Visual elements or other aspects of an over-the-top reinterpretation are often to the detriment of playability. For me, not only did the game have to remain playable, but it had to do so exceedingly well; the pieces had to be sized and balanced so as not to interfere with gameplay.

The pieces also had to feel good in the hand and be easily recognizable as their respective game pieces without obstructing the field of play. In addition to their function within the game, I wanted the individual pieces to stand alone as something purely sculptural and be apparent as an example of my art.

I also attempted to incorporate some basic rule elements of the game into the visual logic of the set. One basic element of chess that not everyone is aware of is that there is a point system assigned to various pieces. As an example, pawns are worth one point each during play. To illustrate this, I designed the pawns to have a single visually dominant protrusion on top to symbolize their value as a piece. Knights and bishops are worth three points each, and so I included three corresponding visual elements. The rooks and queens had five and nine corresponding elements, respectively, to represent their point values.

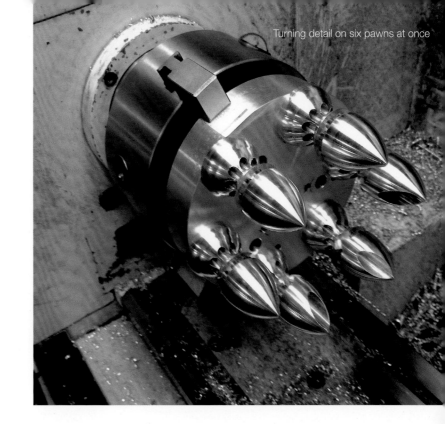
Turning detail on six pawns at once

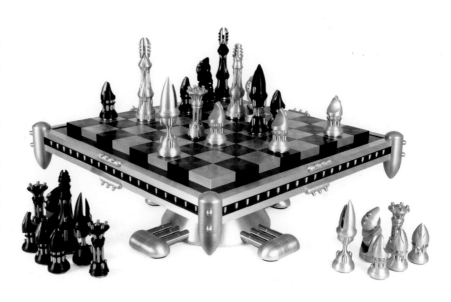
Chessboard and pieces during play

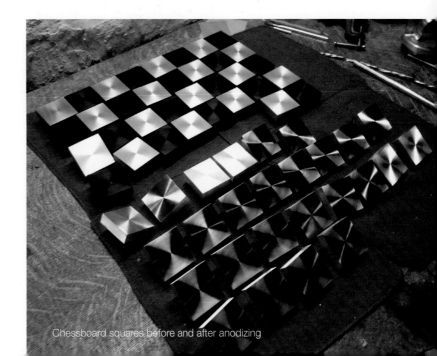
Chessboard squares before and after anodizing

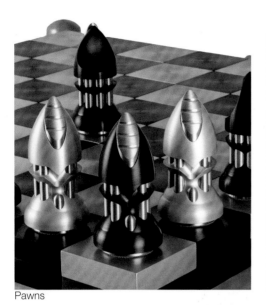

Pawns

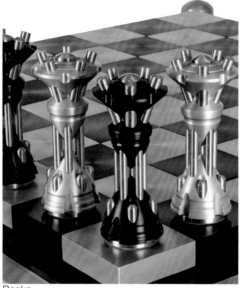

Rooks

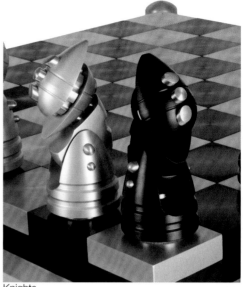

Knights

Apart from the pieces, the design of the game board proved to be its own separate adventure. It would have been easy to make a traditional board; I could have cut some slots in a piece of aluminum plate and called it a day. However, I wanted the board to be just as sculpturally interesting as the rest of the set, so my first thought was to make a freestanding table-like design. There are many examples of this kind of chessboard, but I felt that a large table wouldn't scale with the pieces in a pleasing way, so a smaller pedestal design resulted. It had plenty of sculptural elements but was also of a size and scale that did not dwarf the pieces that would sit atop it.

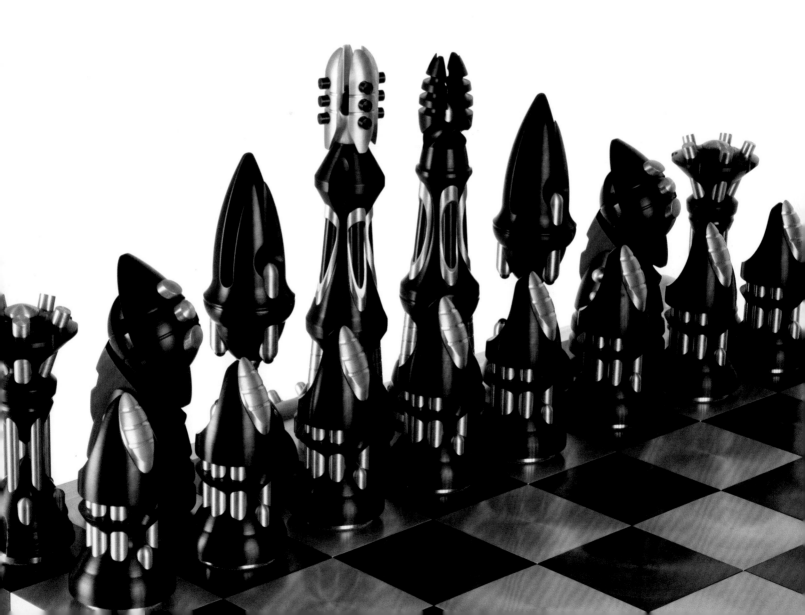

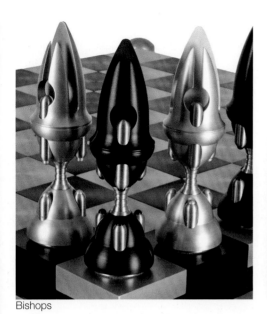

Bishops

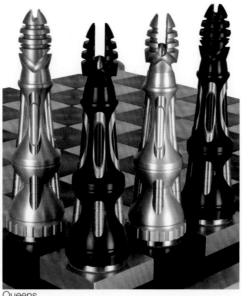

Queens

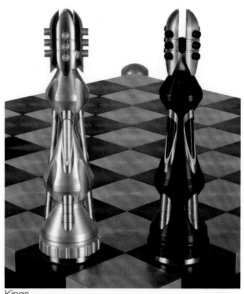

Kings

While the many considerations a chess set requires might seem too compromising for some, I have always found working within restrictions, be they arbitrarily imposed or due to the physical limitations of a material or process, to be a great source of inspiration. Creating something visually distinct, while taking into account the many utilitarian constraints of a chess set, planted the seed for an approach I had sternly resisted. It would take a few years to sink in, but it opened the door (just a crack) to the possibility that functionality, if approached in a thoughtful way, could be leveraged for unique aesthetic and conceptual insights.

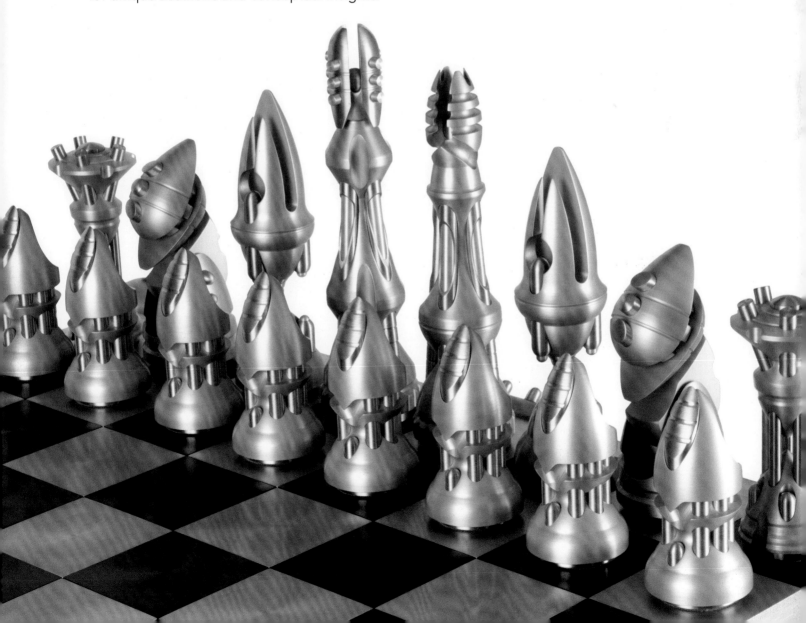

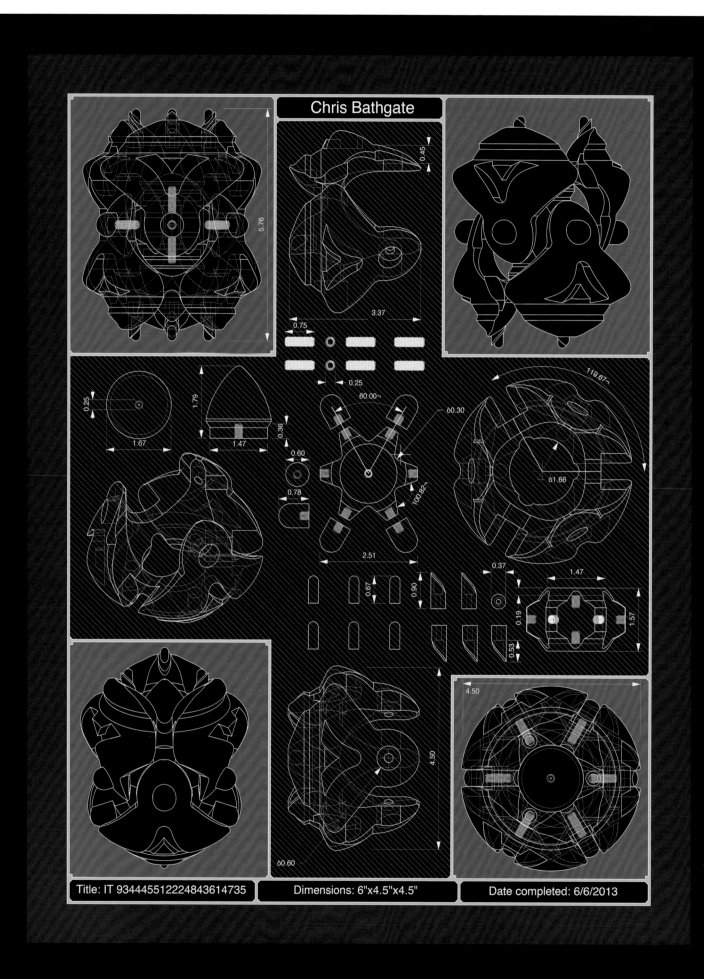

Chris Bathgate

Title: IT 93444551222484361473 | Dimensions: 6"x4.5"x4.5" | Date completed: 6/6/2013

IT technical drawing

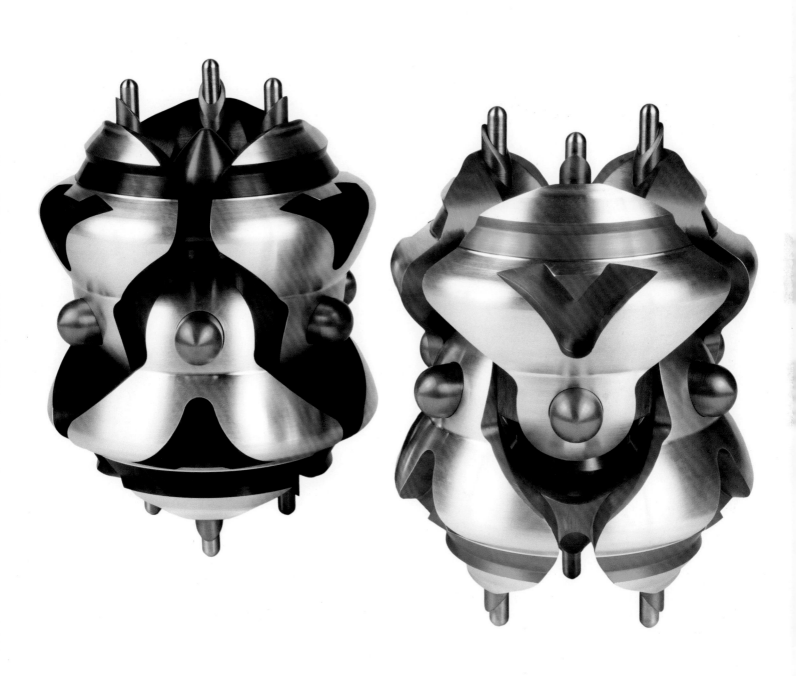

IT 934445512224843614735
Aluminum, bronze, and stainless steel
4.5" x 4.5" x 6", 2013

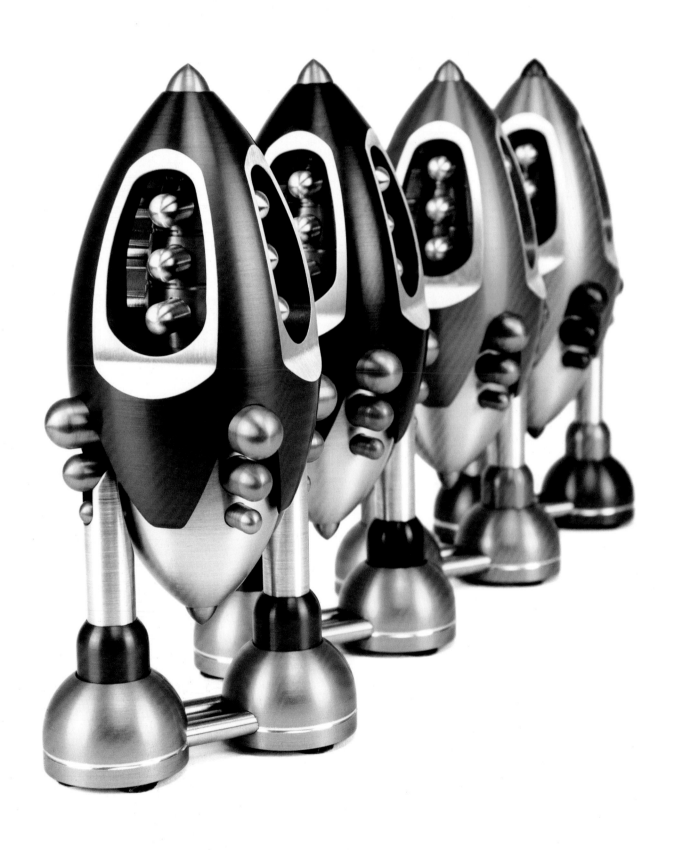

CT 345542422
Aluminum and stainless steel
7" x 3.5" x 3.5"

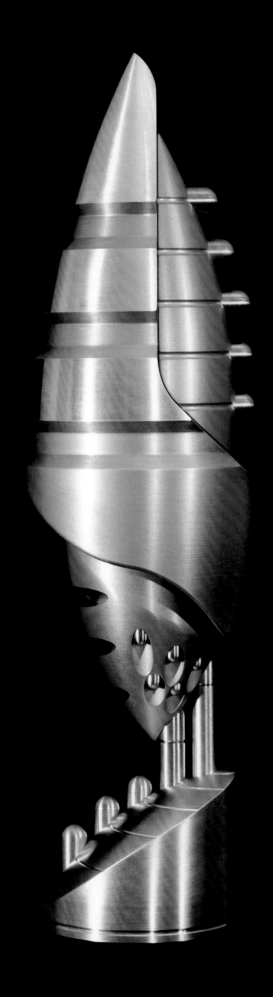

LS 322244414
Aluminum and stainless steel
11" x 3" x 3", 2012

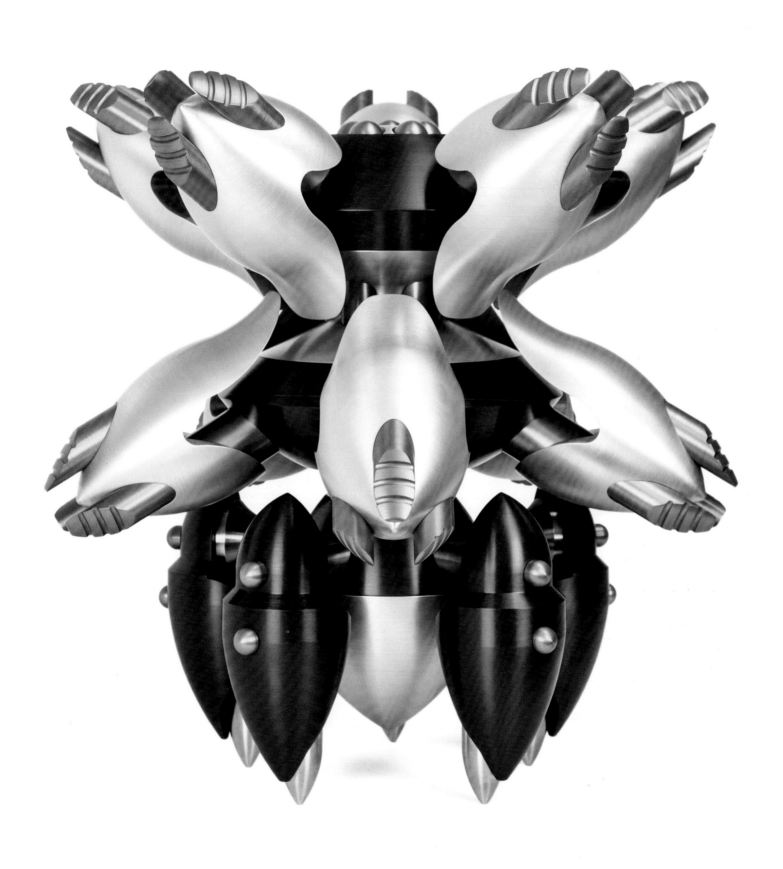

UN 712254435523314645
Aluminum and stainless steel
14" x 13.5" x 13.5", 2013

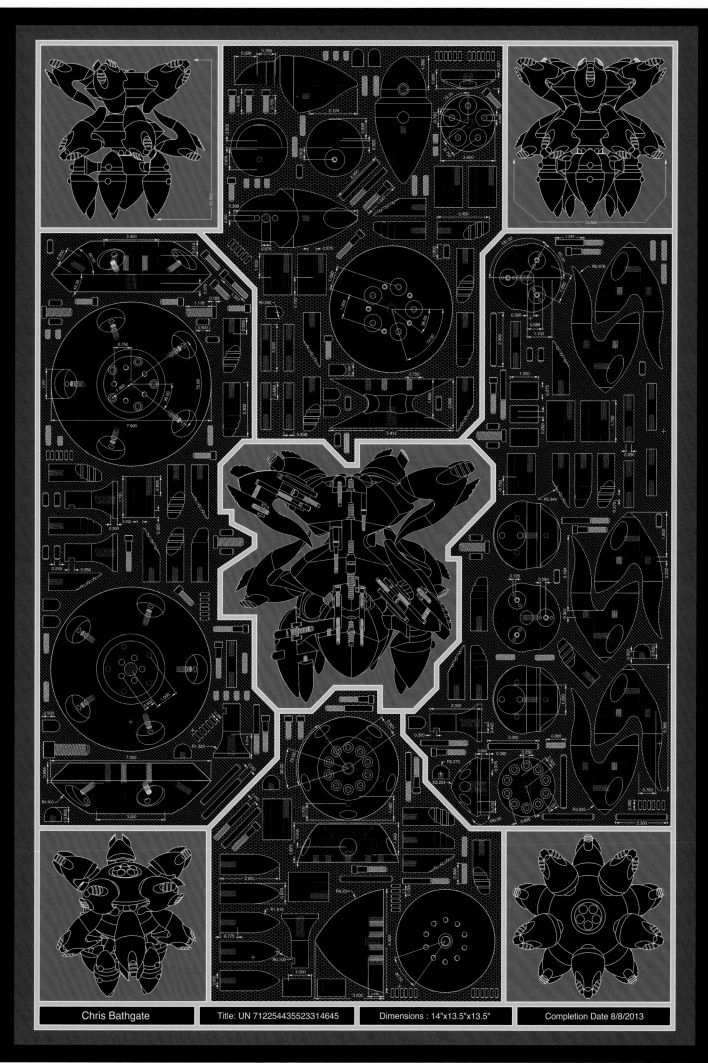

Chris Bathgate | Title: UN 712254435523314645 | Dimensions : 14"x13.5"x13.5" | Completion Date 8/8/2013

UN technical drawing

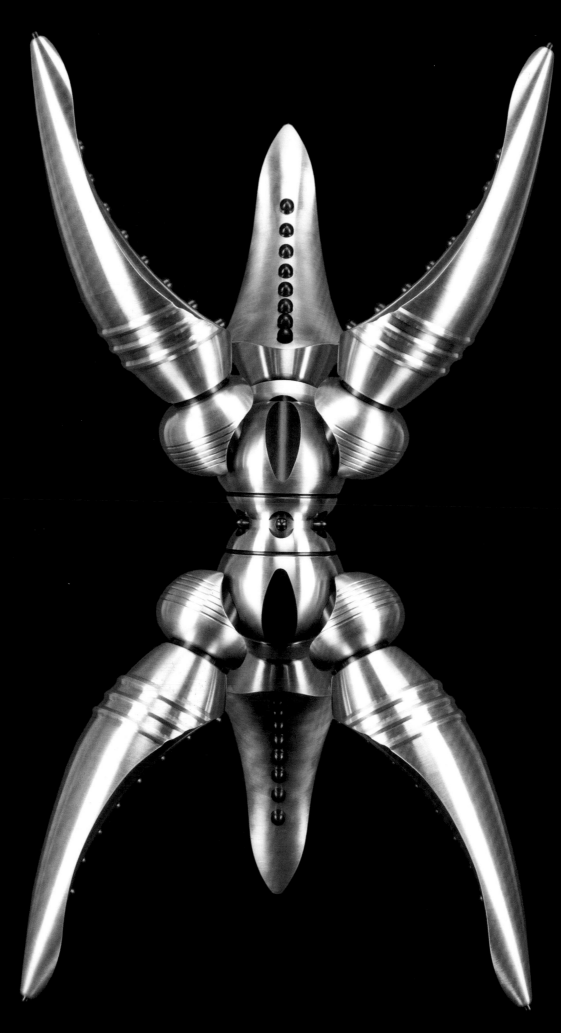

MX 535612252312412
Aluminum, bronze, and stainless steel
26" x 16" x 16", 2013

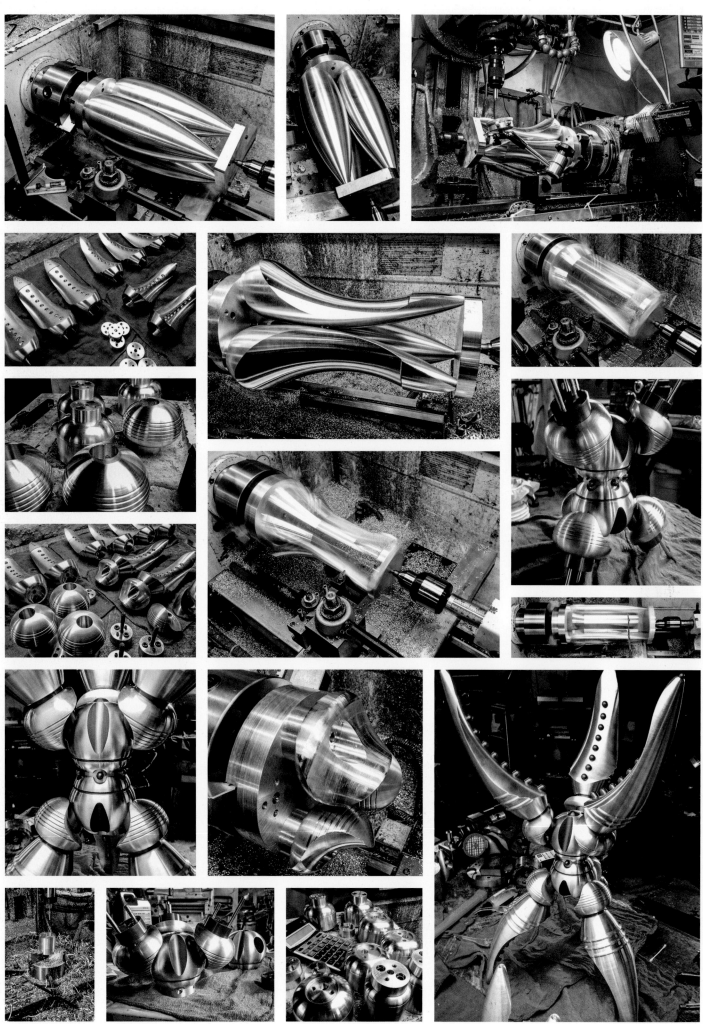

MX process collage

111

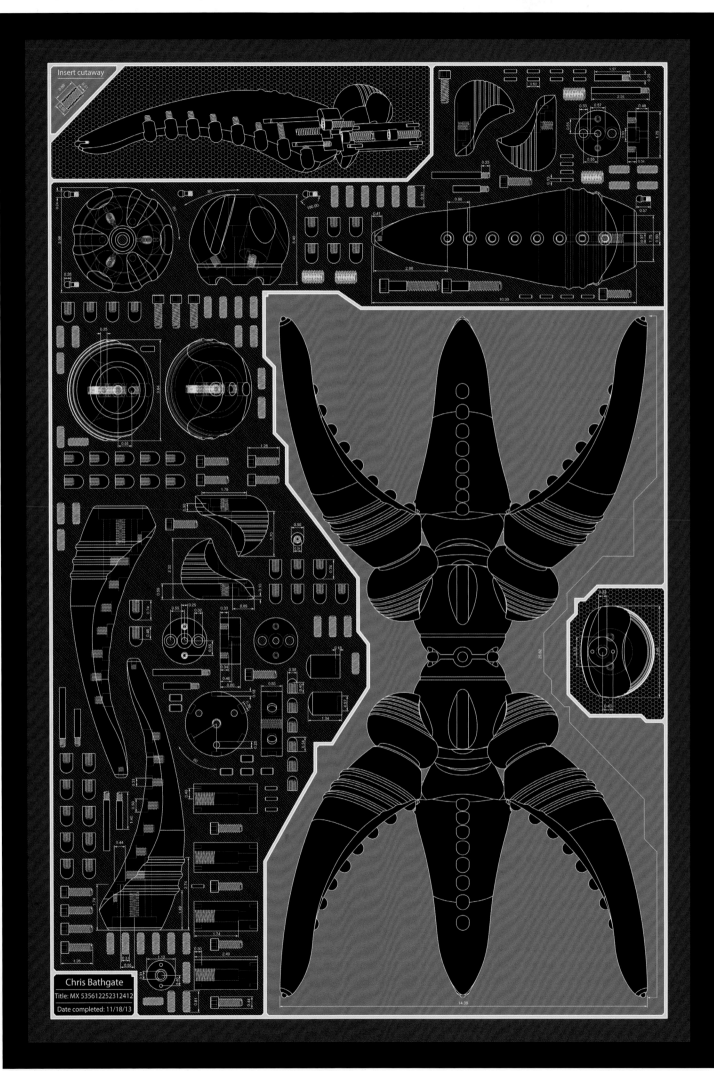

Insert cutaway

Chris Bathgate
Title: MX 535612252312412
Date completed: 11/18/13

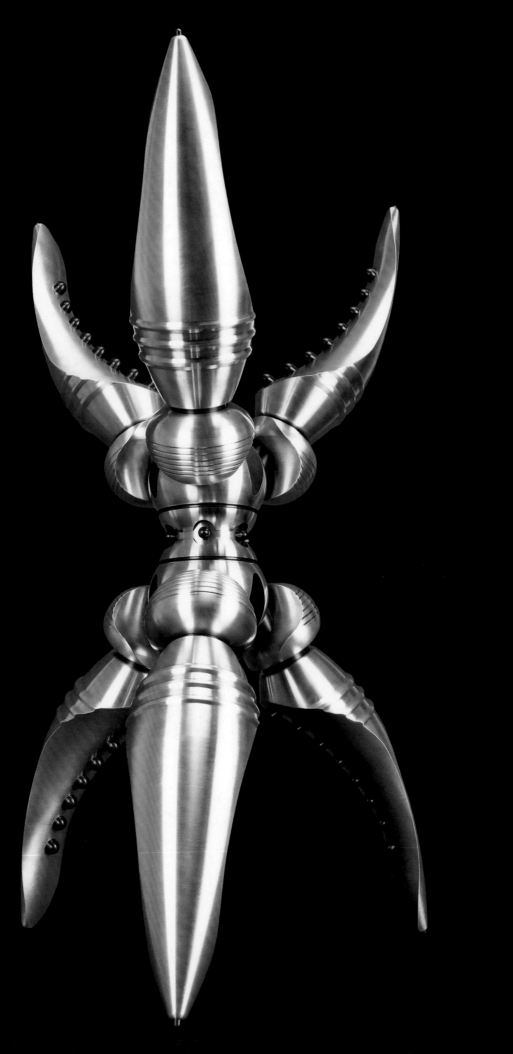

MX 535612252312412 detail

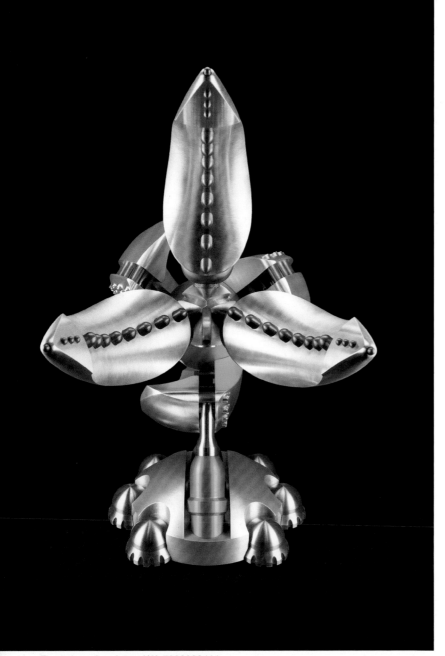

Front view of sculpture WA 5233322411

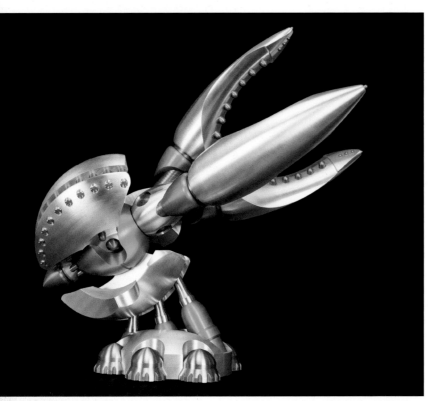

Side view of sculpture WA 5233322411

114

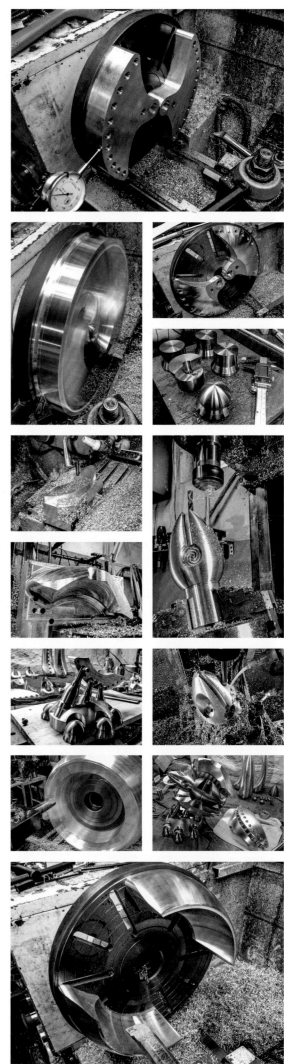

WA process collage

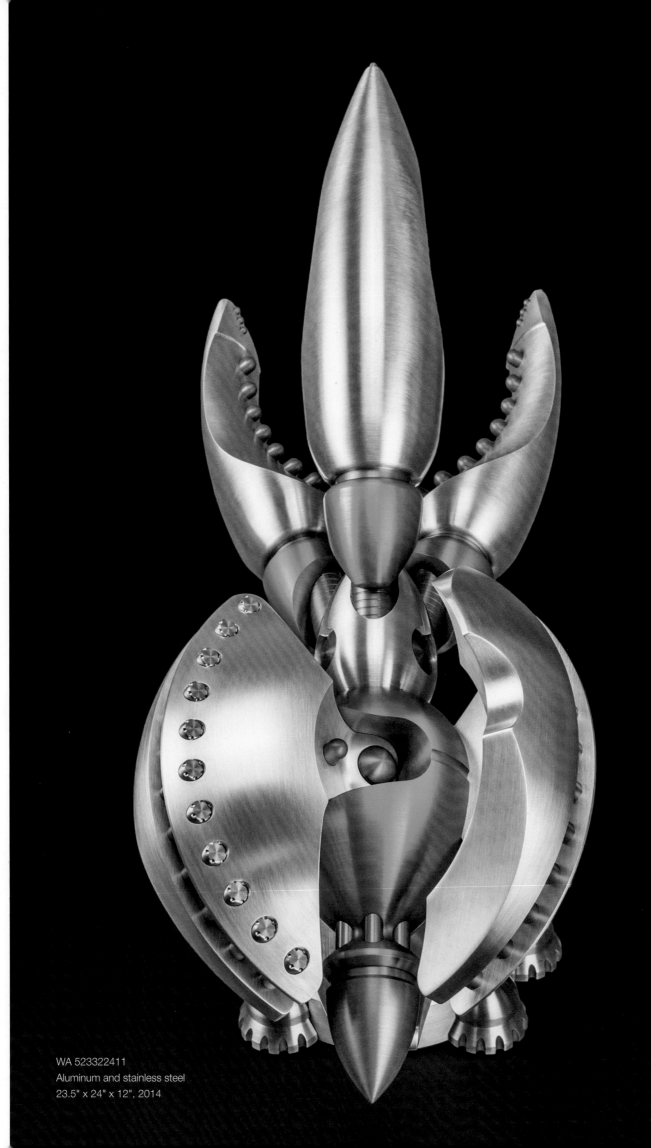

WA 523322411
Aluminum and stainless steel
23.5" x 24" x 12", 2014

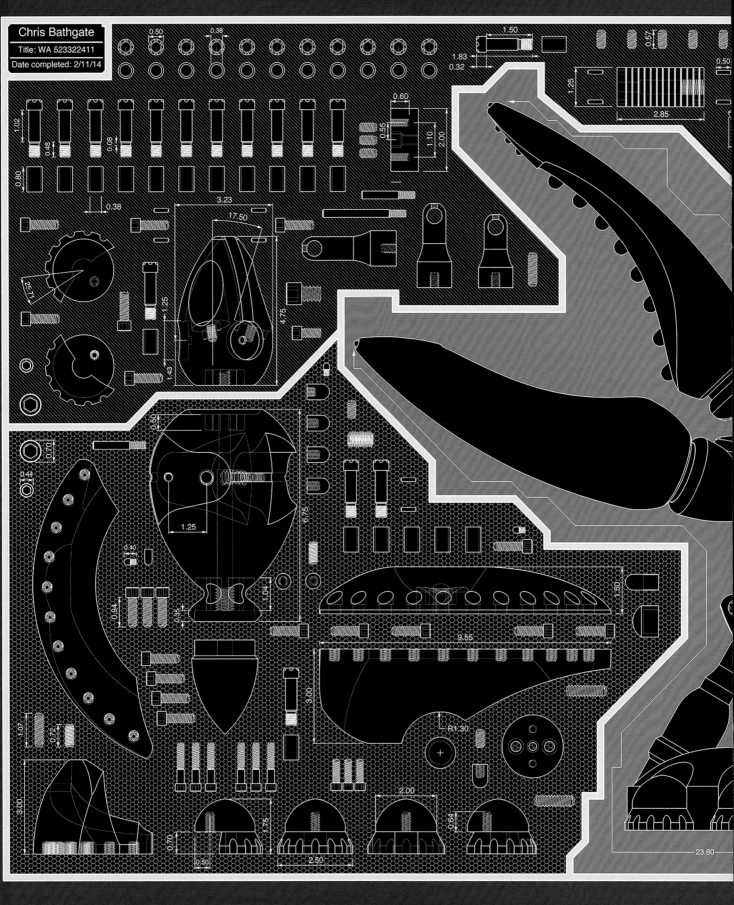

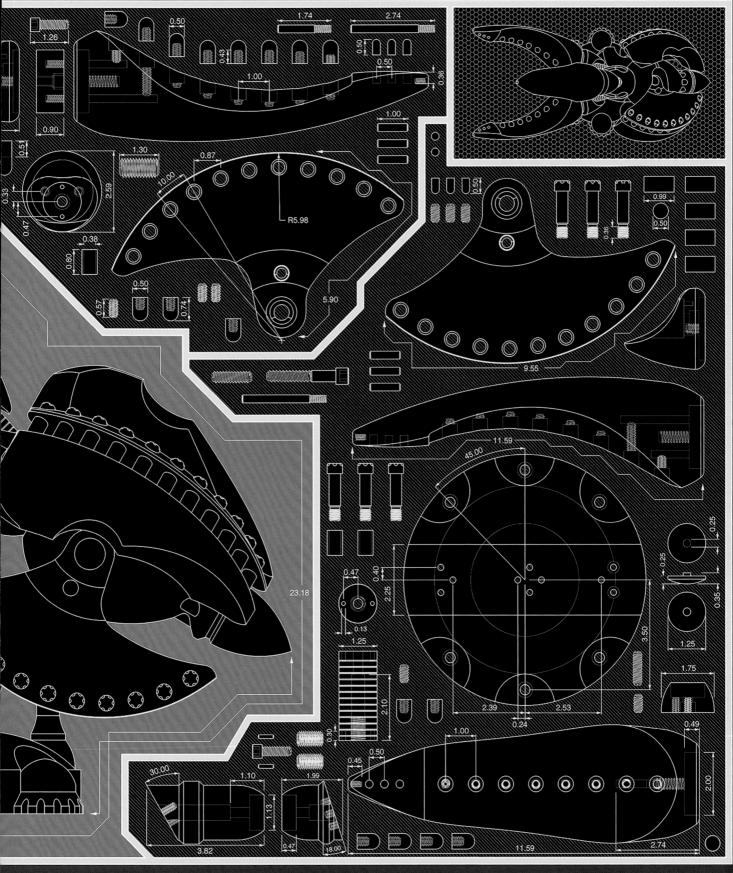

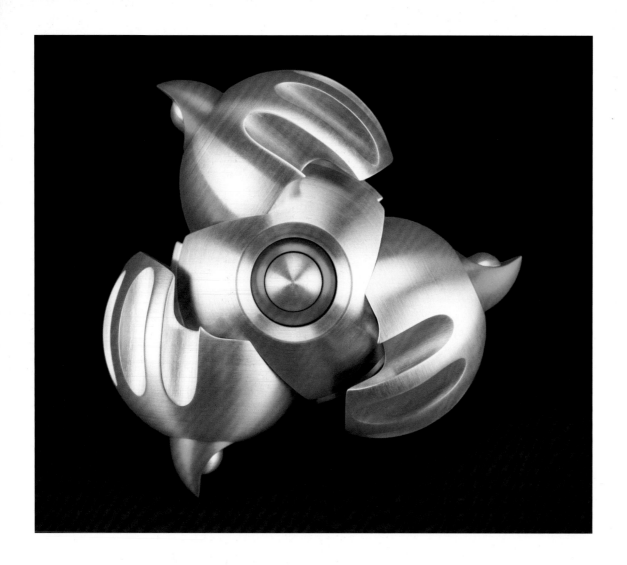

Fo 412341
Aluminum
4" x 4" x 2.75", 2014

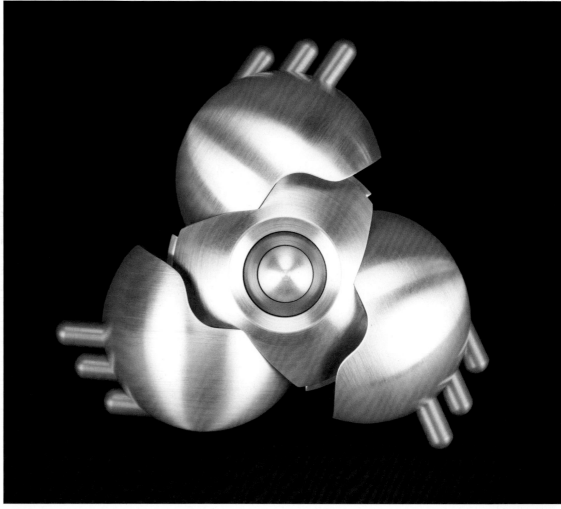

Fi 445351
Aluminum
4" x 4" x 2.75", 2014

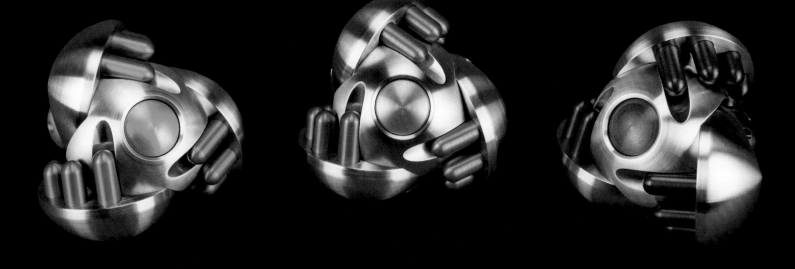

EC 561122233, Aluminum and stainless steel, 3" x 3" x 2", 2014

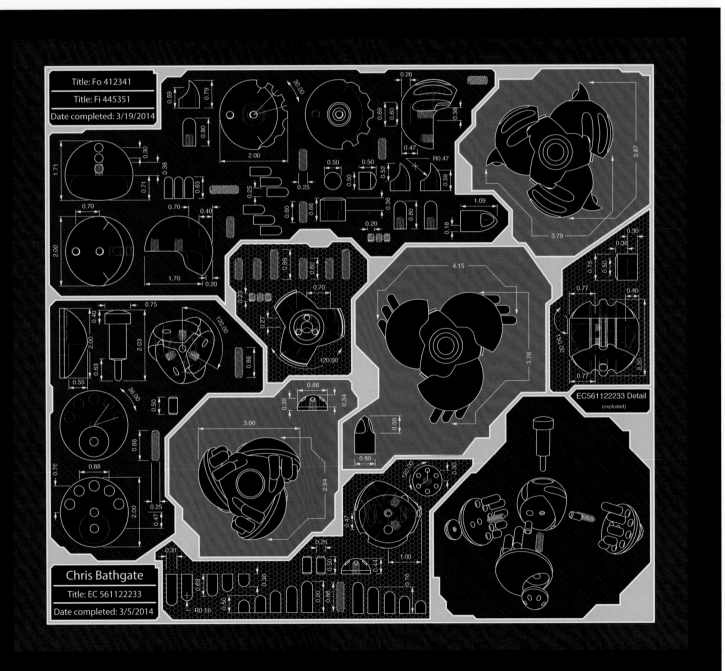

Detail of ML622 print

Chapter 8
Any Part of Your Process Can Become Art

Technical drawings, be they hand drafted or computer generated, are a foundational element in the worlds of architecture and design. Even though very few things today are manufactured without them, technical drawings are generally seen as boring utilitarian documents, and professional draftsmanship is rarely thought of in the context of art.

Developing a detailed and accurate drawing has always been an integral step in my process. Technical drawings have many functions within my practice; they serve as a platform for refining visual forms, as a reference for calculating machining tolerance, and as a document for planning the logistics for fabricating each of the pieces within a composition. Over the years, these drawings have progressed from rudimentary hand-drafted sketches on graph paper to meticulously crafted CAD models. During this transformation, the purpose of the drawings has also evolved from mere utility to a creative exercise that raises important conceptual questions

There is a certain amount of subversion in creating an extremely accurate technical document to build what is essentially a nonfunctional art object. Indeed, in much of my work, there is a dissonance between engineering a complex array of parts that assemble in mechanically diverse ways and the reality that the end result is an object that serves no real utilitarian purpose. My works are constructed like machines, yet most do not move or have a function. The sculptures resonate because each one feels like an irresolvable paradox, full of implied yet undefined purpose.

Much of the inspiration for my forms is derived from the visual language intrinsic to my work environment, and this includes the development of a technical drawing. I look to my process for visual cues that can become the catalyst for future work. In this way, my sculptures and the processes that produce them have become a sort of feedback loop, with every aspect feeding into this system. Because of this, I came to believe that I should approach drafting with the same care and respect I give to crafting the works themselves. I do this to ensure I create as many opportunities for inspiration as possible. To some, this may seem like an insular concept, but I have found both complexity and diversity within this framework.

Diazo blueprint drafts

The drawings have also become indispensable for demonstrating that the pieces are constructed objects with complex assemblies and inner workings, as opposed to purely figurative ones (such as a statue). Indeed, much of the engineering and design elements are completely hidden in a finished sculpture, so the schematics are a natural way to demonstrate how unseen mechanical aspects of the work influenced the design. They show that even in art, an object's construction and form have a relationship that should be considered; the drawings are a bridge between what I find so technically fascinating about engineering a piece of art and the aesthetic pieces that result.

My drawings have taken a number of forms over the years. I have experimented with hand-drawn compositions on graph paper and attempted to create isometric drawings using only 2-D drafting software. As an homage to an older way of drafting, I spent some time restoring an ammonia vapor blueprint machine and learned how to develop authentic Diazo blueprints. All of these experiments have shaped my philosophy on what a technical document can be in relation to a sculpture practice. In the end, digital CAD drawing has become the dominant format in my drafting work. The need to iterate and shed arbitrary rules has led to a more relaxed and free approach to representing important information. As a result, a number of compositional shifts emerged, and with it, a realization that nearly any aspect of one's craft can transcend its basic function, rising from mere utility to becoming a work of art in itself.

PCT exploded diagram

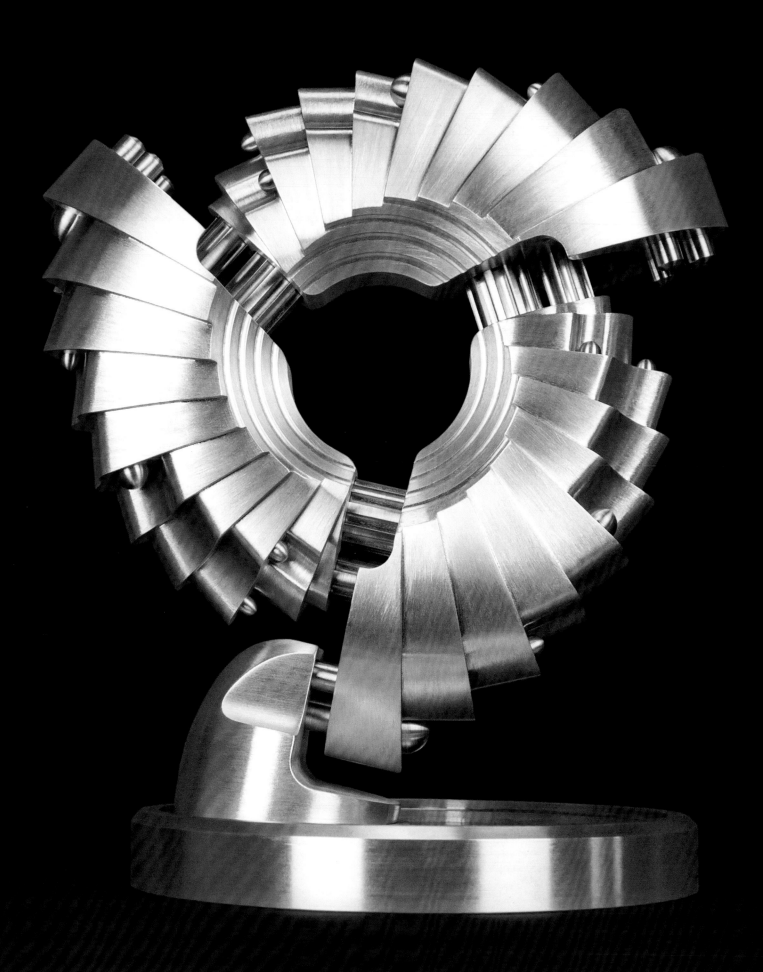

ST 724433335533635
Aluminum and bronze
8.75" x 7.64" x 6", 2014

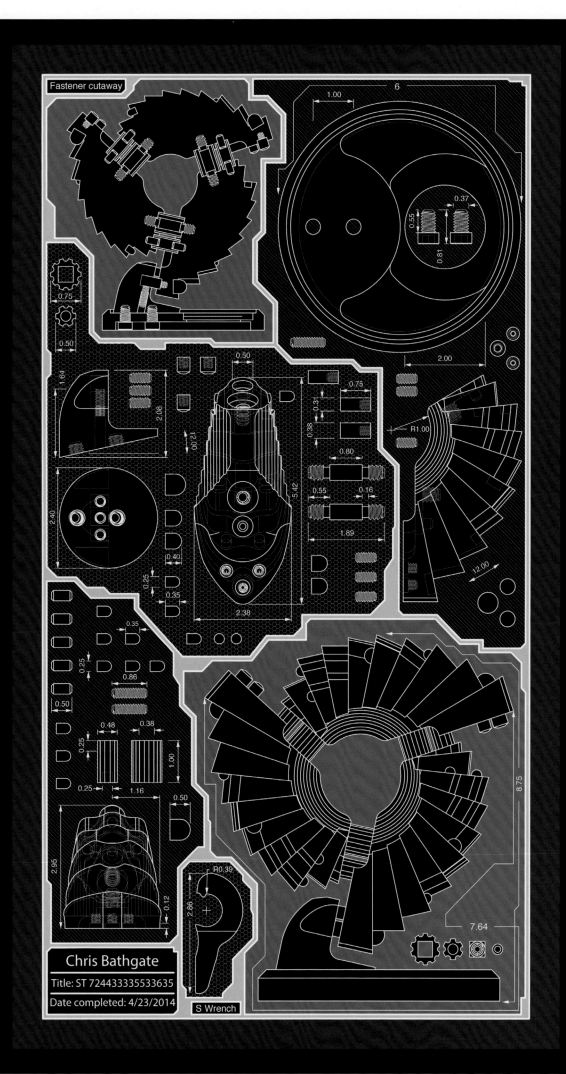

Fastener cutaway

Chris Bathgate
Title: ST 724433335533635
Date completed: 4/23/2014

S Wrench

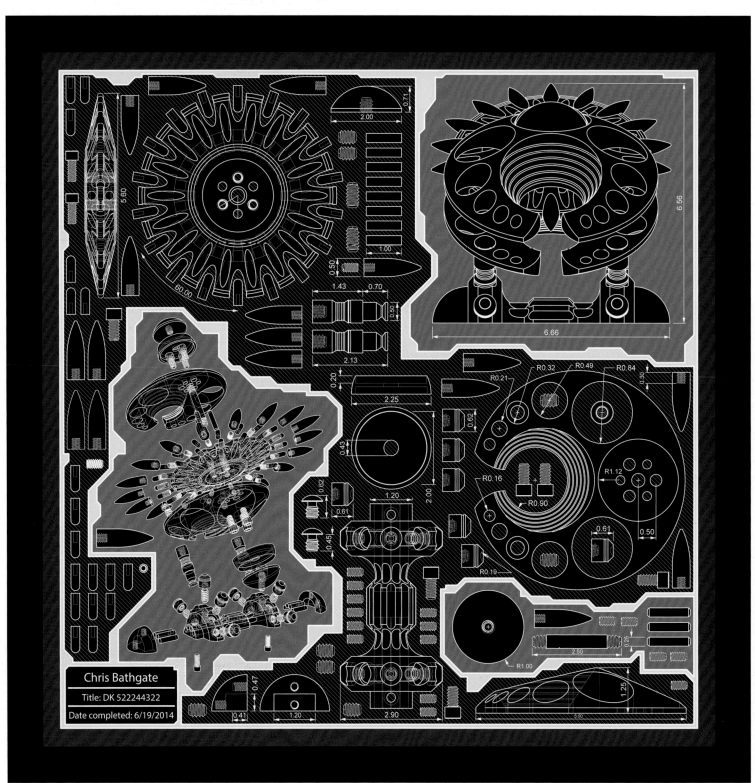

Chris Bathgate
Title: DK 522244322
Date completed: 6/19/2014

DK technical drawing

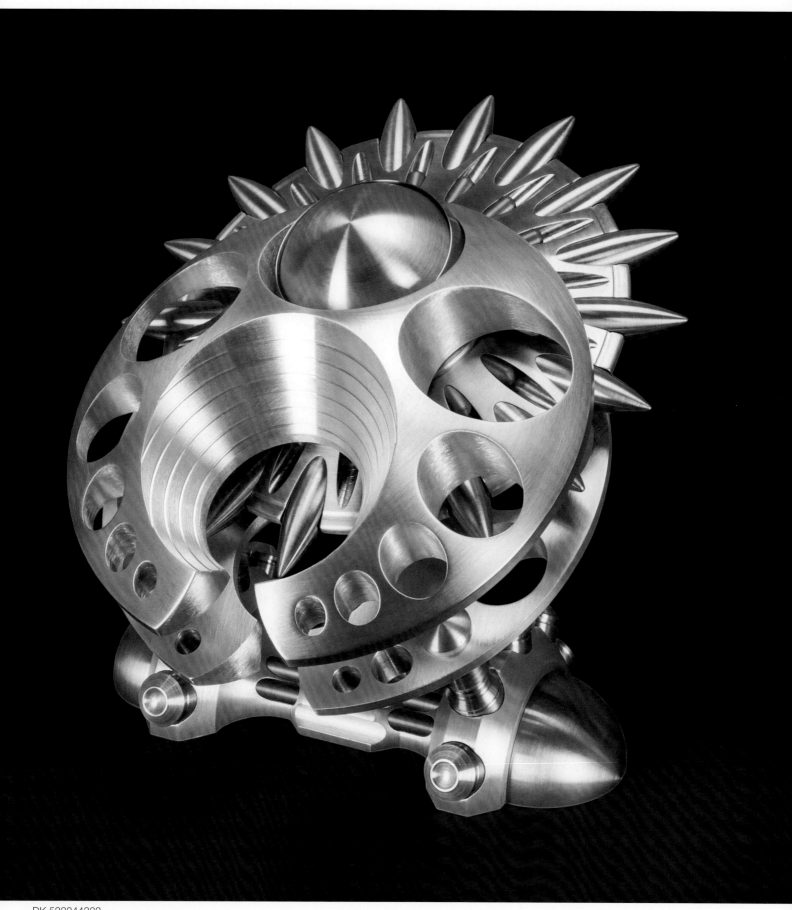

DK 522244322
Aluminum, bronze, and stainless steel
6.5" x 6.5" x 6.5", 2014

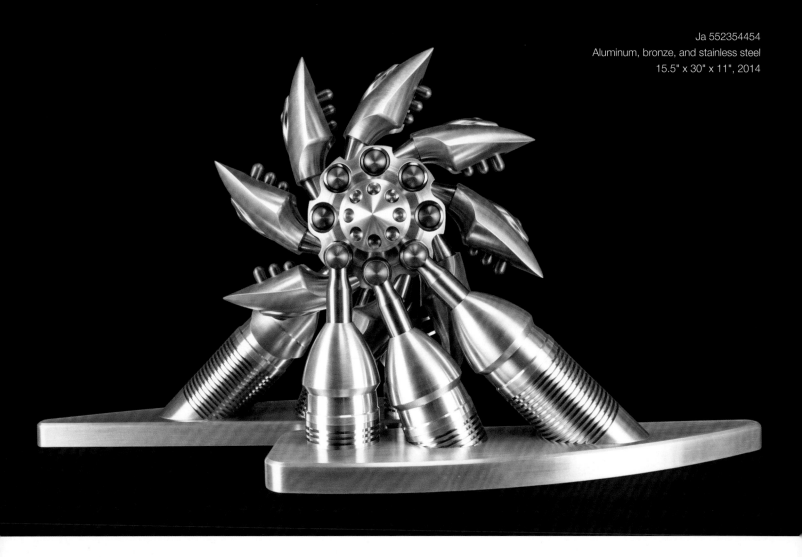

Ja 552354454
Aluminum, bronze, and stainless steel
15.5" x 30" x 11", 2014

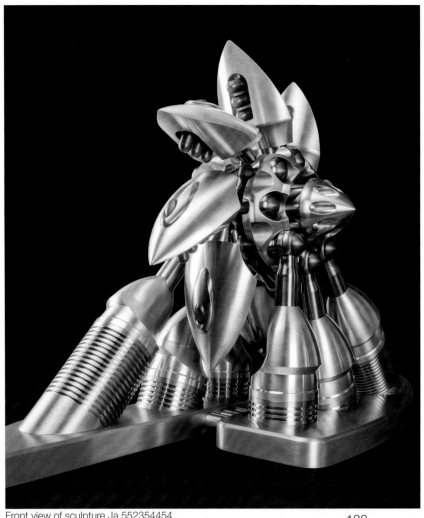

Front view of sculpture Ja 552354454

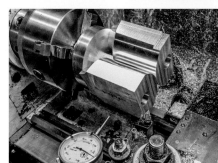
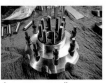
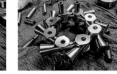
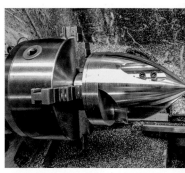
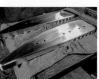

Ja process collage

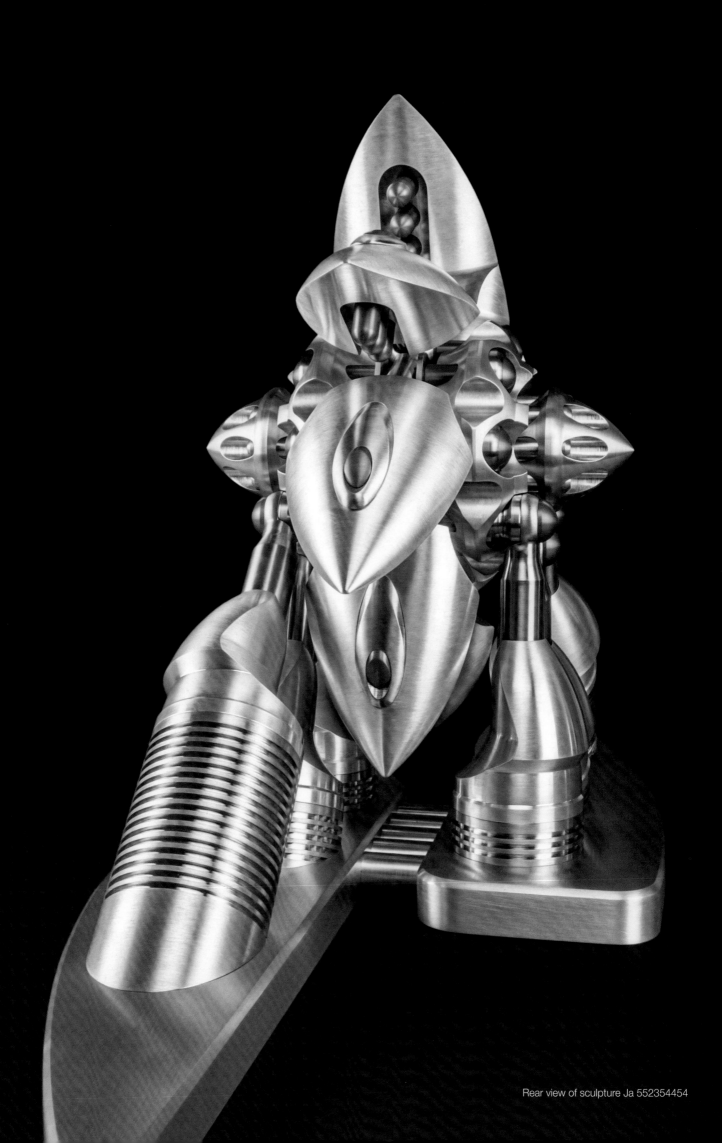

Rear view of sculpture Ja 552354454

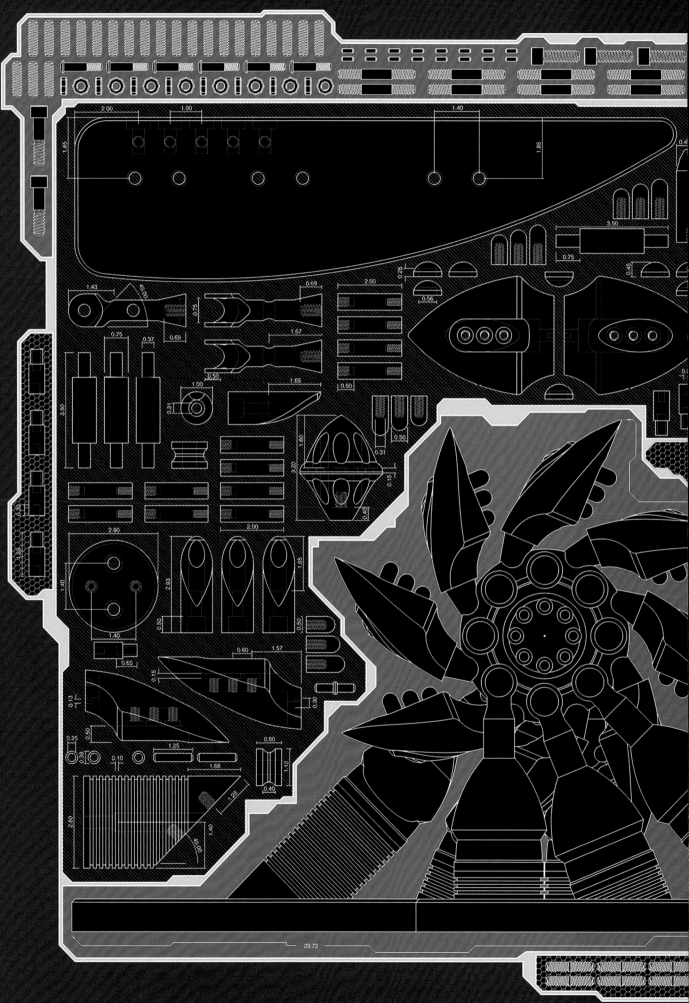

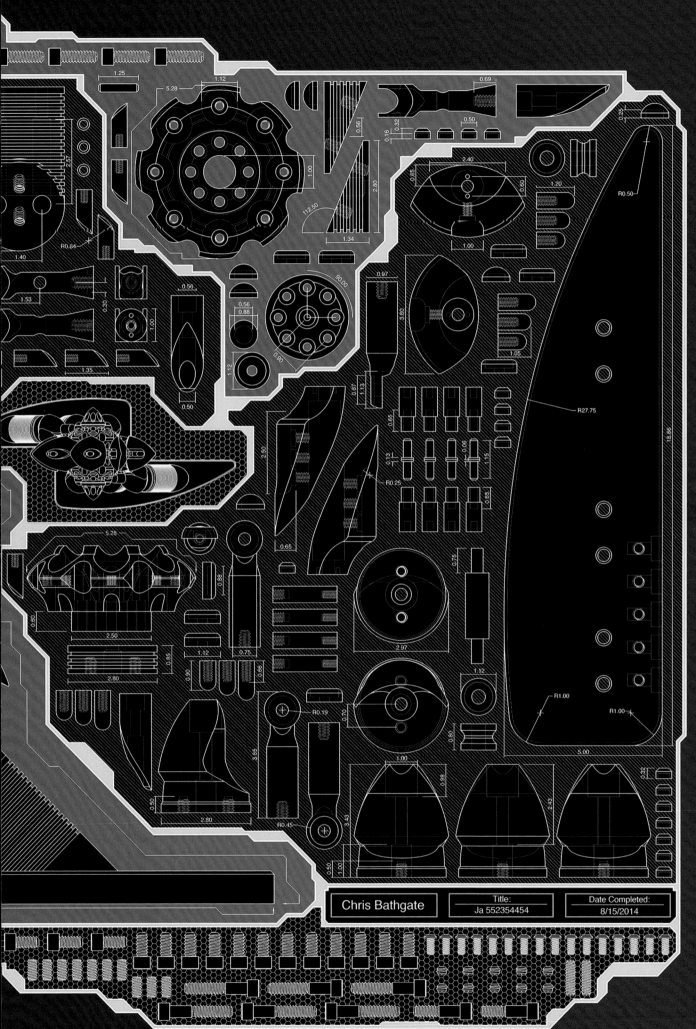

Chris Bathgate

Title:
Ja 552354454

Date Completed:
8/15/2014

TB 611523322235
Aluminum and brass
12" x 8" x 8", 2014

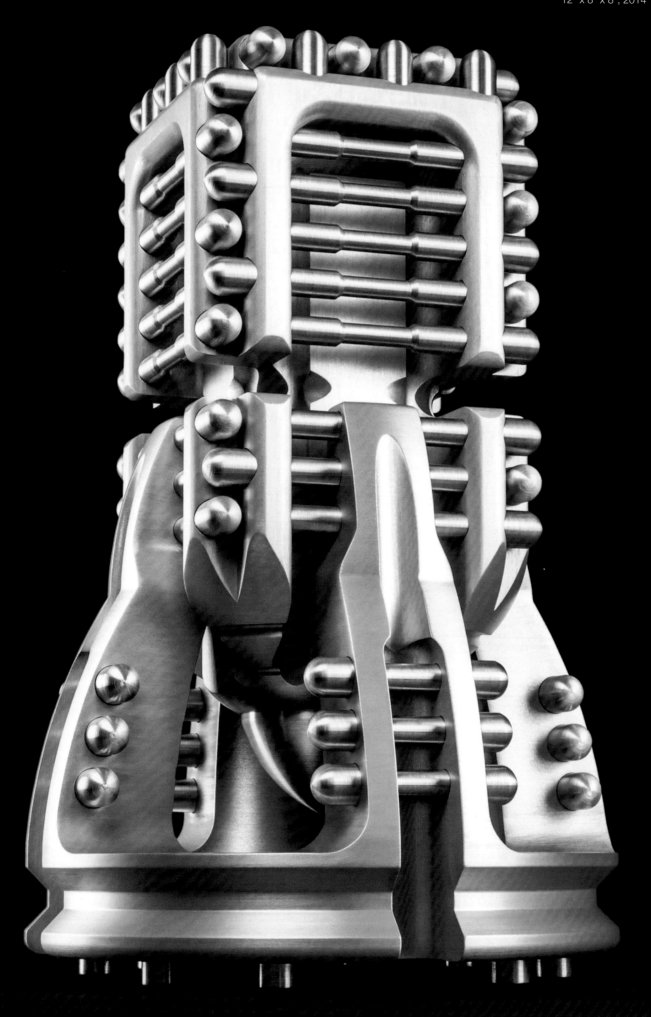

NP 625544312235
Aluminum, bronze, copper, and stainless steel
4.5" x 5.5" x 2.5", 2014

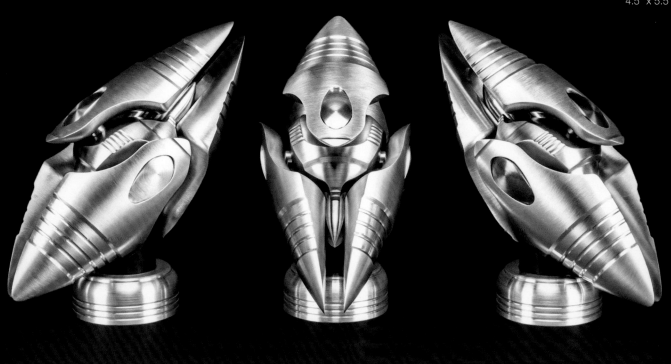

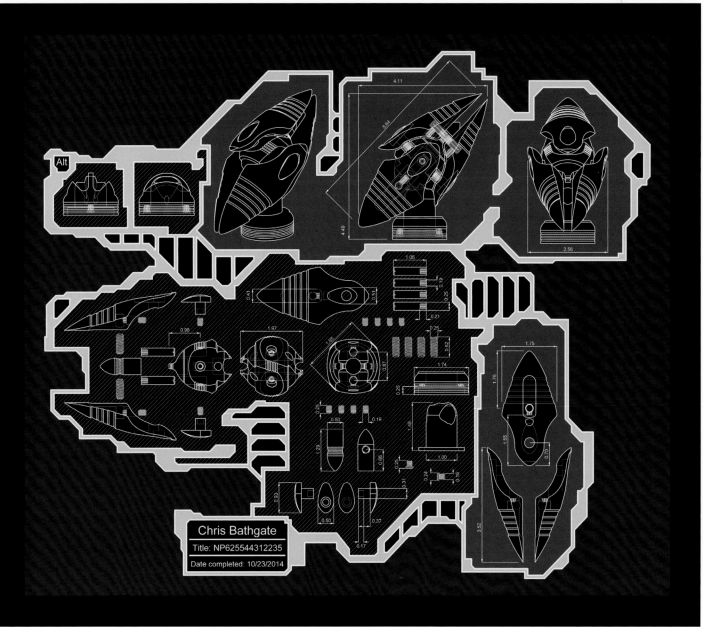

NP technical drawing

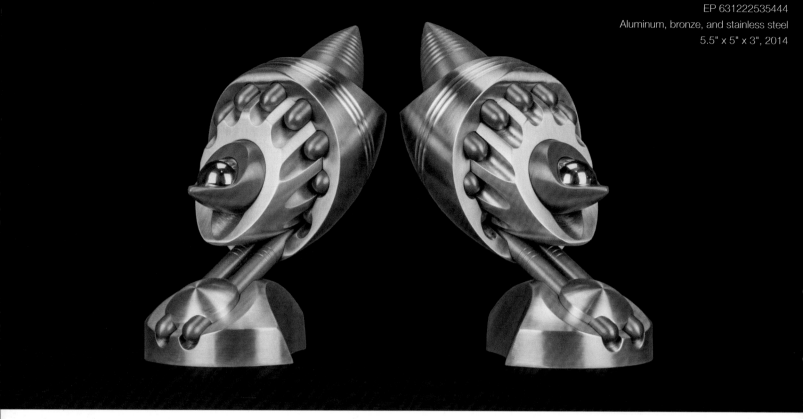

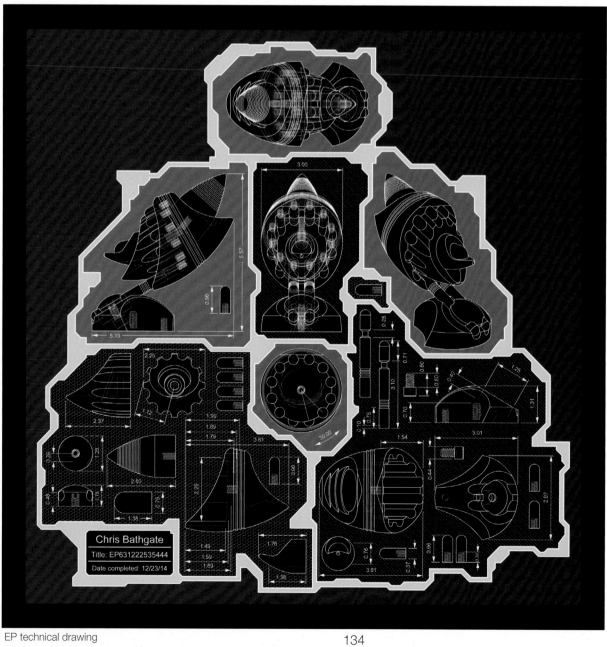

EP technical drawing

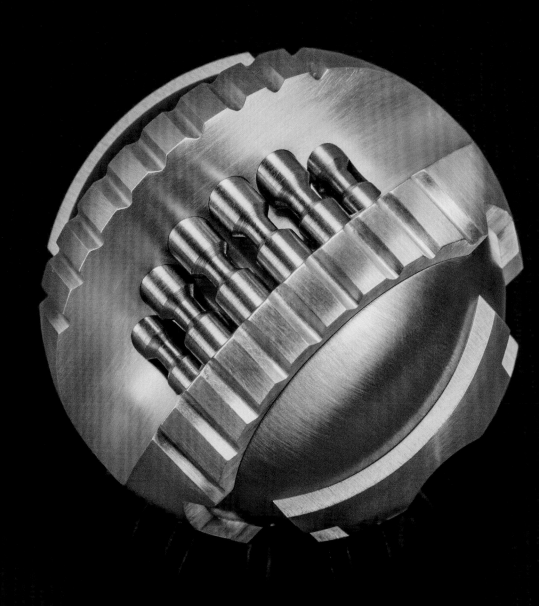

Stainless steel a

2.5" x 2.5" x 2

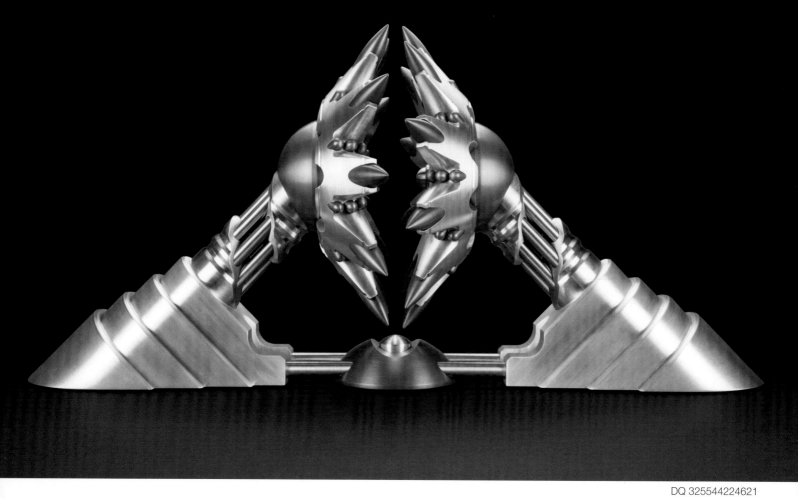

DQ 325544224621
Aluminum, bronze, and stainless steel
17" x 8" x 7", 2015

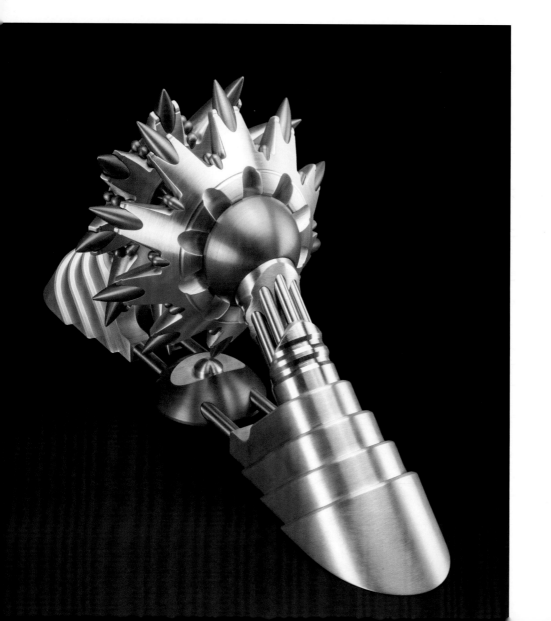

Side view of DQ 325544224621

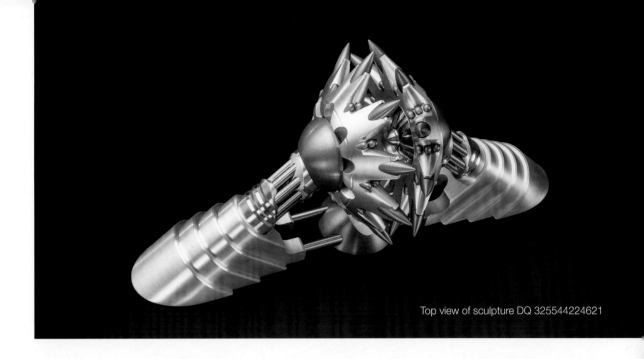

Top view of sculpture DQ 325544224621

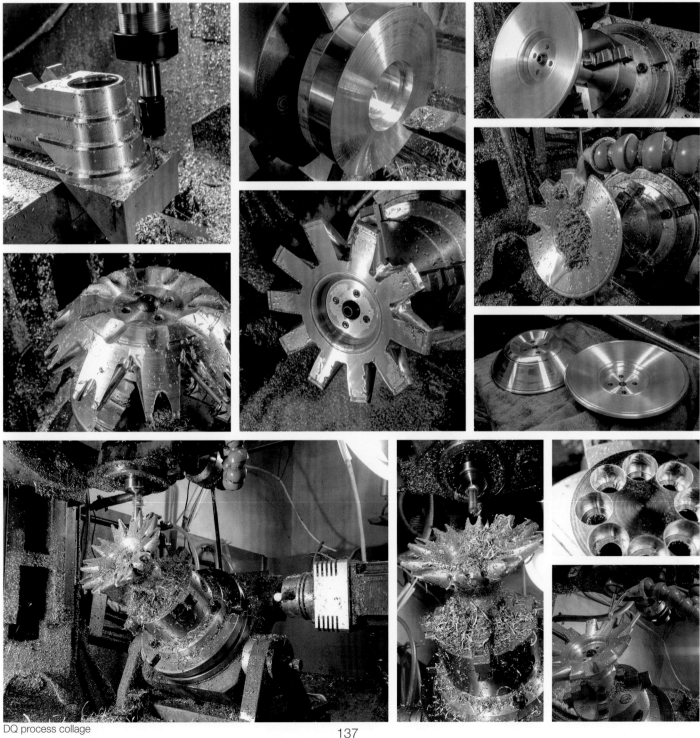

DQ process collage

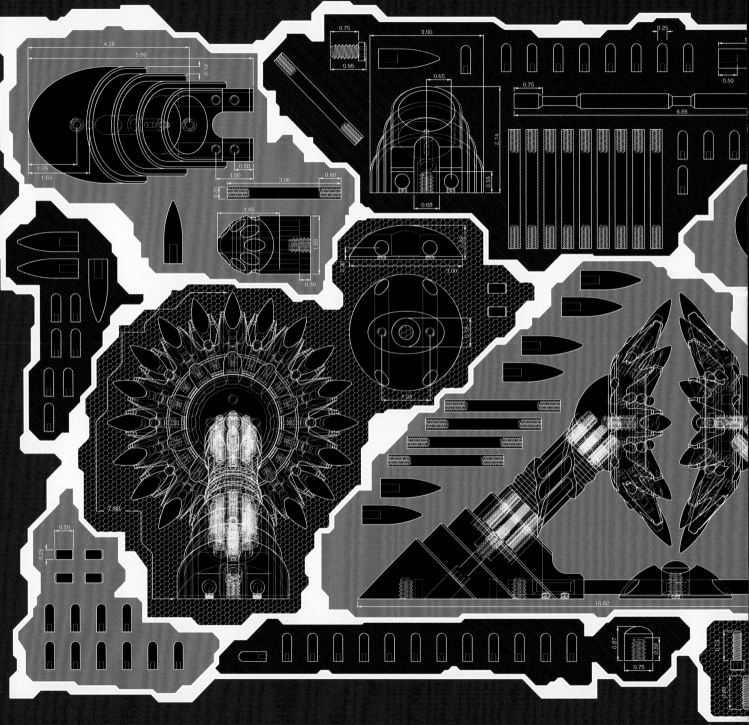

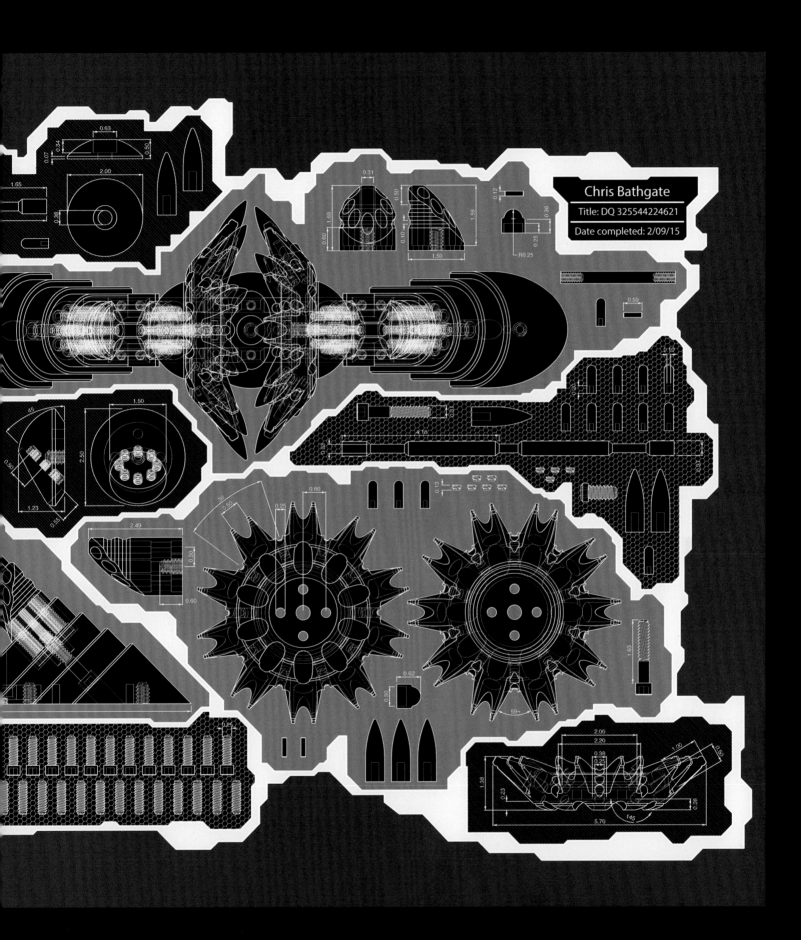

Chris Bathgate
Title: DQ 325544224621
Date completed: 2/09/15

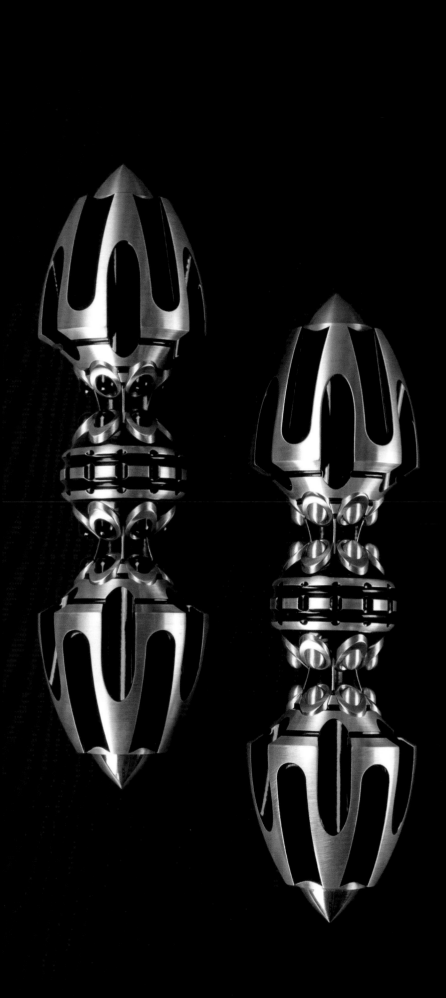

RG 355113224
Aluminum, brass, and stainless steel
7" x 2" x 2", 2015

RG technical drawing

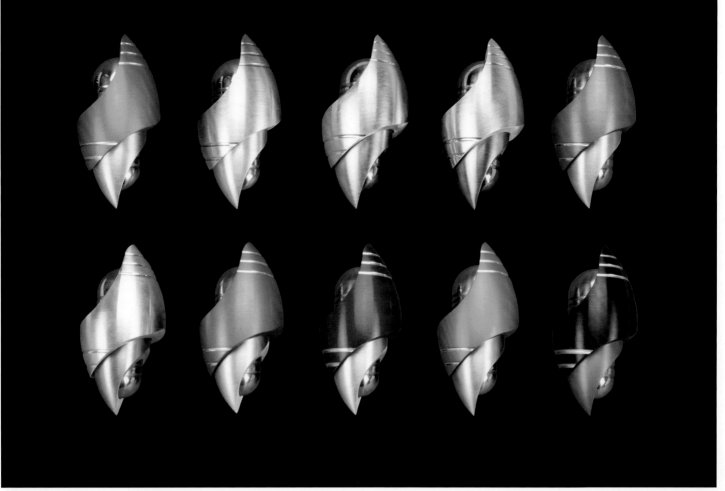

GT 652231344421
Aluminum, stainless steel, brass, bronze, and copper
1.5" x 1.5" x 3", 2015

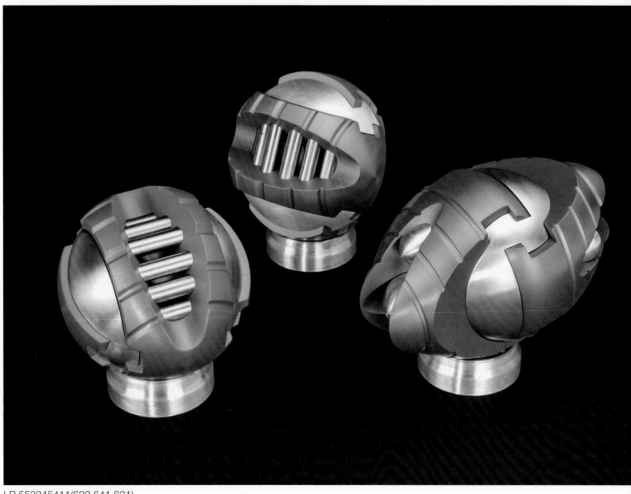

LP 553345411(622,641,631)
Aluminum and stainless steel
2.5" x 2.5" x 2.5" and 2.5" x 4" x 2.5", 2015

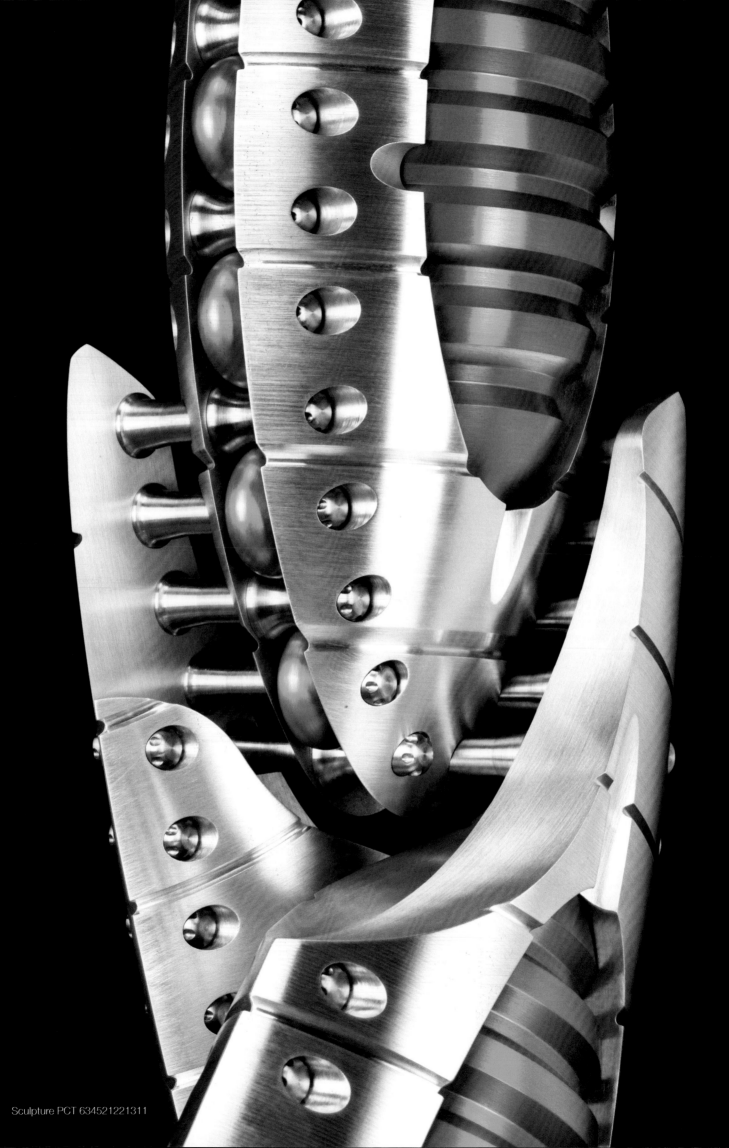

Sculpture PCT 634521221311

Chapter 9

In the fall of 2013, the Museum of Art and Design staged a show called *Out of Hand: Material-izing the Postdigital*. The exhibition was billed as the first major museum exhibition to examine advanced methods of computer-assisted production known as digital fabrication. I was honored to be included in this landmark exhibition alongside fine-art luminaries, architects, and designers such as Chuck Close, Frank Stella, Anish Kapoor, Zaha Hadid, and Marc Newson. There were numerous exciting technologies on display in the exhibition, including a woven tapestry made on a CNC loom, CNC knitting, architectural elements and furniture made on automated routers, and even a purpose-built art-making machine that dripped polyethylene to create blob-like sculptural forms.

It was an incredible showcase with a wide range of technologies represented. However, given its importance to all the other technologies on display, I found it odd that there were so few objects that could be readily identified as being made on traditional automated machine tools (mills, lathes, etc.). Indeed, I was the only machinist in the show. I asked the curator about this, and he expressed to me how he had struggled to find artists working directly in the medium of machined metal. I felt this couldn't be true, given what a powerful tool machining was for explaining how we had reached this particular moment in craft.

Indeed, additive manufacturing and 3-D-printed objects would dwarf nearly everything else in the exhibition. There were 3-D-printed jewelry, clothes, prosthetics, teapots, furniture, sculptures, a racing bike, and more. Attendees could have their bodies scanned and printed while they waited. It was certainly awesome to see, but the sheer novelty of the 3-D-printing movement, which was at its peak, would overshadow other aspects of the show. With machine tool processes so underrepresented, the show became much more a commentary on design innovations and postproduction trends than a comprehensive look at digital fabrication. Given the imbalance of the show, one might get the wrong impression of which technologies remain dominant in terms of industrial use.

I am perhaps a little biased in this, but given how historically important machining as a trade has been to the development of 3-D printing and all the other attendant technologies on view in the exhibition, I think it was a missed opportunity to create a powerful context not just of where technology is headed, but where it came from. The most interesting thing about the technologies on display, for me, is that they have historical layers, with new processes stacked on top of old ones. Walk into any machine shop, and you will see state-of-the-art equipment right up front. But sneak to the back, and you will see shops that still rely on tools that are a half century old and still making parts. This is a metaphor for the state of craft as well, with artists engaged in creative processes of every vintage. Talk to most crafts people, and they will express how exciting it is that technology can augment rather than replace their abilities and traditional processes to make something new.

I remain grateful for inclusion in such an important exhibition. The *Out of Hand* exhibit did a wonderful job drawing attention to how design and craft are intrinsically entwined with my medium, and that if I am to place it into its proper context within the arts, I would need to do a better job of connecting my work to the work of others.

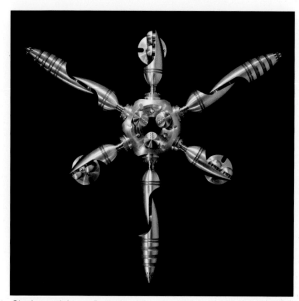

Single module configuration of sculpture ML 622254434732323

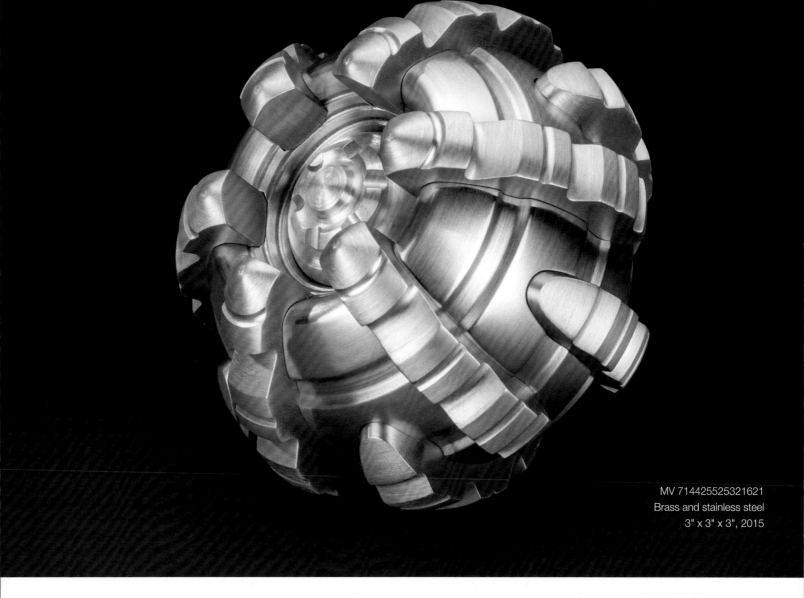

MV 714425525321621
Brass and stainless steel
3" x 3" x 3", 2015

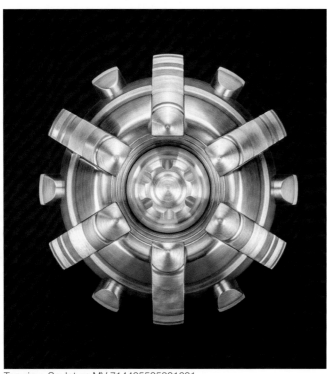

Top view, Sculpture MV 714425525321621

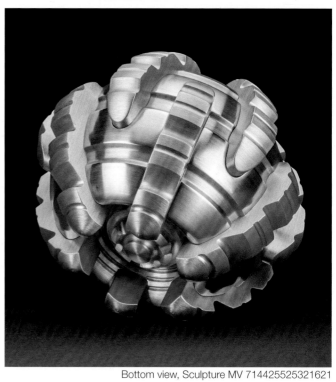

Bottom view, Sculpture MV 714425525321621

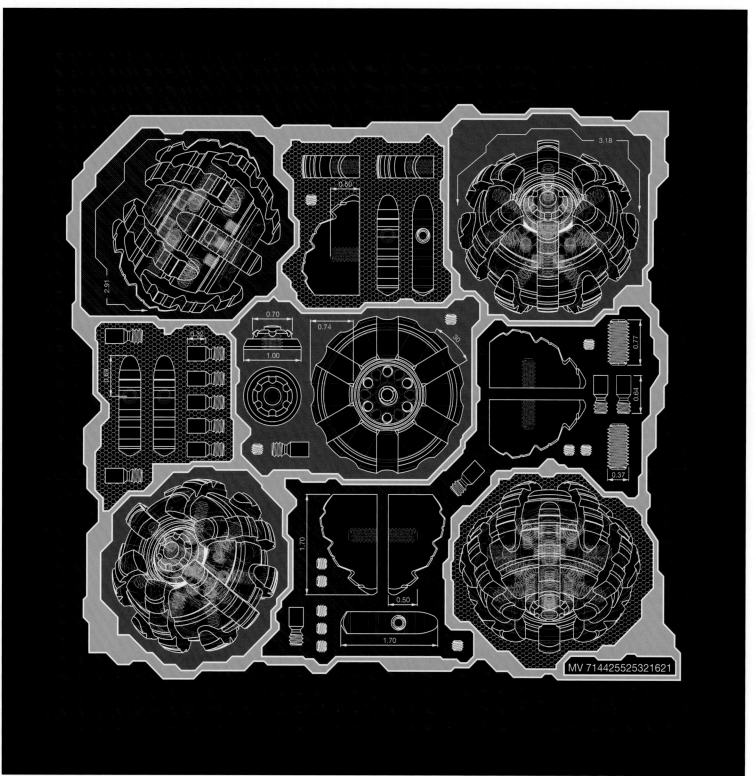

MV 714425525321621

MV technical drawing

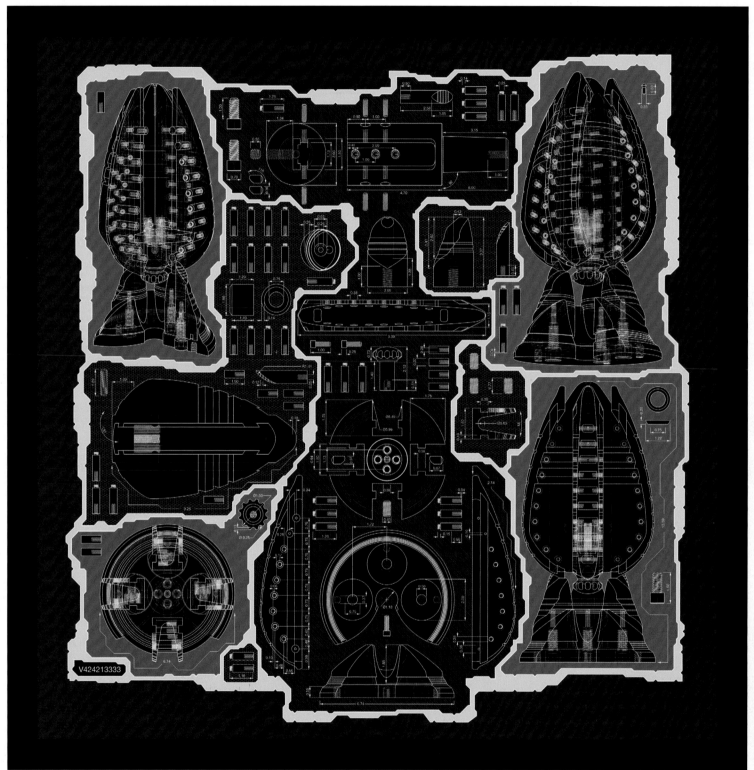

V4 technical drawing

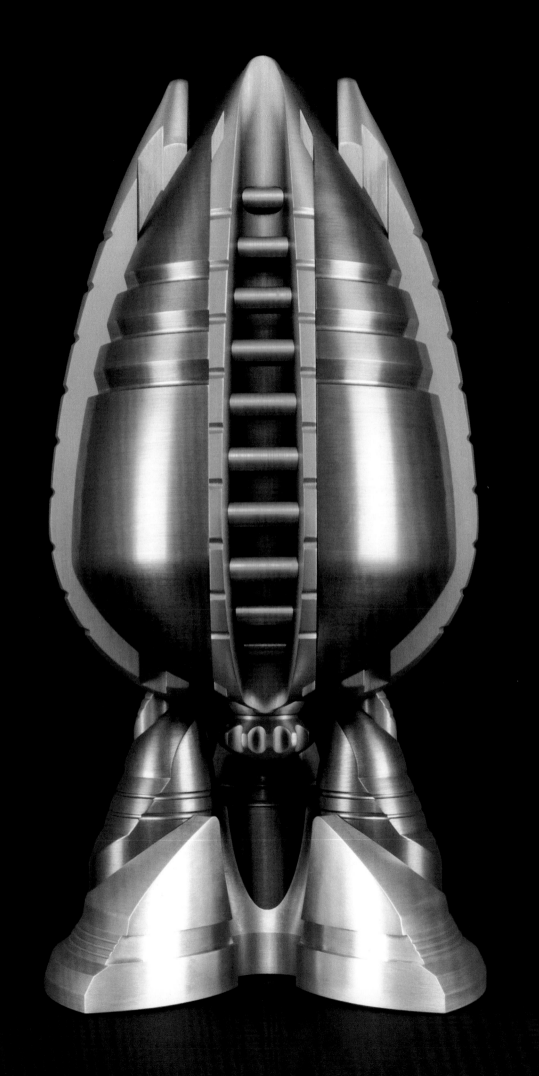

V424213333
Aluminum (anodized)
14" x 7" x 7", 2015

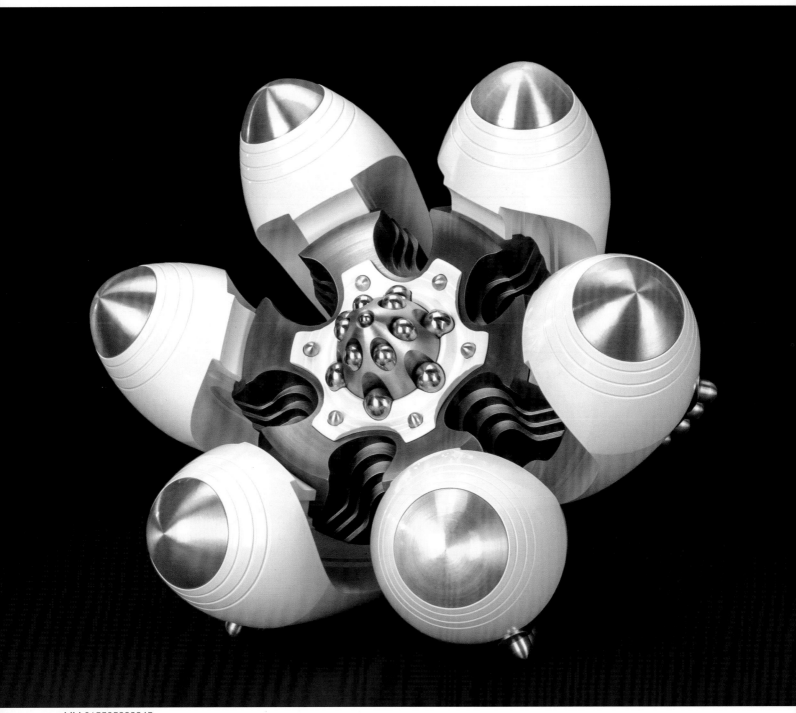

MM 615535332245
Aluminum, bronze, stainless steel, and brass
9" x 9" x 10", 2015

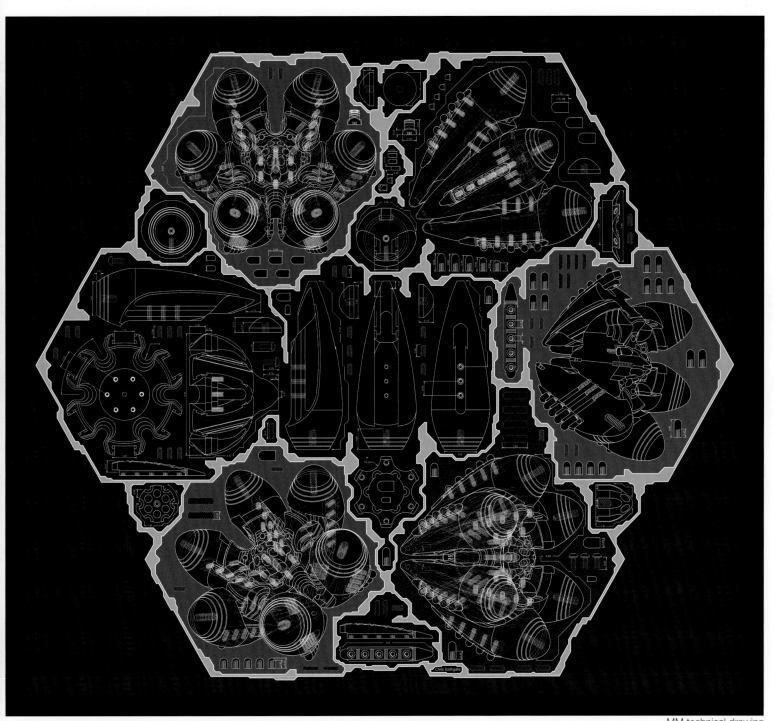

MM technical drawing

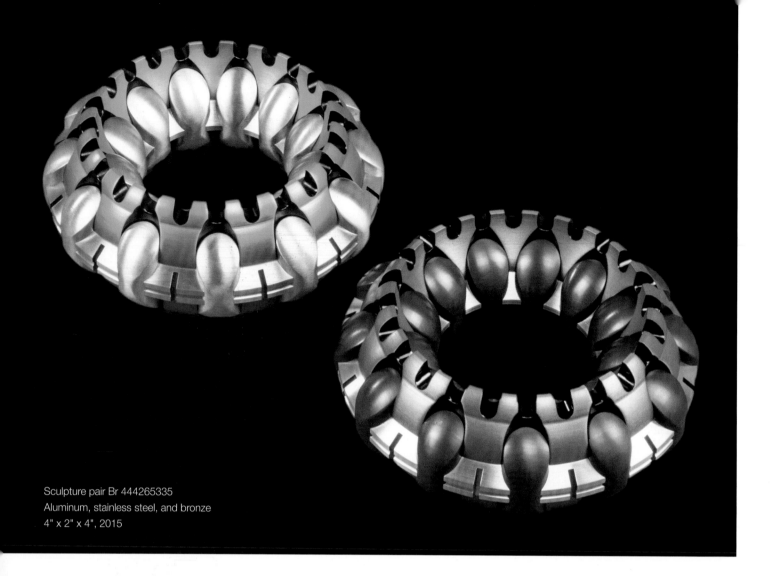

Sculpture pair Br 444265335
Aluminum, stainless steel, and bronze
4" x 2" x 4", 2015

TT 412232523
Titanium, brass, and copper
1.5"x1.5"x2.2", 2016

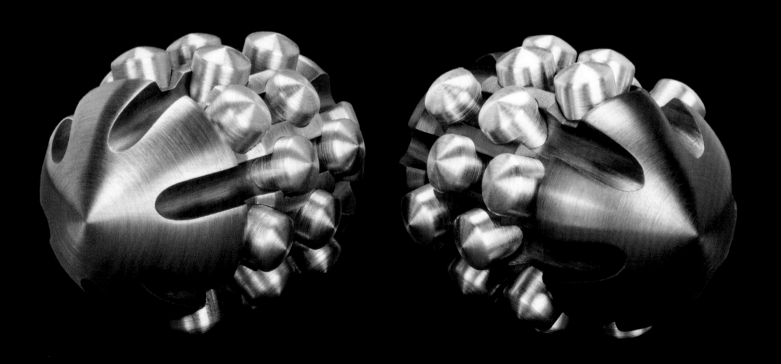

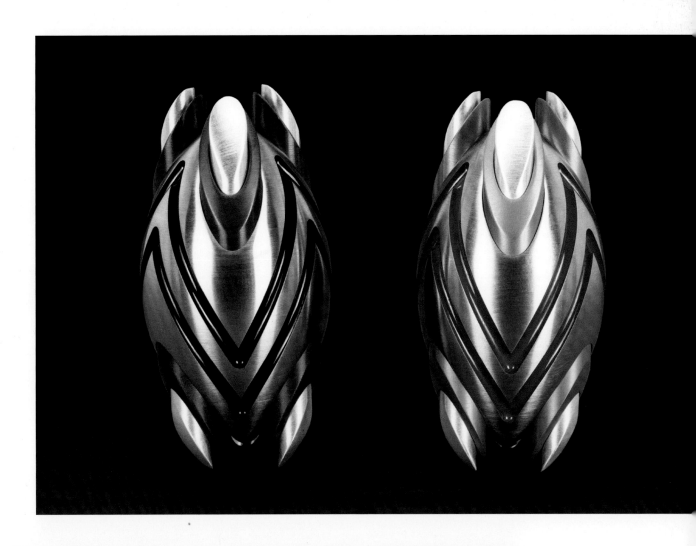

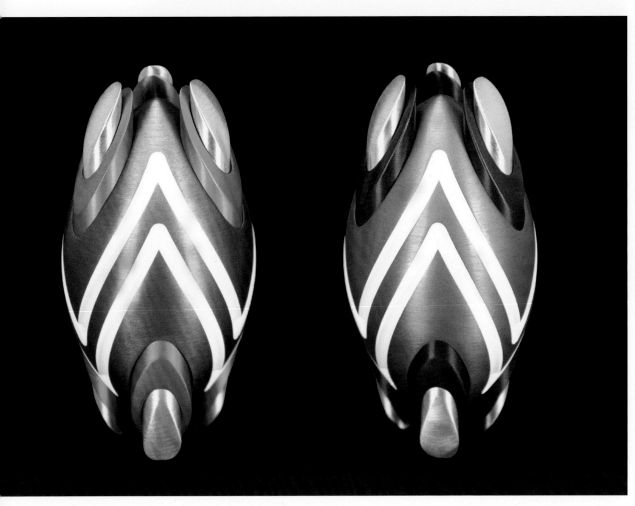

NV614434235524 (four works)
Aluminum and stainless steel
3" x 1.6" x 1.6", 2015

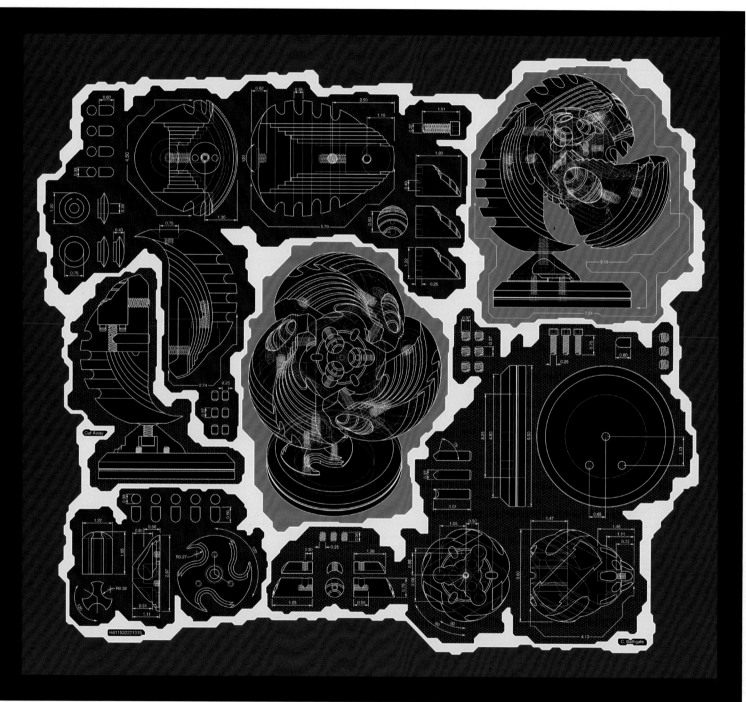

H4 technical drawing

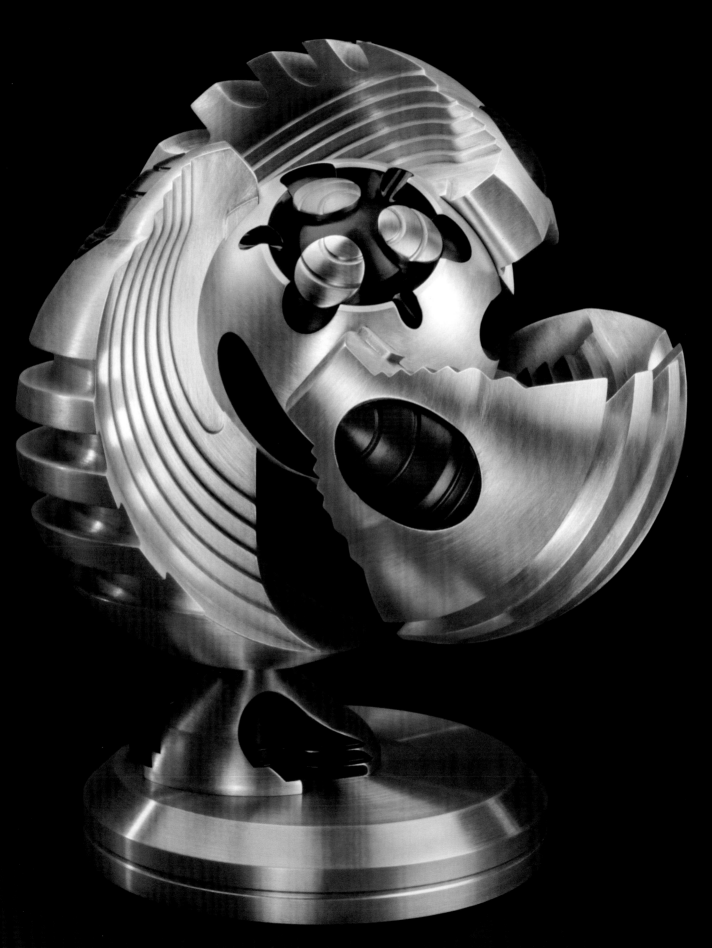

H 411532221315
Aluminum and stainless steel
9" x 8" x 8", 2015

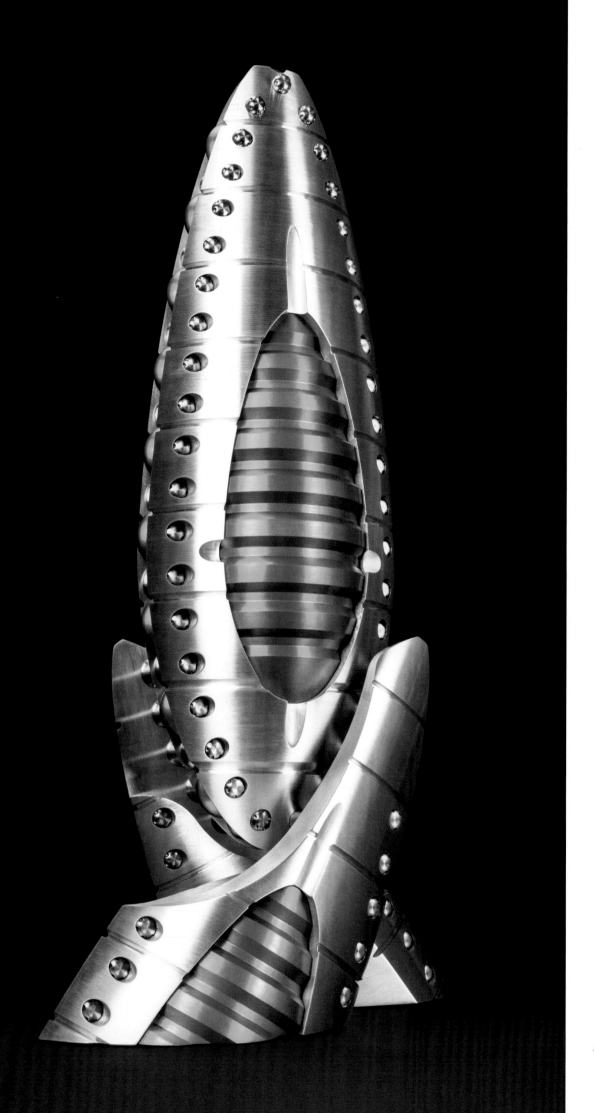

PCT 634521221311
Aluminum and stainless steel
24" x 13" x 8", 2015

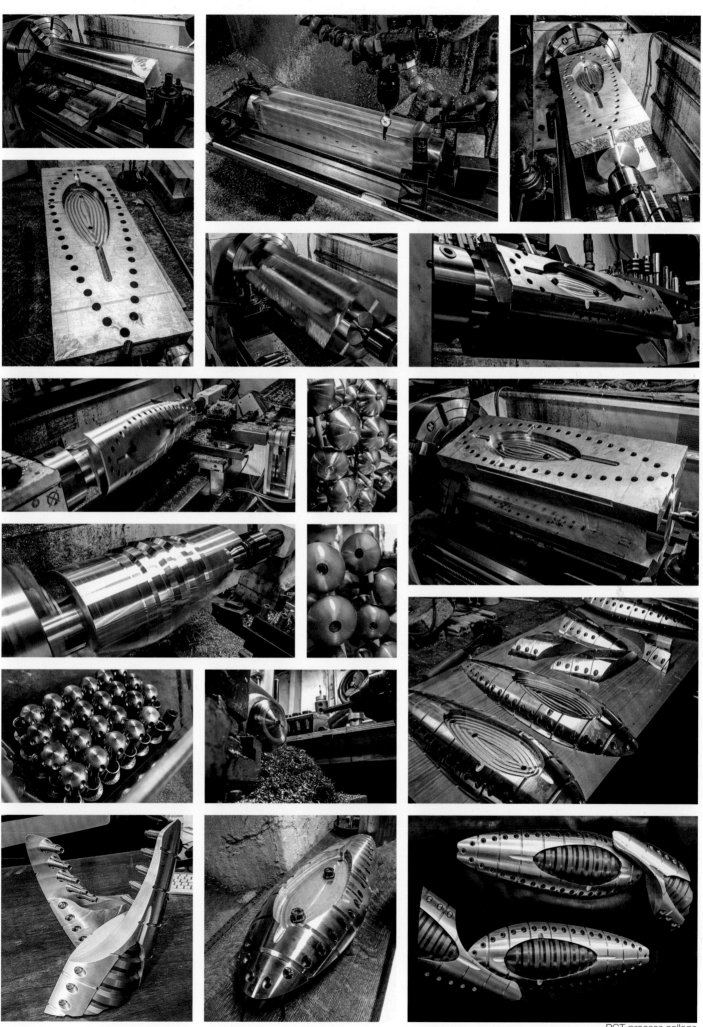

PCT process collage

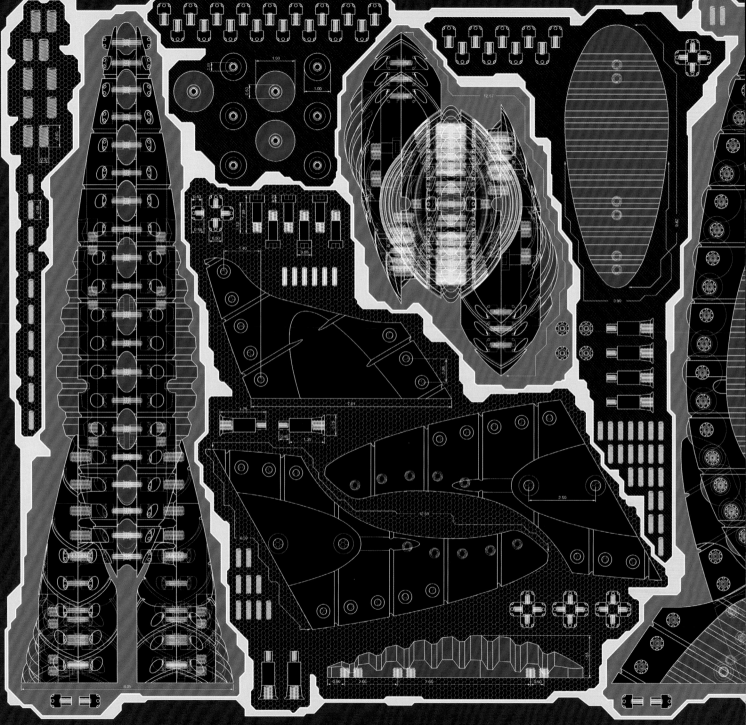

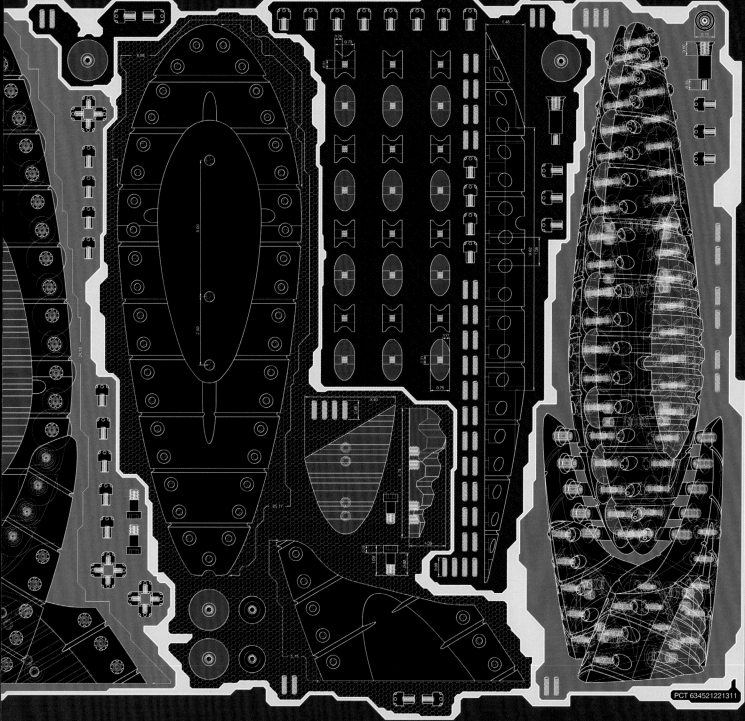

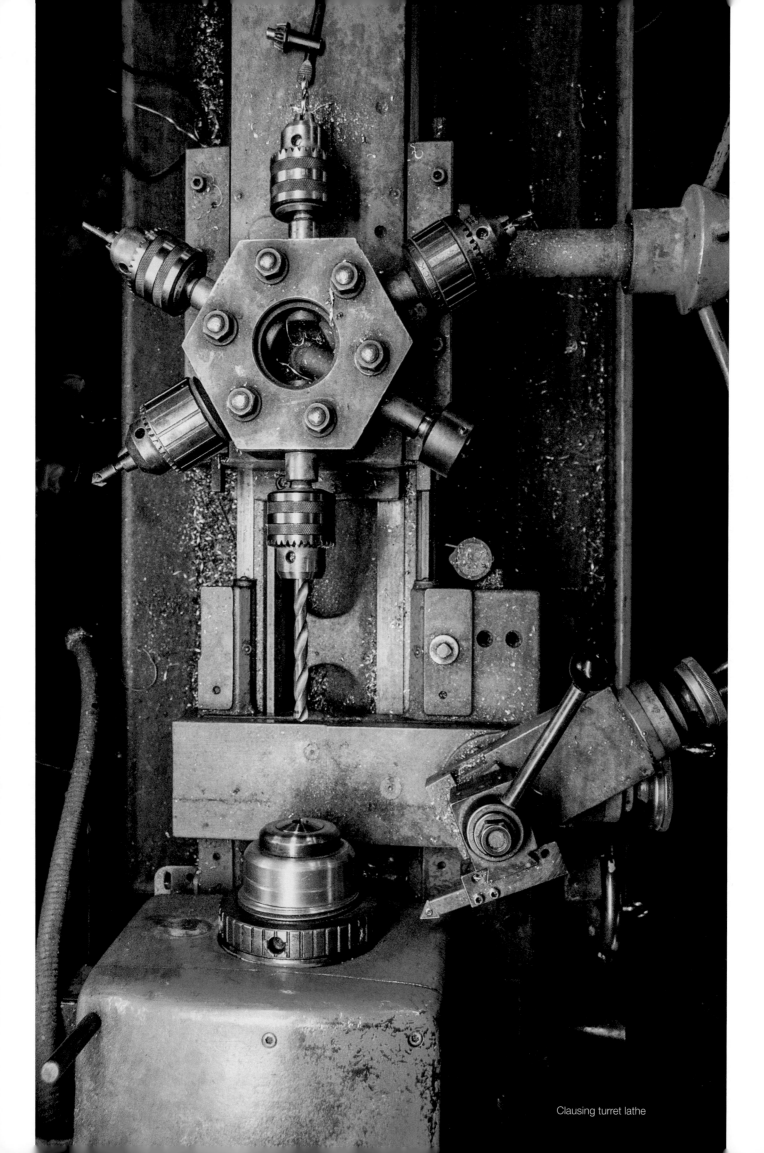
Clausing turret lathe

Chapter 10
Looking to History for Clues about the Future of Studio Machining

When we think about the term "industrial arts," I think it is safe to say that most of us think of shop class or vocational training; it might also conjure up the idea of industrial design and the large-scale production of standardized physical objects. For me as an artist, my mind quickly shifts to those fine-art processes that have emerged from historical vocational programs that were designed to train and prepare the working class for factory work. In the early twentieth century, these processes and the programs that taught them were initially intended to give the population a general proficiency with making things, so that people could easily transition into some form of factory work. Delightfully, parts of this program morphed into the vast cultural landscape we now call craft.

For most of its existence, machining has been a straightforward vocation. When used by artists, it has primarily been seen as a means to an end rather than an end possessing its own intrinsic qualities. Machine work is vital to manufacturing, the world's economy, the sciences, and our general way of living. As a vocation, it remains a vibrant industrial field with hundreds of thousands of practitioners in the United States alone. One question I have attempted to ask with this book is whether some of its practitioners may be influenced to turn their skill set to cultural work in addition to productive work, and if such an active vocation can also find a creative niche as a studio art form. One of my approaches in attempting to answer this has been to look to other studio arts to see what similarities I can find between mediums born of industry and my own. What concepts can I borrow from history? What lessons can I use to define and develop my craft?

At the risk of becoming an anachronism, I have spent much of my career pursuing a somewhat traditional approach to sculptural objects. That is, I have intentionally turned all the engineering and technical aspects of my craft toward making intentionally nonutilitarian works. I do this because it has an interesting psychological impact on viewers who have grown up steeped in the language of industrial product design. However, it has also helped me define what is truly unique about my craft while also highlighting its commonalities with other fine-art mediums.

Over the two decades that I have been investigating machine tools, the wider world of machining has followed its own natural course. Instead of developing into its own unique artistic discipline, digital-fabrication technologies have been embraced by nearly every field. I have watched digital-fabrication tools become widely adopted by the whole of the crafts community. Jewelry making, woodworking, and knife making have been completely transformed by automation. Diehard handcrafts such as ceramics have employed CNC technology and 3-D printing to create precise molds from digitally rendered forms. Even bakers and painters are employing automation technology in surprising ways. Many art schools have also adopted machine tool technologies, rebuilding their arts programs around digital fabrication and design tools. On balance, it is probably quicker to list the professions that don't use these technologies, since the transformation has been swift and all encompassing.

Despite wholesale adoption of digital-fabrication technology within other disciplines, there remain a core of general practitioners (mostly commercial) and an intrinsic aesthetic that makes machining ripe for the studio environment. To make the case for machining as a future studio craft, I think it worthwhile to look at the history of other industrial crafts that now enjoy fine-art status. I'd like to individually highlight a few different craft traditions and try to connect their histories with ideas that I've brought into my own practice to chart out a possible future for machining within the arts.

Studio ceramics: It is a strange quirk that, as a metal sculptor, I find myself inspired by ceramic artists more often than metalworkers. There is something irresistibly elemental about ceramic art and something disarmingly humble about many of its practitioners. As I would come to learn, this is not a phenomenon unique to just me.

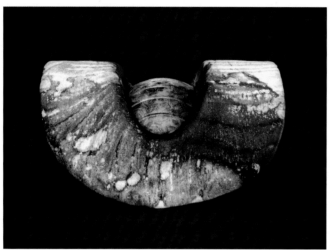
Waveform "touchwood" stoneware and amboyna burl, 2020

While the entire history of ceramics is impossible to capture in one coherent timeline, the main period for the studio ceramics movement is regarded as 1940-1979. During this time, the practice of ceramics moved from being a utilitarian necessity, to a therapeutic aid and hobby, to a medium with well-developed fine-art aspirations. While ceramics as a whole espoused an ethos that valued handwork over industrialized factory ceramics, it would later come to champion artists who embraced both robust studio practices as well as design work that relied on more-industrial methods. It would help develop the theory of design as being a distinctly separate discipline from the act of art production.

Although studio practice requires a certain amount of solitude, the ceramics movement is well known for fostering strong communal relations to share ideas and trade technical information. This emphasis on community would help spread the clay lifestyle and would translate to schools and cultural institutions that would create the framework for the artification of the craft. This would become a blueprint that other craft movements would emulate. In this way, the story of the studio ceramics movement is by and large the story of the entire studio arts movement; it is the archetype for the notion that any craft, when approached with care and intelligence, can elevate itself to the status of high art.

One of the great strengths of ceramics as a medium is its low cost of entry and accessibility to the novice. Unlike machine work, the ceramics movement was founded on some pretty basic technology. Clay can be dug locally from streambeds for free, and there are many low-tech ways to fire the finished pottery. A person willing to put in the physical effort to dig their own clay and construct their own primitive kilns can start a practice for very little money. I don't think that one can understate how affordability can contribute to the popularity and sustainability of a craft. In machining, however, the cost of tools and materials remains a huge barrier to entry into the practice. Those interested in learning machine work have had to rely on educational institutions and maker spaces for access to equipment. While this is perfectly reasonable to begin a practice, it comes with its own pitfalls if one is to take up machining professionally.

Waveform collaboration with sculptor Eric Moss

While technologically very different from machining, ceramics have many aesthetic qualities to share with machinists, as well as philosophical ones. My journey with machining began with a primary interest in fine art, but I have begun working backward toward a more comprehensive ideal inspired by the ceramics movement—one that incorporates ideas around craft and design as well as seeks inspiration from decorative subcultures.

Studio glass: Decorative glass has been around for centuries. However, before the studio glass movement came to prominence, most decorative glass was made largely in design houses or larger factories. Glass objects could be decorative or utilitarian, but they all were made in industrial settings by teams of operators running large furnaces. While there were plenty of successful attempts at art making, and there is no doubt that many factory workers were skilled technicians and craftspeople, the work of these large glass producers was constrained by the economics of what could sustain the factory. The vast majority of the pre-studio output was stained glass, lighting, vases, and the like.

Contrast this with the birth of the studio glass movement. In 1958, on the heels of a boom in interest in the studio ceramics movement, artist Harvey K Littleton began experimenting with glass in his studio. In 1962, he partnered with glass research scientist Dominick Labine, who developed a design for a small and affordable furnace that could melt glass. This advent would prove a watershed moment, since it removed the need for a large crew of operators as well as financial and physical infrastructure. It created a means for solo artists to bring the production of glass art directly into their studios. In the same manner as a painter might paint, artists were now able to work freely with glass, away from outside eyes and commercial influence. And while glass artists continue to choose to work in small teams (for lack of enough hands to manipulate molten glass), it can be effectively practiced by one artist in one studio.

Glass art's popularity began to grow, and experimentation was rampant. An explosion in creative output would soon follow. Suddenly, a piece of glass art could be anything—or nothing at all. This era is responsible for many of the examples of glass sculpture we see in museums, and gave rise to the fine-art landscape we see in glass today.

Heat-treating oven used for knife making and glasswork

The story of glass art resonates with me as a machinist, because very similarly and until very recently, artists looking to leverage machine tools and CNC technology for the creation of art would likely have been dependent on design firms, tech schools, or fabrication shops who could assist in programing, running, and maintaining large pieces of equipment that were beyond their experience and financial reach. Like early glass factories, access to machine tools was severely limited by the considerable cost and infrastructure these large industrial tools required. While cost is still a very real issue for aspiring machinist-artists, scalability is not. The marketplace for machine tools is now full of small and incredibly versatile pieces of equipment. Even an artist with a very modest studio space can bring a lot of production capacity to bear.

One of the prerequisites for exploring a medium as a true studio craft—by my estimation—is that an artist must be able to bring the entire enterprise under their control as one artist, one studio. In the most decadent way, every aspect of a practice must become available for creative appropriation and exploration. A solo artist practice is one of the few environments that can provide the freedom necessary for the uninhibited level of investigation it takes to create artifacts that both influence and distinctly represent a medium. The lesson I take from the history of glass art is to seize the means of production and make it a conceptual part of your art.

Woodturning: The history of woodturning is a bit clouded, with more than a few competing versions. Like many handcrafts, woodturning existed as a utilitarian necessity practiced by professional woodturners for much of recorded human history. Evidence for early woodturning dates back to at least 320 BCE. Decorative woodturning began to appear in Europe around 1700, and it has been documented as a hobby of the European rich in the 1800s.

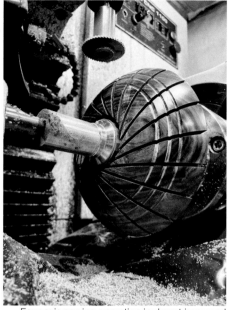
Four-axis sawing operation in desert ironwood

In more-modern times, woodturning was encouraged as a sort of therapeutic practice beginning just after World War II. Small hobby lathes began to be manufactured in the US in the 1940s, and magazines started publishing articles on technique. From there, the practice more or less hummed along as a sort of noble pastime, with an emphasis on technique and smooth design, for the remainder of the twentieth century. But unlike many of the other studio crafts, fine-art woodturning would not rise with the tide of the studio craft movement; it would resist artification until much later and initially struggle to find the same acceptance as other hand arts. While ceramics, glass, and metal art all were being well received within the arts community by the late 1960s, woodturning seemed a bit left behind.

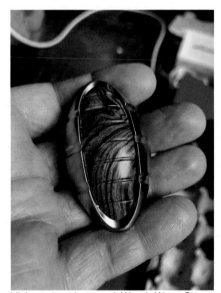
High-contrast ironwood, Woody Worry Stone

While there is no clear answer as to why that was the case, I think it is easy to speculate that this was due in part to the bias against mechanized art that persisted into the 1970s and a misunderstanding of the technology involved in woodturning. It is interesting to read accounts of woodturners who have expressed an uneasy relationship with the tools of their trade.

Woodturning, even now, is viewed primarily as a handcraft. Using a metal rest to steady the tool, an operator shapes a piece of rotating material by guiding the cut with their own two hands. It is a skill set that requires both dexterity and knowledge of how a material will respond while being shaped. However, the material being turned is also constrained and rotated by an admittedly consequential piece of iron machinery, the wood lathe. There is a tension between the practitioner's desire for freedom of movement and expression with the necessary reliance on large tools and equipment to control that very same cut. No doubt this dichotomy of constrained yet free work influenced the acceptance of turned wood as an expressive art to some degree. While it is clear that most woodturners did see their process as a skilled handcraft, they themselves seem to have had their own biases toward automation.

In my research into wood turning, I came across the stories of many woodworkers who were also engineers. They reportedly engaged in highly technical careers within industry during the day, and it was only in their leisure time (or in retirement) that they escaped to their wood lathes to relax. One such artist was Mel Lindquist, who is regarded as one of the pioneering figures of studio woodturning. Although he is remembered for his contribution to his craft, in his career he was also a master machinist for General Electric. Operating a vertical turret lathe as his profession, he no doubt understood well how machine tools worked and what they were capable of, yet it was in woodturning that he felt he could find true creative expression. At the risk of projecting my own

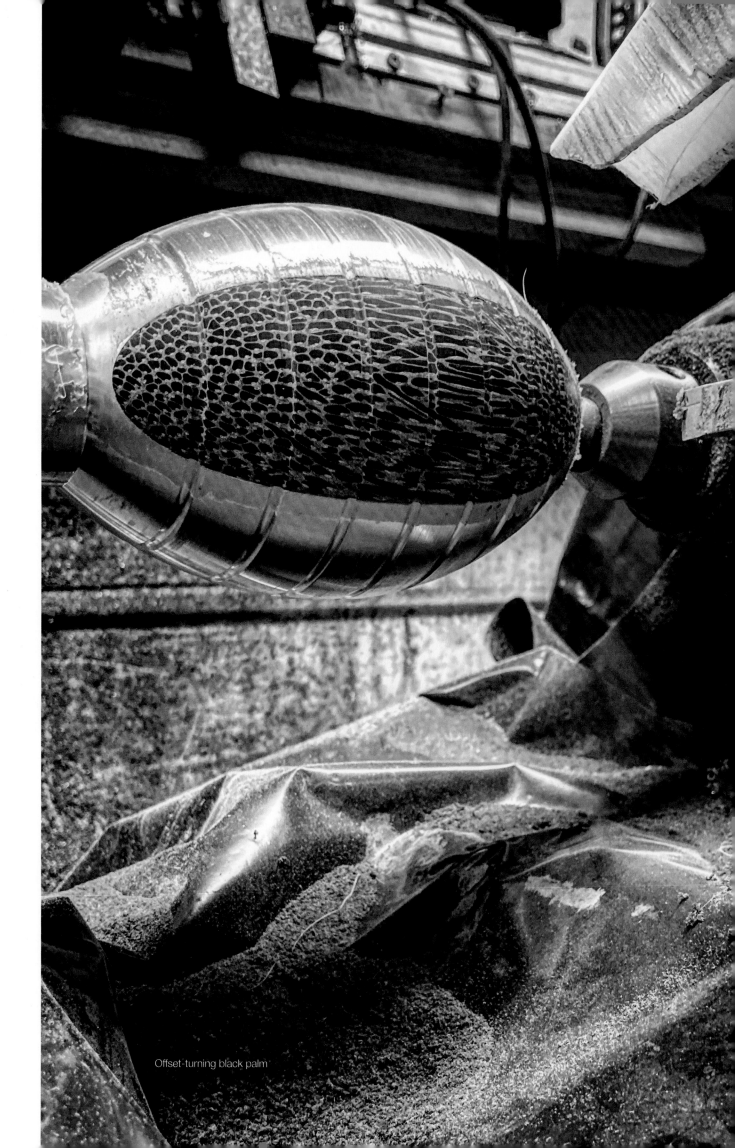

Offset-turning black palm

values on a different era, I do find it curious that as a professionally trained machinist, Mel Lindquist never saw the same potential in the machine tools he employed in his career as an engineer. Or perhaps he did but refrained from acting on it for other reasons. We may never know.

In the book *The Lindquist Legacy*, author Seri C. Robinson makes the case that singular personalities can have an outsized influence on a craft, writing about how artist Mark Lindquist (son of Mel) so thoroughly broke with the traditions of the woodturning movement that the shift into the arts was all but ensured by those who came after. Mark, unlike his father, went to art school and was trained both in metal and ceramic sculpture making. After dropping out of Pratt in 1971, he began working on woodturning with his father, and the two went on to influence and inspire one another. Mark began blending ceramic ideologies with woodturning techniques, and the results were transformative. Mark's and Mel's work introduced many new sculptural ideas to woodturning, including the use of spalted or partially rotten or insect-damaged wood, and the use of live-edge and knotted wood. Their approach to materials allowed the natural beauty and intrinsic properties of their medium to guide their ideas about form. They inspired and encouraged the work of many other woodturners, and before long the production of vessels gave way to full-blown sculpture making. The rest, as they say, is history.

Mark and Mel went on to pioneer a number of tool innovations and spearhead the professionalization of exhibiting their wood objects at craft fairs. Once they began to display their work as if it were fine art, the public began to see their works as such. It just goes to show that what is really required to transform a medium into a studio art practice is simply the belief and confidence that you can—or at the very least, the lack of an upbringing that says you can't.

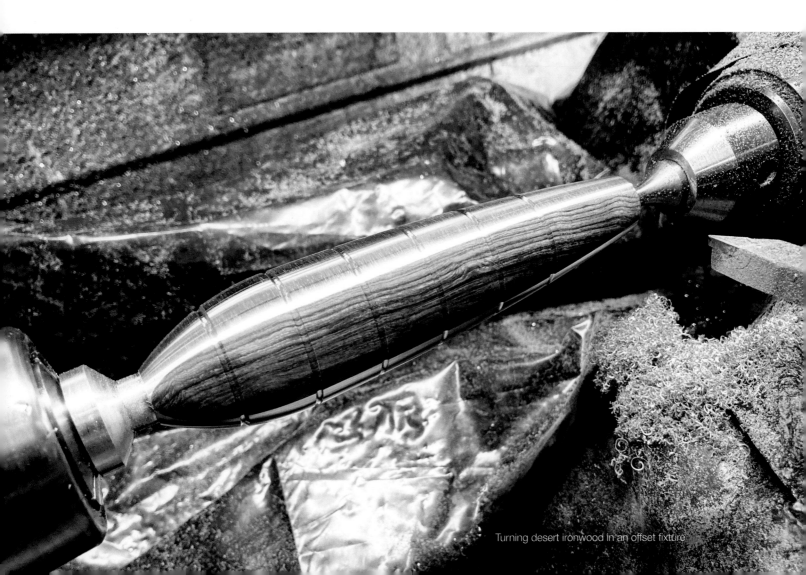

Turning desert ironwood in an offset fixture

Hobby machining: There is a strong hobbyist presence within all the arts and crafts. This fact has been used both as a way to advocate for the wider appreciation of the arts and as a tool to denigrate craft as unserious and unworthy of artistic merit. That the presence of a hobbyist movement within any given field is proof one way or another of its artistic value is, of course, nonsense, but it is also true that a hobbyist element does not always translate into artistic pursuit. While it's not considered a studio craft, one cannot discuss the connection between craft and machine work without mentioning the hobby machinist movement.

Unlike many fine-art crafts, the hobby machinist movement seems to have had very little pretension toward art. The rise of a hobbyist-machining community roughly coincides with the wider adoption of CNC and automated machine tools in US industry during the late 1970s. Its early membership consisted of a professional class of engineers, machine builders, and operators and would take on a heavy DIY element. Like many studio crafts, the hobby-machining movement seems to have been its own sort of rejection of automation, at least initially.

With CNC machine tools beginning to replace manual machinists in factory settings, there was a growing interest in practicing machining as a leisure activity. In 1982, the *Home Shop Machinist* magazine was founded, containing multi-issue projects and tips for aspiring amateur machinists to follow and learn the craft. In the magazine's early years, it focused exclusively on manual machining operations and projects. Within its ranks, various subcultures formed, such as model engine enthusiasts and firearm modification. Particularly interesting to me was a craze for using machine tools to fabricate miniature versions of the very same machine tools!

In time, the slow march of progress found its way into the hobby machinist community, and trends in automation began to take hold. In May 2017, nearly a decade after I took up my first CNC machine-building experiments, a sister publication to the *Home Shop Machinist* called the *Digital Machinist* saw its first issue published for a growing community of CNC enthusiasts.

In my early years learning about machining, these magazines—along with some of the online forums they sponsored—proved to be an indispensable resource for technical information, if not for artistic inspiration. With very few exceptions, art is something that rarely came up in the machinist community—that is, unless I was the one instigating it. Regardless, this group of hobbyists, and all hobbyists really, is responsible for accumulating and maintaining the base of knowledge necessary for an artist like myself to come along and pick up the torch in the name of art making.

Hobbyists are vital to any creative ecosystem. They are a steady base of practitioners learning and teaching the basics over and over again; they are a reservoir of firsthand knowledge that would quickly become lost without them. The presence of a hobby community does not diminish an art form; it is an indicator of its health and a force for preservation within it.

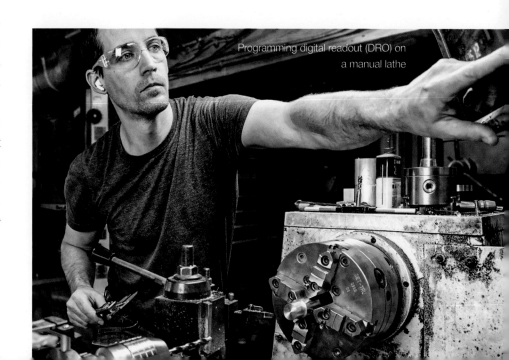

Programming digital readout (DRO) on a manual lathe

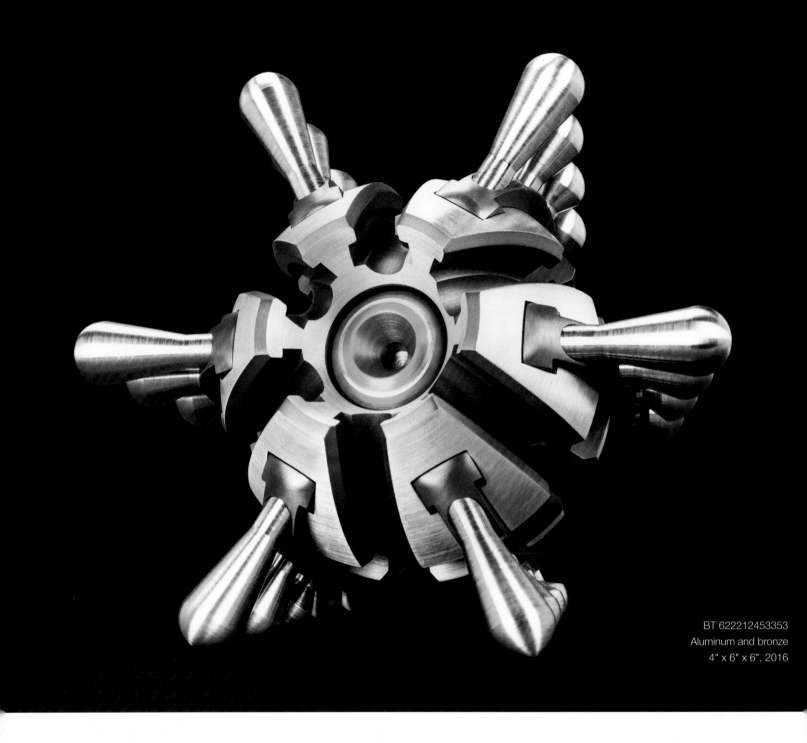

BT 622212453353
Aluminum and bronze
4" x 6" x 6", 2016

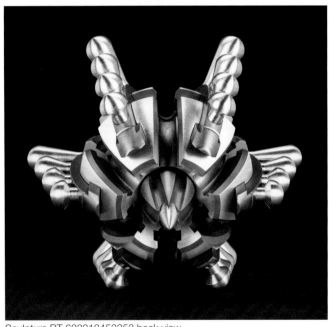

Sculpture BT 622212453353 back view

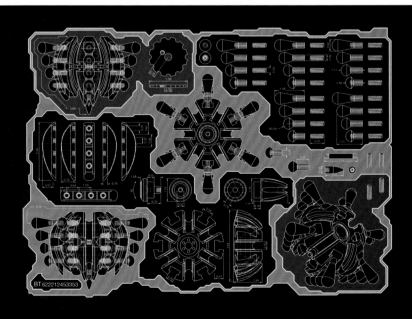

BT technical drawing

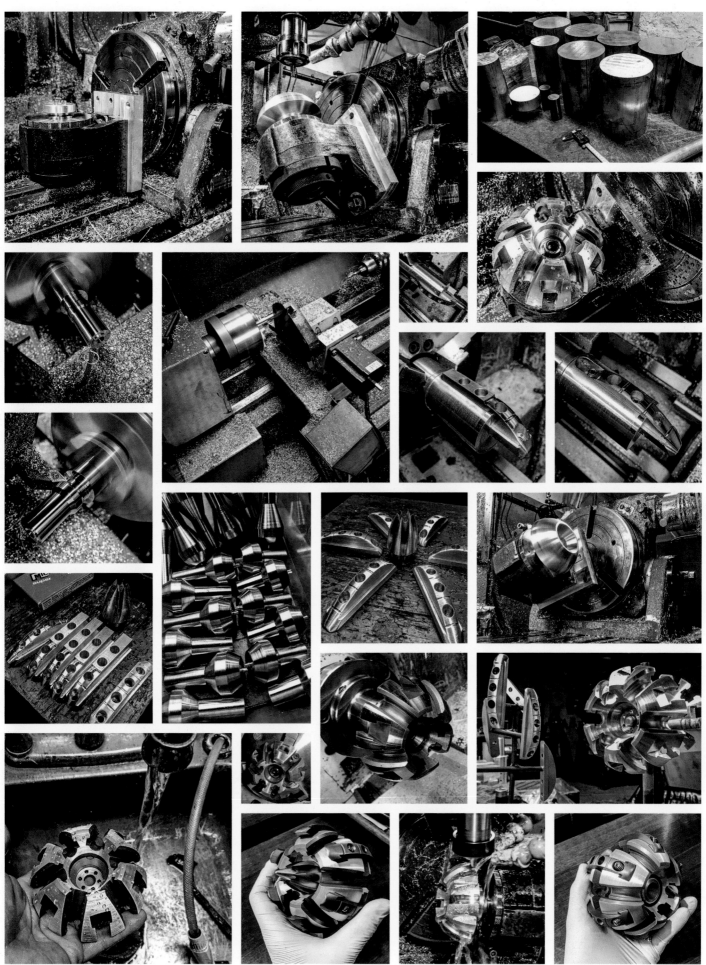

BT process collage

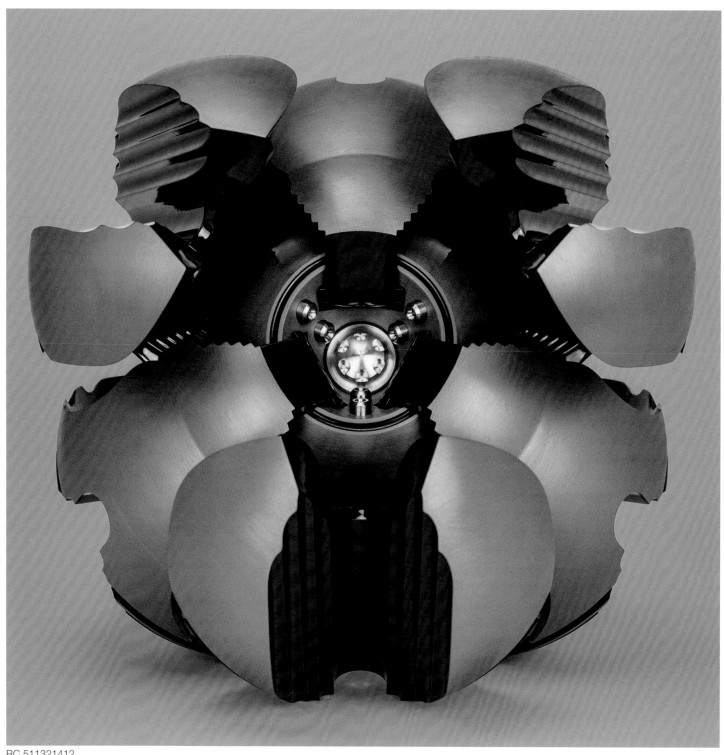

RC 511321412
Aluminum and titanium
8" x 8" x 9", 2016

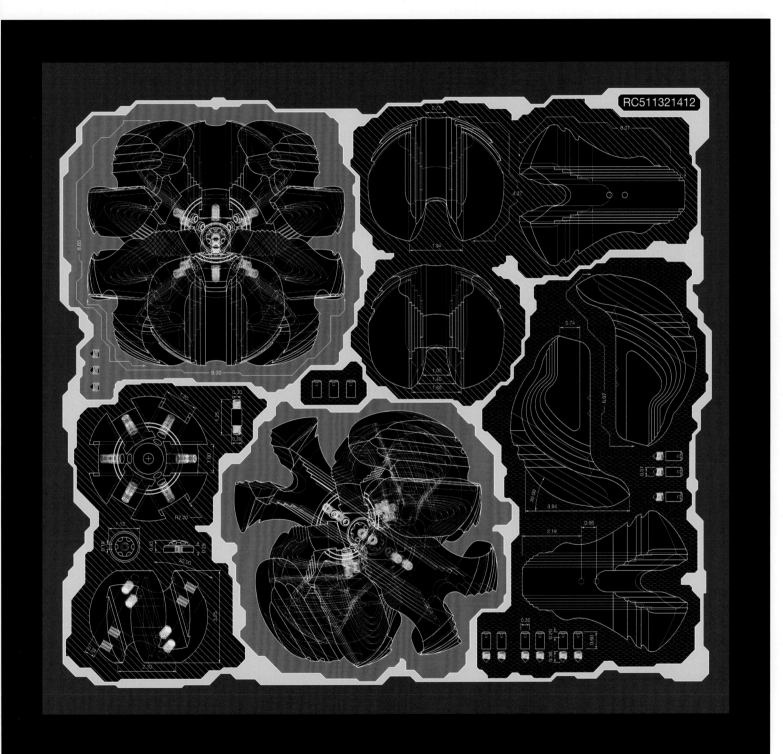

RC511321412

RC technical drawing

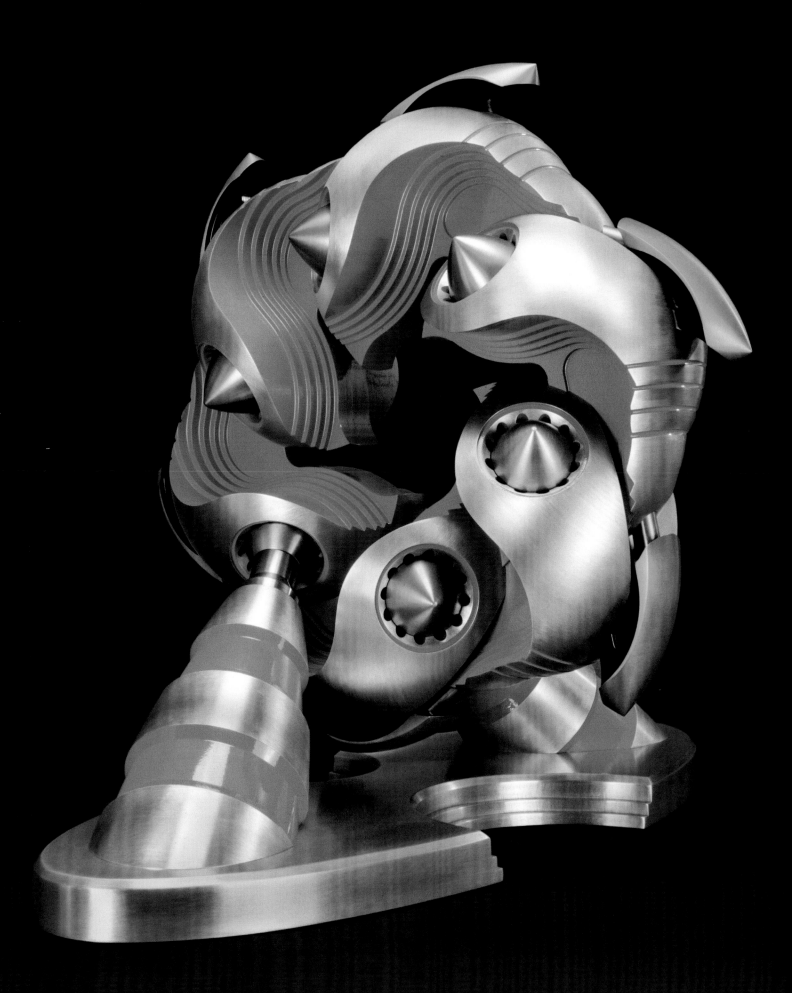

AP 531322421
Aluminum and stainless steel
15" x 15" x 22", 2016

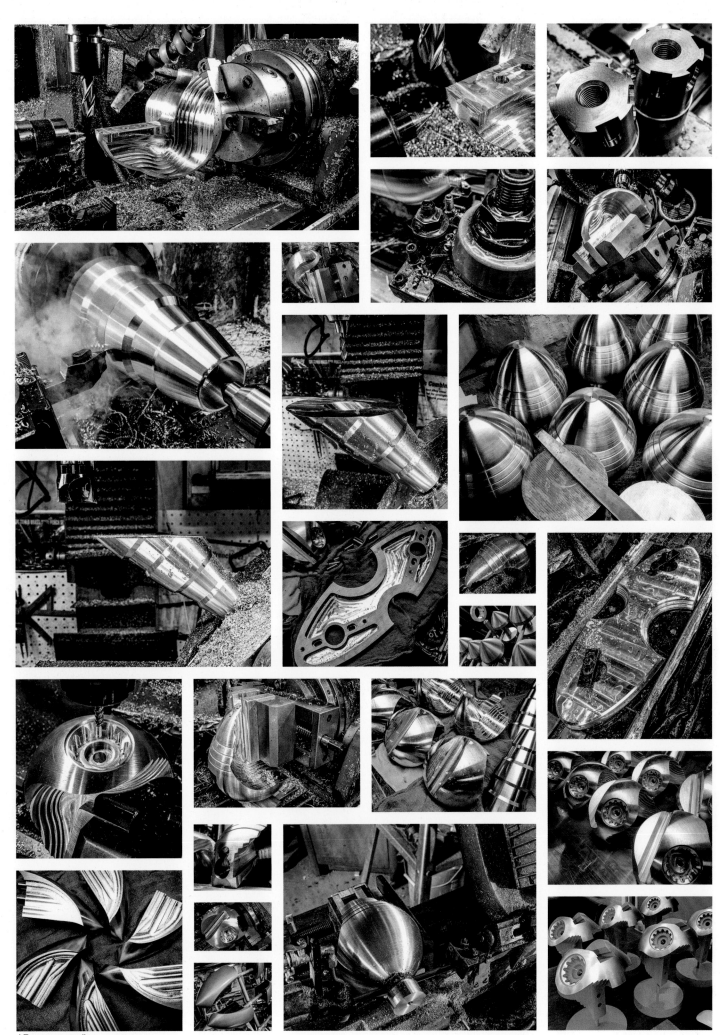

AP process collage

171

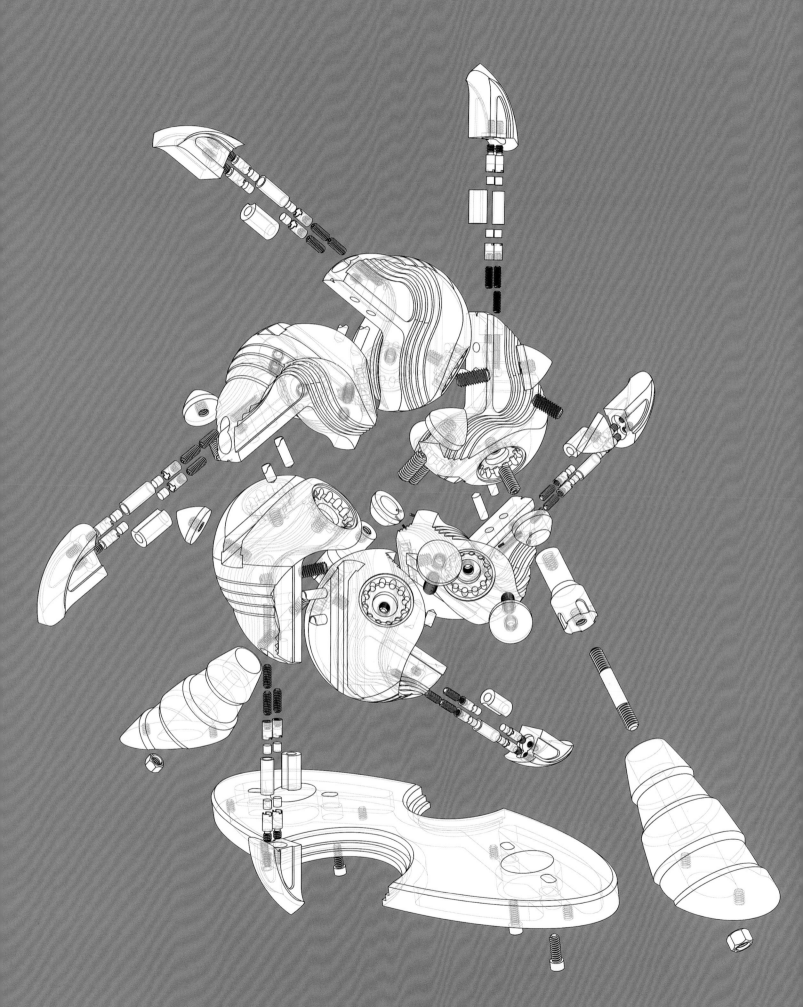

AP exploded diagram

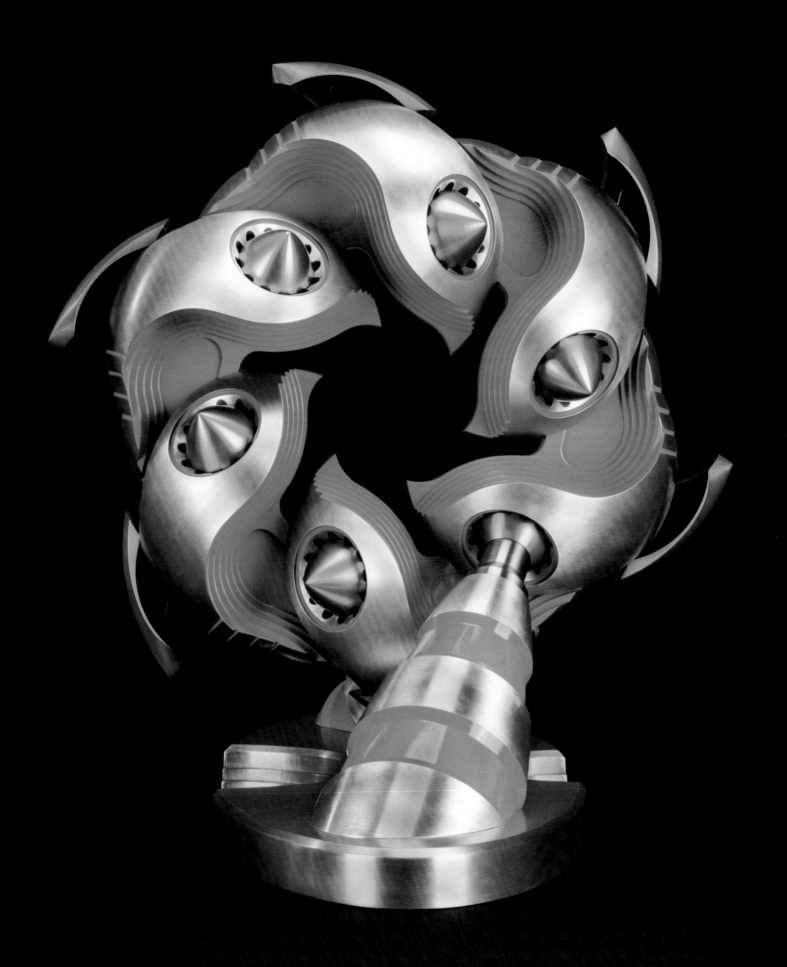

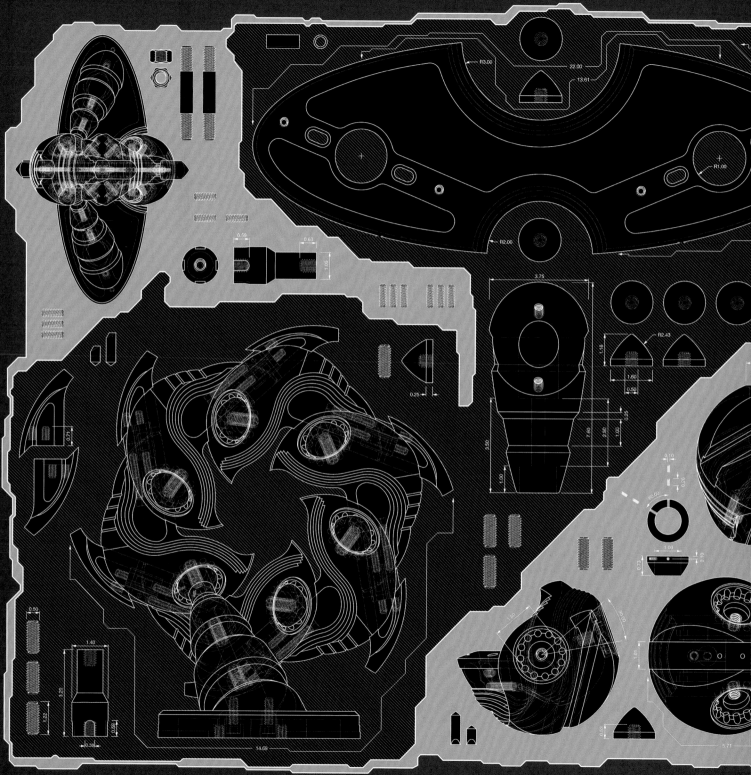

AP 531322421

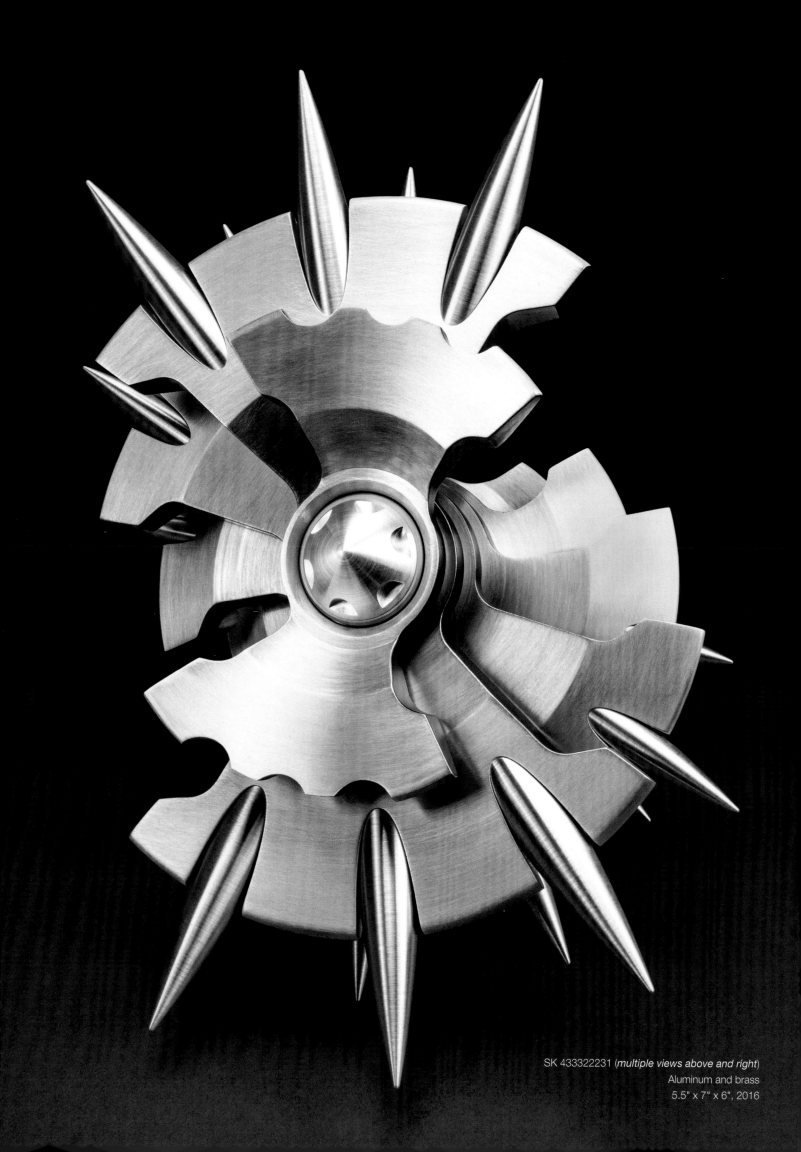

SK 433322231 (*multiple views above and right*)
Aluminum and brass
5.5" x 7" x 6", 2016

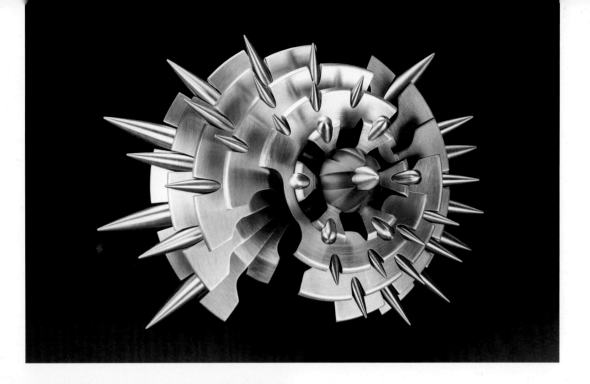

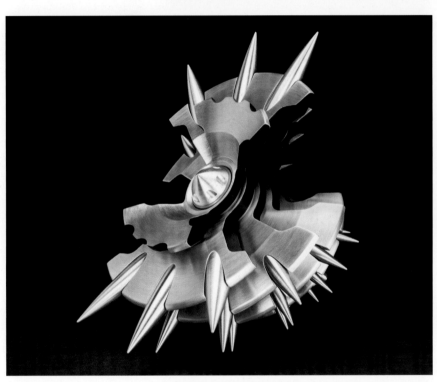

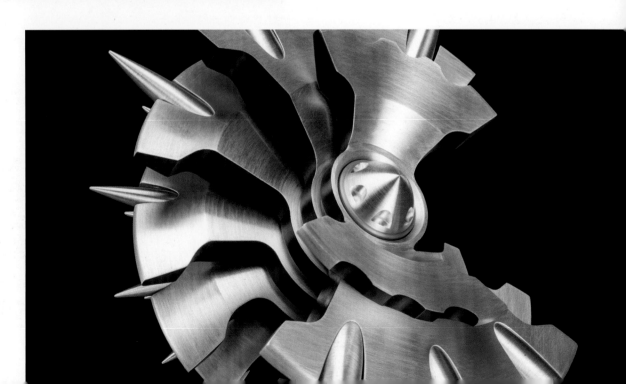

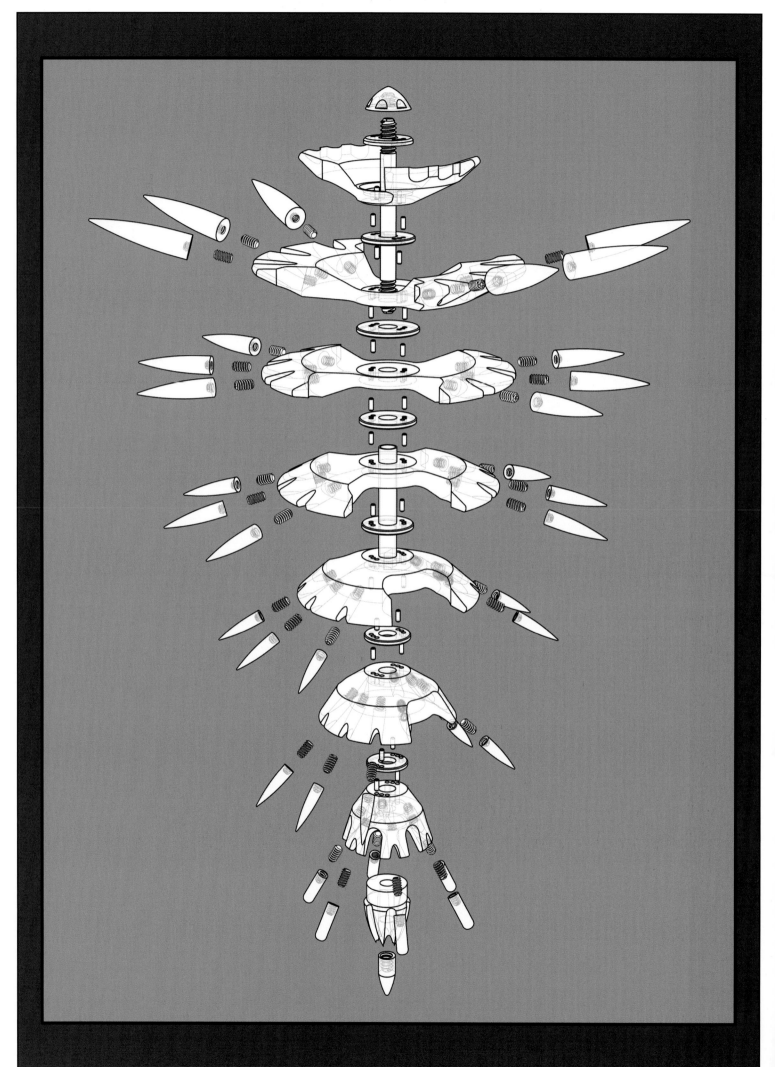

SK exploded diagram

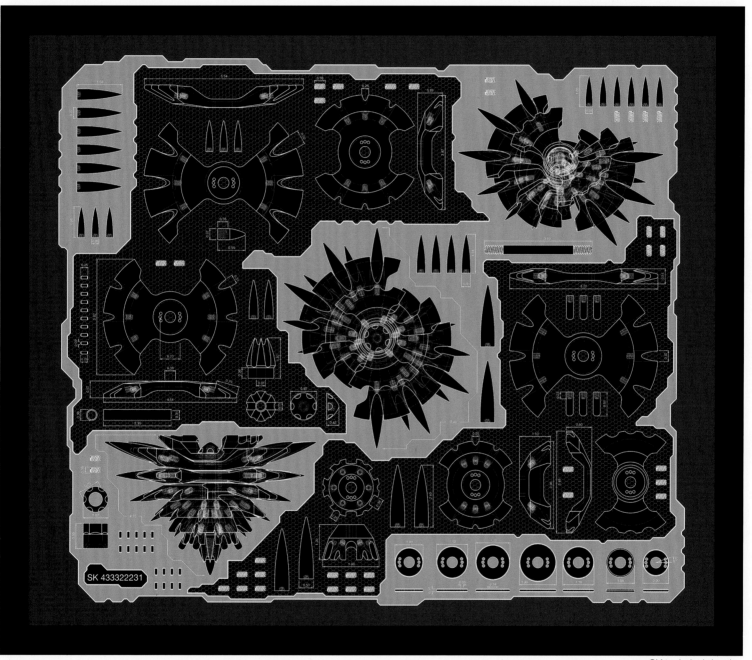

SK technical drawing

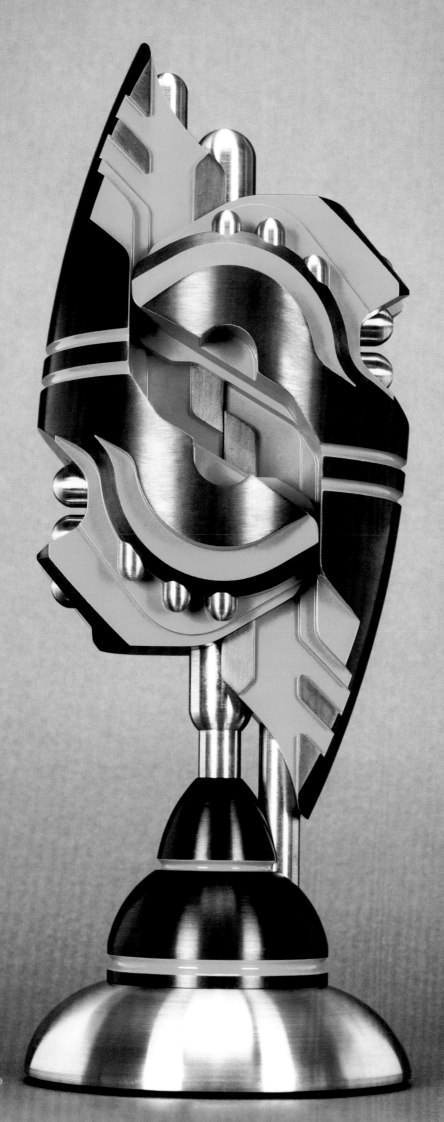

BB 522353452
Aluminum and bronze
12" x 4" x 4.5", 2016

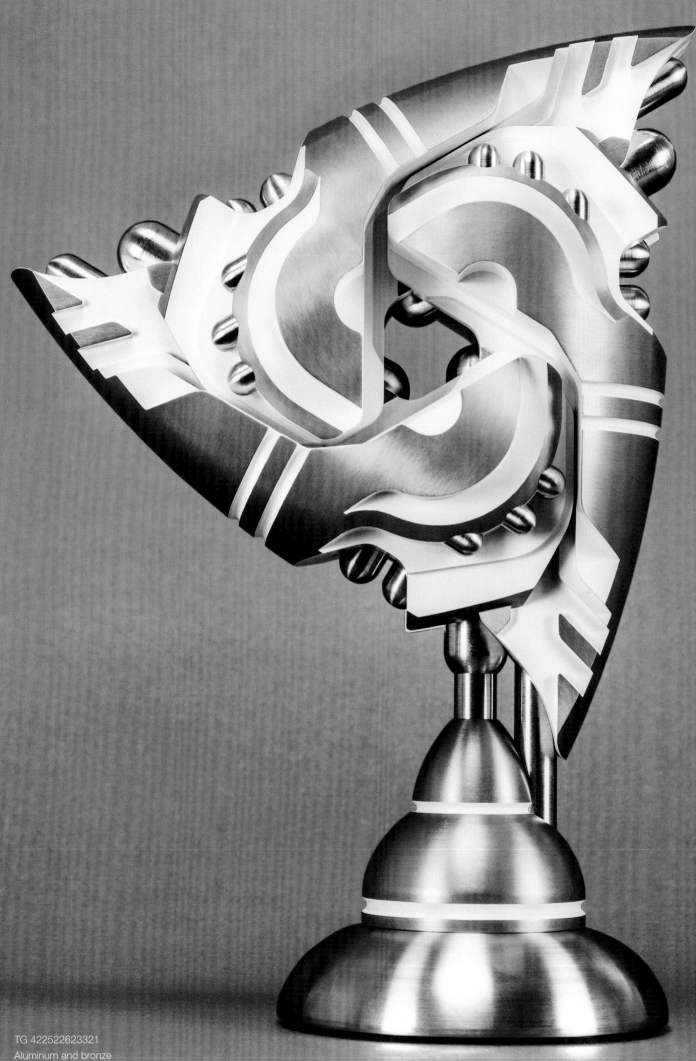

TG 422522623321
Aluminum and bronze
12" x 8" x 4.5", 2016

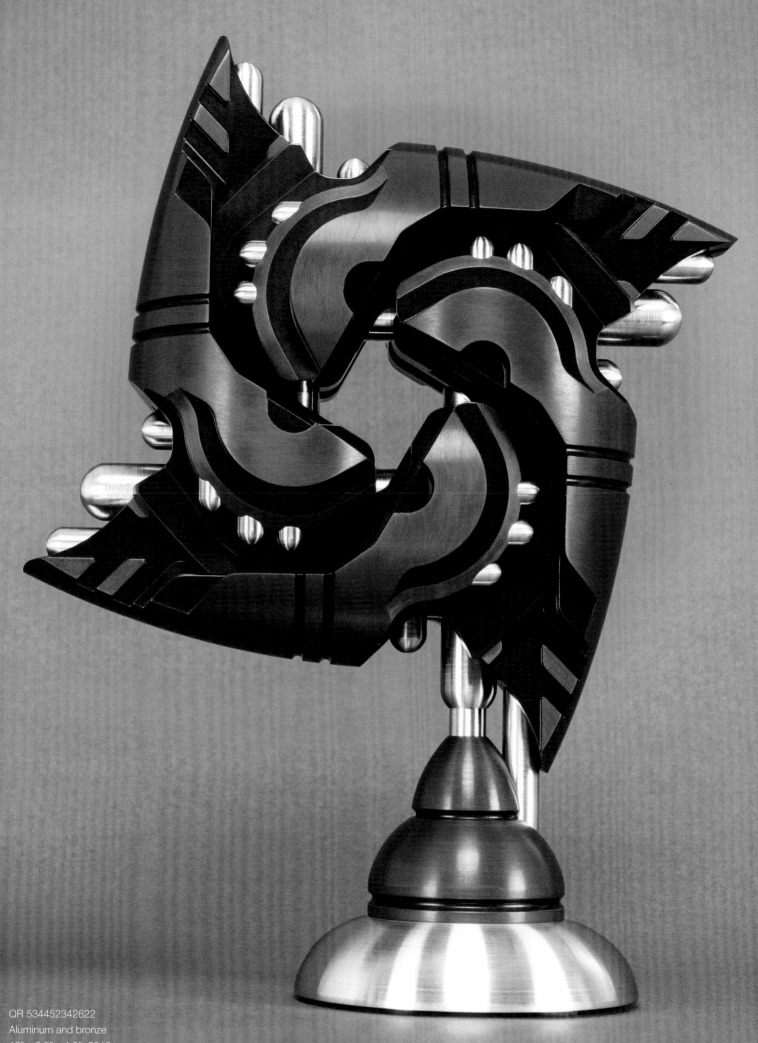

QR 534452342622
Aluminum and bronze
12" x 9.5" x 4.5", 2016

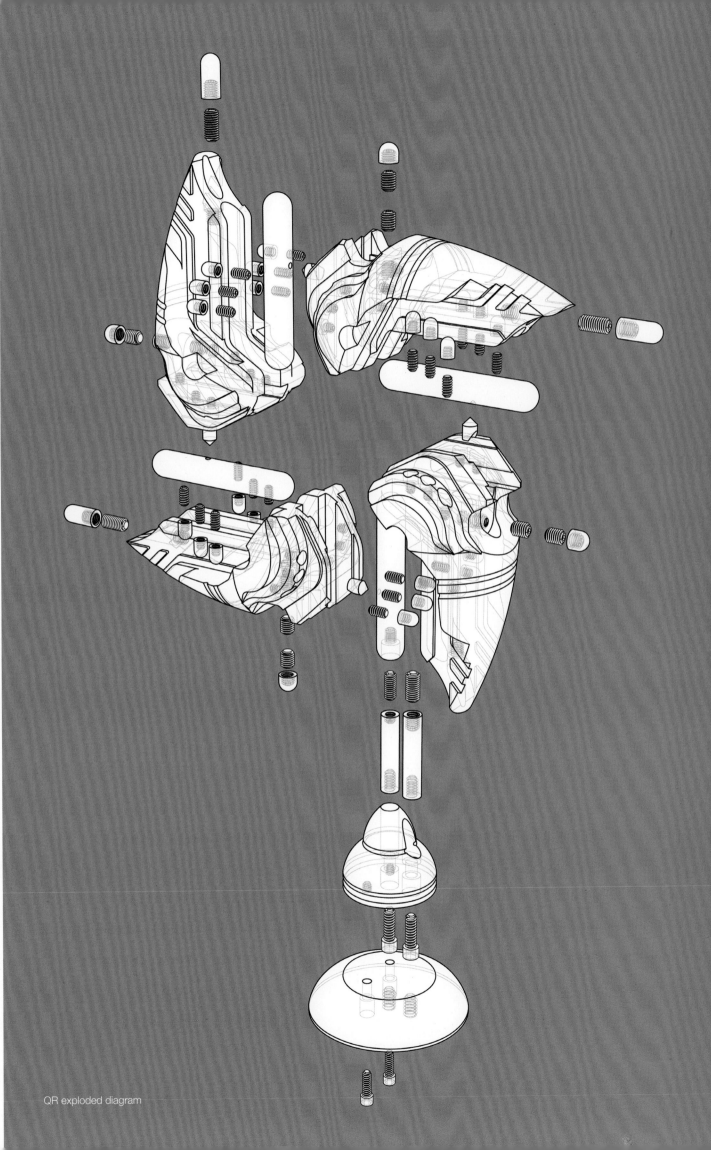

QR exploded diagram

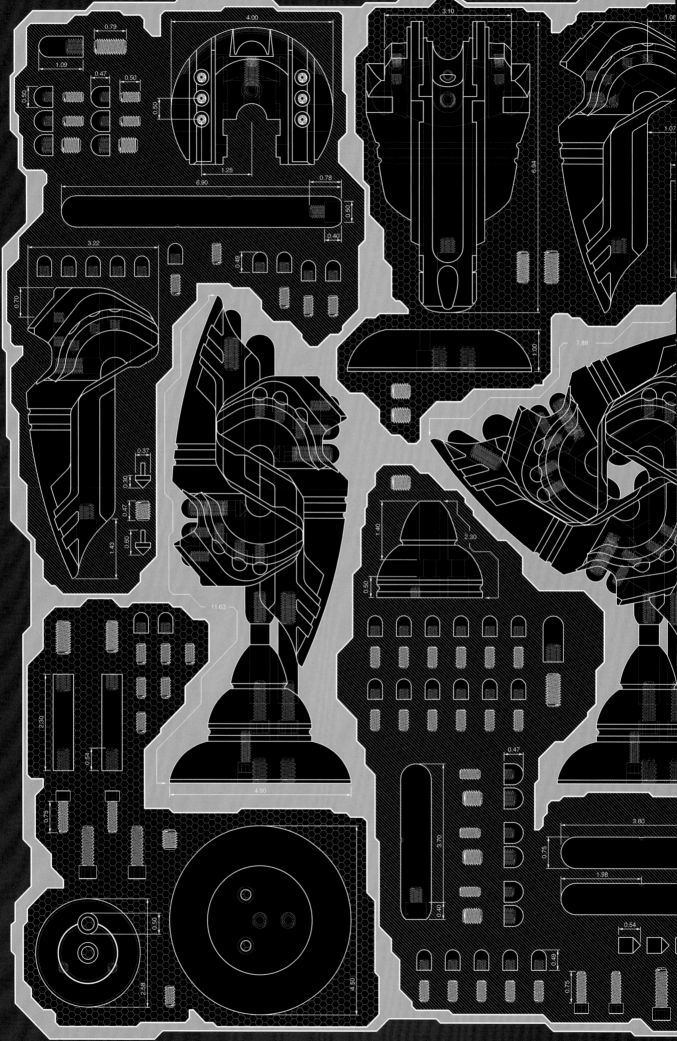

BB 522353452

TG 422522623321

QR 534452342622

Design as Muse

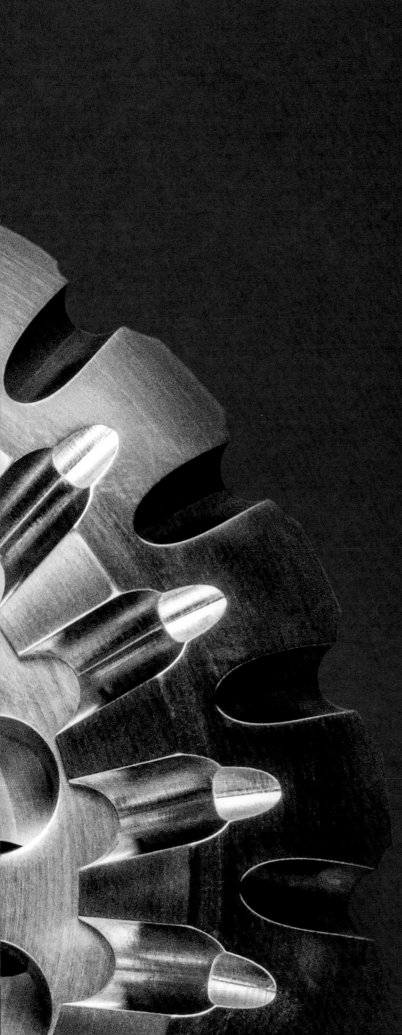

If engineering is the practical application of science, art may well be its impractical application. Neatly straddling the gulf between the practical and impractical is something we call design. Within the arts, design is typically thought of as the idea or planning stage of creating, but it is also a cultural construct we can analyze and leverage for conceptual use.

There are many artists who, because of scale, complexity, or other factors, supply only the technical specifications for a work of art; they delegate all or part of the fabrication to laborers or more-specialized craftspeople. Think of artists who run factory-style practices. If one was strict about classifying this role, one might just as well call them designers instead of artists. I am not inclined to think in such rigid terms, but I want to make a point.

CNC machine work is frequently characterized as a design-heavy process, with the implication being that one merely contributes a schematic or program to a machine, and then an automated process does most of the work. Within a solo studio practice, nothing could be further from the truth. In machining, one does not just build a sculpture; one builds a process that can build a sculpture. This is no perfunctory step. Having a design for a work of art that one might want to machine is meaningless without the expertise to break that design into machinable geometries that can be accurately held and positioned for cutting. One must then design and physically build a setup to hold and position those parts. Even a well-planned machining setup amounts to little more than a hypothetical process that may or may not produce consistently good performance. One must troubleshoot problems that arise, and maintain tolerances amid changing machining conditions. This process can create a constantly changing workflow that has the hallmarks and creative problem-solving you might expect to find in other skilled handcrafts. This also precludes any real handwork a machinist might be required to do in order to deburr and finish parts, surface-treat materials, and assemble the parts into the final sculpture.

As this description illustrates, the process of CNC machining often bears little resemblance to the popular conception of a mass production environment. The idea that an artist using these tools might simply upload a design and hit a button to produce their art is plainly false and serves as a powerful argument against the machinist as a designer analogy.

Within the studio craft movement, design was often thought of as an integral subdiscipline of a given craft. Indeed, in the early half of the studio ceramics movement, "designer-builder" was one term used by potters to identify themselves, denoting that they both designed and produced their own work. By the 1960s, however, the term "design" within the field of ceramics had become understood as a discipline distinctly separate from physical production. The label of "designer" then came to refer to ceramicists who had embraced industrial production to produce work on a larger scale and for more profit. Ceramicists who viewed themselves more as artists would use this as a way to differentiate more-commercial potters from those seeking recognition within the arts.

I find the dichotomy of the word "design" to be fascinating; it is at once a part of and distinctly separate from art making. When you look at the world of commercial designers, it shares many commonalities with the world of fine art. Consumer product design, luxury automotive design, or even web design seems to embody aesthetic trends that—irrespective of functionality—move through seasons of fashion. If one so chose, an artist could spend a lifetime commenting on myriad design subcultures in the same manner that so much fine art is endlessly self-referential.

If one accepts the characterization of "design" as simply a mark of commercialism, how might one approach that as an artist? What is gained from designing work for mass production as opposed to a single iteration of an object? How does that change one's identity as an artist? My time researching the work of decorative machinists and product designers within the maker community showed me there might be a way to examine such questions through sculpture.

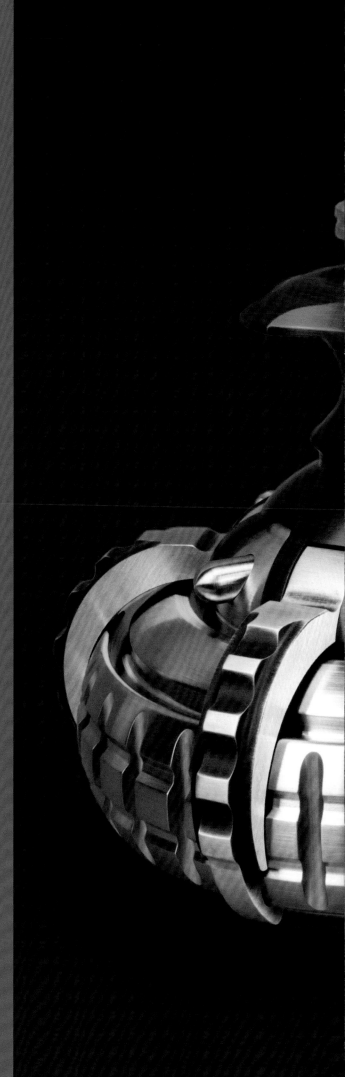

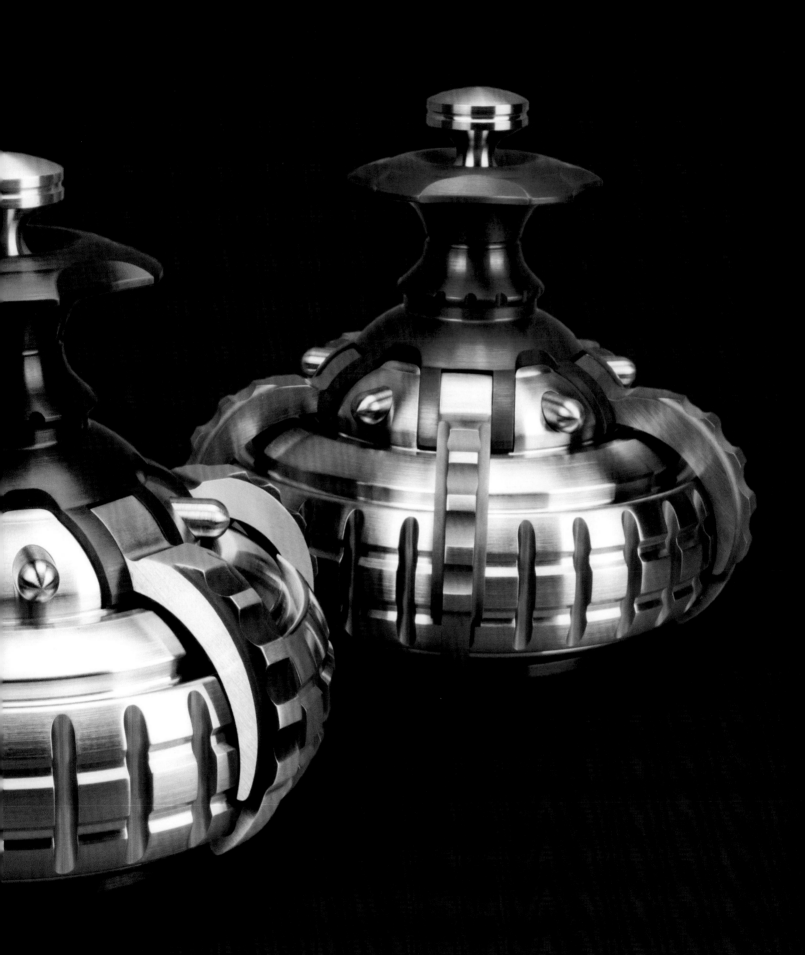

Special color editions of the SMV3

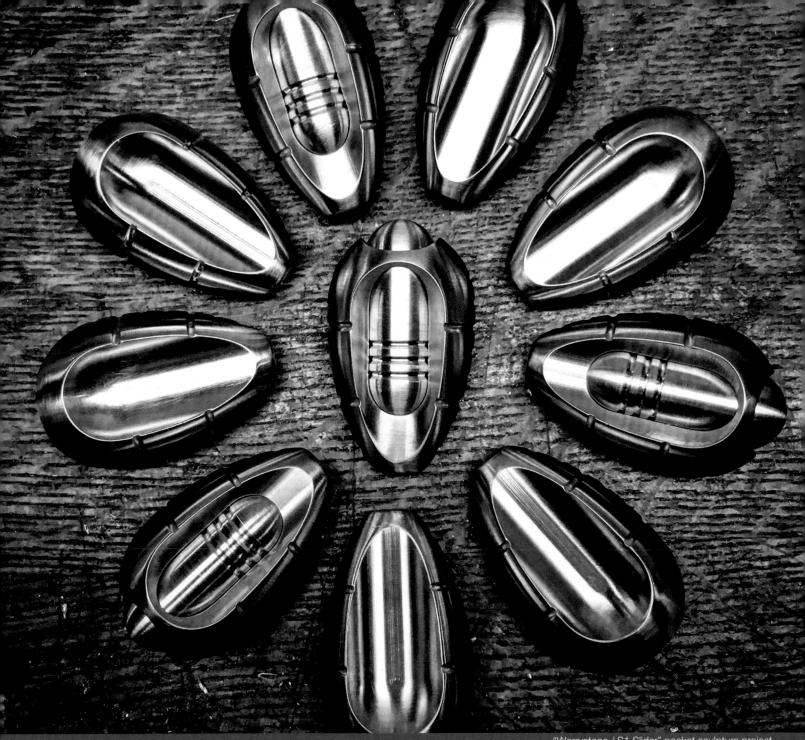

"Worrystone / S1 Slider" pocket sculpture project

Within the machinist community, there are people who make objects that have much in common with fine-art and craft traditions. Some make metal lanyard beads, metal wallets, or key chains. Some of them are knife makers who dabble in decorative accessories or even a kind of machined jewelry, and more still make what are known as "fidget spinners" and "fidget toys." These works are ambiguously situated between commercial product design and decorative art. Yet, to me, they are aesthetic explorations of the same medium I have been pursuing as a means of making sculpture.

I stumbled into this community of makers by accident. A friend of mine asked if I might consider making a pocket-sized sculpture that one could hold as a worry stone. Seeing an interesting opportunity, I sketched a few things down and then made a small object that would serve wonderfully as a worry-stone sculpture. Among those sketches was also an idea for a small kinetic work. It was this kinetic sculpture that gained a cult following of collectors and set the stage for a parade of kinetic pocket art designs intended to explore the intersection among functional design, craft, and fine art.

Up until this point, I had stubbornly refused to consider making anything other than "traditional" sculpture. But over the years, I have slowly come to realize that from a process perspective, the act of making art is largely indistinguishable from making almost anything else. From a domain knowledge standpoint, there is equal value in making something such as a tool as there is in making the most inspired work of art (emphasis here on the making, and not the viewing). I have also come to understand that domain knowledge is the well from which most creativity springs. It is the act of making that leads to inspiration, and not inspiration that leads to the making of art. So whether you call it design, craft, or art, it makes no functional difference to an artist in their studio. The result of any single project may or may not invoke a sense of awe or even be viewed as art by an audience, but for a disciplined artist, it is very likely a step toward something else that will.

So in 2016, I began a series of projects that were intended to tackle the reality that machining is a process that is hopelessly entangled with industry, commercialism, and design in ways that many other mediums are not. My intention was to highlight some of the niche commercial design trends that have sprung up throughout the machinist community, and to see how they might be bent toward the arts.

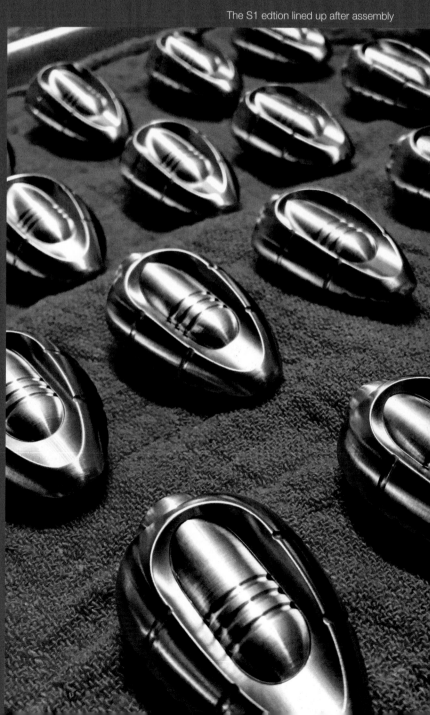

The S1 edtion lined up after assembly

I have come to refer to this facet of my work as "Design Projects," because while I still regard them as fine art, they are also a meditation on what design might come to mean within a studio machinist practice; they represent a rather intentional delve into the commerciality of modern machine work as a decorative-arts cottage industry. They are a notable departure from previous work because they are produced in editions, often contain functional mechanics, and are intended to be tactile pieces one can hold and manipulate. This is in contrast to my traditional, one-of-a-kind sculptures that are primarily for the eyes only. Some of these works are true design collaborations with makers whom I have come to know; others are investigations into concepts and trends I have observed within the maker community.

All these works are an attempt to highlight what is sculpturally significant about the designed and engineered objects we often overlook. Because of this, the works in this section require a little more context, so each will have text frames with additional info on each project.

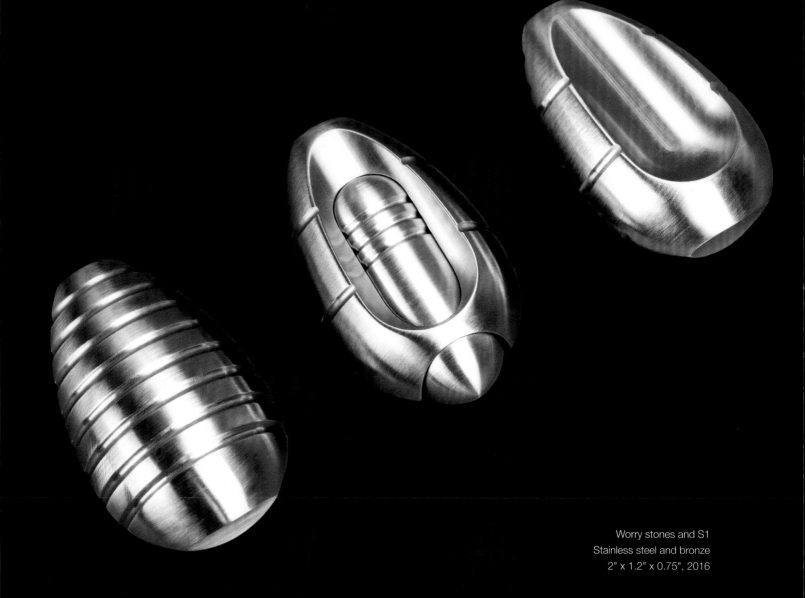

Worry stones and S1
Stainless steel and bronze
2" x 1.2" x 0.75", 2016

The worry stone and S1: My first attempt at a tactile sculpture was something akin to a worry stone. A variation on that design would transform the idea into my first piece of true kinetic art. It had just two parts and incorporated a sliding mechanism that utilized what is called a spring-ball detent. The work had the barest of functions; the center element could simply slide out and be pushed back using the thumb and forefinger. The detent locked the sliding element between the two positions, giving a satisfying click. That was it, and that was the point.

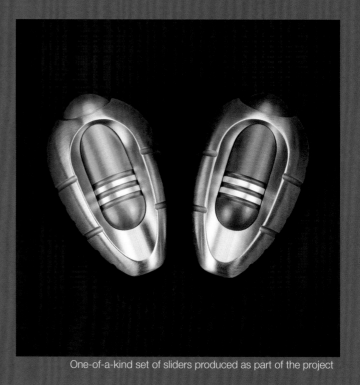

One-of-a-kind set of sliders produced as part of the project

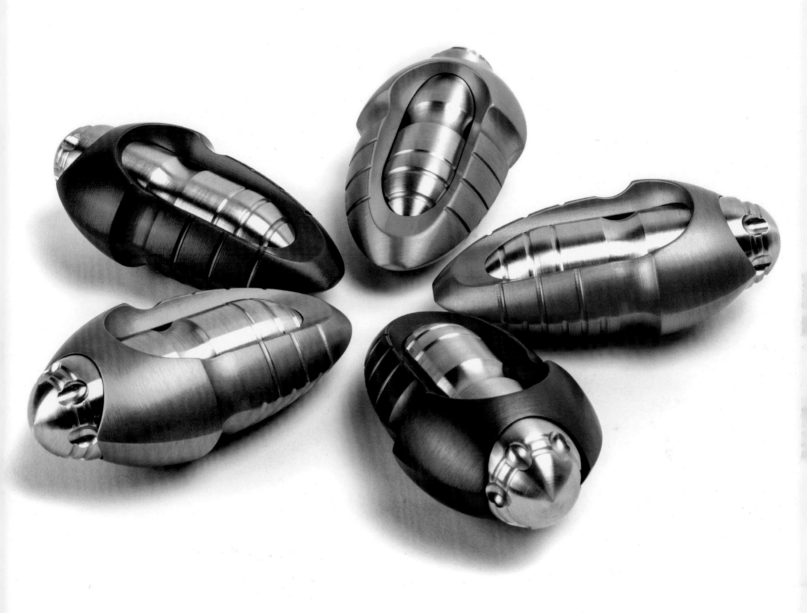

I came to understand that making works that could embody a trivial functionality allowed me to explore the mechanical aspects of my craft without compromising my fixation on producing stubbornly sculptural work. The S1 quickly earned the nickname "the Slider" and surprisingly garnered a robust following with collectors of intricately machined metal objects.

After a little experimentation, I was able to further iterate on the design with a larger, much more colorful array of works that had their own unique appeal.

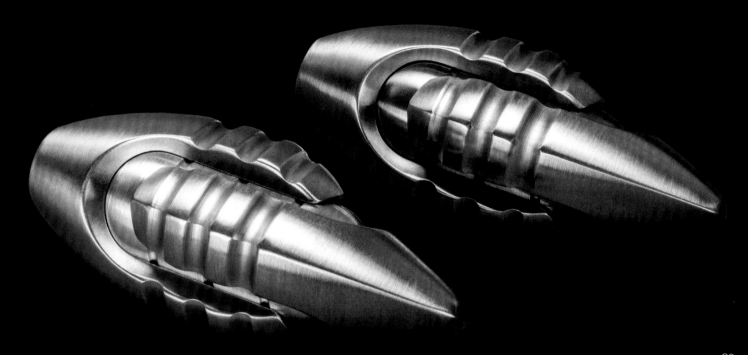

S2
Stainless steel and brass
3" x 1.25" x 1.25", 2016

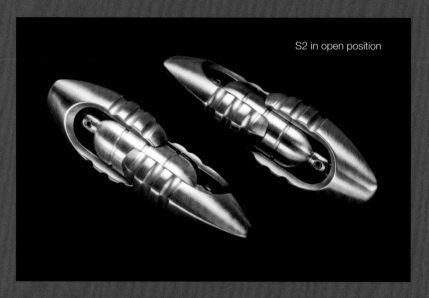

S2 in open position

S2: The second design in the Slider series was an expansion on the themes of the first. It was essentially a double-acting version of the original. However, this small change escalated into a significantly more complex interlocking design. This new version had a much different feel in the hand, and its operation was more reminiscent of the way people habitually flip knives as a meditative activity. It was a natural evolution from the first and was a nod to how quickly complexity can arise out of a relatively simple concept. Unsurprisingly, this work became the "S2."

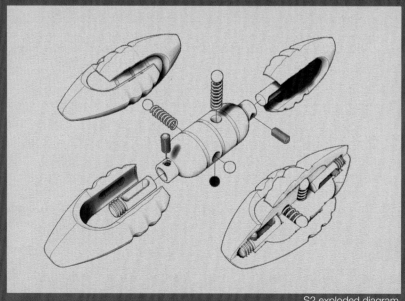

S2 exploded diagram

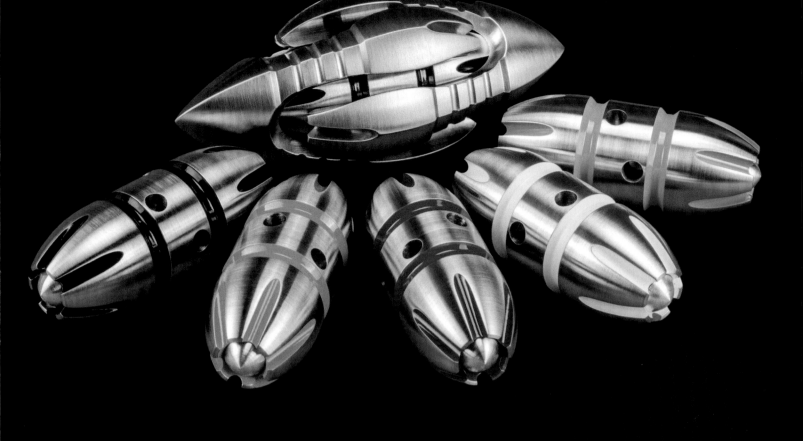

S3 sculpture (with all five available insert colors)
Stainless steel and brass
4.25" x 1.8" x 1.8", 2018

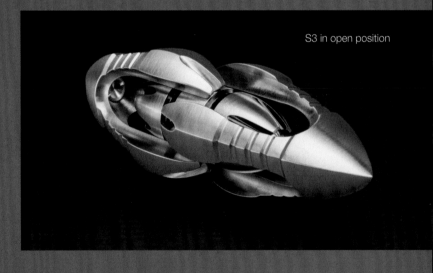

S3 in open position

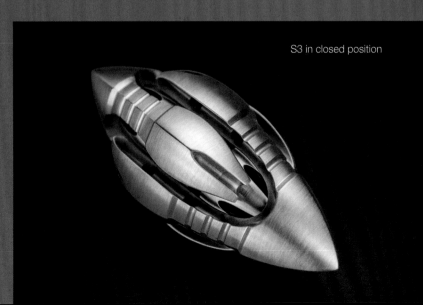

S3 in closed position

S3: The third and final install-ment in the Slider series culminat-ed my first kinetic sculpture ex-periment. Much like the S2, it is a double-acting pocket sculpture. However, the engineering is much more sophisticated, both in the way it's fabricated and how it in-corporates the mechanical fea-tures. Gone are the visible screws and locking hardware from its predecessor; through the use of custom tools, everything is clev-erly hidden within the work, allow-ing it to be more properly consid-ered as a tactile aesthetic object.

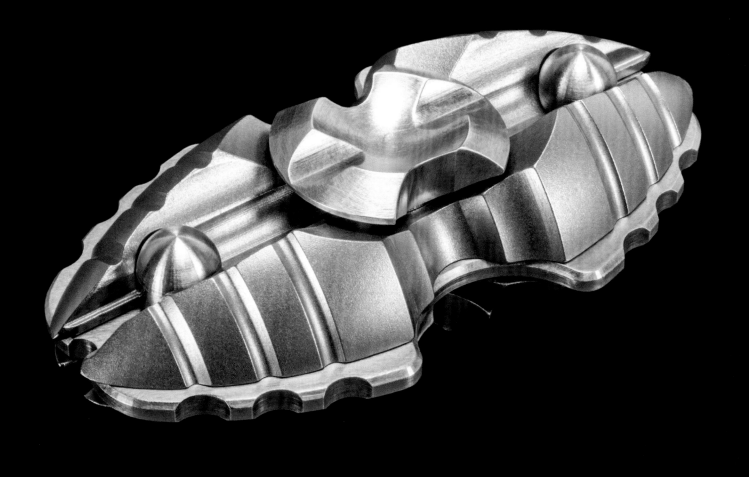

Artifact Spinner: This project was a collaboration with a team of makers out of northern Virginia—Mike Hogarty, who is a master mechanic and designer, and Callye Keen, who is a product designer with a family-owned manufacturing company.

In order to properly explain this project, I need to first start with some context on what are currently known as "fidget spinners." In the spring of 2017, when this project began, a spinner was a little-known, very niche, and mostly machined object. Although its invention is contested, spinners were originally made of metal and sold within a very small cottage industry of makers and machinists. Before they became popular as children's toys, they seemed to have the hallmarks of an emergent craft form, something one might make to learn elements of machine work in a more creative context.

This project was appealing because, unlike traditional fine-art crafts, there really are few universal objects that machinists create. A fidget spinner seemed like a rare, sculpture-like object that machinists were enthusiastically making. For me, it seemed like a gateway for talking about sculpture within the machinist community.

Mike, Callye, and I had a lot of fun overengineering and manufacturing this beauty. Unfortunately, by the time we had completed our project in the fall of 2017, the fidget spinner—and the popular understanding of it—had changed rather dramatically.

Over that summer, small Chinese toy manufacturers began copying the designs of many of the makers in our community (mine included). These counterfeiters began flooding the commercial market with low-cost knockoffs of various spinners. These low-cost clones proved incredibly popular and set off a race to make the cheapest, most commercially viable version of what was, to me, a budding craft object.

Long story short—by the fall of 2017, fidget spinners had morphed into a worldwide toy fad. The world's popular understanding of a spinner had become that of a cheap plastic toy, one whose most predominant iteration was wholly uninteresting as an art object (except as a conceptual foil). While this is a fascinating story in its own way, the narrative surrounding our project changed considerably, and communicating the original intent became much more difficult. Nonetheless, I think we made an interesting piece of art, and I continued with my desire to find craft forms that machinists might experiment with in order to think about what their trade does that is beautiful, rather than what is profitable or useful.

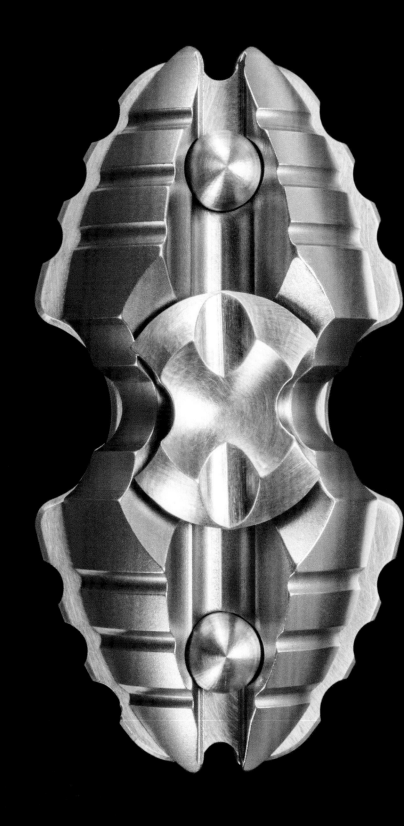

Artifact
Stainless steel and brass
2.5" x 1.25" x 0.75", 2017

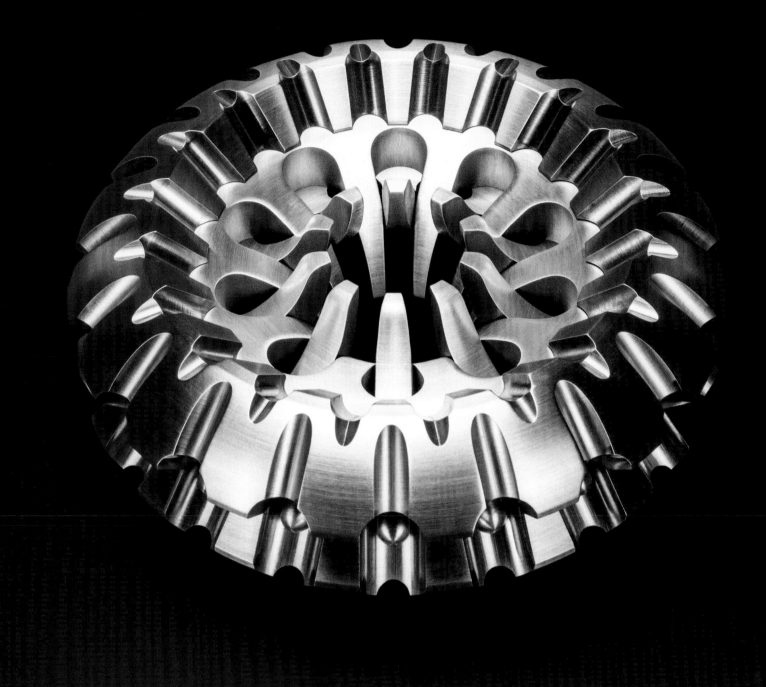

TP 533351444623, stainless steel and brass, 5.5" x 5.5" x 1.8", 2017

Spinning tops as machined art: The sculpture above and the spinning tops on the following page are from a collaboration with machinist and spinning-top artist Richard Stadler. I wanted to highlight Stadler's work because, unlike my background as a fine artist who found his way into machining and engineering, Stadler is a second-generation machinist and engineer who found his way into the decorative arts.

Richard grew up steeped in the commercial side of machining. Working for his family business since he was thirteen years old, he nonetheless made the leap from manufacturing custom parts for various tools and equipment to pursuing a more creative passion project. In doing so, Richard now finds himself making some of the most beautifully machined spinning tops I have ever encountered. His work has attracted an enormous following, and his tops and other decorative gear are regarded as some of the most iconic and well-collected machined objects in the world.

Upon seeing my early kinetic works, Stadler reached out, we struck up a dialogue, and a collaboration soon followed. I could see no better way to expand on my under-standing of machined decorative traditions than to build a spinning top with Richard.

While I was eager to collaborate, I wanted this project to embody both a design and sculptural outcome. So when Stadler pre-sented technical specifications for creat-ing a spinning top, I made my decisions with an eye toward visual elements that could then translate into a larger sculptur-al composition. In so doing, it was plain to see how the design was a catalyst for a sculpture I could not have arrived at any other way.

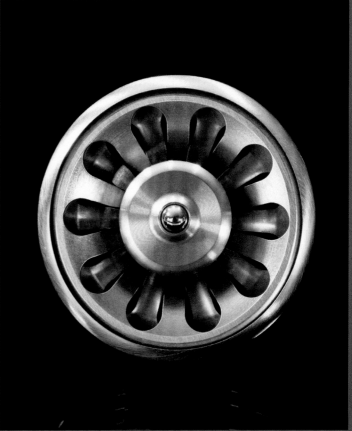

Stainless-steel spinning top

Brass and stainless-steel spinning top

Copper and stainless-steel spinning top

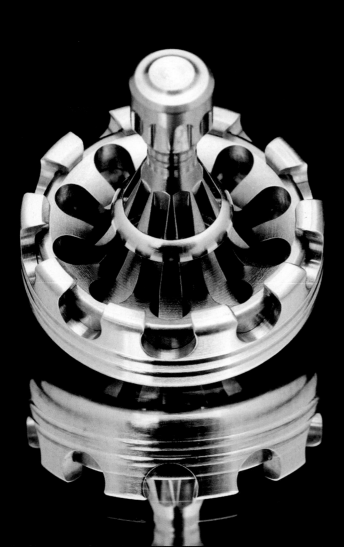

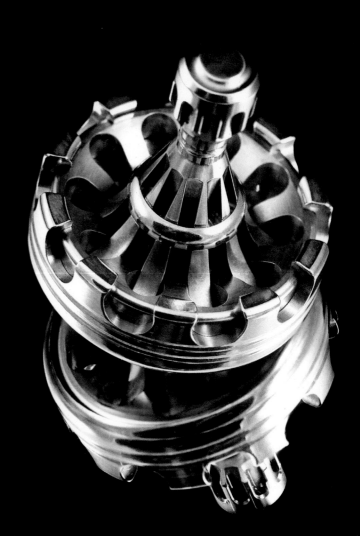

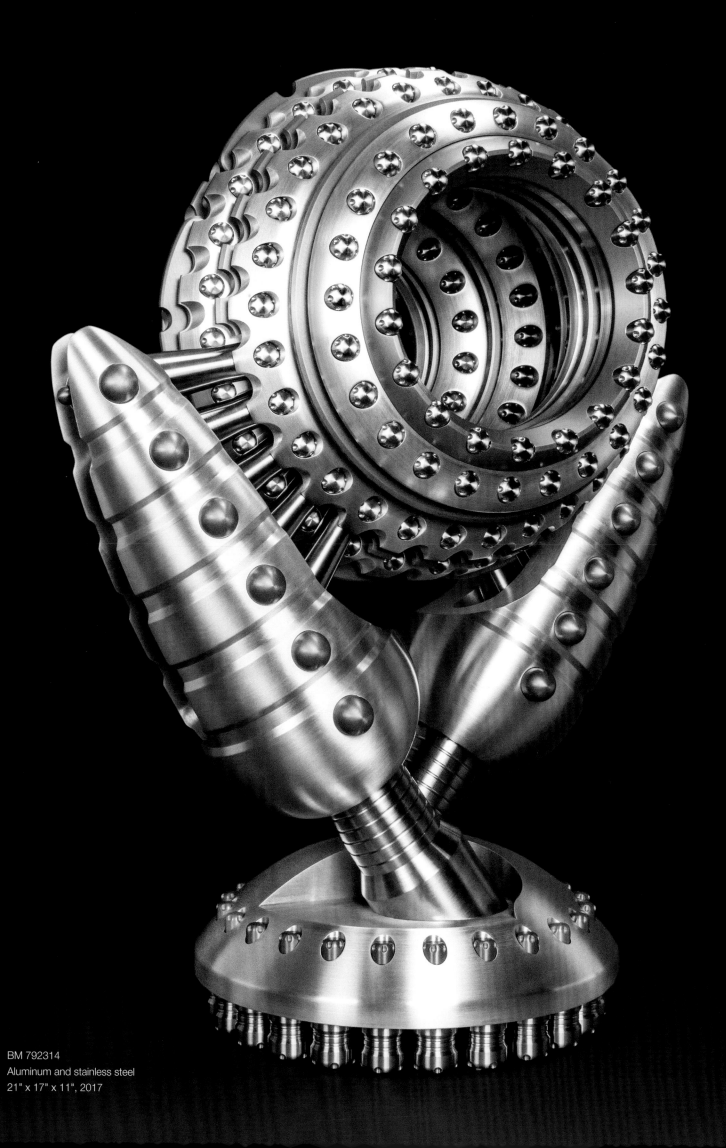

BM 792314
Aluminum and stainless steel
21" x 17" x 11", 2017

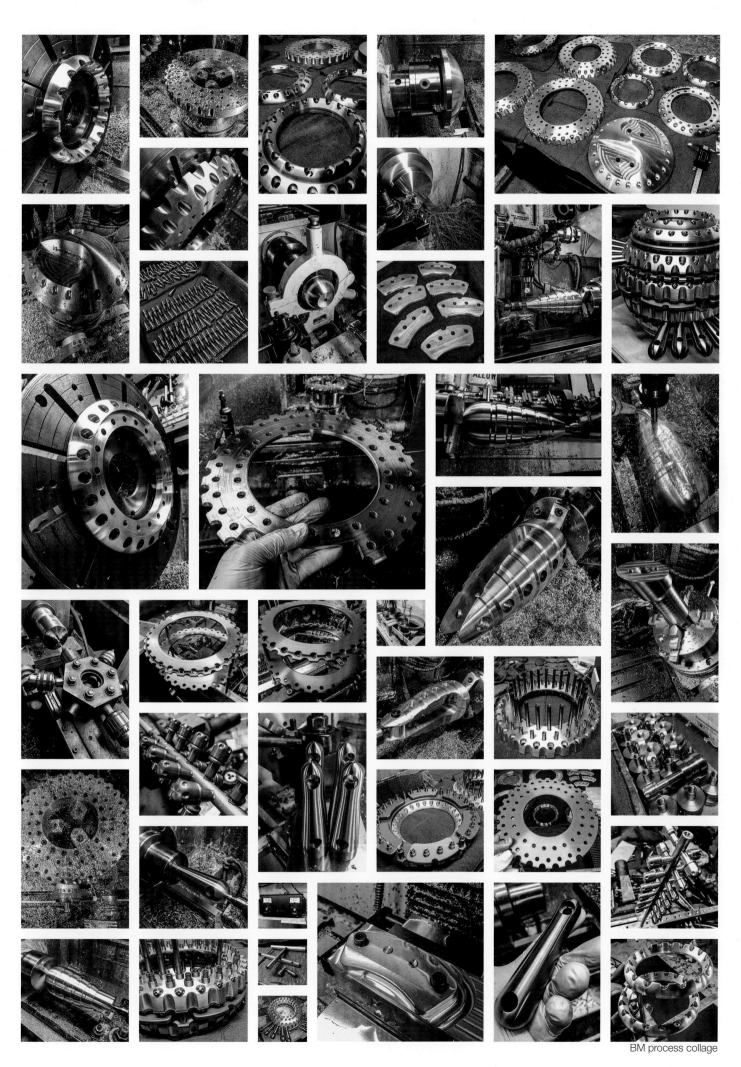

BM process collage

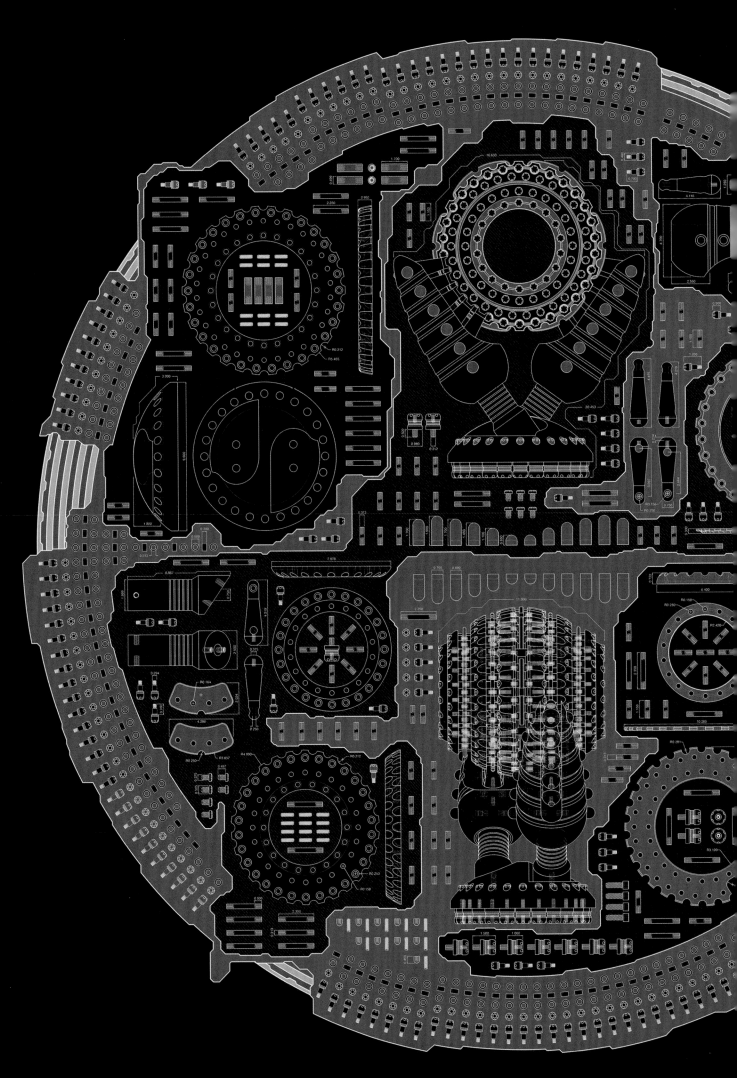

BM 792314
BATHGATE

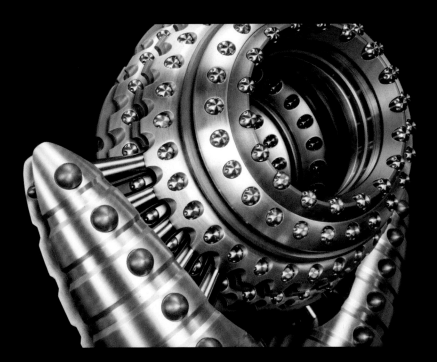

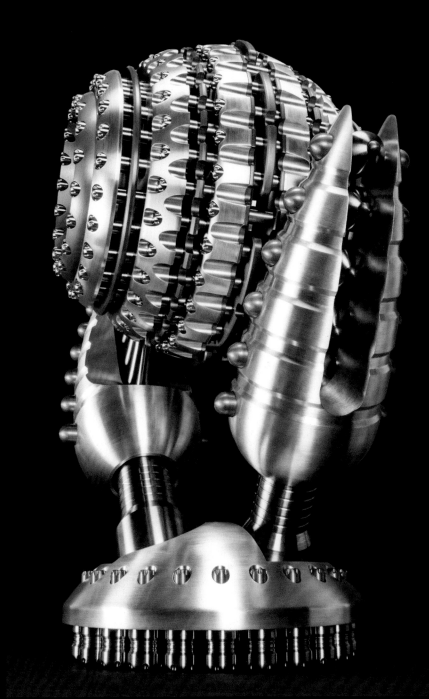

BM 792314 alternate views

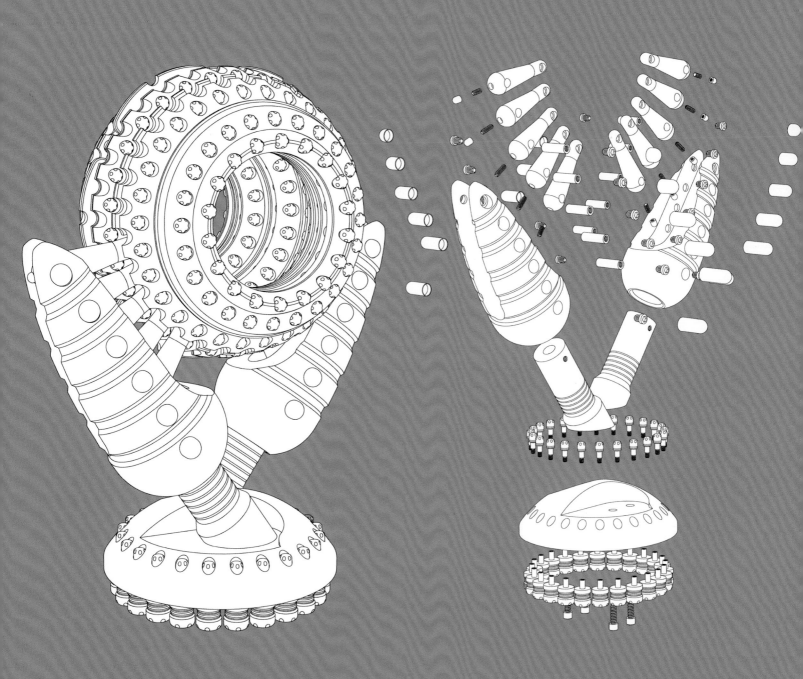

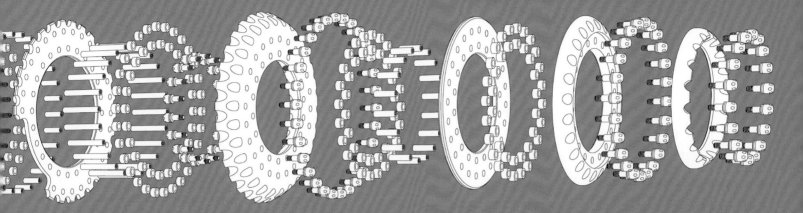

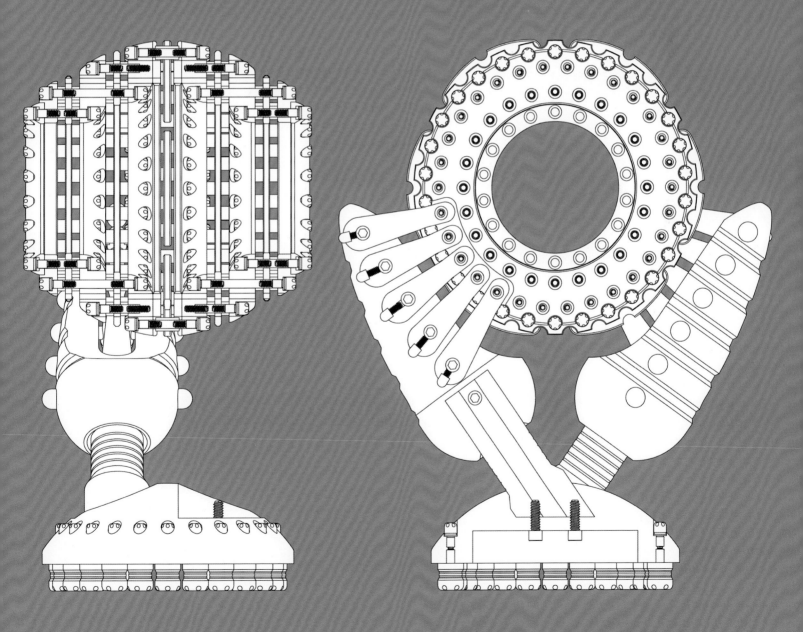

BM exploded diagram

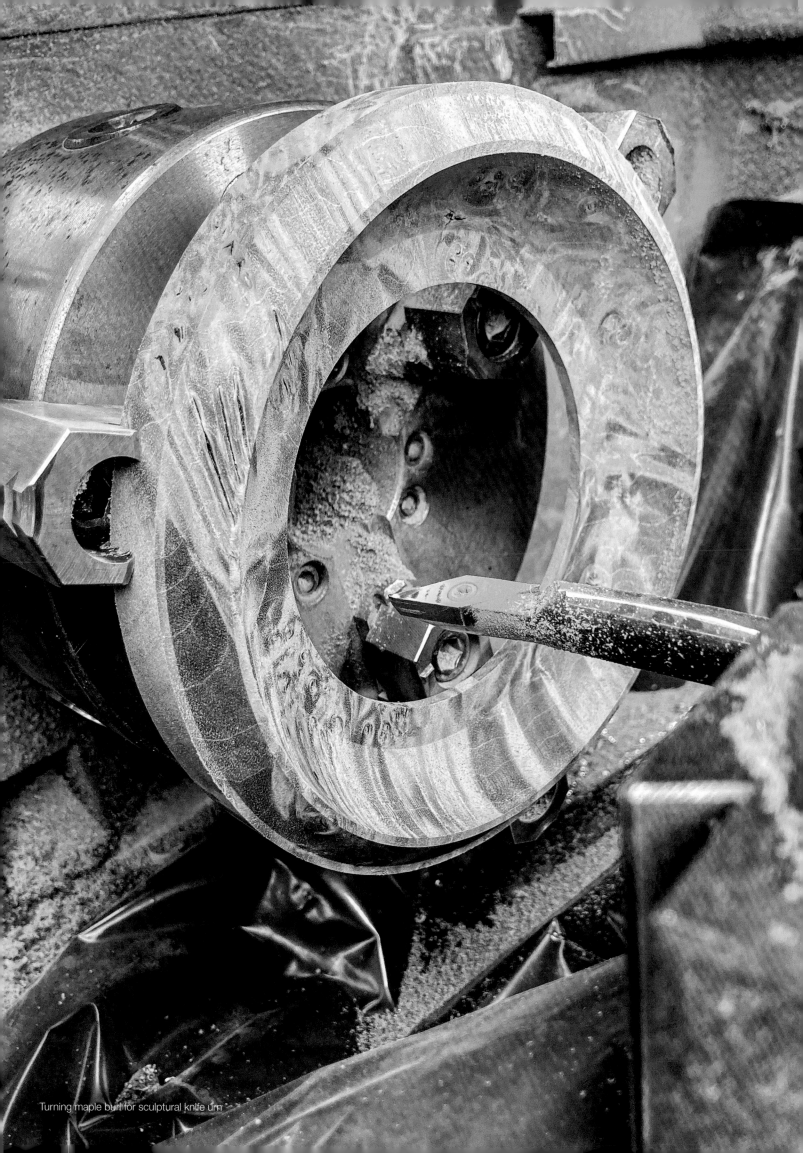

Turning maple burl for sculptural knife urn

Chapter 12
Process as Teacher

The most comprehensive and influential text I have found on the subject of workmanship and craft is *The Nature and Art of Workmanship* by David Pye. First published in 1971, it is a dry, nuts-and-bolts look at the anatomy of making things. Whether you are an artist, designer, or engineer, it's an applicable text.

David Pye was an industrial furniture designer and studio woodcarver. His book attempts to take the language we use when talking about art, craft, and design and make it much more precise. Art writing is notoriously squishy because it (often intentionally) uses vague terms with multiple meanings. This book strives to build a structure for talking about the more tangible parts of designing and creating works of art. It has parallels to how engineers and scientists have created much more rigorous definitions and methods for describing things, so that discussions don't get bogged down with syntax or semantics. This is something the art world very much needs.

Additionally, *The Nature and Art of Workmanship* can be seen as a treatise on the evolution of the arts and crafts into ever more automated and digital formats. While slightly dated, it talks about concepts in such universal terms that it is still able to speak to the contrast between modern digital fabrication and old-fashioned handwork. It dissects the dichotomy between concept and execution, reinforcing the fact that there is no bright-red line that cleanly separates the two.

Although nobody writes more astutely about the relationship between workmanship and craft than David Pye, I will do my best to make my own contribution here, not because I love being redundant or cliché, but because I feel that it is paramount to reiterate again and again that without craft, there is no design or fine art. There are many who get this, but there is a perennial bias against craft that must be consistently countered. Just as surely as someone standing near a Jackson Pollock painting will eventually hear someone utter the phrase "A two-year-old could do that," someone else will invariably claim that making pots and bowls can't be high art. Likewise, I have heard my share of people claiming that using CNC tools as an artist is somehow "cheating" or "unskilled work." Without constant reinforcement, elitist thinking about craft begins to muscle out the idea that skills and technique are not just a way to make things, but that they are a type of memory and a type of thinking that are the building blocks of any creative pursuit.

That said, craftsmanship is not a prerequisite for making good art; anything sufficiently clever or passionate, no matter how poorly constructed, can be inspired. In fact, sometimes poor construction is the point for some incredible works of art. But for my money, craftsmanship is an important element of art making and an even more important element for art thinking. Without a rigorous focus on technique and process, I would have far fewer tools with which to think about the concepts that interest me.

In the past, artists and craftspeople have sought to distinguish themselves from each other by delineating the degree to which they depend on tools or processes that aid an artist's hand. Additionally, many craftspeople have also sought to distinguish themselves from makers who only design their work and do not undertake the production of those ideas (myself included).

The thing that makes discussions around skilled craft or design difficult is that there are typically no bright lines that separate the two. An artist may engage in skilled labor on one part of a project but outsource a process on another; they may employ a CNC machine to cut part of an object, then hand-carve the rest. In this scenario, we have an artist employing many different modes of making all at once—not because of laziness or a lack of skill, but because they are responding to the situation at hand and using the best tool for the job. It is usually impossible to disentangle the conflicting intentions and abilities of a maker and put them into neat little boxes.

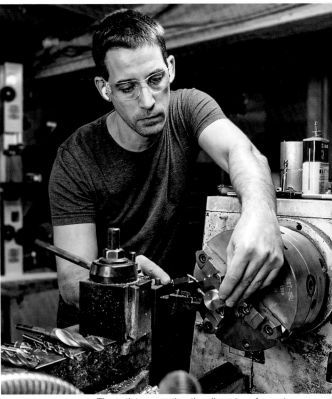

The artist measuring the diameter of a part

As a machinist, I enjoy the intricacies of making precision parts, of making things with an accuracy that far surpasses human perception. It does not make the design better, but there is satisfaction in doing it. As a craftsman, I also enjoy achieving consistent results by using relatively crude methods. There is a different kind of accomplishment in being clever and coaxing good results with a simpler approach. Because of this, I employ a range of manual and automated processes, none of which ever makes my work easier or better, only different. I do not just create sculptures, I design and construct processes that create sculptures. From the outside, process design can sound like . . . well . . . design. However, once one gets into the act of physically (and accurately) setting up machines and running that process, the physicality and finesse needed to do this accurately become apparent. On an individual level, the idea of a designer as detached from process becomes harder to maintain. If you look at any particular automated process, you will usually find that there is far more skill and technique involved than is first assumed.

Machines, even highly automated ones, are not intelligent; they can't see, and at least for now, they can't think. Everything a CNC machine tool does is reliant upon a skilled human to take into account the myriad conditions of the process to be performed, and to ensure that they are safely met. While modern equipment might seem sophisticated, it can easily be misdirected or misused and cause tremendous damage to the tool, the workpiece, or the operator. While it is true that once a process is refined, repeatability on an automated machine tool becomes straightforward, success when developing a new process or design is far from ensured. In the context of craft, the period of refining and performing a design is not so estranged from what one encounters in handwork. In terms of manual dexterity and physical skill, I would like to offer a personal example of what this might look like in the context of a studio machine shop.

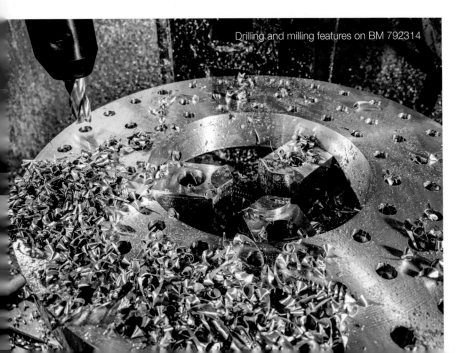

Drilling and milling features on BM 792314

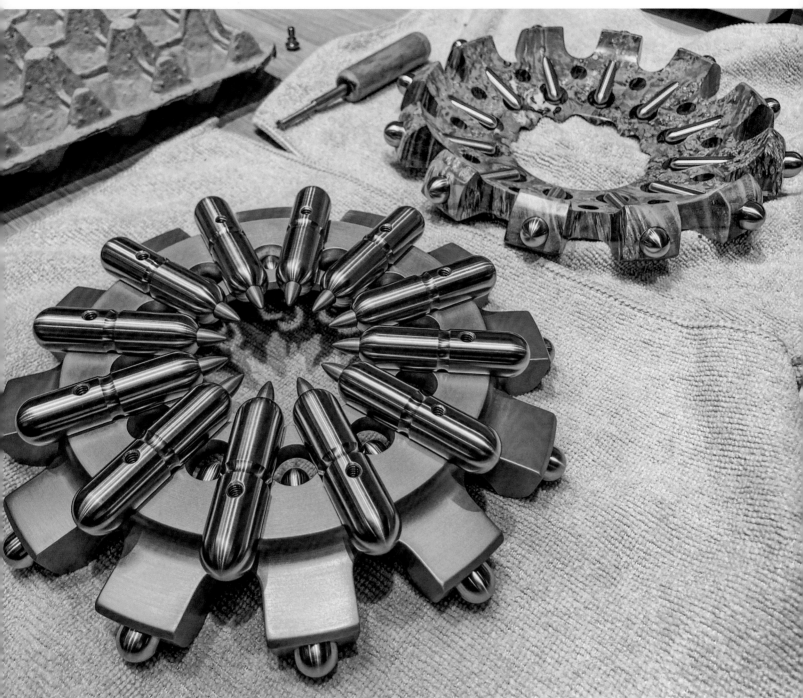

While it might be tempting to set up a CNC machine, push the run button, and sip coffee while the machine chugs along, that kind of work ethic runs contrary to meaningful art making. I approach the process in terms of how it can amplify my efforts and enhance my ability to make wonderful aesthetic things. In most instances, I am able to organize my workflow so that I am engaged in many activities, some creative and some practical, all at once. Whether I am running parts while making changes to a program or design, or even writing this book, there are countless ways to make sure you are consistently engaged in creative work. In terms of large-scale parts production, machining the hundreds (sometimes thousands) of parts that a sculpture can require can become a physical performance in its own right.

Since it is true that an automated process, once refined, can be managed in a partly unattended way, it creates the opportunity to layer tools and processes to augment one's individual output rather than replace it. Even though I am just one artist, I've had many occasions where I am able to

orchestrate the use of seven different machines simultaneously. That is, within my shop, I've developed the competency to bounce between all five of my CNC machine tools, ensuring that each one is running efficiently, and cutting parts on a saw (which runs partly unattended as well), while also prepping and drilling parts on a manual lathe. I do this not as some kind of stunt, but to be as effective and engaged in my work as possible. Instead of being idle while my machines work, my body is moving at its full capacity to attend seven processes as seamlessly as possible. Like a form of juggling, it is both physically demanding and mentally engaging.

To perform this dance, one must hold in their mind the time it takes to cut each part, then flow between each machine to load metal, check tolerances, make adjustments, and perform other needed work while utilizing the intervals to turn, polish, and perform other needed operations on manual equipment. Like spinning plates, there is a rhythm to running multiple tools that relies on knowledge and timing, but I have found that being attuned to the sound of each process and other visual cues going on in the shop works best. From experience, I know where I am needed in the shop by parsing the cacophony of sounds coming from each machine tool; I can observe the motion of tools out of my periphery and get a read on where in the process a particular part might be. This familiarity with the soundscape (and landscape) of my shop lets me achieve an awareness that is hard to describe. It also alerts me when something is going haywire, so I can rush to shut down a malfunctioning tool. The point I am trying to make is that even if automation supplants some aspects of handwork, the instincts of a craftsperson simply find a new way to manifest.

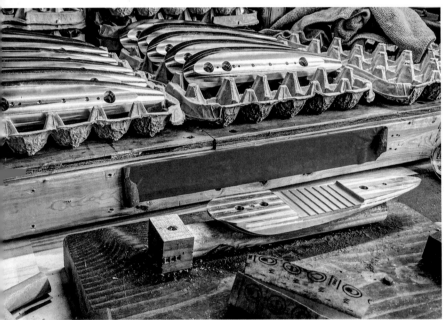
Hand-sanding and hand-polishing machined parts

The term "creative flow" is often used to describe when an artist is fully engaged in their work; I can attest that the level of engagement among my mind, body, and senses within my production environment conjures up a level of engrossment like nothing else that I know of. This is why I feel it is so important to counter dogmas about automated tools, because like any other practice, you get out what you put in. That tools and practices evolve and change over time should actually come as a comfort to craftspeople and artists alike. You will never run out of ideas if you embrace the notion that you always have something to learn. Many skilled craftspeople have adopted CNC technology, not to replace their manual skill set but to improve and amplify it in new ways. I think we do a disservice when we try to elevate our work by putting down the tools and processes of others. All makers practice their work along a spectrum from very free to highly constrained workmanship, and they all bring different aesthetics and ideas to the table. If history has taught me anything, it is that times change. If you make up your mind today about what counts as art or skill, time and change will surely intervene to prove you wrong.

Machined vessels: For this series, I once again found myself thinking about traditional forms within the studio crafts. Practices such as glasswork, woodwork, and ceramics interest me because I see a connection between their history and my journey with machining. Even though these crafts are now firmly entrenched within the fine arts and have expanded into modern sculptural formats, they continue to be learned (and expressed) through the creation of traditional vessel forms. This is something that (for now) seems to make machine work as a craft just a little bit different.

Machining remains an active industry, which limits its integration into the arts. As the name implies, machining was born of the need to create the goods, tools, and machines that drive our modern world. It has its roots in the development of the steam engine, automobiles, and airplanes, not to mention myriad weapons of war. At its best, it has put humans on the moon and robots on Mars, and it has been the driver of every conceivable innovation for the last two centuries. Machining is a sprawling discipline that also encourages specialization; aside from the tools themselves, it lacks a recognizable body of shapes or projects that its practitioners might use to develop a visual vocabulary.

To correct for this lack of craft forms within the world of machining, I thought it would be interesting to borrow from other mediums that got their start on the factory floor. It may seem counterintuitive to use such a technologically advanced process to revisit forms from bygone industrial eras, but it is important to remember that every craft, no matter how old, was cutting-edge technology at some point in time. The impulse to formally explore technology transcends vintage. A project like this was a way to demonstrate what is similar across disciplines, as well as highlight what is distinctive about machining.

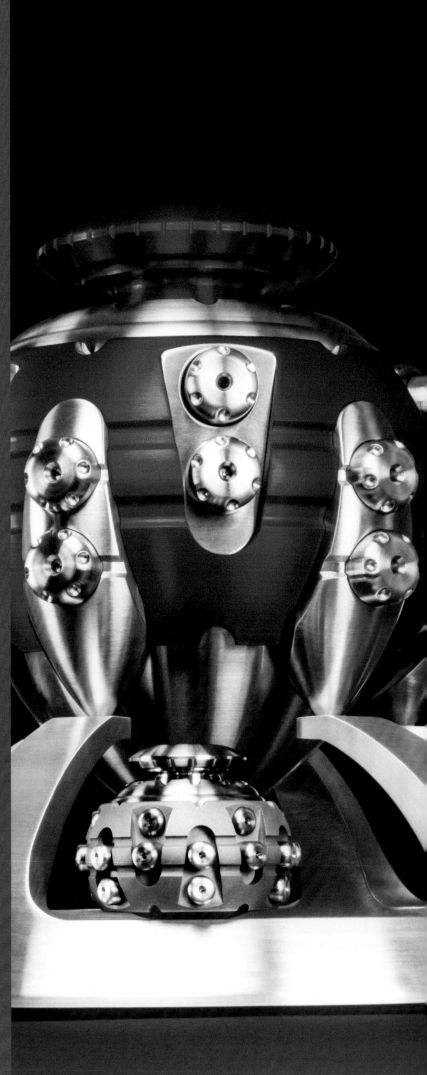

Sculpture urn "BV 753322622451551" with NHVB for scale

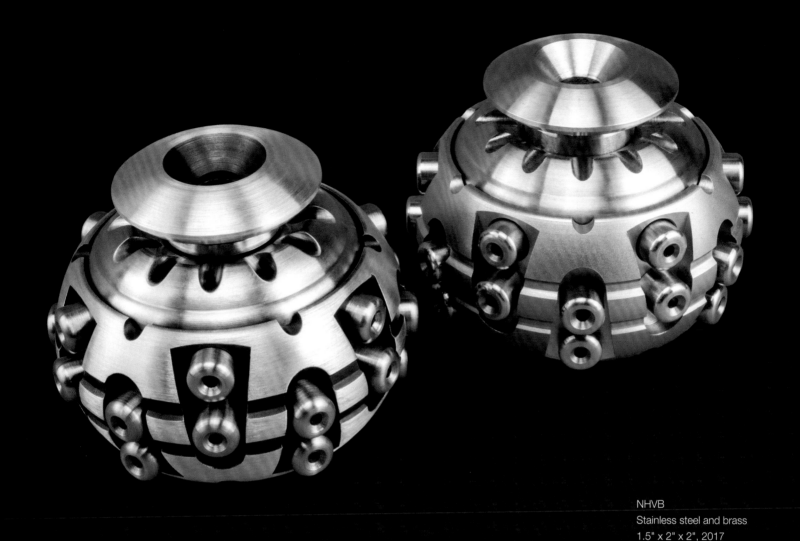

NHVB
Stainless steel and brass
1.5" x 2" x 2", 2017

NHVB: In my research for this project, I looked to centuries-old forms of utilitarian art to see what parallels I could draw with modern industrial crafts. In doing so, I was quickly drawn to Japanese netsuke and Chinese snuff bottles. These object forms, with their fascinating histories, had qualities that seemed perfectly adaptable to the contemporary machined decorative arts. The similarities between netsuke and some of the finely machined and decorated lanyard beads I observed within the machinist community seemed especially intriguing.

While the look of these traditional Japanese and Chinese decorative forms may be quite different from most machined objects, I was more interested in the impulse they represent: the desire to decorate and improve one's most cherished utilitarian possessions, and how this act often grows to a point where the art begins to take priority over the original function of the object.

The transformation from functional craft to creative art form can happen over years, decades, or centuries, but the process is usually the same. The focus of the work becomes

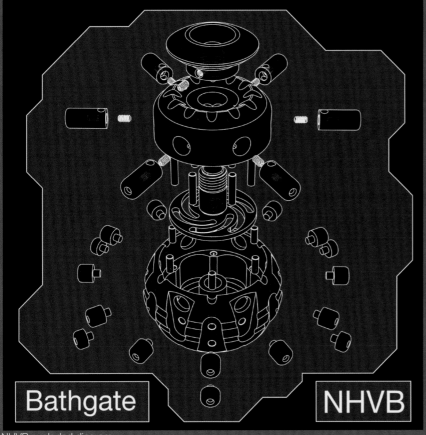

Bathgate | NHVB

NHVB exploded diagram

less about the usefulness of the thing, and more about the craft itself. The object becomes secondary to the act of making; eventually, the original object can be completely abandoned in favor of new technical or conceptual challenges within the craft. What remains is a medium ripe for "art for art's sake."

I sensed the potential for collaboration with the past; the result was the "Netsuke Hybrid Vessel Bead" (NHVB), an oversized bead-like container with a unique iris-style locking mechanism. This work also inspired a larger, one-of-a-kind urn that appears on page 224.

NHVB with lid removed to show iris mechanism

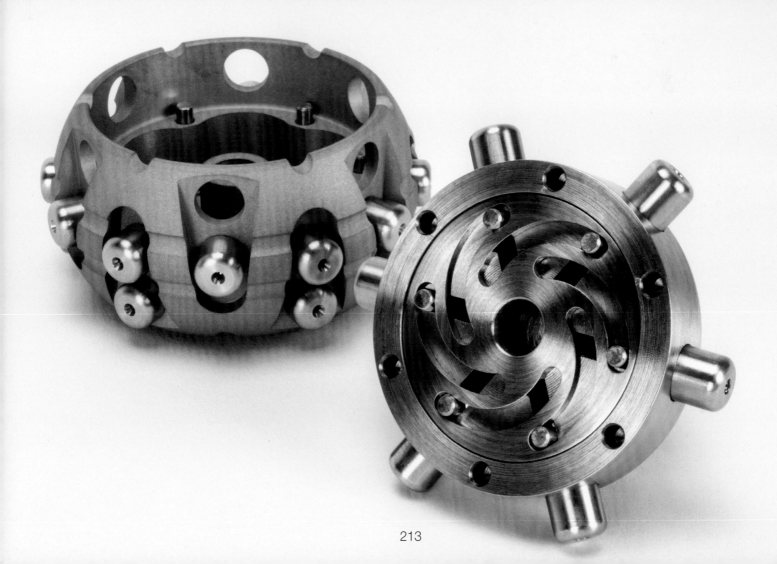

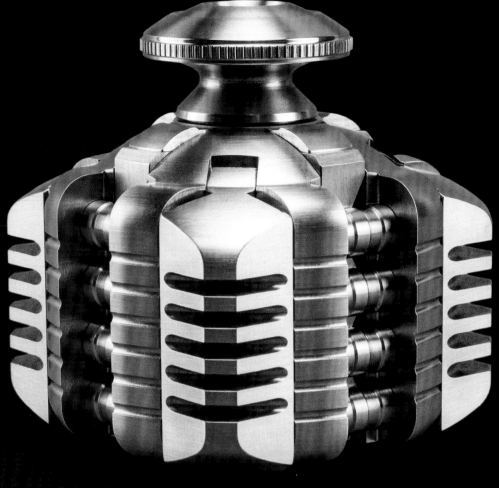

NV2
Stainless steel and bronze
2.7" x 2.7" x 2.8", 2019

NV2: I'd observed that most craft forms seem to trend away from utility over time, so it wasn't lost on me as a sculptor that I suddenly found myself trending toward it. Continuing my line of thinking, my starting point for this work was a kind of snuffbox. I wanted to increase the internal volume of this vessel to make it a bit more useful, so this piece is considerably larger than its predecessor.

The locking mechanics for the lid are quite intricate. The lid section contains sixteen cross-pins, each of which serves as a kind of latch. The cross-pins are actuated by turning the knob on the lid, which screws itself down and applies a force onto a thrust bearing and pressure plate; this pressure plate acts on four bronze keys with wedge profiles cut into them. These keys slide down a channel and act on small cam shapes cut into the backs of each of the sixteen cross-pins that secure the lid.

The whole assembly functions much like a lock and key (if one were to leave the key partially inserted into the lock) and is an elegant marriage of mechanics, machining, and aesthetics. Both the NHVB and NV2 were further collaboration projects made with Mike Hogarty and Callye Keen.

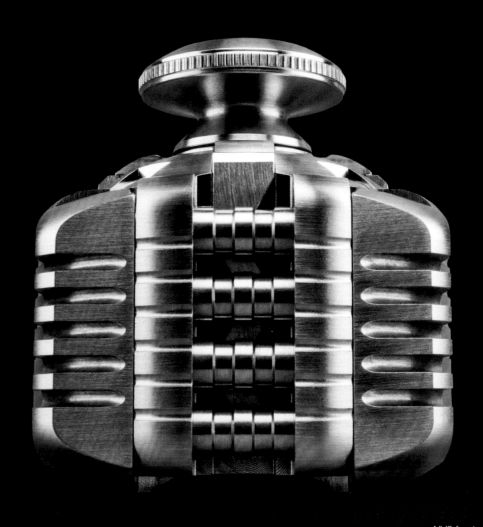

NV2 front view

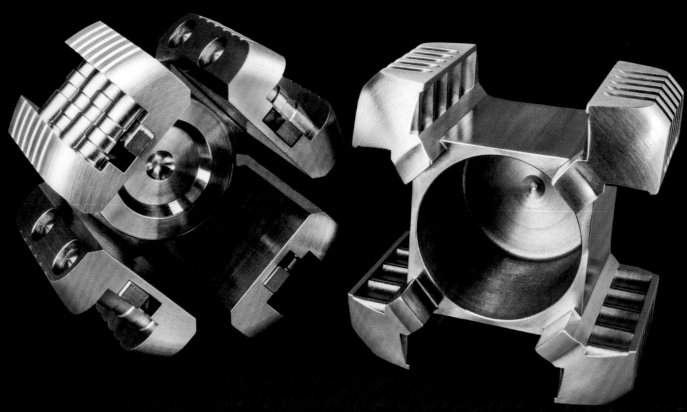

NV2 with lid removed to show interior

NV2 technical drawing

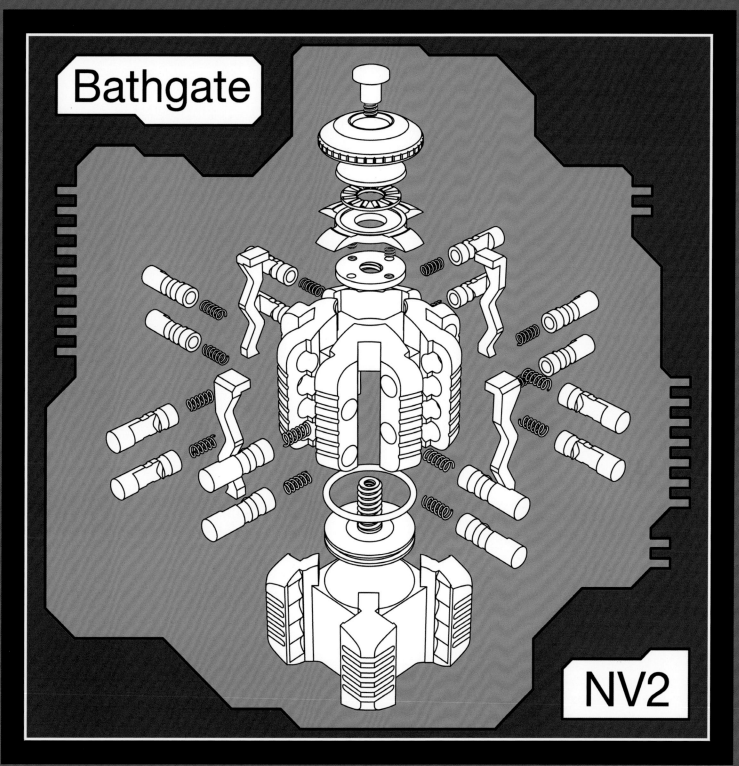

Bathgate

NV2

NV2 exploded diagram

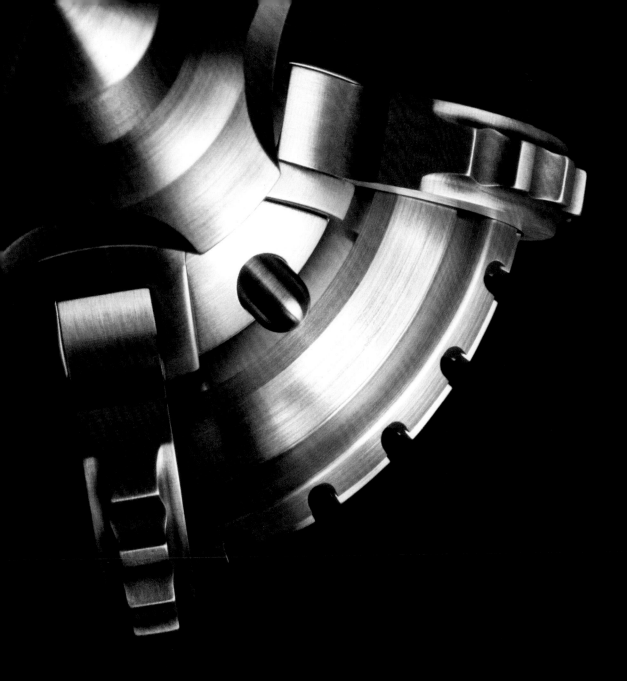

SMV3: Of the sketches I made for various vessels in early 2016, this design was the one I was least confident I could pull off. I knew roughly how the mechanism might work, but I couldn't quite crack how to incorporate it without turning the composition into a mechanical monstrosity. I decided to set it aside, thinking that maybe in time I could come back to it. Three years later, I picked it up again. As I had hoped, time (and experience) had given me fresh eyes to see the problem, and a novel solution emerged. I was able to rework the design in a way that now balanced both the aesthetics and function of this rather rare piece.

The mechanics for SMV3 may seem straightforward, but they are deceptively complicated. On first impression, it looks as though depressing the plunger on the top simply flips the arms out to the side, allowing the lid to be lifted off. But this is not correct. In order for the arms to properly release, they need to be able to swing down and under the gripping edge of the container to clear it for a release. The same goes for securing the lid. In order for the container to have a firm lock, the arms need to be able to swing down under the gripping edge and then lift up against it to keep tension on the lid, engaging like a hook. To do both of these things, the pivot point of the five arms needs to be able to shift up and down at the appropriate time.

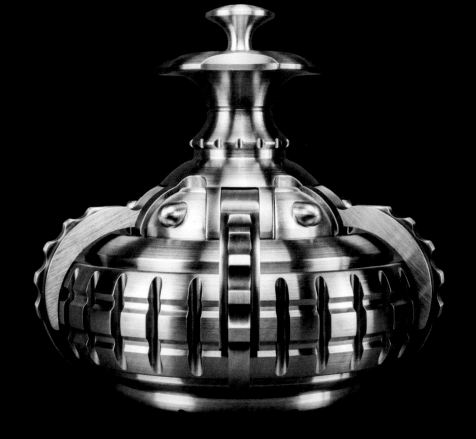

SMV3 (Snatch Vessel), stainless steel and brass, 4.25"x4.25"x4", 2019

To achieve this, the lid was made in two parts, an upper and lower half. These halves can slide up and down independent of each other. The lower half of the lid seats onto the lower vessel, sealing it shut. Its geometry also conceals the hinge pin openings on the upper half, preventing their removal. And last, it holds a spring that acts against the upper half of the lid, keeping it in tension.

The top half of the lid houses the hinges for the plunger-actuated arms and floats on top of the spring in the lower half. When the plunger on the top is depressed to rotate the arms, it also transfers the force into compressing the float spring. This allows the upper lid and hinges to drop the fraction of an inch required to allow the hook-shaped arms to clear and swing free of the lower vessel. This all works without any extra steps or motion from the operator. It all works exceedingly well, and I count it among one of my most elegant technical achievements.

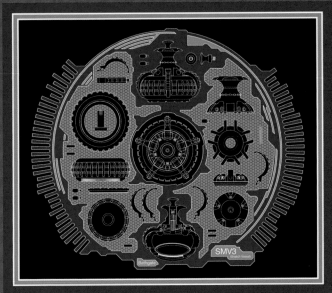

SMV3 technical drawing

SMV3 with lid removed

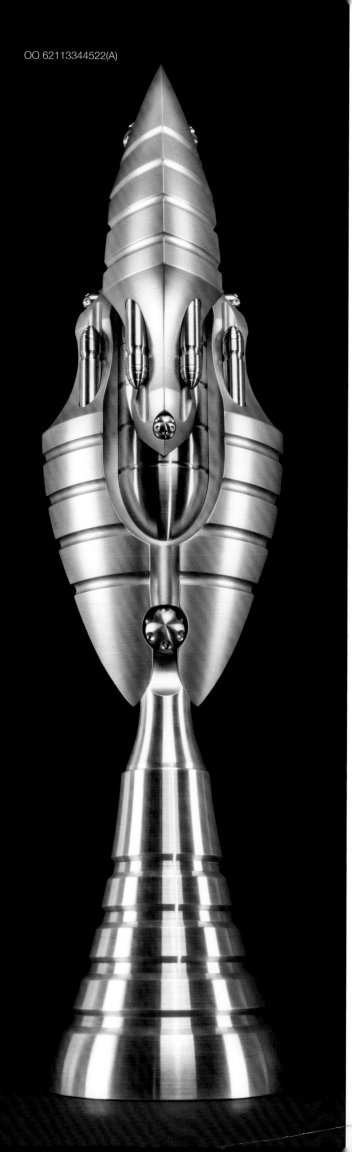

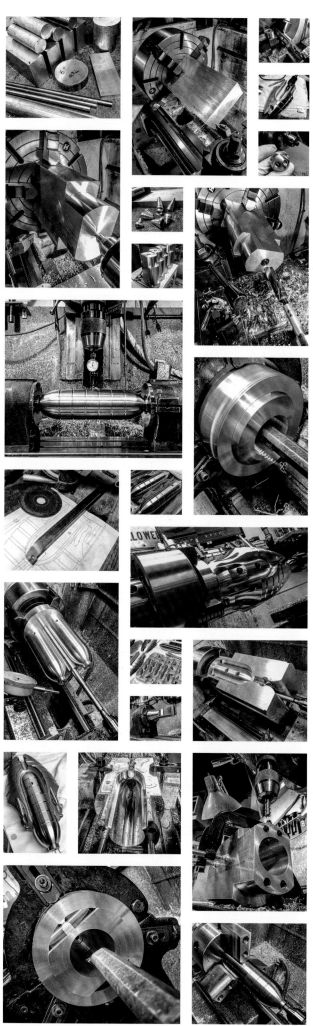

OO process collage

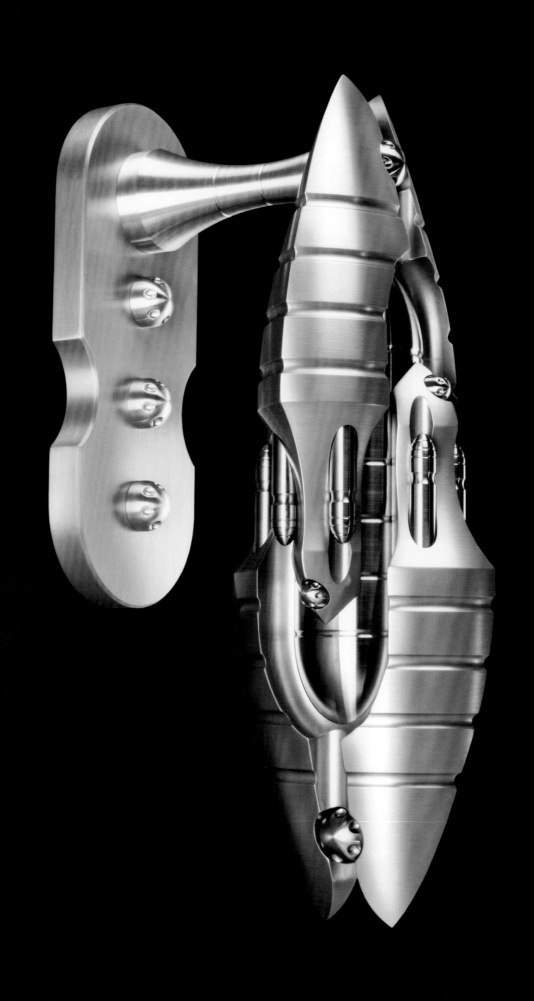

OO 62113344522(B)

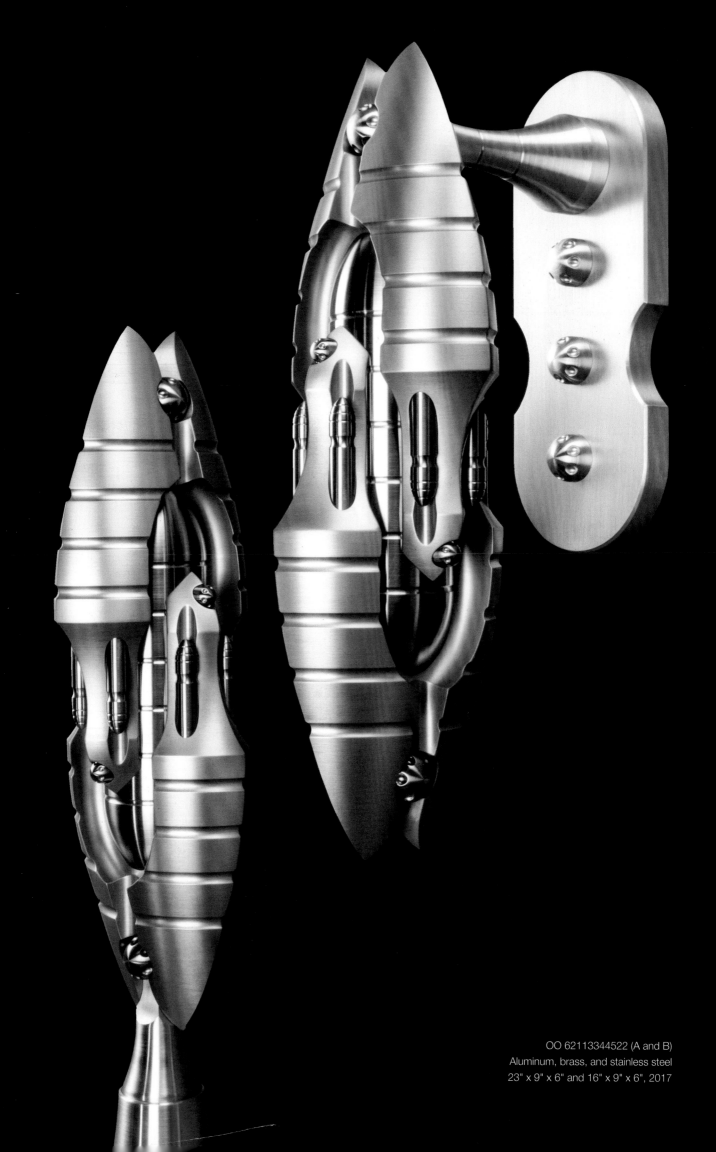

OO 62113344522 (A and B)
Aluminum, brass, and stainless steel
23" x 9" x 6" and 16" x 9" x 6", 2017

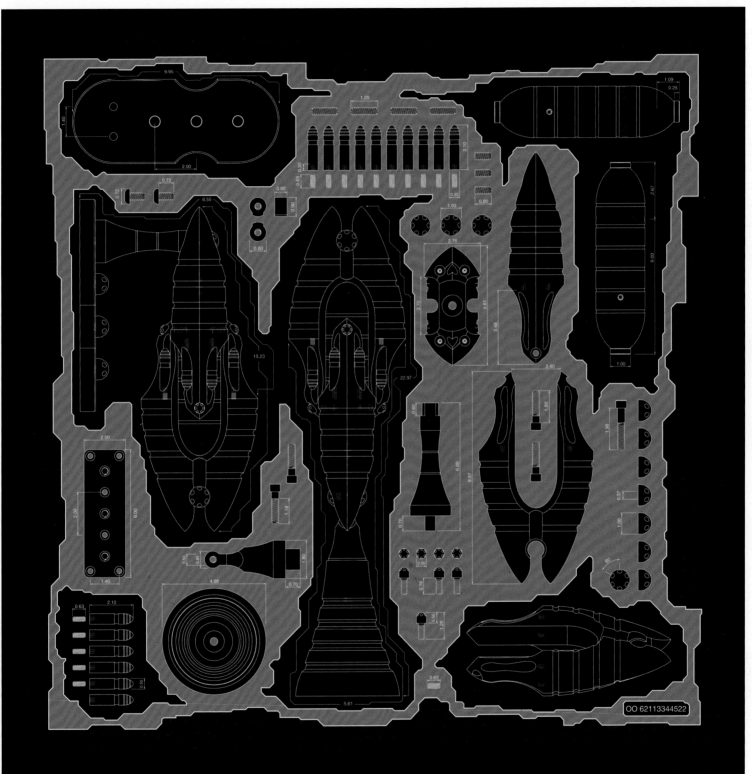

OO technical drawing

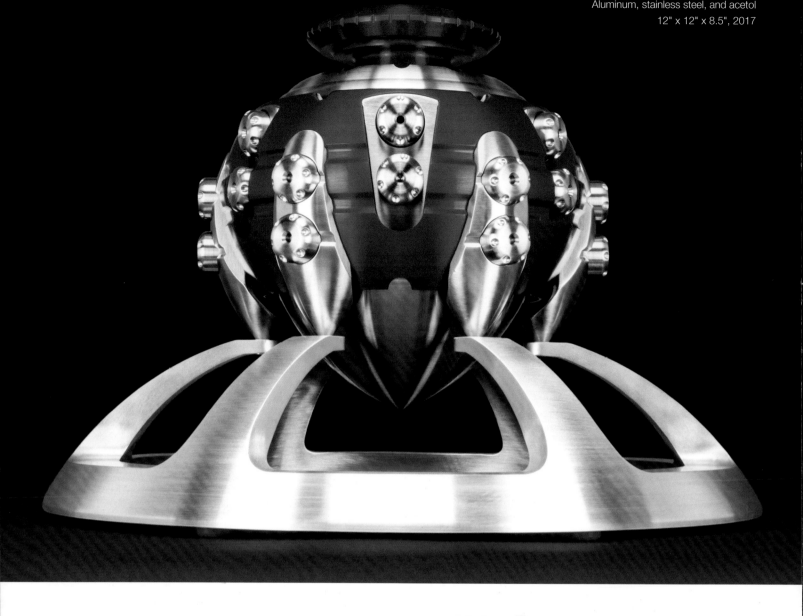

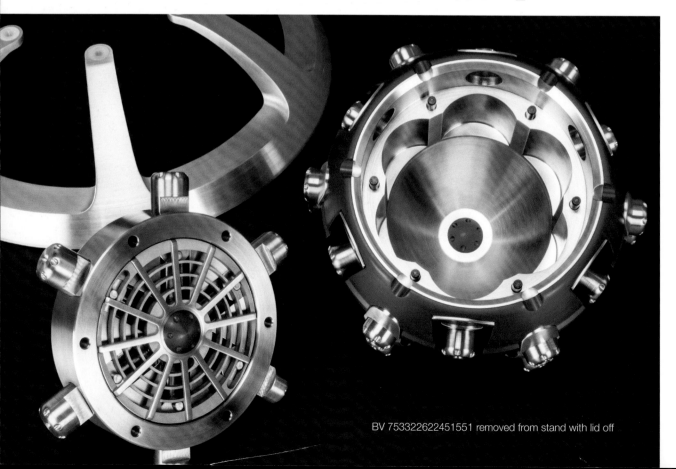

BV 753322622451551 removed from stand with lid off

BV753322622451551 Bathgate

NHVB

BV technical drawing

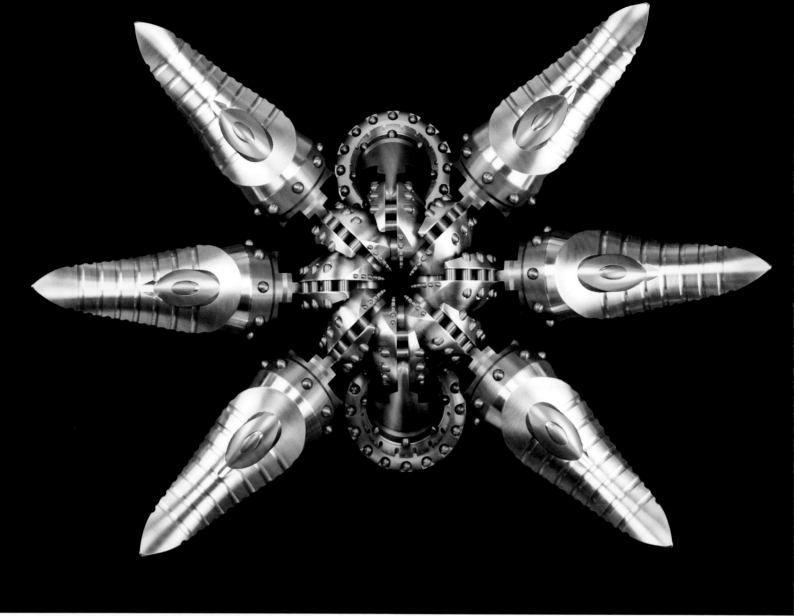

BU 622411311751, aluminum and stainless steel, 37" x 26" x 14", 2018

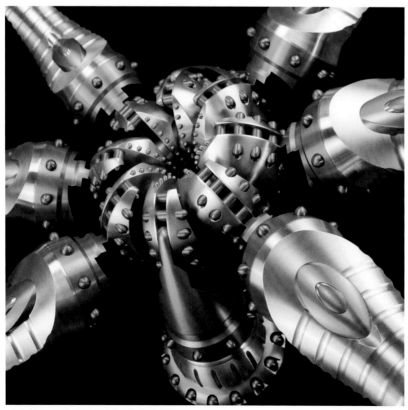

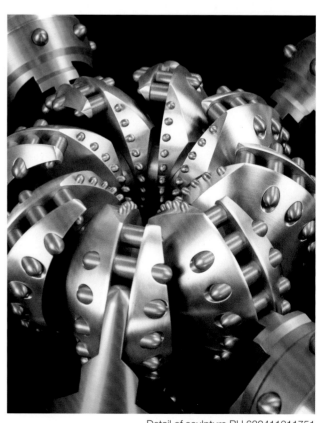

Detail of sculpture BU 622411311751

Detail of sculpture BU 622411311751

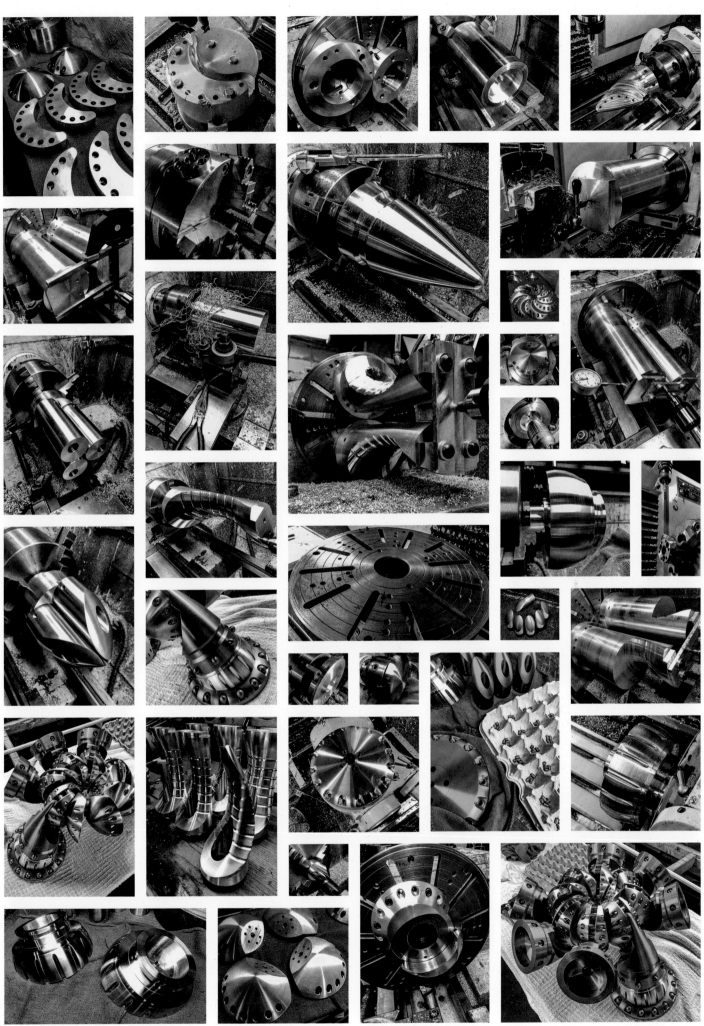

BU process collage

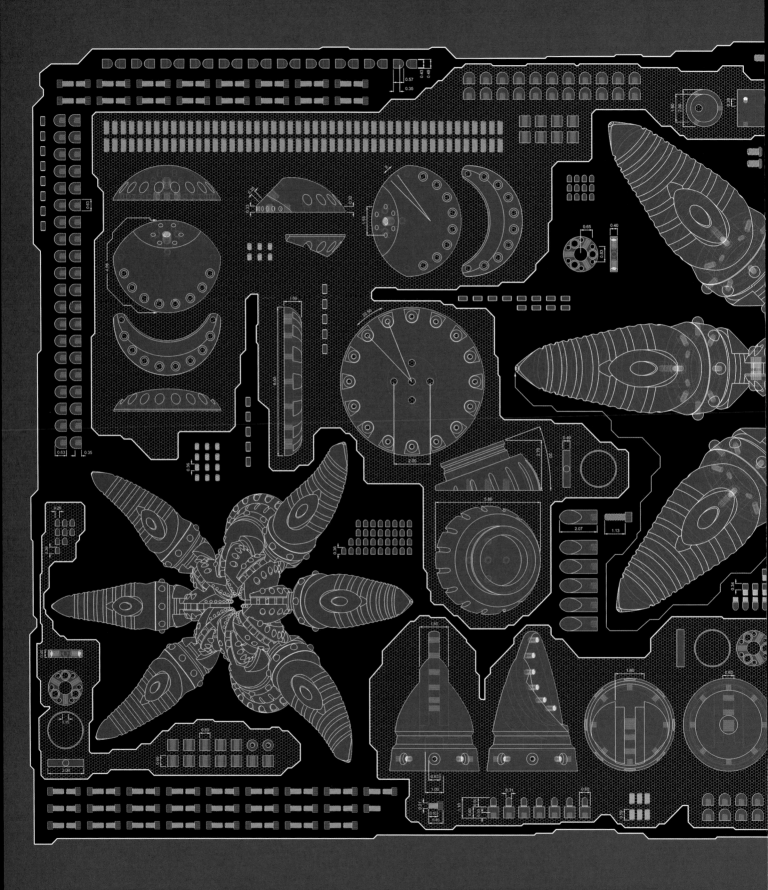

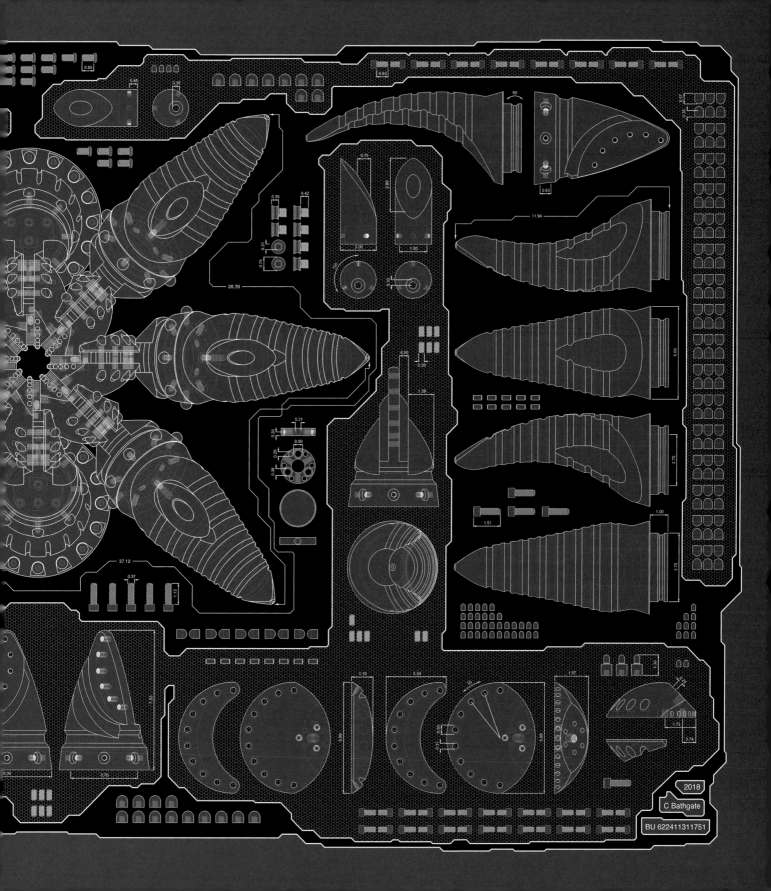

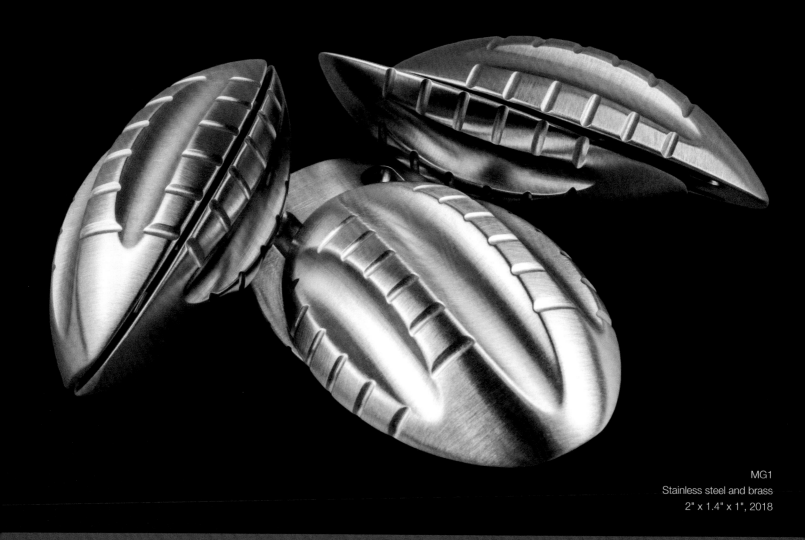

MG1
Stainless steel and brass
2" x 1.4" x 1", 2018

MG1: This series is a unique take on the popularity of magnetic devices, haptic coins, and other "fidget" objects circulating throughout the machinist community. I had never incorporated magnets into a mechanical piece before, so I was eager to dig in and see what might develop.

The MG1 is a kind of sliding clamshell design; it uses ceramic ball bearings that run in individual channels. This allows the two halves to roll freely over one another. However, their movement is constrained by a row of magnets on each half. These magnets provide an attractive force to hold the halves together, and their arrangement provides only three stable positions where the magnets are aligned. This creates a very pleasing haptic effect because, as the piece is manipulated, it wants to jump from position to position to keep the polarity of the magnets aligned. This feels very strange in the hand.

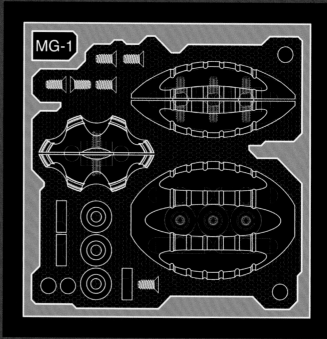

MG1 technical drawing

230

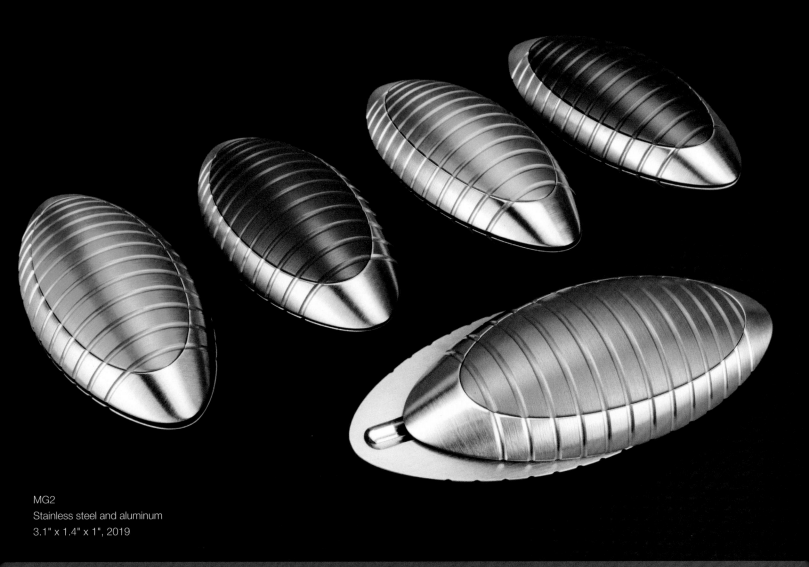

MG2
Stainless steel and aluminum
3.1" x 1.4" x 1", 2019

The MG2 and MG3 were iterations on this successful design. While a bit larger (and a lot more colorful) than the MG1, both of these works required considerably more logistical considerations. Chief among the challenges was preserving its simple functionality while increasing its size relative to the original. Since this work relies on delicately balanced magnetic attraction, any increase in mass has a detrimental effect on the mechanic. A heavier work simply will not react in the same way.

In order to account for its increased size, lighter materials were needed. Some clever hollowing out of the internal geometry and the addition of aluminum inserts were major factors in ensuring that the overall weight remained unchanged.

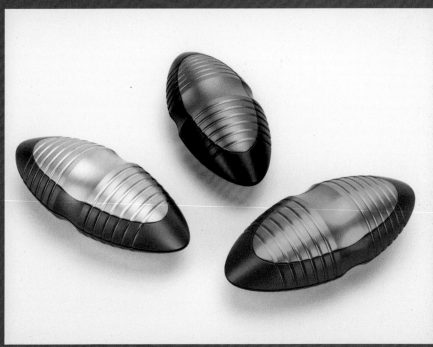

MG3, aluminum, 3.1" x 1.4" x 1", 2019

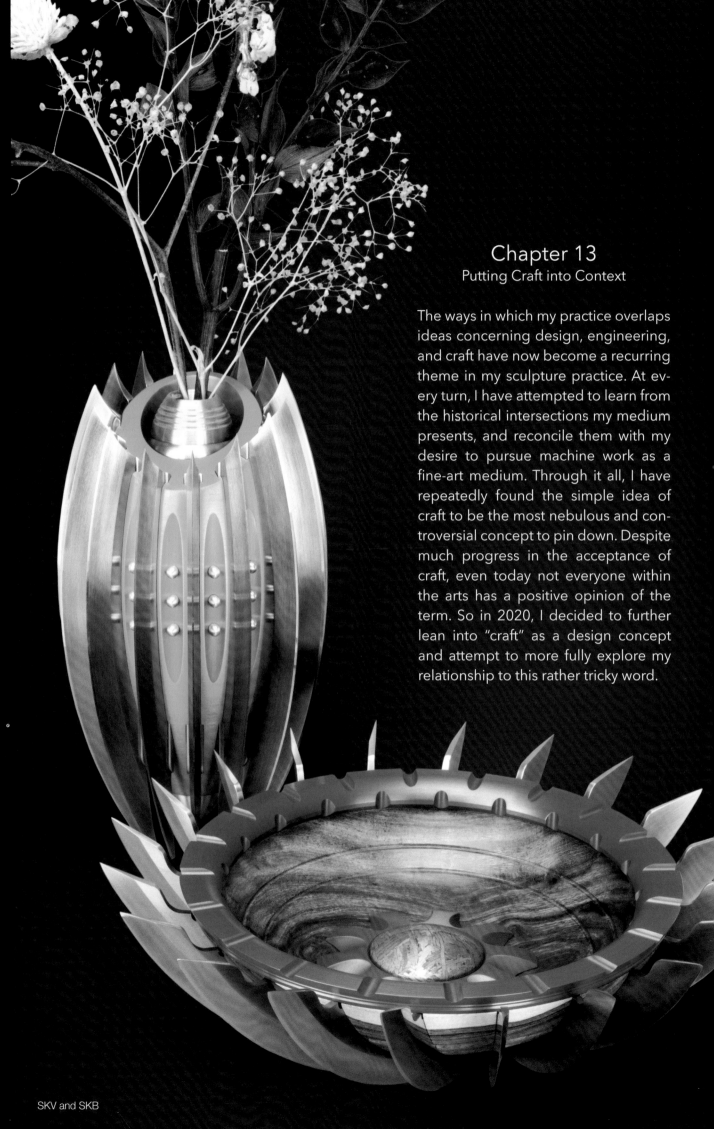

Chapter 13
Putting Craft into Context

The ways in which my practice overlaps ideas concerning design, engineering, and craft have now become a recurring theme in my sculpture practice. At every turn, I have attempted to learn from the historical intersections my medium presents, and reconcile them with my desire to pursue machine work as a fine-art medium. Through it all, I have repeatedly found the simple idea of craft to be the most nebulous and controversial concept to pin down. Despite much progress in the acceptance of craft, even today not everyone within the arts has a positive opinion of the term. So in 2020, I decided to further lean into "craft" as a design concept and attempt to more fully explore my relationship to this rather tricky word.

SKV and SKB

Turned ironwood inserts

Within the arts, the word "craft" has always been problematic. Even in basic usage, it can be a noun (what you do) and it can be a verb (how you do it). It is used to describe a class of practices (such as pottery), as well as elements within them. Like the word "art," it can be nearly impossible to define in a way that satisfies everyone.

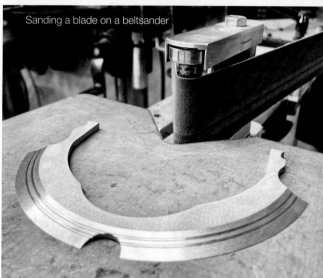
Sanding a blade on a beltsander

When viewed through the lens of modern manufacturing, the idea of craft, with its traditional emphasis on handwork and dexterous skill, can seem at odds with the very constrained and automated processes of machine work. However, as a metal sculptor whose work has progressed from detailed handwork through highly automated processes, I believe that the meaning of the word "craft" has become a rich and nuanced field of artistic inquiry. Dispelling dogmas about skilled and unskilled workmanship and countering wrongheaded perceptions of "mindless and talentless automation" have become fertile ground for a range of digitally fabricated works.

Additionally, because machine work has technological layers, with newer processes augmenting rather than replacing older ones, it is often possible to find historical connections between various craft movements. Industrial practices such as glasswork, woodturning, and ceramics all are regarded as contemporary fine-art crafts; yet, they got their start on a factory floor just like the machine processes I use.

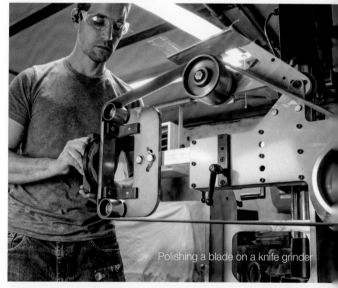
Polishing a blade on a knife grinder

These historical crafts have been transformed through their adoption by artists, but they differ from machine work in important ways. Unlike machining, these craft movements represent processes that have largely fallen out of commercial use. Much of the firsthand knowledge we have about their use is because of artisans who have turned these practices toward more-creative ends. Likewise, these crafts have signature forms that are common within their trade (vases, bowls, urns). Shapes that tell that craft's particular history and have become inseparable from the visual language within them.

While machining is a vocation that shares an industrial past, it is an evolving industrial process that remains in commercial use today. Likewise, there are few signature objects that uniquely represent modern machine work as a medium; the same paradigm of craft and craft form simply does not exist. Because of this, I have spent considerable time exploring what a "machined craft form" might be and what forms might come to define such an expansive discipline as it cements its place within the arts.

Turning stabilized box elder

233

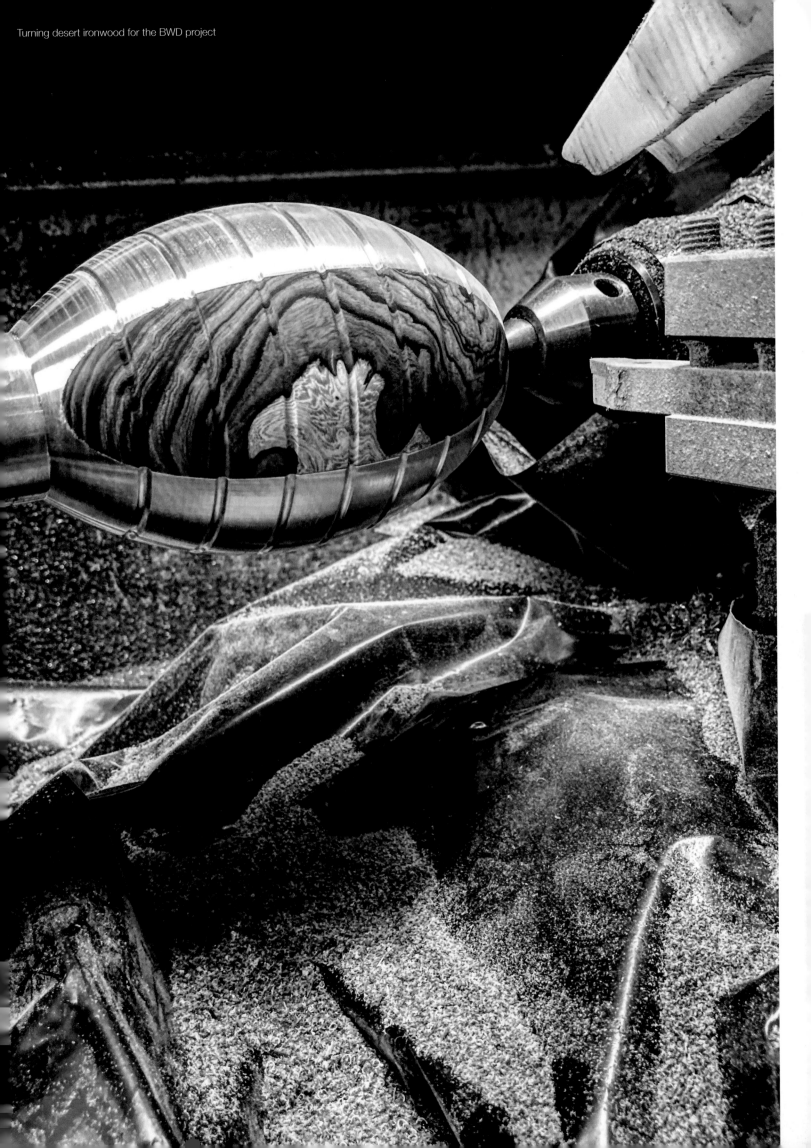
Turning desert ironwood for the BWD project

In my sculpture work, I have become captivated by the idea of borrowing craft forms and materials from other industrial mediums. I might remix a simple flower vase into a highly engineered object ringed by razor-sharp knife forms or take a novel mechanic and integrate it into a stubbornly sculptural format. The goal is to bring attention to the sculptural nature of these utilitarian subjects, challenge their own functionality, and use them to comment on my own medium. By thwarting easy classification, these objects ask that they be considered for more than mere utility.

This renewed emphasis on craft-centric work seeks to find connections across industrial and decorative eras. It is an attempt to explore how the modern-day understanding of craft shapes interpretation of my work, and the industrial arts as a whole. The arts are the most powerful tool we have for understanding and preserving our technological heritage. It stands to reason that a better understanding of the history that underlies my process can uncover the depth of context needed to create something truly meaningful.

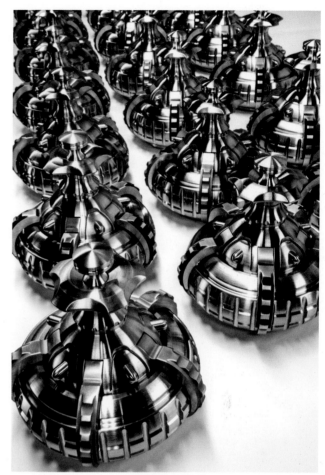

SMV3 edition lined up during production

Collection of BWD sculptures

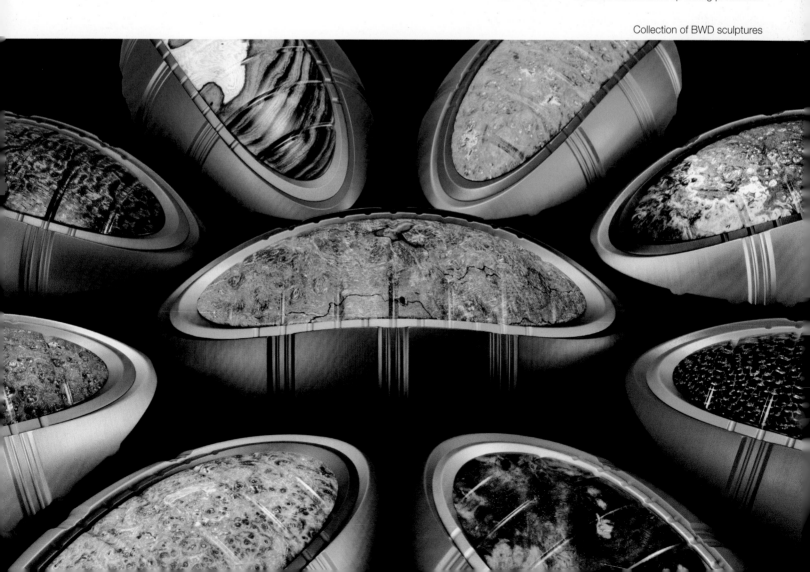

OTFB,
Stainless steel and titanium
3" x 3" x 6" 2019

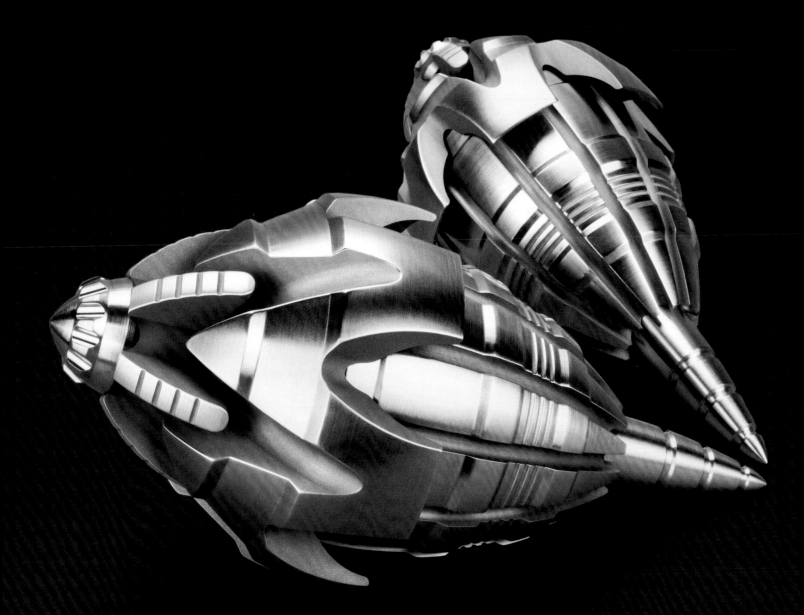

Design Projects

OTFB: Knife making is a craft as old as civilization. It is also one that has been utterly transformed by the adoption of modern machine tools. While I have no plans to abandon sculpture to take up knife making, there is an inspiring decorative-arts community within the world of knife makers that any serious machinist would be foolish to ignore.

As I was researching this fascinating craft, I realized that handmade knives aren't necessarily utilitarian. I found craftspeople who were extremely concerned with process and material, making a wide array of intricately detailed (often machined) pieces of metal art that was often more decorative than functional. Something else that caught my attention was the many types of automatic knives that open and close in novel ways, probably because they possess an excessive amount of engineering to function. One common type is called an "OTF" or "out the front." Sort of like a switchblade, it has a spring-loaded assembly that extends and retracts the blade through the top of the handle by means of actuating a small lever. I was captivated. I had to adapt this mechanism into a piece of sculpture in order to better understand it.

The design of the OTFB takes the mechanics of an OTF knife and completely reimagines them into a piece of kinetic art with a sort of head and tail that extends and retracts instead of a blade. The mechanism that operates the sculpture was redesigned to be cylindrical and open on both ends so that the center shaft of the assembly moves both "out the front " and "out the back" of the sculpture. Rather than having a visible lever or switch, rotating the body of the work actuates the inner workings through the use of a helical cam.

With this reinvented mechanic, I was less constrained when devising an aesthetic object that could contain it. As with all of my kinetic projects, it is important that the works function as a sculpture above all else. So while this piece does not exactly resemble a knife, it most certainly shares its DNA with one variety of them.

237

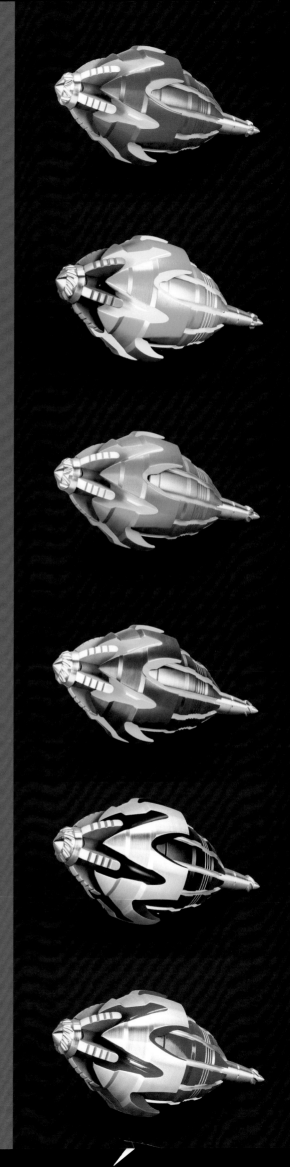

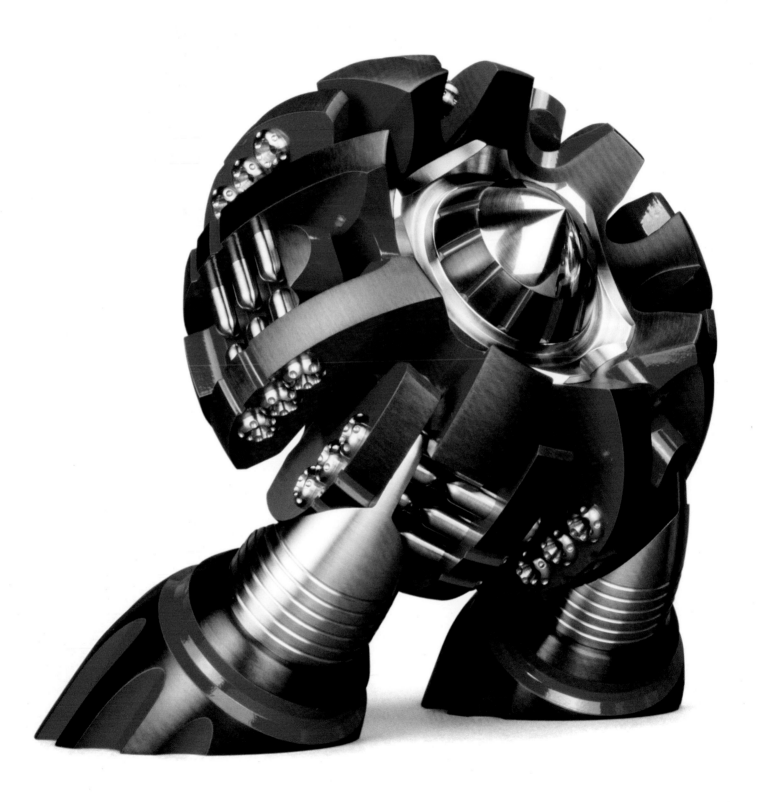

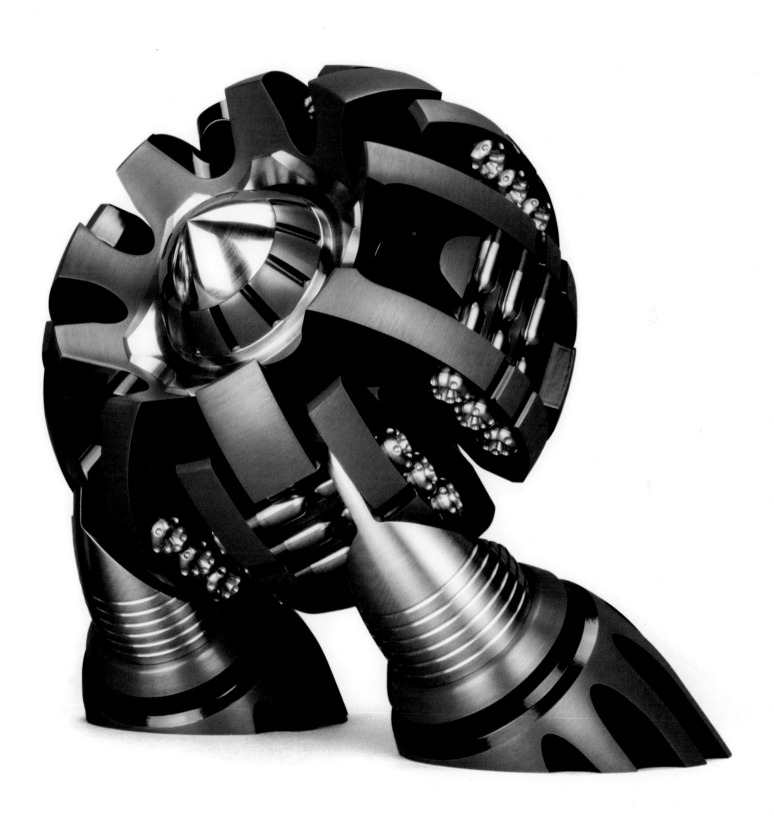

BL 551433342
Aluminum and stainless steel
7.5" x 8" x 6", 2018

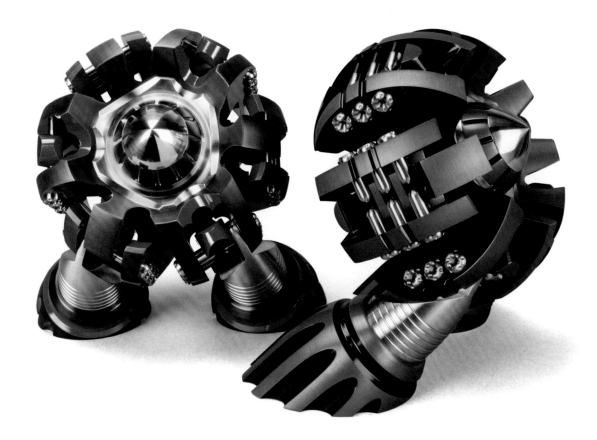

Sculpture BL 551433342

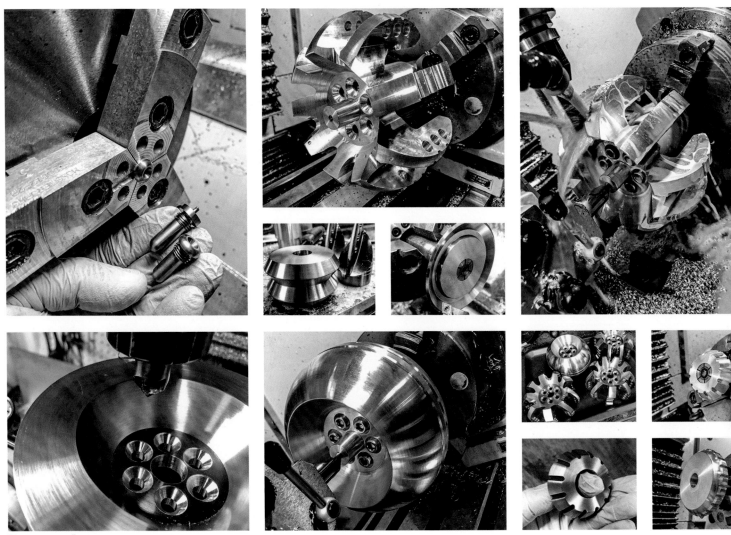

BL process collage

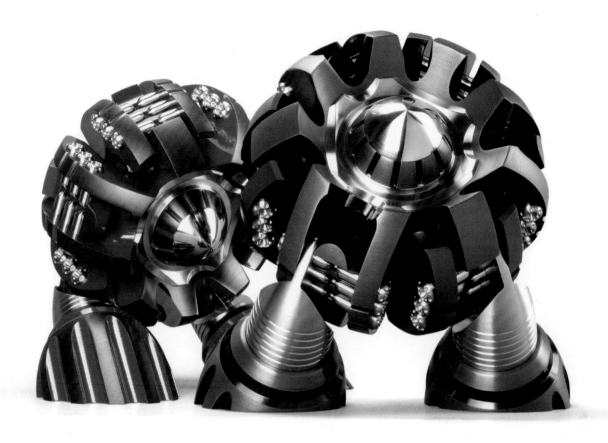

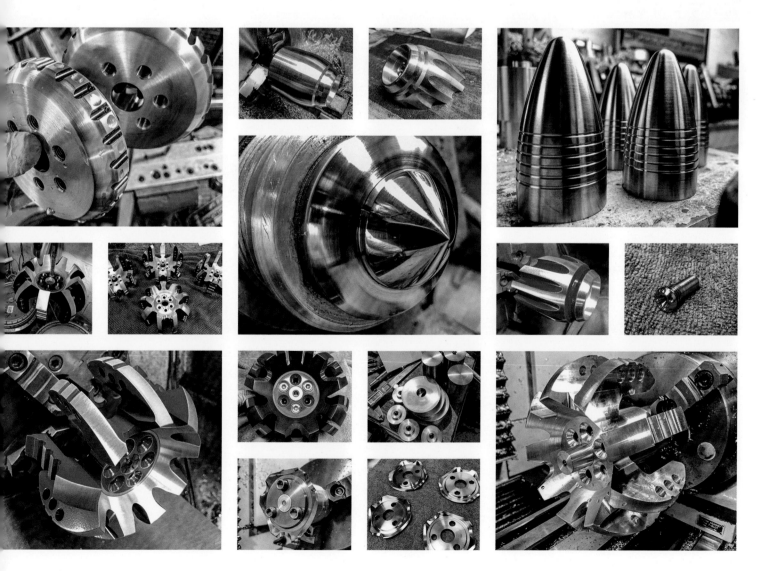

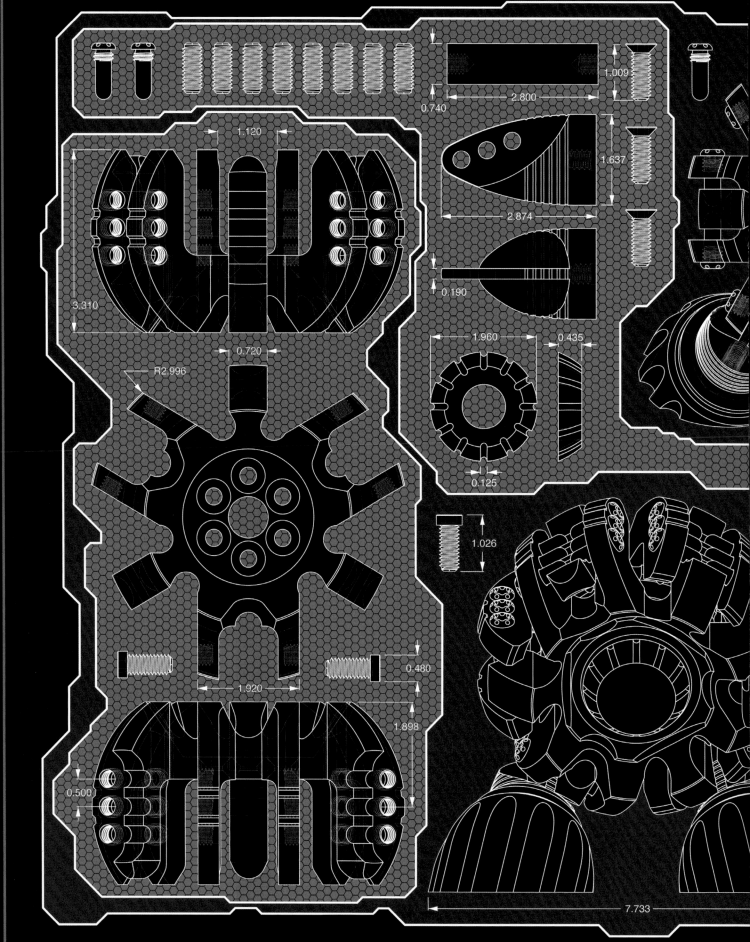

C Bathgate

BL 551433342

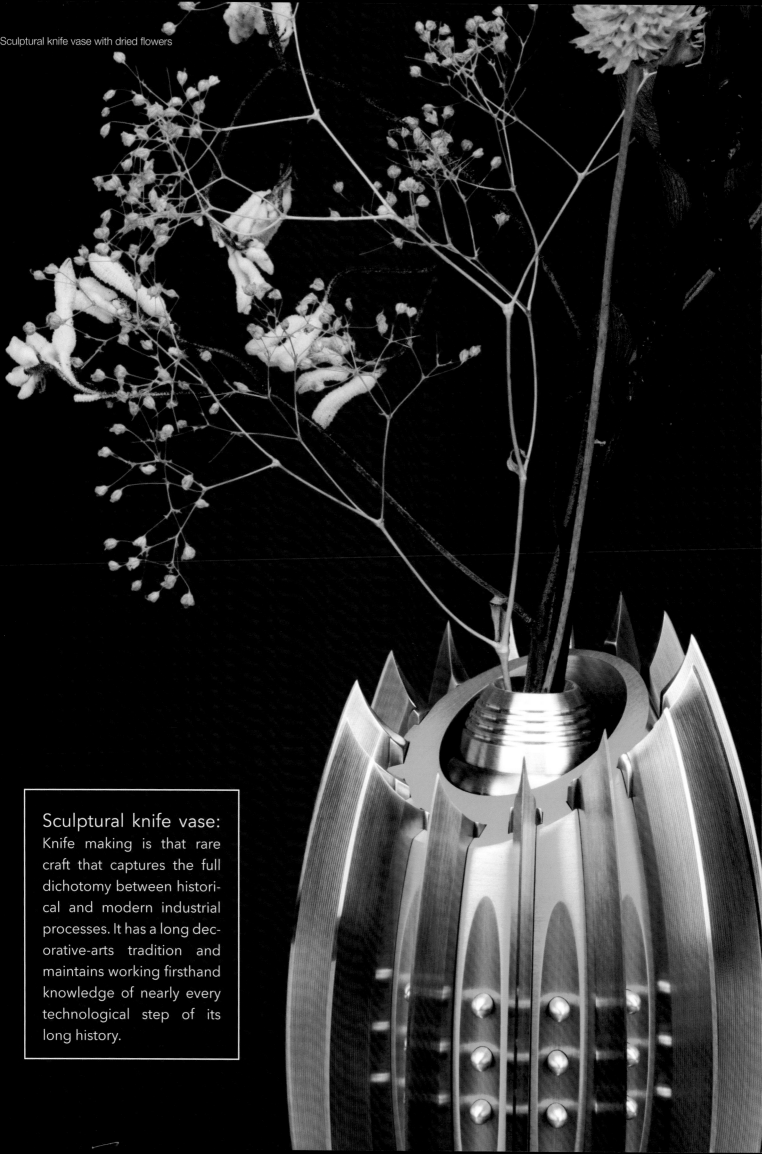

Sculptural knife vase with dried flowers

Sculptural knife vase: Knife making is that rare craft that captures the full dichotomy between historical and modern industrial processes. It has a long decorative-arts tradition and maintains working firsthand knowledge of nearly every technological step of its long history.

Knife making has roots that go all the way back to the Stone Age; yet, it has evolved with each technological epoch. The history of the knife is the history of man's material progress; there would seem no better analogue for a craft-conscious approach to my medium. That said, I am a sculptor, not a knife maker, so in the past I have found it difficult to approach blade making directly. The challenge was to find a context for blade making that I could get my sculptural hooks into, both conceptually and aesthetically.

My approach was to use the blades as sculptural elements in a way that created an unexpected context for them. Rather than an elaborately machined or decorated knife form, the knives themselves would become the adornment. The result is an intentionally overengineered mash-up that subverts functionality, making the object much more easily understood as an aesthetic object.

Ringed by fifteen razor-sharp blades, the sculptural knife vase is an object that requires the utmost care to handle and arrange. It is like nothing that I have made to date.

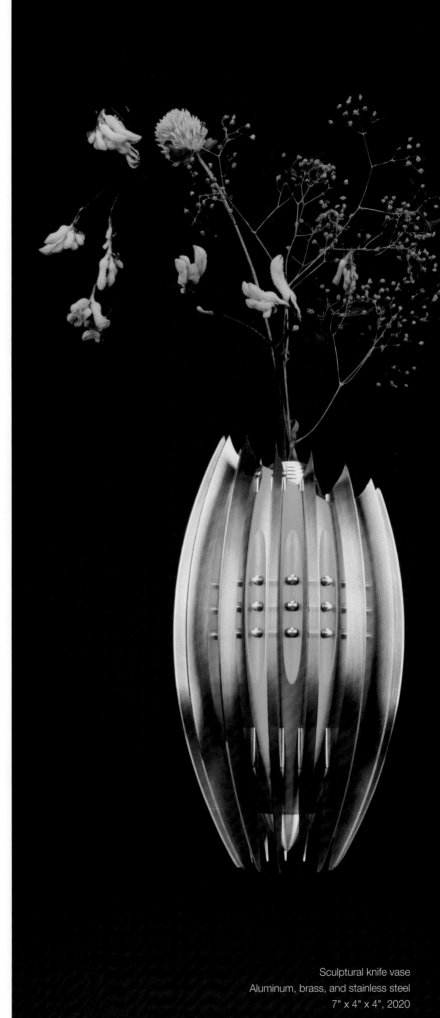

Sculptural knife vase
Aluminum, brass, and stainless steel
7" x 4" x 4", 2020

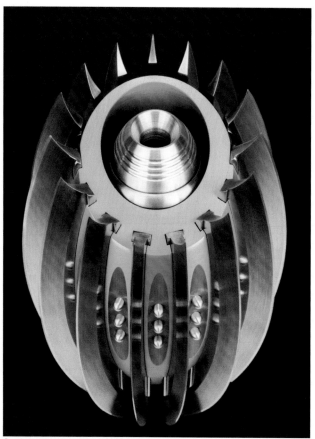

Sculptural knife vase, detail

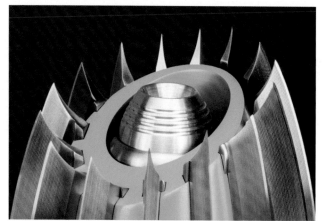

Sculptural knife vase, detail

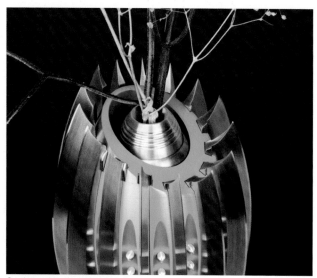

Sculptural knife vase, detail

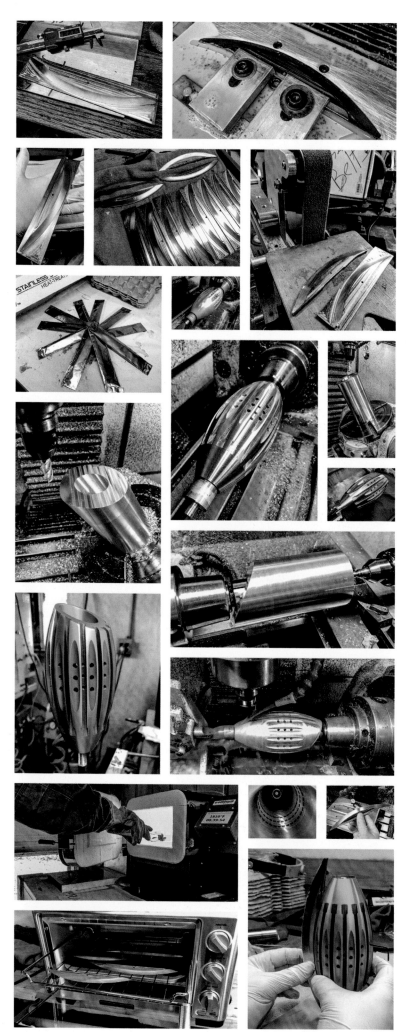

SKV process collage

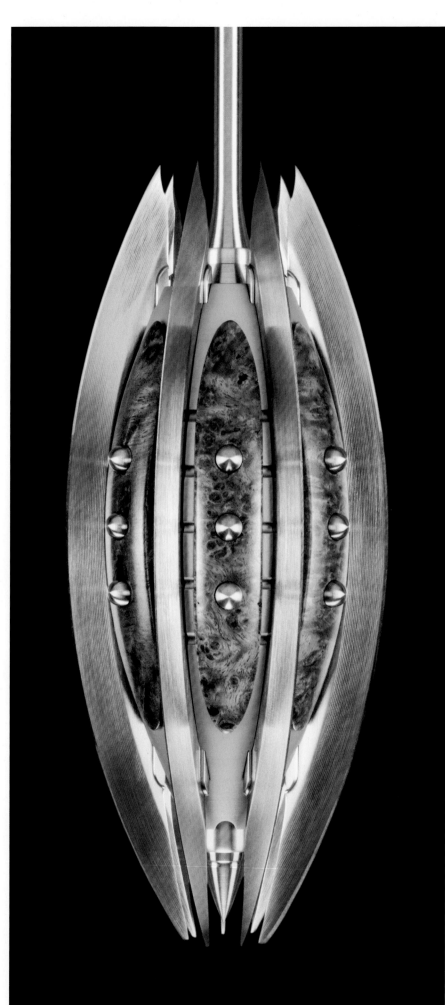

Sharps #2 detail
Aluminum, stainless steel, bronze, and amboyna burl
28.5" x 3" x 3", 2020

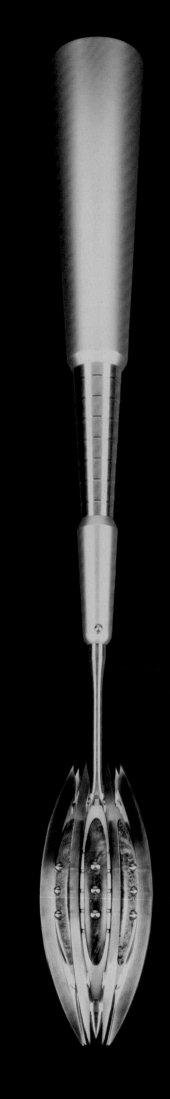

Sharps #2, full length

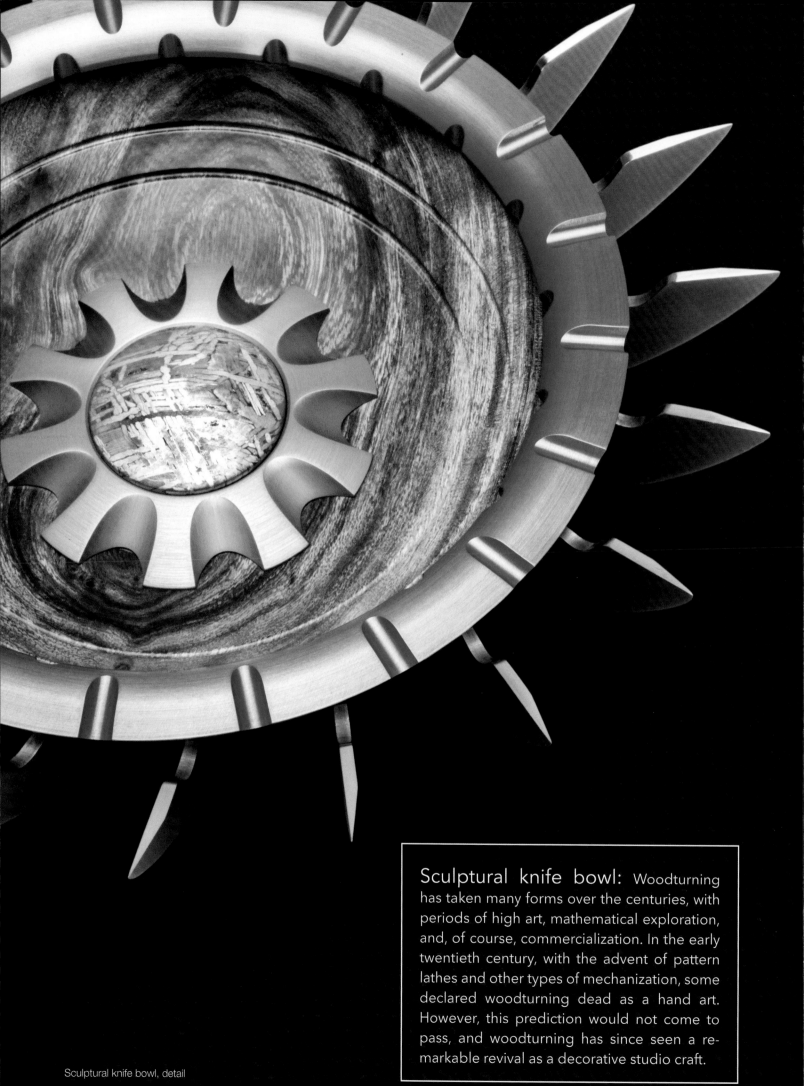

Sculptural knife bowl, detail

Sculptural knife bowl: Woodturning has taken many forms over the centuries, with periods of high art, mathematical exploration, and, of course, commercialization. In the early twentieth century, with the advent of pattern lathes and other types of mechanization, some declared woodturning dead as a hand art. However, this prediction would not come to pass, and woodturning has since seen a re-markable revival as a decorative studio craft.

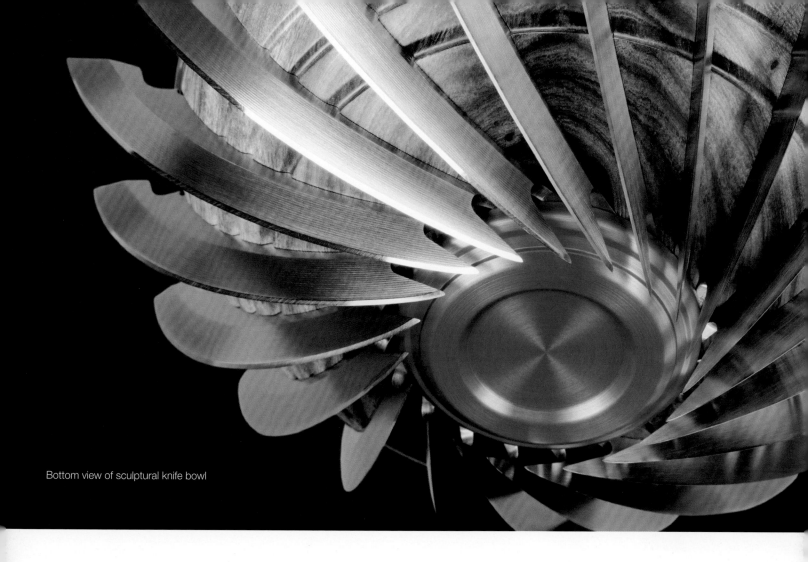

Bottom view of sculptural knife bowl

There are many woodturners who demonstrate a manual dexterity as well as thoughtfulness with materials that I find inspiring. I have found much comradery in talking to woodturners about overlapping elements in our processes, and I find that they are able to easily relate to many of the concepts I express in my work. Like the vase project that preceded it, the sculptural knife bowl begins with the premise that by contrasting multiple craft forms, one can tell a more nuanced story about the shared history of the industrial crafts. Being a metal sculptor, I needed to approach woodturning in my own particularly cautious way.

When working with wood, there are real concerns about the dimensional stability of the material. Wood will expand, shrink, or change shape in various temperature and moisture conditions. This is something I am not accustomed to with metalworking. While metal does experience thermal expansion in extreme conditions, the effect is minuscule in an everyday environment, and so the way that many types of wood move and change over time makes engineering a precision composition with mixed materials extremely complicated. To mitigate the very real possibility of the wood splitting due to shrinkage, I sought out one of the most stable hardwoods there is, desert ironwood.

Prized by knife makers, it is a beautiful natural hardwood that is incredibly stable and, as I have come to find, excellent for machining. It is difficult to source, especially in larger sizes, since the trees it grows from are a small, twisty, and protected species. It can be harvested only under strict guidelines. I was eventually able to procure an appropriately sized piece from a licensed supplier for this project. However, the ordeal made it clear that, going forward, I would need to broaden my horizons if I wanted to continue integrating woodworking with machine work.

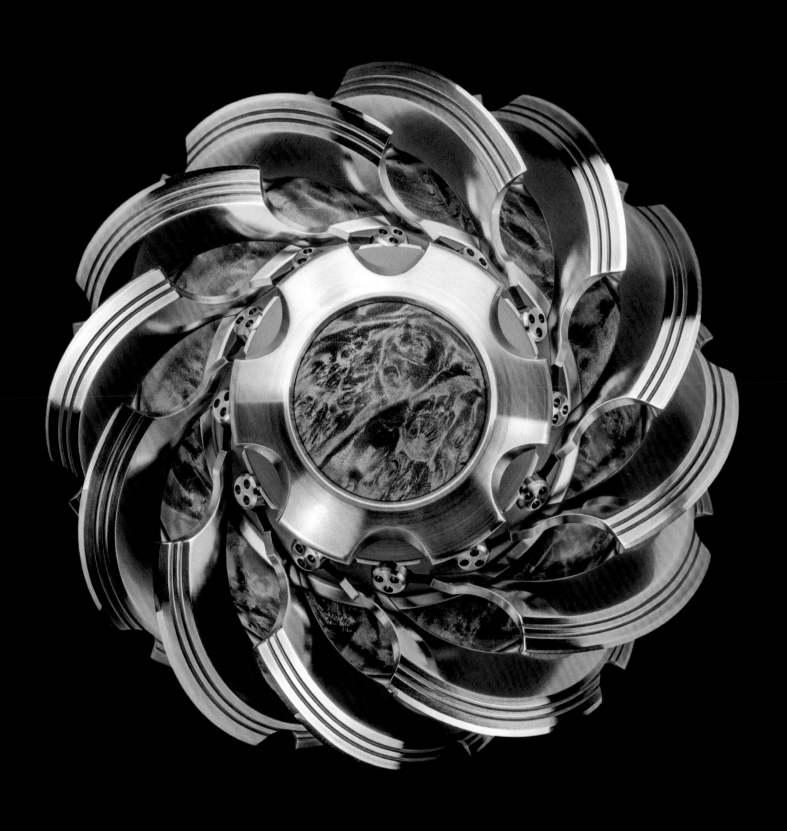

Sculptural knife urn
Aluminum, stainless steel, and stabilized maple burl
8.5" x 8.5" x 5.5", 2022

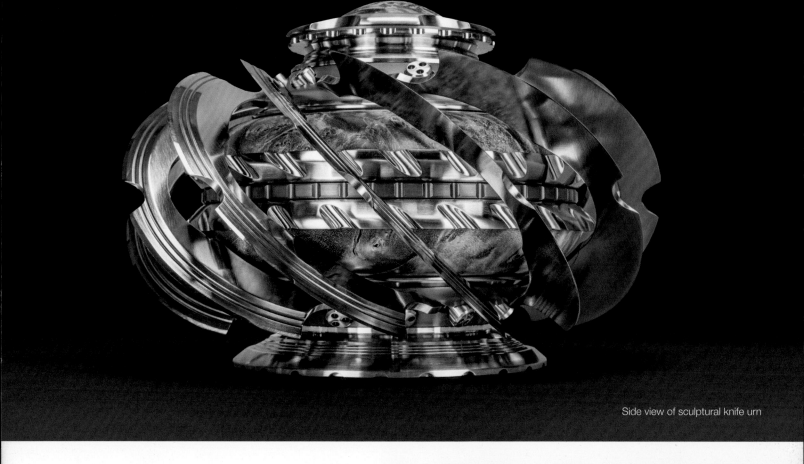

Sculptural knife urn: In all my research into knife making, it always seemed like the smooth curved bevels on some knife blades might be achieved using a turning operation on a lathe. These forms are typically produced by either grinding or milling the geometry, but under the right conditions I thought I could use my lathe. There is, of course, no reason to do it this way, and to my knowledge it has never been done this way, but that was all the more reason to try it. I think it speaks to the idea that craft isn't some rest home for defunct trades and idiosyncratic processes; it is a place to experiment and try things out just because. So with this in mind, I built a rather elaborate turning setup on my CNC lathe and carefully set about planning a process that would allow me to machine knife geometry in a whole new way.

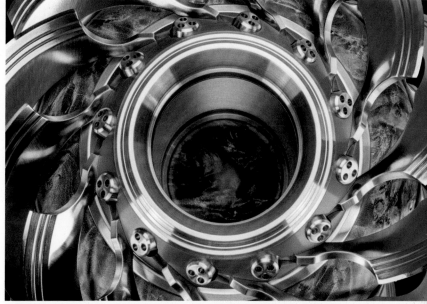

Interior view showing hidden boss detail

Knife urn with lid removed

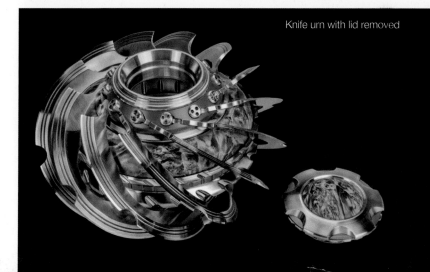

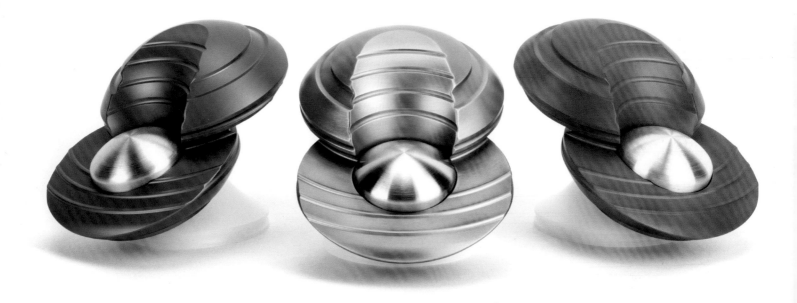

DoT in blue and copper, green and stainless steel, and orange and brass

DoT technical drawing

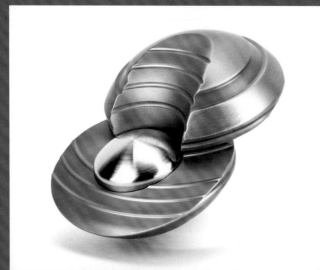

DoT, aluminum and stainless steel
2.7" x 1.6" x 1.3", 2020

DoT: A chance encounter led to the catalyst for this piece. I was talking to a fellow machinist who had come to the misunderstanding that I use only metal lathes in my work. This isn't at all accurate, but the comment hung in my mind, and I took their words as a creative challenge rather than an insult.

In my research, I often see examples of incredibly advanced five-axis machine tools making relatively simple parts. It always seems like overkill, and it got me thinking that instead, why not try to make a comparably complex piece using only two axes of machine motion? How much complexity could I achieve even when constrained to using only turning operations? So with the use of just one metal lathe, I set out to find a sculptural solution to an invented problem. This work is my first experiment with that simple premise.

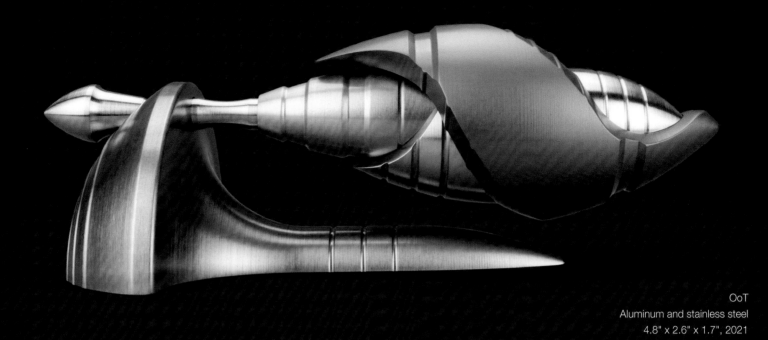

OoT
Aluminum and stainless steel
4.8" x 2.6" x 1.7", 2021

OoT: Based on the same design principle as the DoT, this is my second attempt at using only turning operations to make a complex sculptural composition. With this design, my approach was to utilize multiple offset bored holes to help index each part in its proper orientation, and then I utilized a novel cam mechanism to lock everything in place. I find time and again that constraints, be they real or arbitrary, are far more likely to be creative catalysts than impediments in my work, and this charming piece is just another example of that principle at work.

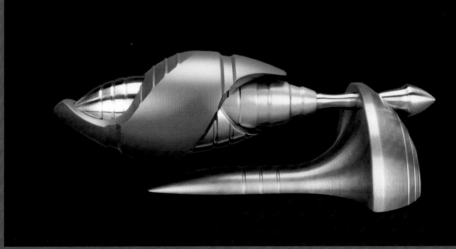

OoT in pink and teal

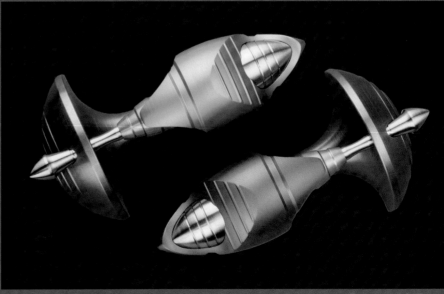

Top view of OoT

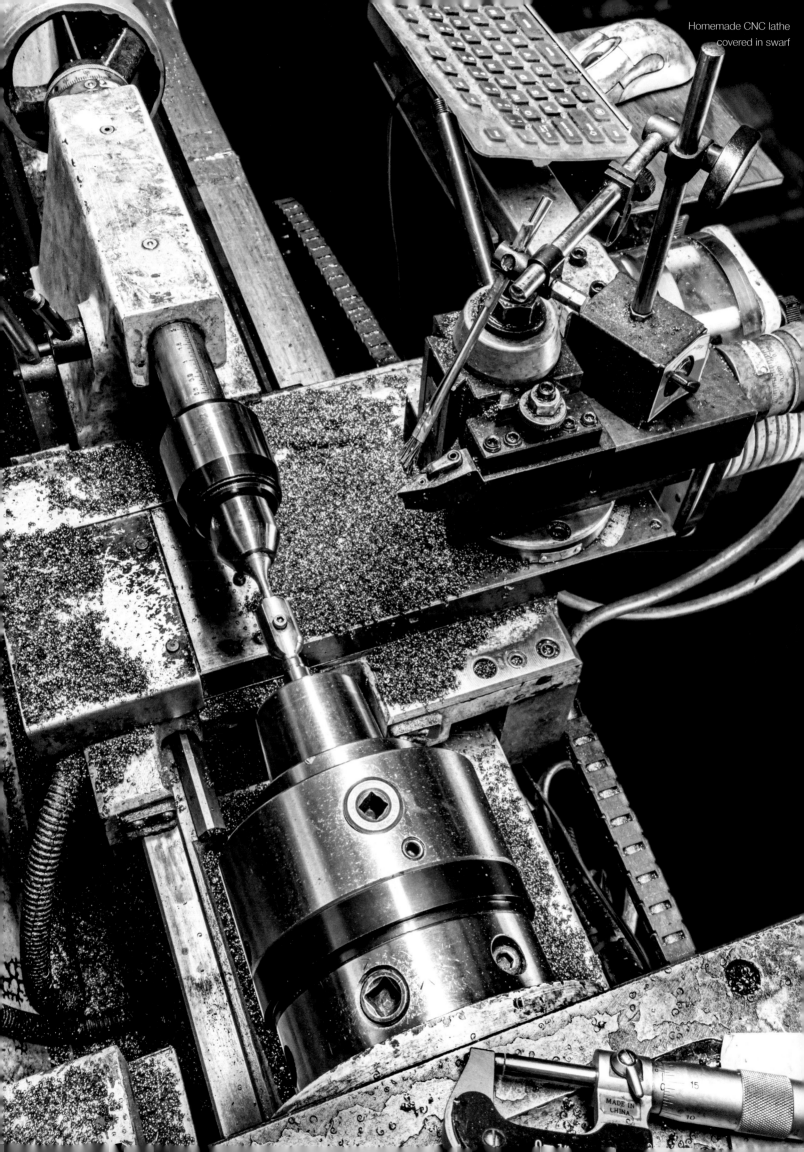

Chapter 14
Toolmaking for Art's Sake

Toolmaking has always been a part of my practice; sometimes this is driven by frugality or necessity, but just as often it is out of a desire to learn something new. I often seek out excuses to employ new tools or to build upgrades to my existing equipment because there is a special satisfaction in inventing novel technical designs that then lead to novel aesthetic ones.

It is also common for other craft practitioners to fashion their own tools; woodturners often shape and grind their own lathe tools, and ceramicists are legendary for repurposing and modifying all sorts of objects into various clay-shaping tools. Machining, however, is unique in that it affords a practitioner who has grasped some basics of engineering the ability to invent and build nearly any tool imaginable. Given time and resources, entirely new types of machines can be constructed if the task at hand calls for it. This distinctive feature of machining means that the possibilities for invention in art making are difficult to understate.

While not all of the machines, fixtures, and cutting tools I have created over the years would be suitable for a production environment, they are more than capable of producing interesting results in the hands of a sculptor. In addition to larger pieces of CNC equipment, I have also produced countless fixtures and ancillary tooling to expand the range and capabilities of those same machines. I have adapted fourth-axis rotary tables for CNC control and modified tool changers to fit machines they were never intended for. For fun, I once cobbled together an automatic drawbar out of an impact wrench and pneumatic cylinder. It worked okay, but it was loud and temperamental. Once, I built a large-format 3-D printer from the parts of a running treadmill that had been struck by lightning.

Even some of the more turnkey pieces of equipment in my shop have needed significant modification to work within a studio context. Many industrial tools are not suitable to run on residential power, and so they need extensive rewiring or to have their motors completely replaced. Given that the entrance to my studio is small, nearly every piece of heavy equipment I own has had to be at least partially disassembled and rigged in order to be brought through the door.

Homemade CNC controller and power supply

In all these projects, whether they were complex multiweek machine builds or quick and dirty modifications to existing tools, they served to inform my attitude that tools are not fixed objects you buy and use for a narrow purpose, but moldable and adaptable things that can be altered as I see fit. It is a philosophy that allows me to think outside the constraints of what is commercially available to me. If I can't buy it, I can build it, and that is freeing in many ways. While there is nothing glamorous about most of my tool-building exercises (they are tools, not art, after all), they still demonstrate some of the ways that engineering has become integral to my thought process.

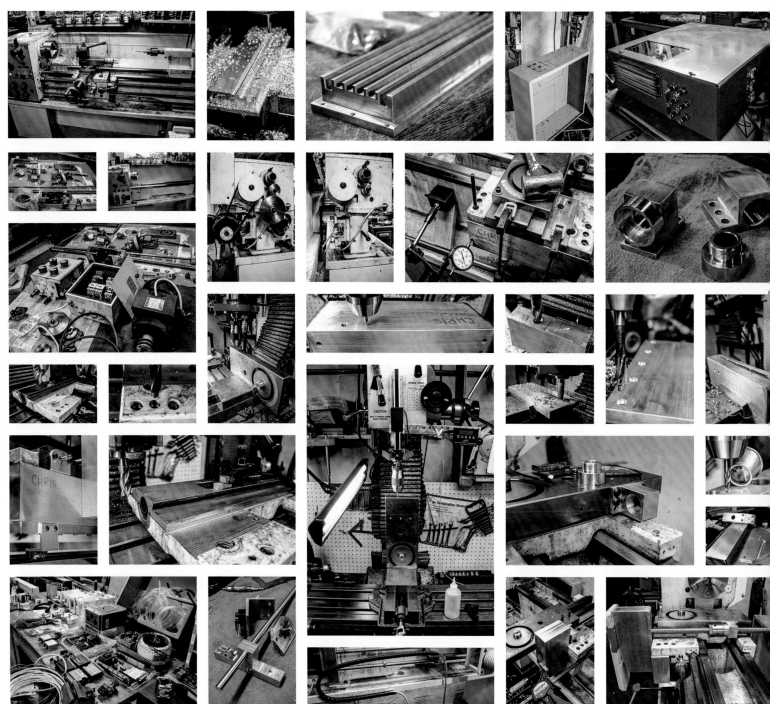

CNC lathe conversion collage

My sculptures are not figuratively derived; their outward appearance is in direct relation to how they are constructed, which is not unlike a machine. However, the phrase "Form follows function" is not an accurate way to describe the relationship I have to engineering, because it implies that function precedes the form in importance, and that is not accurate. Many times, the function of a sculpture is derived as a result of a form I want; other times, it arises by addressing both a mechanical and an aesthetic element at the same time. There is a give and take that one simply would not find in industrial design, because if the function doesn't work with the form, it is simply discarded in favor of something else. A designer would never say, "I tried to make an interesting clock, but it didn't look right so I turned it into a beautiful pizza oven instead." It's a stretch, but that is a closer analogy for my approach.

I thought it would be instructive to include documentation from one of my tool builds. On these pages are a smattering of images from a project I undertook in 2011 to convert a 14 x 40 conventional engine lathe into a CNC lathe. Even today, there are very few options for amateur machinists

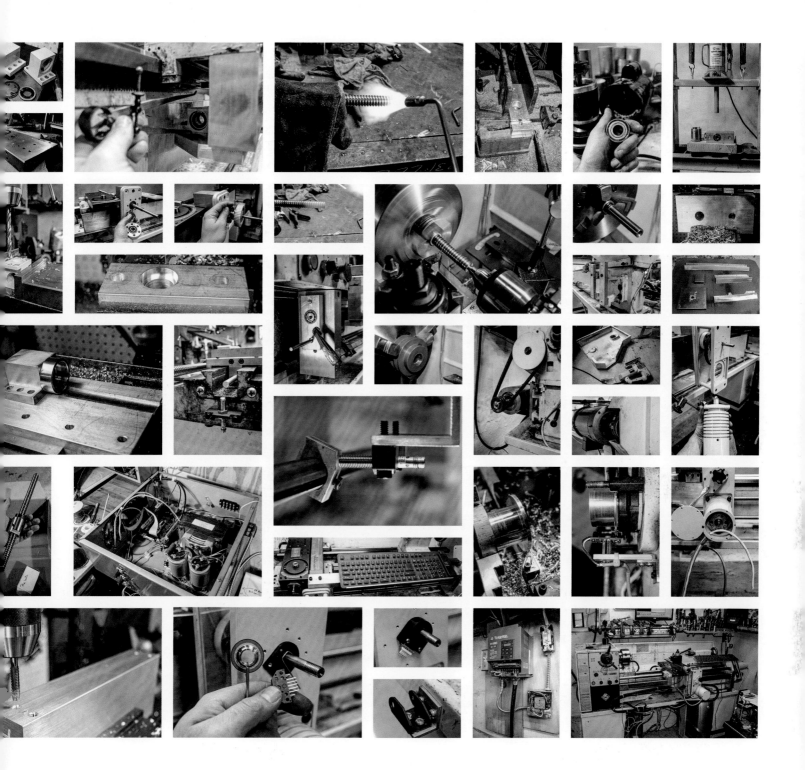

and artists to own an automated machine with this size of work envelope and flexibility. Most hobby CNC lathes are smaller and of a completely different design. These have their own advantages, but if you need to get large workpieces onto a turning center, you are out of luck unless you have a big budget. So the best option in some scenarios is to build your own. This is the third CNC conversion I undertook, following a milling machine and a smaller CNC lathe. Out of all three machines, this is the only one still in full use in my shop. I have modified, broken, and repaired this machine many times since these photos were taken. And while there are quite a few design changes I would make if I were to build this machine today, this piece of equipment remains one of the most versatile and useful tools in my studio.

If the images in this section remind you of the ones from my sculpture process collages, then you are on to something. It is just one more example of how machining dissolves the lines among art, craft, design, and making of every kind.

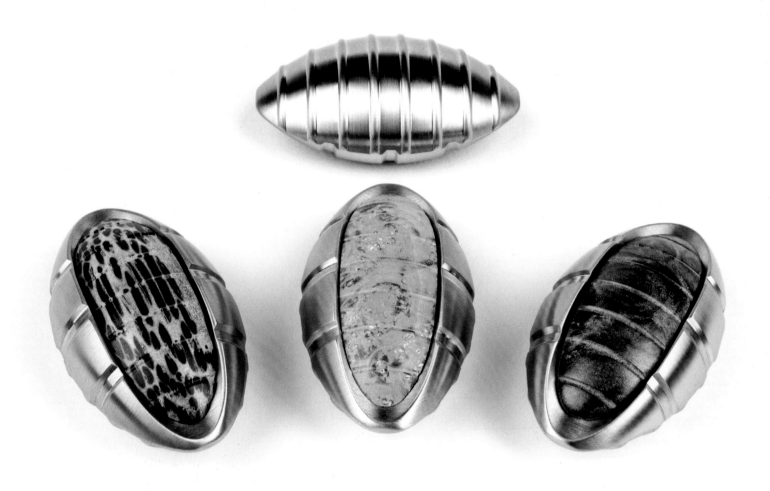

Woody Worry Stone in black palm, box elder, and redwood
2.2" x 1.25" x 1", 2020

Projects in hardwood:
Within the knife-making community, there is a tradition of using a wide variety of domestic and exotic hardwoods to fashion handles and other decorative elements. Overall, the importance of material selection within knife making seems so strong that it often is the determining factor in any given design.

In my own work, my exploration of sculptural knife making became a rather unexpected gateway to the incorporation of hardwoods. For so many craftspeople, working with wood is a given; as a material, it is both timeless and familiar. For me, having spent my career solely as a metalworker, I had the uncommon luxury of approaching wood as an almost alien substance, with characteristics that would take me far outside my comfort zone. I reasoned that if I was going to go down this road, I wanted exposure to as many varieties of hardwood as possible. So throughout 2020, I would embark on a number of projects that would facilitate an expansive education in a medium that is, to many, second nature.

The Woody Worry Stone was my first project and introduced me to dozens of species of natural and stabilized hardwood. From there, a kinetic work called the SPG (which incorporated haptic elements) and a larger, more sculptural design based on the Woody would soon follow. Each of these projects utilized standard knife blocks that are made and sold within a cottage industry of niche suppliers.

258

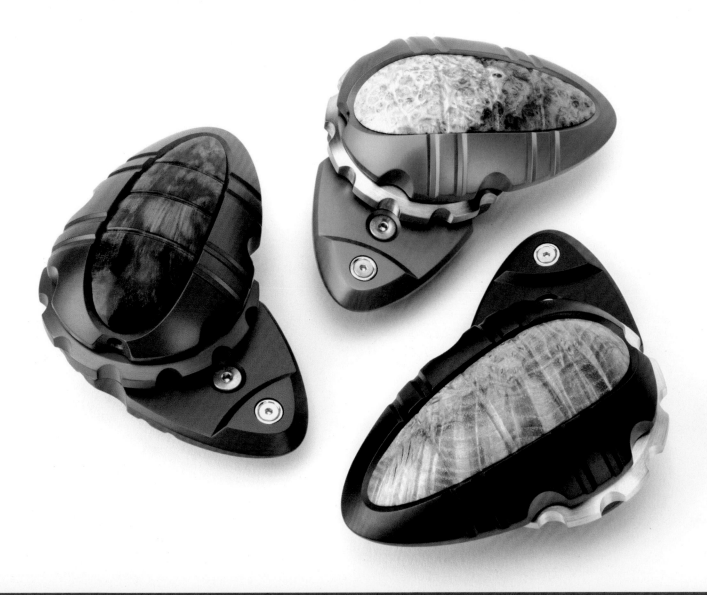

SPG

Aluminum, brass, stainless steel, amboyna burl, snakewood, and black ash

3" x 2" x 1.5", 2020

SPG technical drawing

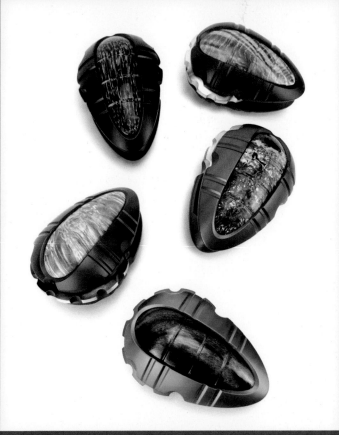

SPG in black palm, black ash, box elder, and desert ironwood

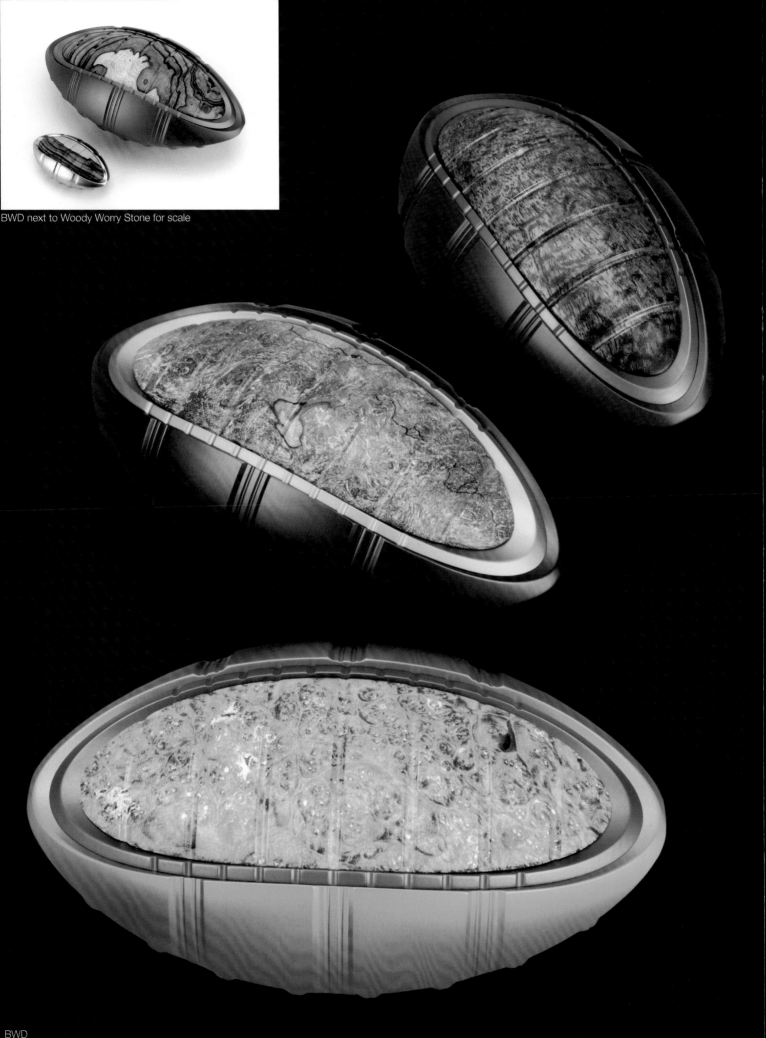

BWD next to Woody Worry Stone for scale

BWD
Aluminum and stabilized afzelia lay (*top*), stabilized spalted maple (*middle*), and stabilized box elder (*bottom*)
5.6" x 3.14" x 2.3", 2020

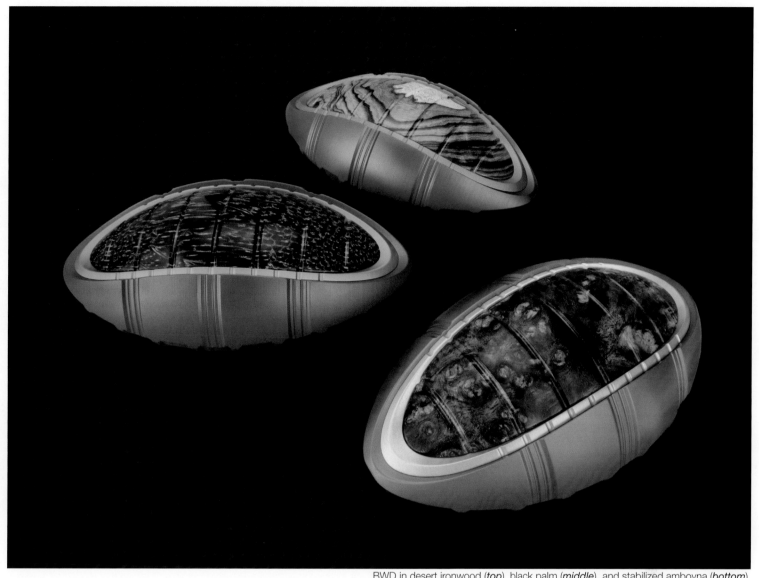

BWD in desert ironwood (*top*), black palm (*middle*), and stabilized amboyna (*bottom*)

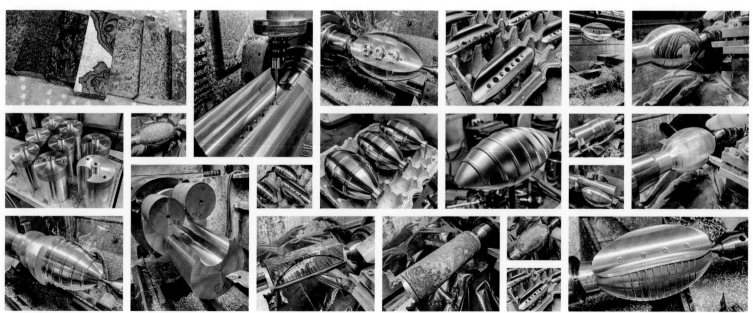

BWD process collage

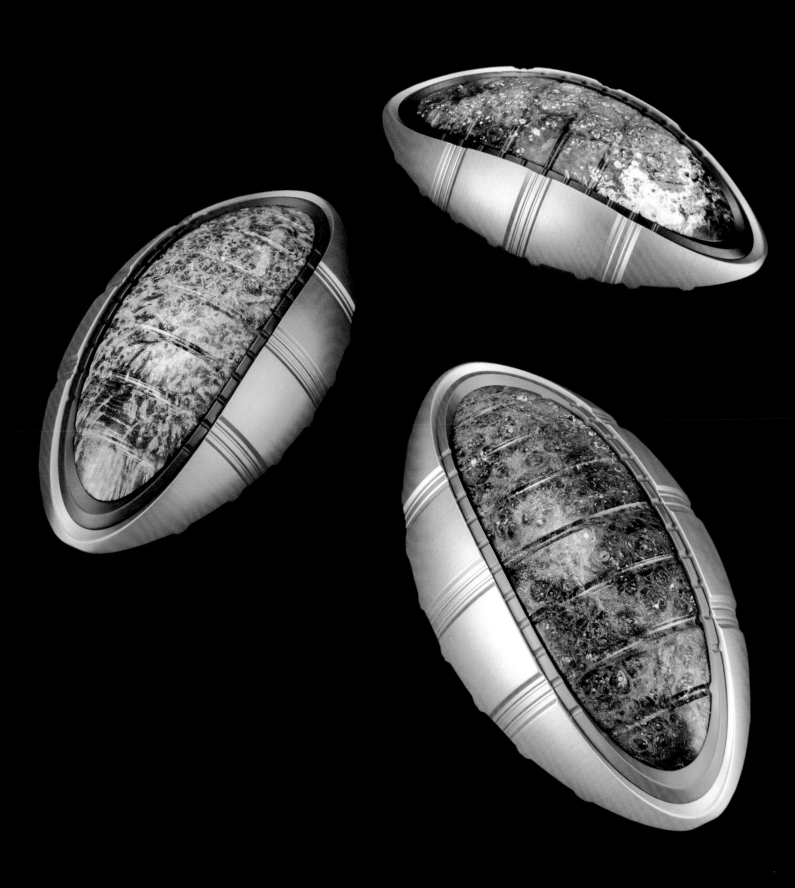

BWD in stabilized black ash (*left*), and stabilized box elder (*top and bottom*)

Meteorite and the decorative arts: This very special, one-of-a-kind variation on the Woody is made using a piece of Aletai meteorite, an iron-nickel meteorite that, when etched, exhibits a fascinating crystalline structure that can be found nowhere on Earth.

This pattern, called the Widmanstatten pattern, is formed when alloys within the meteorite cool very slowly over millions of years. This incredibly slow cooling allows crystals of different elements within the meteorite to form and grow very large. Only rocks of extraterrestrial origin have this pattern, and it is not possible to create them artificially. While this pattern's existence has been known for only two centuries, makers have been using this naturally occurring steel for millennia.

Before humans had the technology to smelt iron ore into usable alloys, they made steel objects simply by finding the stuff lying around on the surface of the earth as rocks. Those rocks were almost certainly meteorites, since it was the only source of refined iron on the planet. Skilled Bronze Age artisans were some of the first to find ways to craft knives and many other objects with this strange and very strong material. Iron meteorite artifacts can be found as far back as the fourteenth century BCE, most famously a dagger found in the tomb of King Tutankhamun.

It is an incredibly popular material within knife making and niche craft circles but has limited applications because of the difficulty in sourcing and working such an exotic material.

Only one of these special pieces was ever made.

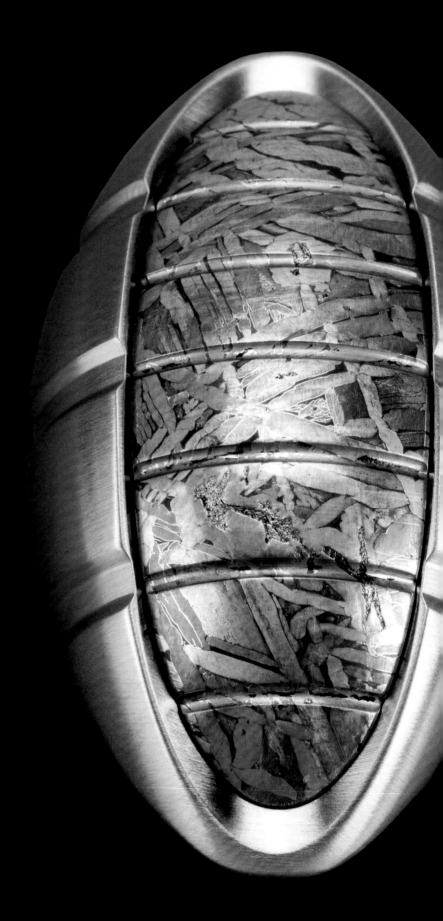

Meteorite worry stone

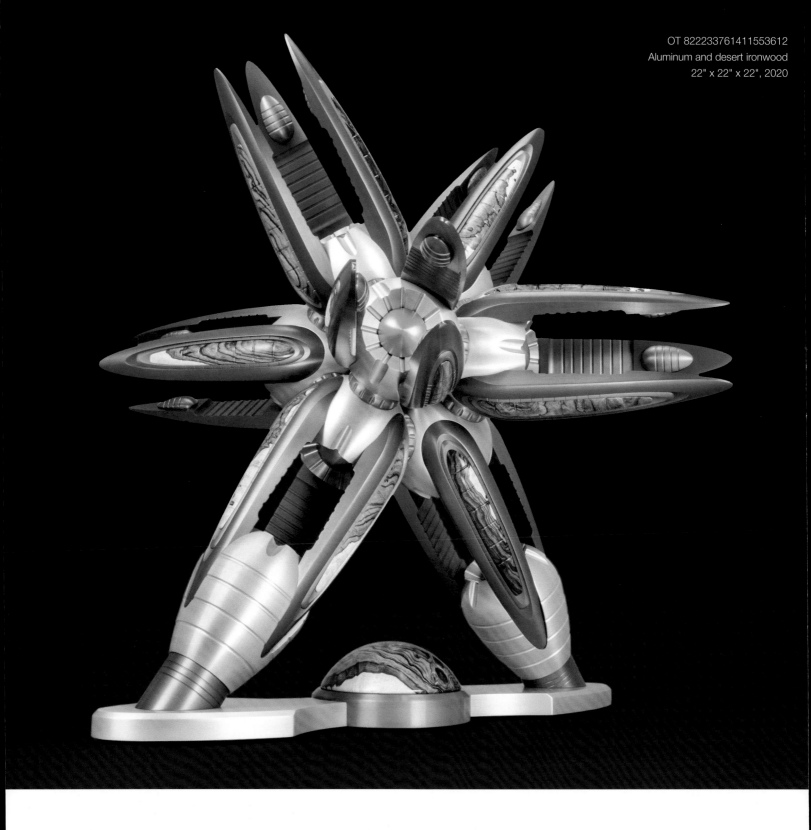

OT 822233761411553612
Aluminum and desert ironwood
22" x 22" x 22", 2020

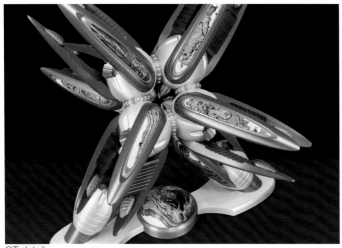

OT detail

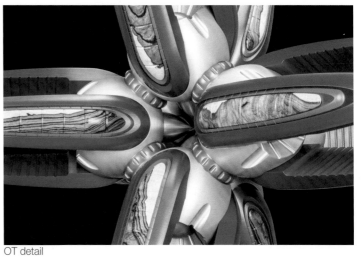

OT detail

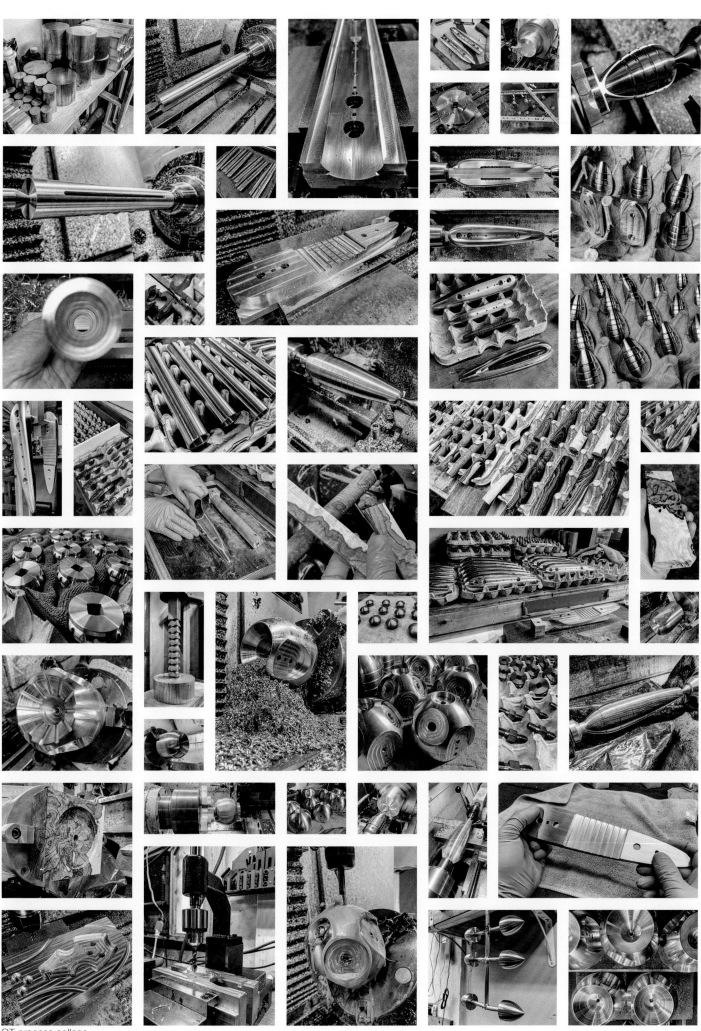

OT process collage

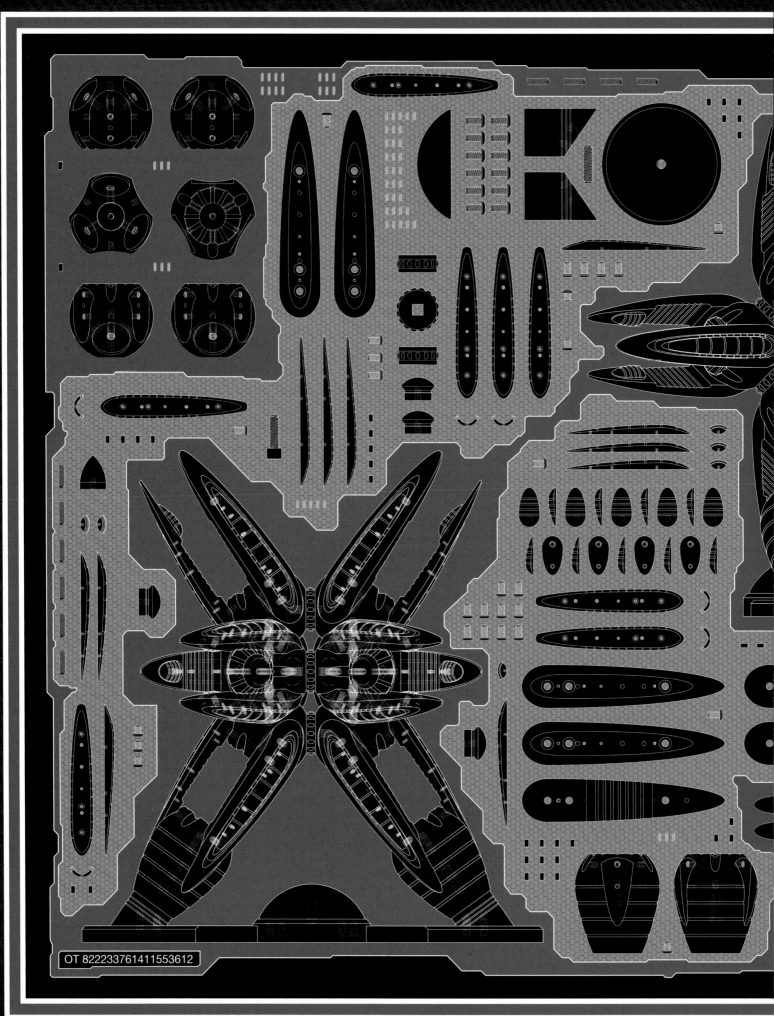

OT 822233761411553612

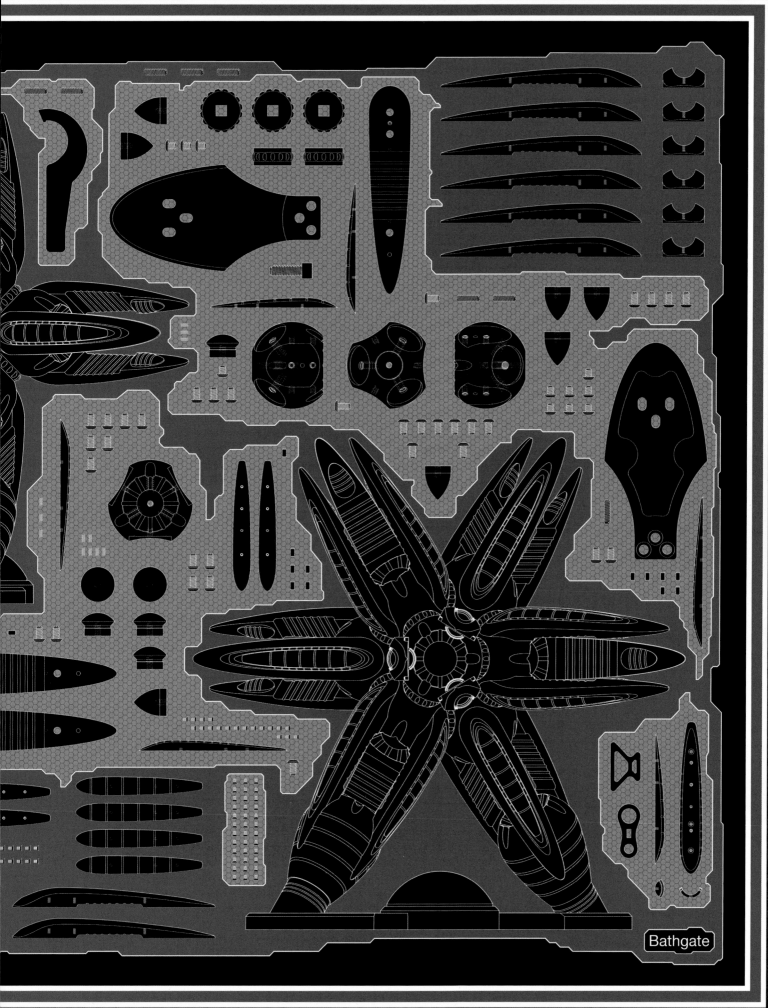

Bathgate

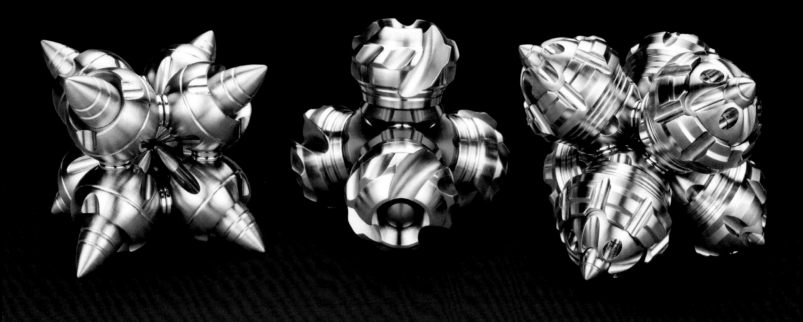

Module series: NC-3 (*left*), TKS (*middle*), and Mod-3 (*right*)

The Module series: This tryptic of small sculptures is a nod to some of the math-art I have encountered while brushing up on the numerous math skills required to be a competent machinist. Geometry is so common within the world of machining that I often take that fact for granted. Luckily, there are artists who relish engaging with mathematical principles, and they have repeatedly shown me there is a lot of beauty in expressing even the simplest of mathematical concepts.

Each work in this series is composed of identical modules that are assembled using an array of magnets. The modules can be quickly disassembled and reassembled, with their arrangement based on the geometric properties of what are known as platonic solids. Each sculpture references a different solid, from which I have taken the constraints that guided the engineering and aesthetics for each work.

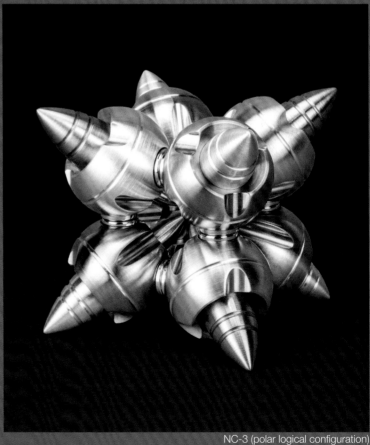

NC-3 (polar logical configuration)
Stainless steel and brass
1.5" x 1.5" x 1.5", 2021

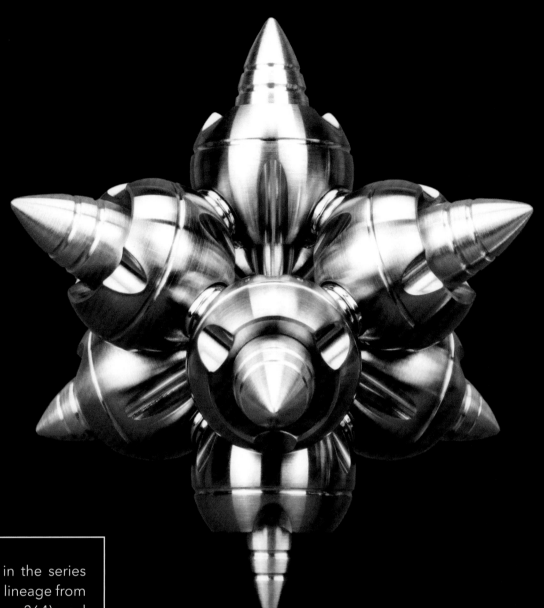

NC3: This first work in the series draws a direct aesthetic lineage from sculpture OT 822 (page 264) and comprises just two unique machined parts. Aside from the fact that you are able to take it apart, it has no other moving parts. Each module simply threads together, the inner part piercing the outer. From there, the magnets do all of the work.

While cubic in appearance, the geometry necessary to machine this piece is derived from the dihedral angle of the faces of an octahedron. Eight faces meant I could evenly distribute the polarity among the modules, simply alternating positive and negative poles on adjacent module faces. The result is that this work is nearly self-assembling.

NC-3 mounted on 3-D-printed stand

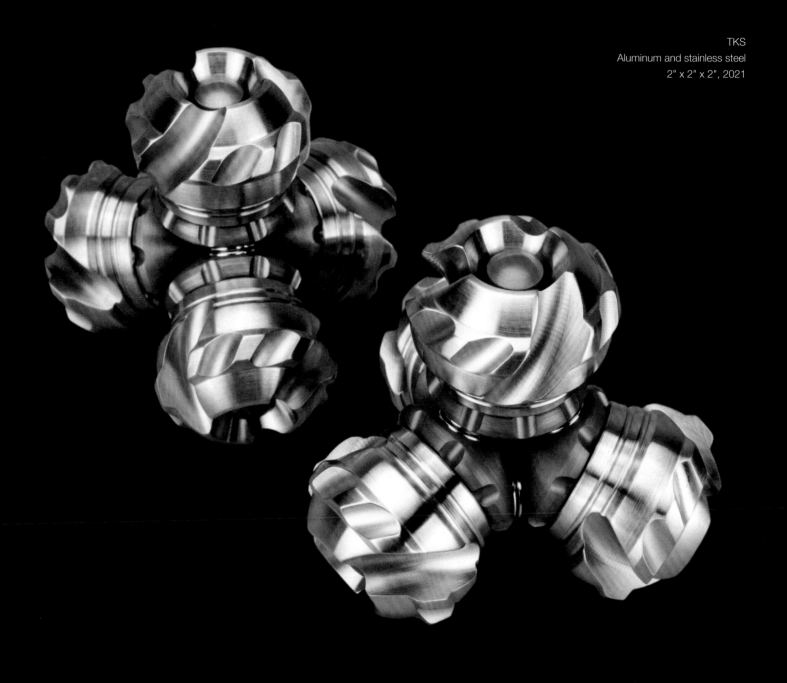

Design Projects

The TKS: Based on a tetrahedron, this design required brushing up on some interesting physics principles to bring it to fruition.

To complement the magnets used in the modular assembly, I introduced a set of ball bearings to the configuration, which allow each module to rotate freely on its axis. This created a remarkably tactile sculpture that spins and rolls in your hand.

Using magnets to mate the modules in the shape of a tetrahedron does not present a straightforward solution in terms of arranging the polarity across them. Getting each module to attract the others in a stable magnetic arrangement required drawing up a complex polarity map that makes assembly much more puzzle-like.

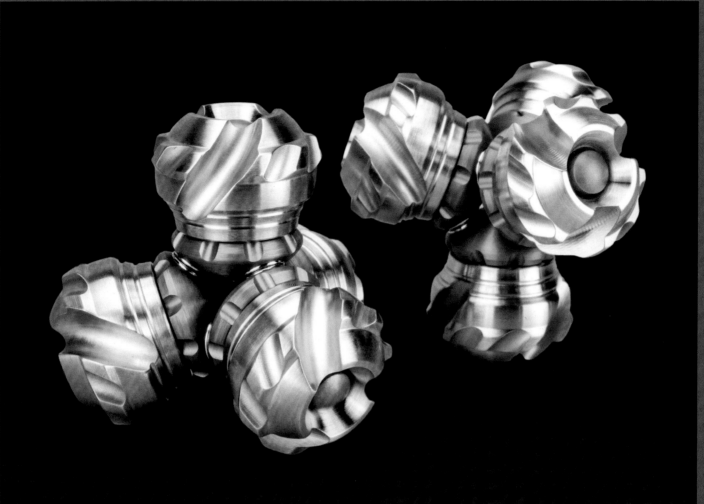

TKS in green and orange anodizing

Getting the bearing mechanic to play nicely with the magnets meant leveraging the magnetism inherent to the assembly. Magnetic bearings were selected to limit the need for additional hardware. However, in early prototypes, the centrifugal force of spinning the sculpture was prone to sending parts flying. Fine-tuning the geometry to balance the mass of the parts and the magnetic forces employed to hold them together was a devilishly fun problem to solve.

In order to tweak the engineering of the piece, I applied what is known as the square cube law to make the parts lighter, and the inverse square law to adjust the position of the magnets to increase the attractive force between them. After many calculations and adjustments to the design, I had a cleverly designed and beautiful, kinetic sculpture.

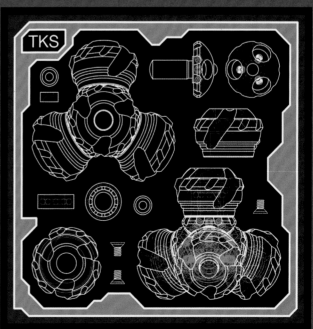

TKS technical drawing

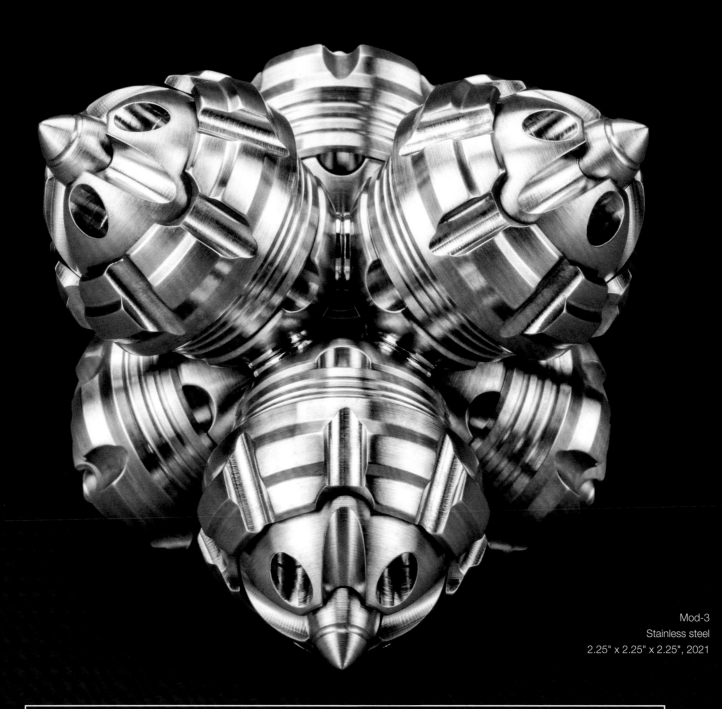

Module 3:
The third and final work in the series uses a hexahedron for its composition. This shape presented an opportunity for creating a linear mechanic, using switching magnetic fields.

Because of the way the modules were assembled, I was able to create an arrangement of magnets that allows a hub on each module to slide along its axle when rotated 90 degrees. This motion is achieved by bringing the polarity of internal magnets into alignment in such a way that they alternately repel and attract one another, not unlike an electric solenoid. The effect is that the work has many different static states, which makes this the most transformative of my works.

While this work was originally intended as a single piece of art, it became two. I was so taken with how charismatic and detailed the individual modules were, I felt they should be considered as a sculpture in their own right. So I 3-D-printed some stands to allow them to stand alone, and simply called it the Mini. Sometimes it is that simple.

There is much about art making that is difficult to explain. Engineering—and the math and science that accompany it—is a great lens for explaining how different modes of thinking come into play when being creative, because engineers (like artists) are problem solvers, and tangible problems can be articulated in a way that some creative behavior cannot. The demands of function do not always play nicely with form (no matter how the saying goes), but when it does work, engineering can be leveraged to reveal aspects of your creative instincts by connecting them to functional outcomes. Likewise, if I am struggling to access my muse, getting my mind and hands moving on an engineering problem can prime the pump to get aesthetic ideas flowing again.

This series helps reinforce something else special about kinetic sculpture. That is simply the tactile nature of object appreciation. Art that you can hold isn't always regarded as a high concept within white-box gallery settings, but there is instinct and history in making objects that satisfy this easily overlooked way of experiencing art . . . with your fingers!

Mod-3 in open position

Bathgate: Module 3

Mod-3 technical drawing

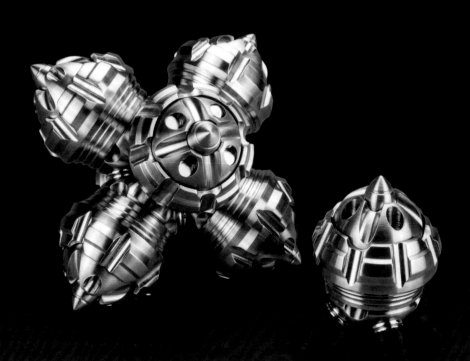

Mod-3 and Mini on 3-D-printed stand

Mazer M1
Desert ironwood, amboyna burl, and stainless steel
6" x 6" x 1.6", 2021

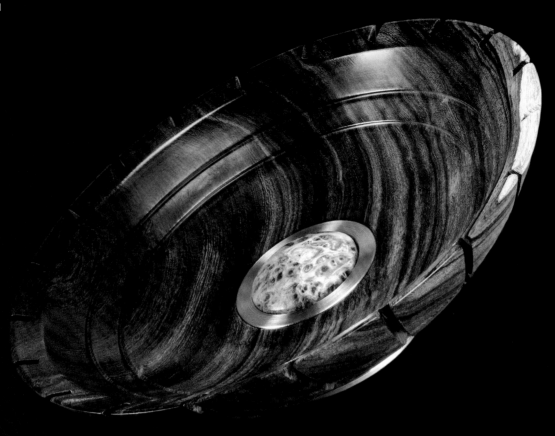

Mazer series: This series of Mazer-style bowls began with an attempt to salvage a piece of desert ironwood left over from another project. It was a beautiful blank, and so I indulged myself. Improvising a decorative foot and boss transformed the blank into a sort of Mazer-style bowl (the M1). I had so much fun, I decided to make it a triptych.

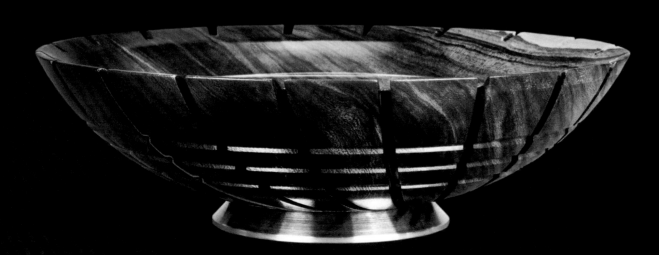

Side view of the Mazer M1

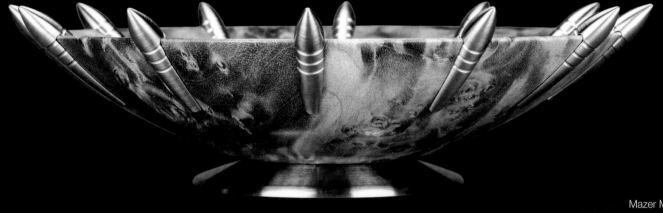

Mazer M2
Stabilized maple burl and stainless steel
7" x 7" x 1.875", 2022

My second attempt (the M2) became a rather pressing excuse to learn more about resin-stabilizing my own hardwoods. For my earliest projects that utilized stabilized wood, I had been completely reliant on material created by other skilled makers. As this work evolved, the limitations and unreliability of these sources became apparent. I realized that if I was going to properly bring these materials into my practice, I would need the ability to make my own—to my exact specifications.

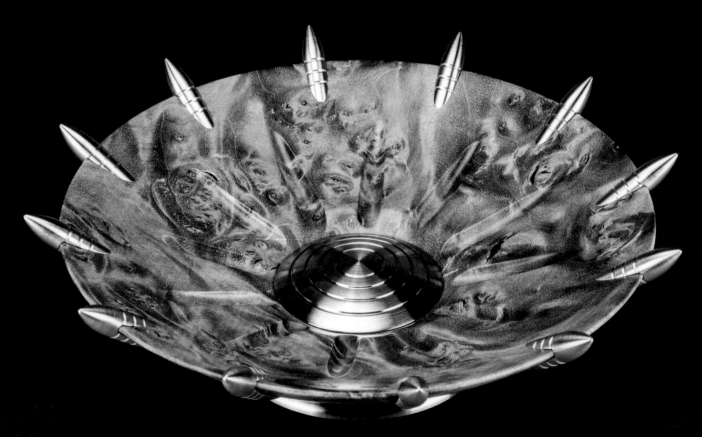

Top view of the Mazer M2

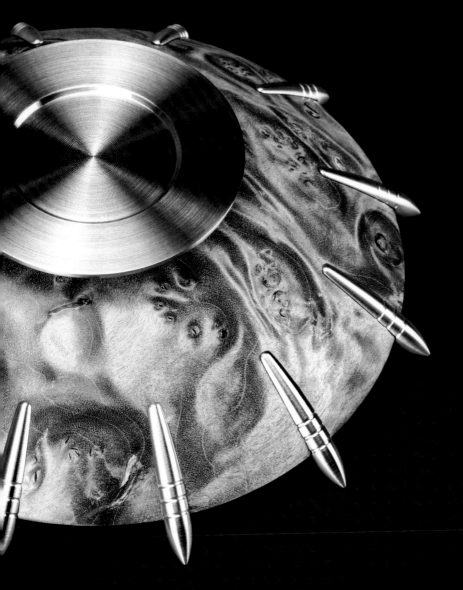

Using heat-activated resins, a vacuum chamber, and a toaster oven, one can transform ordinary hardwood into a much-harder and dimensionally stable substrate that is well suited for integration into engineered compositions. One can also introduce colored dyes into the heat-cured resin for a much more dramatic transformation of the wood.

The composition of the M3, the final work in the series, is quite shallow; one could barely call it a bowl at all. But I decided to run with the idea that many utilitarian crafts eventually drift from function in pursuit of more-decorative concepts. So I prioritized the aesthetic I was hoping to achieve, and adhered only to the barest interpretation of what a bowl could be.

Bottom view of the Mazer M2

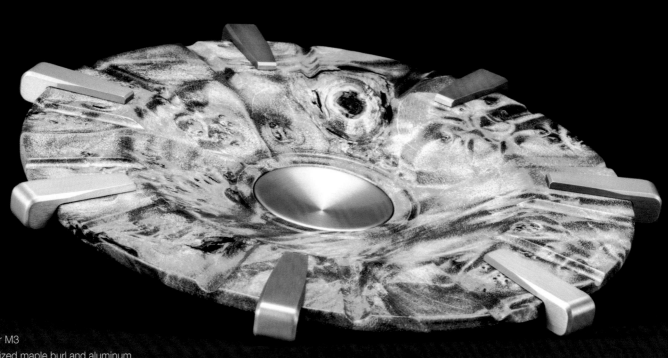

Mazer M3
Stabilized maple burl and aluminum
7" x 7" x 1.125", 2022

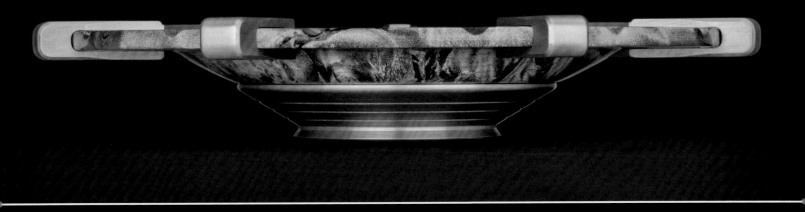

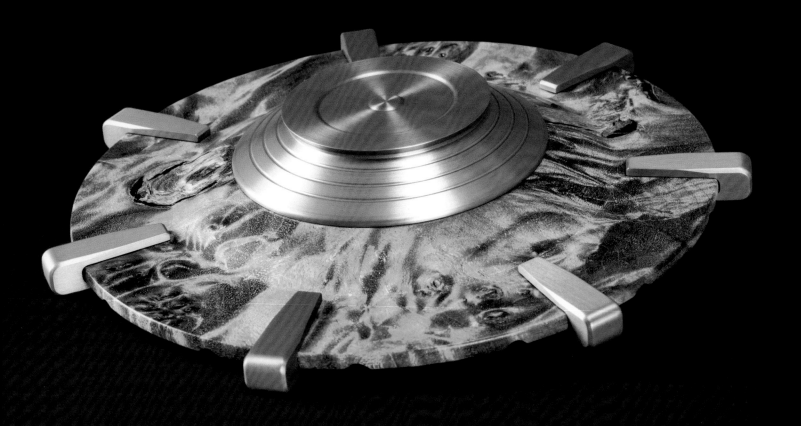

Parts in egg crates

Chapter 15
It Isn't the Tools, It's Who Gets to Use Them

We often look to the past to put the present into context and formulate educated guesses on how to most effectively move into the future. But try as we might, objective history inevitably gets tangled up with nostalgia, and we often draw the wrong conclusions from idealized histories. Even now when I talk to craftspeople, I get the sense from many that they long for an older, simpler way of doing things—as if life and art making have ever been simple. From the narratives that have been handed down through various craft movements, I suspect that there were elements of well-meaning if misplaced protectionist instincts as well. Whatever the reason for the delayed integration of automation technology into the arts, I am glad to find myself in a time where whatever spell turned artists against it has been broken, because I think it helps reveal a broader truth (or warning) about technology.

After two decades of working with digital-fabrication technology and observing the ways that artists are now bringing it into their crafts, it's apparent to me that the arts are far better for it. Like many vanquished dogmas, the danger of automation turns out not to have been with the tools themselves, but with who gets to use them and for what. It is now clear that in the hands of skilled craftspeople, the tools of mass production can be leveraged for remarkable creative achievements. However, that doesn't mean that craftspeople in the twentieth century weren't on to something when so many turned their back on modernization. The forces that drove the studio craft movement to reject the machine are still at work today, but they have much more to do with the way technology is applied than with technology itself.

In his book *Shopcraft as Soulcraft*, author Matthew B. Crawford argues that in the early 1900s, it was the organizational structure of industrialized workplaces that brought about the separation of thinking from working within the manual trades. It wasn't the machines that craftspeople should have been wary of; it was the work ethic they fostered and the social forces they helped amplify. That is, the de-skilling of workers and the stratification of knowledge within the trades was the result of making each worker responsible for only a tiny element within the production of an object, thus depriving them of a deeper understanding of what they were doing and the ability to take pride in how they were doing it. The division of labor greatly diminished the need for holistic knowledge and encouraged the replacing of skilled workers, who possessed broad technical expertise, with low-skilled interchangeable workers who could be trained to perform a single simple task ad nauseam.

Process design streamlined many aspects of how a product was created. It produced enormous benefits for society but also allowed companies to limit the amount of transferable skills their employees could acquire, and moved institutional knowledge out of the labor force and into the office suite. It consolidated power within management, and it limited competition and the bargaining power of employees for equitable accommodation. Indeed, it was poor conditions, the mind-numbing nature of the factory environment, and the desire to make a living through meaningful and varied work that drove so many to abandon modernization to take up the craft lifestyle and attempt to generate an income selling their wares.

This is poignant today because it points to the importance of acquiring and maintaining a diverse range of skills both for personal well-being and as an antidote to exploitation and change. It is never the case that technology is destined to rob us of the knowledge and opportunity to make expressive art or to find meaningful work, but it will if we allow technology to empower others to do so.

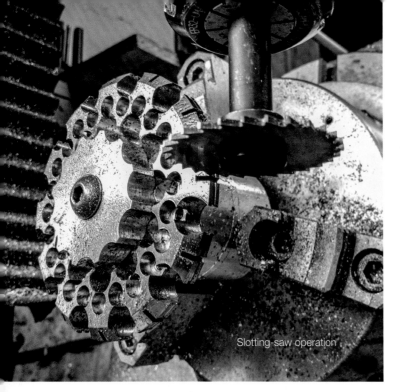
Slotting-saw operation

I am not recommending that everyone become a machinist or some kind of technologist, but if we fail to develop at least a baseline of savvy, then others may attempt to use technology to exploit and extract value from our creative output. In the 1900s, industrialization was the technological double-edged sword; today, it is the web. Any artist who has become reliant on social media, a streaming service, or some other aspect of the consolidated internet to reach an audience is acutely aware of the power imbalance in which many of us find ourselves. Likewise, the peril and promise of artificial intelligence has now moved off the horizon, and looms as a massively disruptive force for the arts and many other professions. And while further discussion of this as a subject is best left to another book (try *Chokepoint Capitalism* by Rebecca Giblin and Cory Doctorow), the most prudent response is not to reject a given technology or foster ignorance of it. Instead, we should strive to understand the mechanisms at work to better advocate for ourselves and bend circumstances toward something more equitable.

Whether you are an artist or some other flavor of maker, we now find ourselves in an information ecosystem where corporations are not the only ones with access to cutting-edge design and fabrication technology. I for one intend to continue bringing every interesting process I can get my hands on into my humble studio for creative investigation. And while we all have to find our calling (and niche) in our own idiosyncratic way, there is no harm in stating that even if you are committed to using the most-basic techniques and materials, being aware of the context in which those processes exist can only strengthen your approach. As artists, craftspeople, and designers, we can refuse to learn new things and complain that technology is pushing the old ways to the margins, or we can synthesize that technology to recontextualize and amplify what is fundamental about historical ways of making. If we don't appropriate technology and use it to empower our work, we may find it used against us in ways that are hard to predict. The choice is ours.

Milling features on sculpture BY 222422

For workers, unlike the archetypal factory floor of the twentieth century, the modern production environment presents a path with many opportunities for skill acquisition and varied, meaningful work. This is especially true if you find your way into the more technical or specialized subdisciplines within the field of machine work. If you work in a small shop, or run your own, you have the tools at your disposal for all sorts of creative or commercial inventions. As I have advocated throughout this book, even if you are a machinist who finds themselves with less than meaningful employment, there is always the possibility of turning your skills toward the arts. With the lines between commercial design and artistic endeavor continuing to blur, it is hard to say what opportunities one might stumble into by taking on a passion project over a profitable one; if we are lucky, the former might just become the latter anyway.

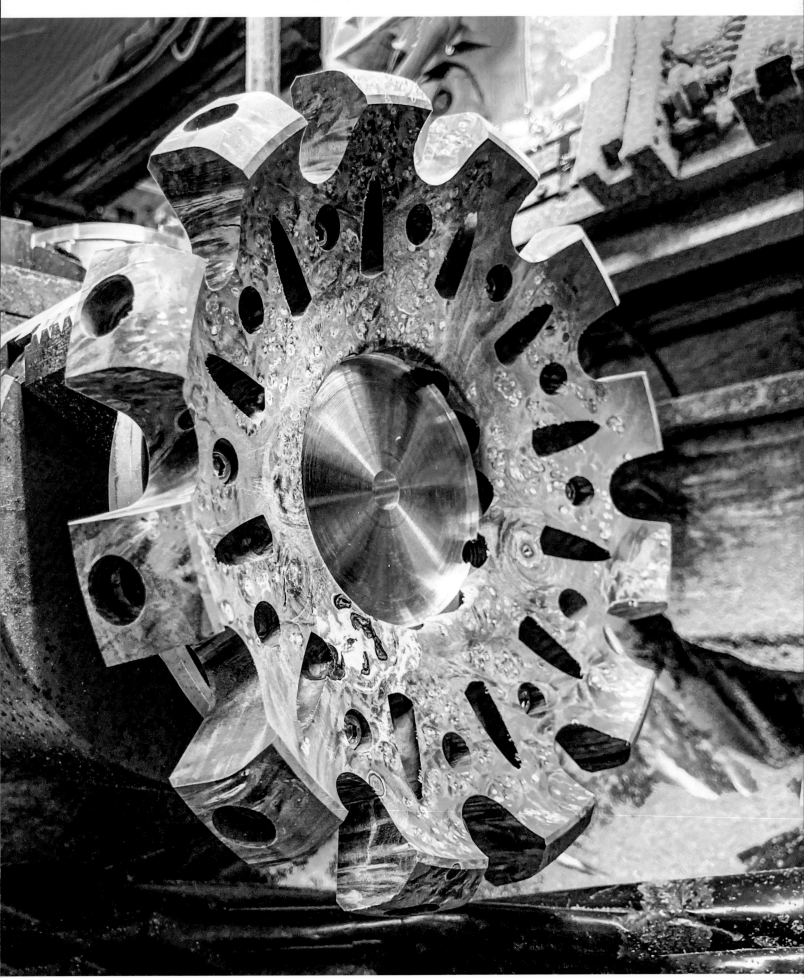

Turning features on sculpture BY 222422

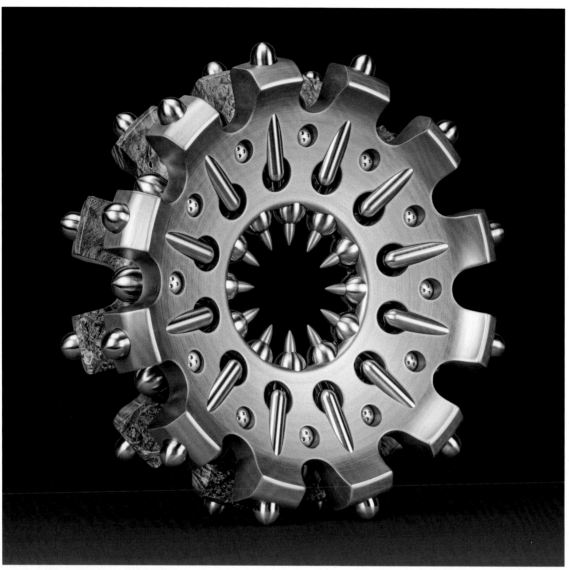

Aluminum face of sculpture BY 222422

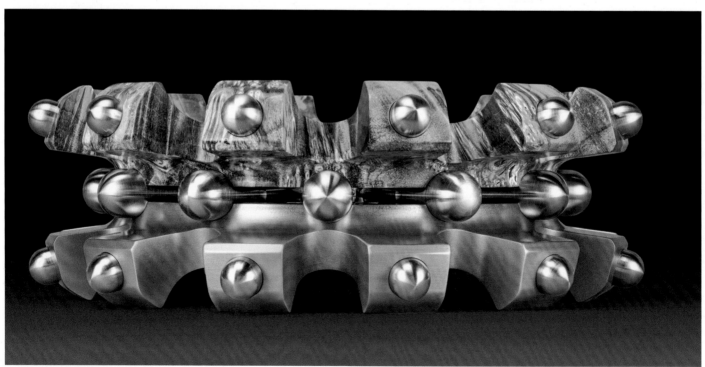

Side view of sculpture BY 222422

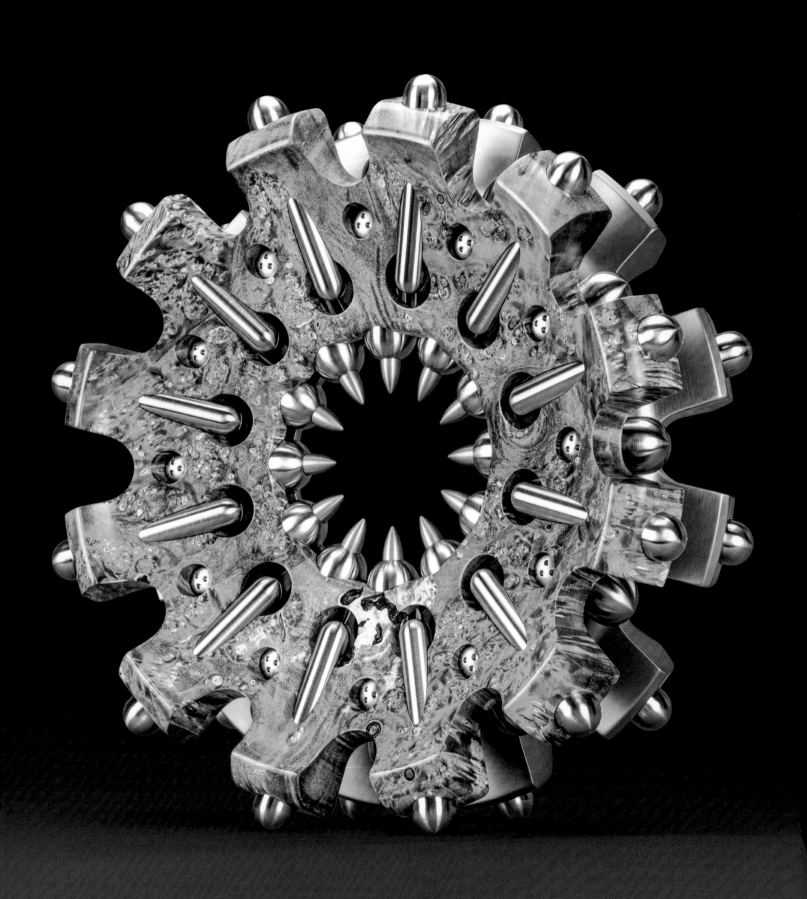

BY 222422
Aluminum, stainless steel, and box elder burl
8.4" x 8.4" x 2.5", 2022

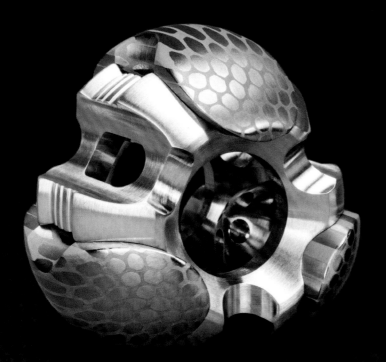
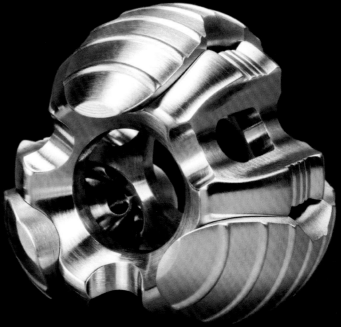

SB312222416, stainless steel, copper, and superconductor. 1.3" x 1.3" x 1.3", 2022

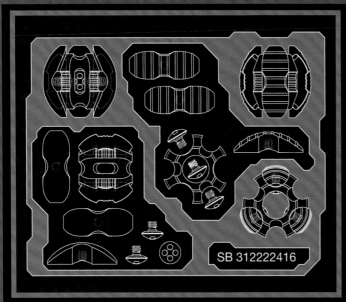

SB312222416 technical drawing

SB312222416 with superconductor

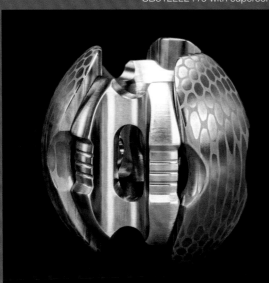

SB 312: As hardwoods and burl are to woodcraft, exotic metals have emerged as a defining feature of many decorative machining traditions. Some of these materials have been borrowed from metalsmithing, while others are more-modern inventions. Either way, I felt it was time I took on some of these materials in a considered way to see what new directions they might enable.

The first material I chose is colloquially known as "superconductor" (*above left*). Originally used for scientific purposes, it is characterized by rods of niobium–titanium, arranged within a larger body of solid copper. It is a metal whose surface presents a sort of abstract end grain that can be obtained in a range of patterns. When it's machined into compound forms, a machinist can reveal a very pleasing type of geometric figure. Etching processes can then be applied to selectively dissolve and accentuate the surface, converting this pattern into a high-relief texture.

S2B technical drawing

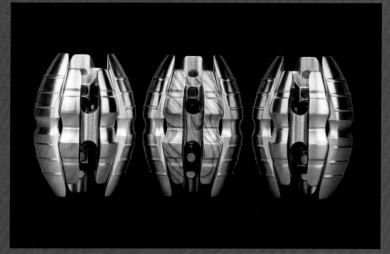

S2B, standing view

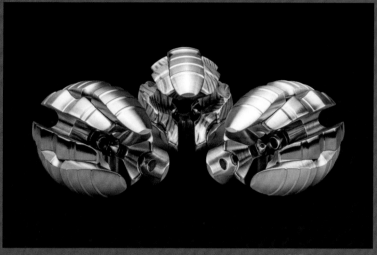

S2B viewed on end

S2B: The next exotic material I chose is called mokumé-gané. Seen here (*right center*) as a copper-and-brass-swirled metal, this material has its roots in seventeenth-century Japan, with the term roughly translating to "wood grain metal" or "wood eye metal." It has been used in decorative metalwork for hundreds of years. Mokumé-gané is made by fusing strips of different metals together into a single billet and then twisting and forming that billet to create different patterns. Some types of mokumé-gané are made from precious metals such as gold and silver, but for this piece the alloy contains the much more utilitarian metals of copper, brass, and nickel silver.

While the first work in the series was a static sculpture, this work introduces a sliding mechanic that allows each of the metal feet to move into different linear positions, using a series of embedded magnets. The configuration is not unlike the MG series (page 230), but it is employed in a much more three-dimensional format.

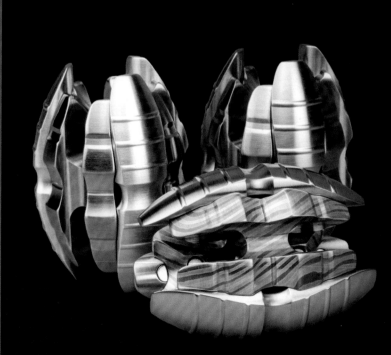

S2B
Stainless steel, brass, and mokumé-gané
2" x 1.5" x 1.5", 2022

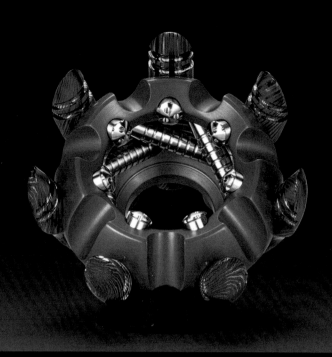
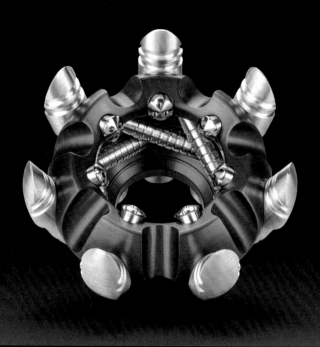
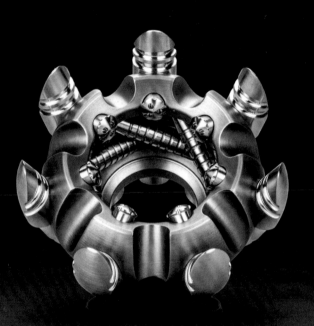
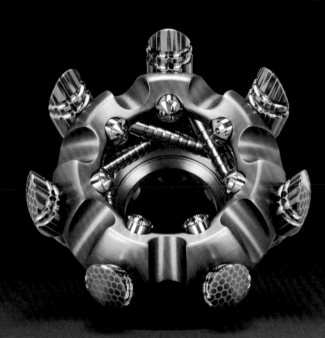

S3C: aluminum, stainless steel, brass, superconductor, and titanium Damascus, 3" x 3" x 2", 2022

S3C: For the final work in the series, I have employed the most modern material of the bunch, titanium Damascus. Made much like mokumé-gané and other Damascus steels, the method for creating this composite was not perfected until the first few years of the 2000s. Forged using different grades of titanium alloy, this material exhibits a striking blue, gold, and purple coloration when subjected to heat bluing and has become an incredibly popular material across many decorative fields.

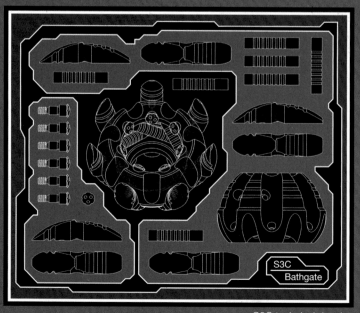

S3C technical drawing

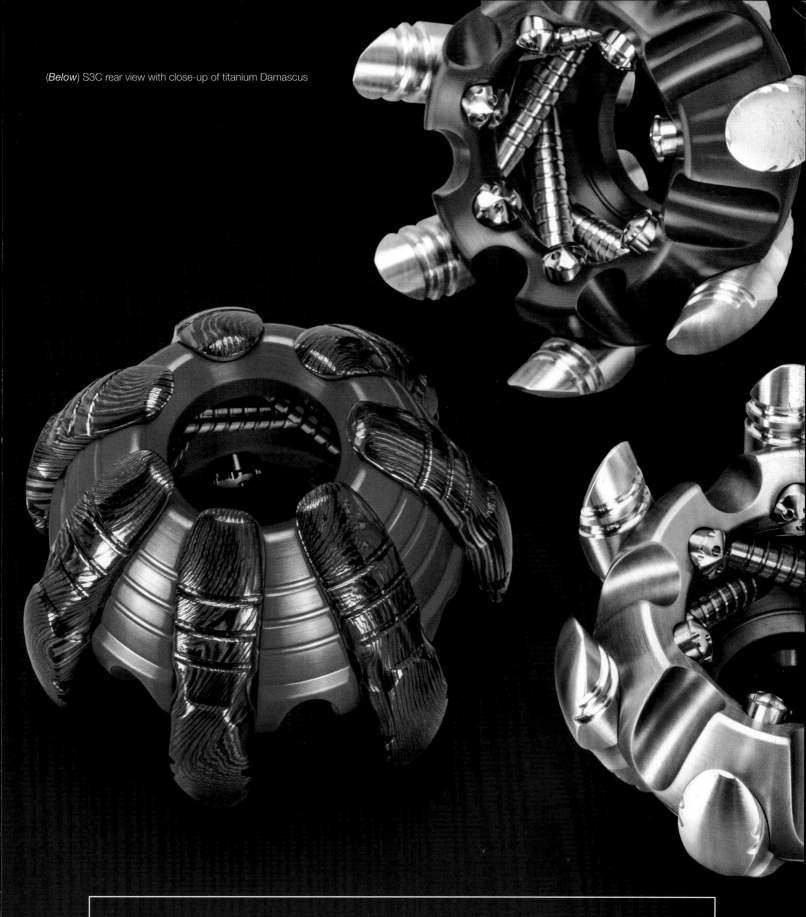

(Below) S3C rear view with close-up of titanium Damascus

While I have highlighted the material elements that are the bones of this particular triptych of sculptures, I would like to close with a theme that has emerged throughout my work; art is at its very best when it is layered and multifaceted. Like Damascus or mokumé-gané, I try to ensure that everything I create is swirled through with the technical, aesthetic, and conceptual qualities gleaned from my process. The rich tableau that is modern machine work, when applied to the arts, can reveal fascinating patterns of meaning and beauty. It is capable of making work as complex as the society that developed these tools and as diverse as the lives of the humble maker who employs them.

Disorganized drills, taps, and wrenches

www.chrisbathgate.com

CHRIS BATHGATE is a self-taught machinist and machine builder whose work lies at the crossroads of fine craft and technology. Born in Baltimore, Maryland, he has spent two decades building and modifying a variety of metal-working tools and machinery. He uses these tools to make intricately machined metal sculptures that defy easy classification. Bathgate has been featured in *American Craft Magazine* and *Make Magazine*. He was twice awarded grants from the Pollack-Krasner Foundation and received Baltimore's Mary Sawyers Baker Prize. Bathgate's works have been exhibited in a variety of museums and galleries, including the Museum of Arts and Design, the Powerhouse Museum, the National Academy of Sciences, the Baltimore Museum of Art, the National Museum of Industrial History, the Baltimore Museum of Industry, and the American Craftsmanship Museum. Bathgate's sculptures are held in private collections around the world.